METHODS AND
MATERIALS OF PAINTING
OF THE GREAT SCHOOLS
AND MASTERS

(formerly titled: Materials for a History of Oil Painting)

by
Sir Charles Lock Eastlake
One-time President of the Royal Academy

In two volumes

**VOLUME
TWO**

Dover Publications, Inc.
New York

Published in Canada by General Publishing Com-
pany, Ltd., 30 Lesmill Road, Don Mills, Toronto,
Ontario.
Published in the United Kingdom by Constable
and Company, Ltd., 10 Orange Street, London
WC 2.

This Dover edition, first published in 1960, is an
unabridged and unaltered republication of the work
originally published by Longman, Brown, Green,
and Longmans in 1847 under the title *Materials for
a History of Oil Painting.*

International Standard Book Number: 0-486-20719-6
Library of Congress Catalog Card Number: 61-459

Manufactured in the United States of America
Dover Publications, Inc.
180 Varick Street
New York, N. Y. 10014

PREFACE

LADY EASTLAKE.

In submitting to the public the chapters des-
tined for the second volume of the *Materials
for a History of Oil Painting*, which Sir Charles
Eastlake left in a state of preparation, Lady Eastlake
is anxious to state how far she has presumed to
exercise the office of editor in the revision of them.
It will not be necessary to assure those readers
already acquainted with Sir Charles's habits of con-
scientious accuracy and patient research that such
habits are as vividly impressed on these chapters as
on all that have gone before. Owing, however, to
the labours of Signor Cavalcaselle,* which were
greatly assisted and promoted by Sir Charles, in-

* A new History of Painting in Italy, by J. A. Crowe
and G. B. Cavalcaselle (1864), authors of the Early Flemish
Painters.

formation has been brought to light proving the falsity of certain long-admitted passages in the history of Oil Painting, without, for the present, substituting any certain facts in their place. This information affects the first only of the chapters now presented—a portion of which has, accordingly, been suppressed. The contents of this chapter especially turned upon the formerly accepted statement that a chapel in S. Maria Nuova at Florence, which belonged to a wealthy family of the name of Portinari, had served as a kind of nursery of the art of oil painting in central Italy. It is known, namely, that a picture by Memling, and a triptych by Hugo Van der Goes—both in oil—were painted for this Portinari chapel (also called the chapel of S. Egidio and the Cappella Maggiore); the triptych by Hugo Van der Goes being still in its place. Vasari also states that Andrea dal Castagno and Domenico Veneziano executed certain paintings on the walls of the same chapel *in oil*. These paintings, which, according to Vasari, illustrated the Life of the Madonna, have long since disappeared, and, with them, all certain evidence of the method of their execution; from the light now obtained, however, it has become doubtful, perhaps more than doubtful, whether any of the series were executed by the process implied by the modern term " oil paint-

ing." The records of the Hospital of S. Maria Nuova, it is true, show that linseed oil was abundantly furnished to Domenico Veneziano during the period of his labours; but this proves nothing more than a use of that vehicle which Sir Charles Eastlake, in his first volume—chapters iii. and iv. especially—has shown to have been, long before the invention of oil painting, common in processes of wall-painting. And this doubt gains further strength from the fact that Signor Cavalcaselle's researches furnish so complete a contradiction to some of Vasari's statements regarding Domenico Veneziano and Andrea dal Castagno, as, in great measure, to invalidate all of them. Not only does it appear that Domenico Veneziano could not have learned the secret of oil painting at Venice from Antonello da Messina, as circumstantially asserted by Vasari (even granting that he ever was in Venice, or ever learnt the secret at all), but it is proved that the crowning act of the romance, which has so long outraged the feelings of Vasari's readers, and of which the possession of this secret is given as the plausible motive, is as untrue as all the rest. It is now known, by incontrovertible documents, that Andrea dal Castagno died in 1457, some years before the alleged murder of his supposed friend and benefactor, and that Domenico

Veneziano survived him four years. The statement also of the rivalry of these two painters—as far, at least, as their supposed simultaneous operations in the Portinari chapel gave it the colour of truth—is equally overturned by Signor Cavalcaselle, who quotes from the records of the hospital attached to S. Maria Nuova, that Domenico terminated his six years' labours in the chapel in 1445, and that Andrea only commenced his in 1451. For all trustworthy information regarding these two painters the reader is referred to Signor Cavalcaselle's work, vol. ii. pp. 302–318.

As regards therefore the importance of Domenico Veneziano and Andrea dal Castagno as links in the generations of oil painters, they may be dismissed from the scene. Still, it is justice to Sir Charles Eastlake to state that his personal observations and complete possession of all other sources of information perpetually led him into modest antagonism with one who, both in style of painting and habits of mind, was perhaps a character as strongly opposed to his own as history could furnish. Many parts of the first volume of the *Materials* bear witness to Sir Charles's conviction of some of Vasari's errors, and to his suspicion of others. As regards Vasari's statement that Antonello da Messina was the first to communicate

the Flemish method of oil painting in Italy, the reader is referred to p. 217 of the first volume, in which Sir Charles shows that many Flemish artists — scholars or followers of Van Eyck—were in Italy and executed works there, about the middle of the fifteenth century. In such portions also of this first chapter of the second volume as Lady Eastlake has ventured to suppress, the difficulty of reconciling Vasari's most circumstantial and positively asserted tale with Sir Charles's own accurate knowledge is throughout apparent. It did not escape Sir Charles's observation that while Domenico Veneziano was asserted by Vasari to be the chief practiser of the new art in Florence, the only two works remaining by his hand, there or elsewhere, are neither of them in oil. The one, the Virgin and Child enthroned, with the figure of the First Person of the Trinity above,* and two heads of saints below,† which till lately occupied the Canto de' Carnesecchi at Florence, is in fresco: the other, an altar-piece in S. Lucia de' Bardi in Florence, signed by the painter, and which Sir Charles, on more than one occasion, closely inspected, is in tempera.‡ He

* This portion is now in the possession of Prince Pio at Florence.

† These two heads have passed from the collection of Sir Charles Eastlake into the National Gallery.

‡ The picture is engraved in Rosini, No. 42.

thus describes it from notes taken on the spot:—
"The picture is in the church of S. Lucia de'
Bardi, and represents the Madonna and Child
enthroned under Italian-Gothic architecture; two
saints stand on each side. On the first step of the
throne is the inscription 'Opus Dominici de Vene-
tiis. Ho Mater Dei, miserere mei. Datum
est.' Of this work Rumohr observes that the
expression of the female saint is not unworthy of
Angelico da Fiesole.* The Madonna and Child
are very agreeably composed, the coloured pave-
ment and architecture are in the Venetian taste, and
from the effect of modern varnishings the picture
has a warm tone which gives it a resemblance (but
it is only a resemblance) to a work in oil."†

But though the part assigned to these two
painters in the first chapter by Sir Charles—and
always with the utmost difficulty in reconciling
facts which he knew to be true, with others which
he had then no grounds to dismiss as false—is thus
necessarily set aside, yet Sir Charles's great interest
in the Portinari family as patrons of the new art
does not, on that account, lack due foundation. In
the mercantile transactions of the Portinari in the

* Italiänische Forschungen, vol. ii. p. 262.

† E. Förster (Kunst-Blatt, p. 67, 1830) calls it an oil pic-
ture; it is now universally acknowledged to be in tempera.

fifteenth century, as partners of the Medici, and agents for them in foreign parts, which probably led to their taste for the newly-practised Northern art—in their employment of Memling and Hugo Van der Goes for the decorations of the family chapel—and in the possible influence of those pictures in Florence at that period—Lady Eastlake has seen sufficient grounds for retaining a page of family history which is interwoven with the palmiest days of Florentine art and prosperity.

With the exception of the omission, thus explained, of part of the first chapter, no alteration has been required in the portion now presented to the public.

It may be added that the edition of Vasari referred to throughout is that of Florence, 1832–8.

December 1868.

CONTENTS.

CHAPTER I.

PROFESSIONAL ESSAYS.

MATERIALS

A HISTORY OF OIL PAINTING.

CHAPTER I.

FOLCO PORTINARI AND HIS DESCENDANTS—HOSPITAL OF S.
MARIA NUOVA—ANCIENT FLORENTINE ACADEMY OF PAINT-
ERS—ANTONELLO DA MESSINA—THE POLLAIUOLI.

THE name of Portinari is connected both with the
history of Italian poetry and Italian art. About
the year 1285, Folco Portinari, the father of Dante's
Beatrice, founded the hospital of S. Maria Nuova
in Florence, and employed Cimabue to paint a
Madonna for its chapel.* More than a century
and a half later a member of the same family, Folco
di Adoardo Portinari †, commissioned Domenico

* Richa, Notizie Istoriche delle Chiese Fiorentine. Firenze,
1754–1762, vol. viii. pp. 175, 190. The hospital of S. Maria
Nuova is not to be confounded with the church and convent
of S. Maria Novella.

† The elder line of the Portinari, from the end of the thir-
teenth to the beginning of the sixteenth century, is as fol-
lows:—Folco di Ricovero, founder of the hospital, died in 1289;
Manetto; Giovanni; Adoardo; Folco { Pigello ; Folco.
 { Tommaso ; Antonio.

Veneziano and Andrea dal Castagno to decorate the
Portinari chapel in the church of S. Maria Nuova,
and to these works were added some Flemish ex-
amples of the new art of oil painting, among
which are especially mentioned a small picture
by Memling and a triptych by Hugo Van der
Goes.*

The ancient Florentine Academy of Painters,
dating from the time of Giotto, held its first sittings
in S. Maria Nuova—an event commemorated in
the sixteenth century by the presentation, on the
part of the Academy, to the same chapel, of an
altar-piece by Alessandro Allori.† The early con-
nection of the painters with this institution is partly
accounted for by their having been at first included
in the same "arte" or guild with the physicians.‡
About the year 1420 the original chapel of the
hospital was enlarged by Lorenzo di Bicci, who,
painter as well as architect, adorned the façade
with two frescoes representing the consecration of

* Vasari, *Introduzione*, c. 21 ; and his notice, *Di diversi
Artisti Fiamminghi.* It may be necessary to repeat that
Ausse, or Hausse, is Vasari's misprint for Hansse, or Hans
(Memling), whom he clearly designates as the scholar of Roger
of Bruges. Vasari, *Vita di Antonello da Messina* ; compare
Baldinucci, vol. v. p. 411 ; De Bast, in the *Kunst-Blatt*, 1826,
p. 321, note ; and Passavant, *ib.* 1843, p. 257. On the works
of Memling and Hugo Van der Goes for the Portinari, see
Passavant, *ib.* 1841, pp. 18, 33, 251 ; and 1843, p. 258.

† Richa, Notizie, &c., vol. viii. p. 191.

‡ See the Florence edition of Vasari, 1832–1838, p. 316,
note 13.

the new edifice by Pope Martin V.* Of other paintings executed in various parts of the vast establishment, some may be noticed hereafter.

The pious and charitable intentions of the founder were carried out by his descendants with equal zeal, and the excellent management of the institution recommended it far and near. When Martin V. entered the cemetery where the bones were exhibited to view piled around, he knelt at the threshold, and, taking up a handful of dust, pronounced the promise of as many indulgences as there were atoms of mortality in his grasp to all who should there pray for the souls of the departed, and to all who might die within the precincts of the asylum.† The last benediction had a powerful influence on the prosperity of the institution. To superannuated painters were now added persons of rank from various parts of Italy and Europe, till S. Maria Nuova almost became to Christendom what the Valley of Jehoshaphat still is to the Hebrew world. The fame of a hospital which was long considered a model for general imitation attracted the attention of Henry VIII. of England, for whom a full description of the institution and its regulations was prepared in 1524 by a Francesco Portinari, who, it appears, was about this

* Richa, Notizie, &c.; ib. p. 197. Vasari, Vita di Lorenzo di Bicci. One of the frescoes is engraved in the Etruria Pittrice, Pl. XV.

† Ib. p. 194.

time ambassador from the republic of Florence to the English monarch.* It remains to observe that the accidental connection which existed between this foundation and the revival and perfection of painting was confirmed by important advantages affecting the practice of that art. Attached to·a chapel where the dead were first deposited was a hall for the study of anatomy, to which was subsequently added a theatre for lectures. The chemical department, again, comprehended an ample dispensary, underneath which, in extensive vaults, distillations and other operations requiring the use of fire were carried on; the whole being under the superintendence of experienced professors.†

Such was S. Maria Nuova. The Pollaiuoli, Leonardo da Vinci, and Michael Angelo may there have become familiar with dissections and with the structure of the skeleton; there the Florentine painters could trace back the traditions of Italian art from the time when Byzantine trammels were first cast aside ; and there they could procure certain materials essential to the practice of the new art prepared in the best manner by chemists who took an interest in their pursuit.

If the institution which has been described might thus, for many reasons, be called the cradle of Italian art, it was also, in a more literal sense, the

* Richa, Notizie, &c., pp. 184, 218. The ambassador is also called Pier Francesco Portinari.

† Ib. pp. 208, 209.

chosen place of rest of the artists. Many an aged professor sought peace within its walls, to quit them no more ; and many a convalescent left its precincts with reluctance. Vasari relates that when the friends of Nanni Grosso, a sculptor, visited him in S. Maria Nuova after his recovery, and inquired after his health, he replied, " I am not well. I am in want of a little fever; I should then have an excuse for remaining where I have had every comfort." An example is afterwards given of the kind of comfort which this artist required. During his last illness, when he was again an inmate of the hospital, an ill-formed crucifix was brought to him; the dying sculptor turned from it with pain, and entreated that a better work of the kind by Donatello might be placed before his eyes.*

With regard to the early oil paintings with which the principal chapel was decorated, it is not known whether the picture by Memling was painted in Italy (which the artist may have visited with his master, Roger of Bruges, in 1450), or whether it was afterwards transmitted from Flanders: that it was painted for the Portinari there is no doubt. The triptych by Hugo Van der Goes, or, as Vasari calls him, Ugo d' Anversa, was probably painted about twenty years later. That work, which is still in the chapel, may be at once described.

The main picture, now separated from the wings, hangs on the wall left of the door on entering: the

* Vasari, Vita di Andrea Verrocchio.

two wings hang on the opposite side. The subject
of the principal picture is the Nativity : angels
hover over the scene, and one of them, in shadow,
is lighted by the splendour from the Infant ; so
early was this idea—often supposed to be an inven-
tion of Correggio—customary in the treatment of
the subject.* Other angels stand around, singing
the " Sanctus," which is inscribed on the hem of
the robes of two who are kneeling. The adoring
shepherds are remarkable for their vivid indivi-
duality and the earnestness of their expression. In
the foreground is a vase of flowers, in the taste of
Van Eyck. Of the wings or doors, one exhibits a
member of the Portinari family and his two sons,
for whom St. Anthony and an Apostle—either
St. Matthias or St. Thomas (as he holds a lance)—
intercede ; the other wing represents the wife of
Portinari and her daughter, introduced by St.
Margaret and Mary Magdalene.†

* The apocryphal sources appear to have been the Protevan-
gelion and the Evang. Infantiæ.

† A portrait, by some writers supposed to represent Folco
Portinari, but which bears the arms of the Bandini family,
was a few years since in the Pitti Gallery (Passavant, *Kunst-
Blatt*, 1841, p. 18 ; Reumont, *ib.* 172) ; it is now in the
Gallery of the Uffizj. On the back, painted in chiaroscuro, is
the Angel of the Annunciation. The companion portrait of
the wife certainly resembles the lady in the altar-piece of Hugo
Van der Goes above described, except that there she is repre-
sented younger ; on the back is seen a chiaroscuro Madonna,
completing the subject of the Annunciation. This work has
been attributed to Van der Goes ; but the portraits, which

Various writers, including Richa, have ascribed these pictures sometimes to Domenico Veneziano, sometimes to Andrea dal Castagno, forgetting (to say nothing of the internal evidence of the art) that those artists painted on the walls of the chapel, and that their works there have long since perished. In consequence of this mistake, the subject has been wrongly described, and the personages who, according to Vasari, were introduced in the wall-pictures, have been transferred to these. Even some modern critics, who have been well aware that the existing work is by Hugo Van der Goes, " che fe' la tavola di S. Maria Nuova,"* have inadvertently followed the remaining part of Richa's blunder by assuming that the figure of the donor represents Folco Portinari. It will appear, as we proceed, that the portrait is much more probably that of Tommaso de' Portinari, a son of Folco, who was more than once in Bruges in the latter half of the fifteenth century, and whose name may be referred to by the introduction of St. Thomas the Apostle. The portraits all appear to be taken from the life, but whether the work was executed in Italy or in Flanders is uncertain.

The small picture by Memling above noticed is twice mentioned by Vasari, who intimates that subsequently to its being placed in the Portinari chapel it became the property of Cosmo de' Medici; he also

are strikingly defective in proportion, are inferior to the generality of his productions.

* Vasari, Introduzione, c. 21, p. 42.

informs us that it represented the Passion.* Such
a subject often comprehended various scenes, and
hence it is not improbable that a picture by Mem-
ling answering this description, and which is now
in the Gallery at Turin, is the identical work exe-
cuted for the Portinari.† No subject of the kind,
by the artist, is known to exist in Florence.

The commercial enterprises of the Portinari are
not to be overlooked in noticing their encourage-
ment of painters who followed or adopted the
method of Van Eyck. A manuscript chronicle
compiled by a descendant of the family about the
year 1700 is preserved in the Riccardian library at
Florence. From these records it appears that
during the fifteenth century the Portinari were
first the partners, then the agents, of the Medici
in various parts of Italy and in other countries.
For example, commercial transactions were con-
ducted in Venice by a Giovanni Portinari and a
Giovanni de' Medici (probably the father of Cosmo)
so early as 1406. In 1448 Pigello, the son of Folco
d' Adoardo Portinari, superintended, with his part-
ners, the affairs of Cosmo de' Medici in that city,
and appears to have resided there some years.

Ten years later we find the same Pigello acting,
apparently alone, in a similar capacity at Milan,
where he ultimately settled with his family, and

* Vasari, Introduzione, and the notice, Di diversi Artisti
Fiamminghi.

† Passavant, Kunst-Blatt, 1843, p. 258.

where he died in 1468. In 1470 and later, others of the house trafficked in Flanders and the North.*

* The writer of the Chronicle containing these details was Folco Antonio Maria Portinari, a priest. The MS. is numbered 1884 in the Riccardian library ; it was first noticed by Mr. Seymour Kirkup, to whom the author is indebted for the following extracts :—

"1406. Giovanni Portinari faceva negozio in Venezia con Matteo Tanagli e Giovanni de' Medici.

"1448. Pigello di Folco d'Adoardo Portinari con Alessandro Martelli e Francesco di Daviti regenti in Venezia la compagnia de' Medici," &c.

"1458. Il sudetto Pigello governava il banco e la ragione in Milano di Cosimo de' Medici." (Vasari, in his life of Michelozzi, a Florentine sculptor and architect, speaks of the palace at Milan, which Francesco Sforza presented to Cosmo de' Medici, and adds : "It appears that the sums which Cosmo spent in the restoration of this palace were furnished by Pigello Portinari, a citizen of Florence, who at that time was at the head of the bank and commercial establishment of Cosmo in Milan, and who himself dwelt in the said palace." Respecting the chapel which Pigello built at Milan at his own cost, see Richa, Notizie, &c., vol. viii. p. 185.)

"1460. Giovanni d'Adoardo Portinari fece negozio in Milano con Piero di Giovanni di Cosimo de' Medici.

"1470. Folco di Pigello di Folco Portinari con Tommaso di Folco Portinari, descritti mercanti famosi e segnalati, negoziavano a Lione in Francia, e la ragione diceva ancora colla famiglia dell' Antella e Ghicci, e tenevano p factori Matteo Ghicci, uno dell' Antella, uno de' Boni, e Zanobi da Scarperia; nel quale anno pure negoziavano p la Fiandra, Inghilterra, Olanda, Zelanda, e Scozia, Giovanni d'Adoardo Portinari e Benedetto Portinari.

"1480. Tommaso di Folco Portinari fece negozio in Bruggia di Fiandra con Lorenzo de' Medici.

"1480. Tommaso di Folco Portinari fece negozio in Londra con Alessandro d'Adoardo Portinari e Tommaso Guidotti.

"Bernardo d'Adoardo Portinari fece negozio di pannini et altro nella città di Lione in Francia.

These data are not unimportant, as serving to ex-
plain the introduction of oil painting into Florence.
Pigello Portinari must have been in Venice when
Antonello da Messina dwelt for a time in that city
on his return from Flanders.

Again, we find that Antonello, during his long
absence from Venice, dwelt for a time in Milan.
Whatever may have led him to visit that city (per-
haps the accident merely of its being in his road
from Venice to Genoa, the most convenient port
whence he could embark for Messina), it is highly
probable that he owed to Pigello Portinari the
attentions which he received there, and which in-
duced him to prolong his stay.* Lastly, the sub-

"1484. Detto negoziava pure in Bruggia.

" 1488. Folco [di Pigello di Folco] Portinari fece negozio di
pannini et altro in Bruggia di Fiandra con Tommaso di Folco
Portinari."

From other passages it also appears that the Medici and
Portinari had still a joint establishment in Venice late in the
fifteenth century.

* According to Vasari, in his *Vita d'Antonio Filarete*, quoting
from a MS. by that sculptor and architect, which is now in
the Magliabechian library at Florence, Pigello Portinari deco-
rated the palace at Milan, mentioned in a former note, with
various paintings, including portraits. The artists, with the
exception of Michelozzi and Vincenzo Foppa, are not named ;
but this edifice, together with Pigello's sumptuous chapel of
S. Pietro Martire at S. Eustorgio, and the Albergo de' Poveri,
built by Francesco Sforza, all which were adorned with paint-
ings and altar-pieces, offered abundant opportunities for the
employment of the artists then at Milan. The following pas-
sage in Filarete's MS. relating to the palace justifies Vasari's
general statement :—" Ancora l' entrata d' essa è degnissima, et

sequent employment of Hugo Van der Goes on a work to be placed in the Portinari chapel at Florence may be explained by the commercial relations of this same family, chiefly represented by Tommaso de' Portinari, with Flanders, about the time when Van der Goes was in the zenith of his reputation.

The earliest Italian oil painters now invite our attention.

Respecting their first teacher, Antonello da Messina, there is little to add to the account already given. Since the publication of the first volume of this work, however, an important date has come to light. It is now certain that John Van Eyck died in 1441:* at that time Antonello was probably about twenty-seven years of age, and the period

maggiormente quando sarà dipinta nel modo che già ragionammo insieme con Pigello Portinari, huomo degnio et dabene, el quale ivi reggia e guida tutto el traffico che anno a Milano ; col quale ebbi ragionamento di quello che dipingere s' aveva." See the note at the end of this chapter.

* See the interesting documents in the pamphlet entitled *Les trois Frères Van Eyck*, par l'Abbé Carton. Bruges, 1848. On the Abbé's mistake respecting the date of Antonello da Messina's birth, see Dr. Waagen, *Kunst-Blatt*, 1849, p. 62. With reference to the date of Van Eyck's death, it is to be observed that as Alphonso of Arragon expelled René of Anjou from Naples in 1442, it follows that the picture by Van Eyck, which, according to Vasari, induced Antonello to visit Flanders, must have been seen by him before Alphonso possessed it ; and hence the conjecture of De Bast (*Kunst-Blatt*, 1826, p. 333, note) that the painting in question was originally sent to King René, and was seen by Antonello while it was in that monarch's possession, is well founded.

of his visit to Flanders is, in some measure, de-
fined. A portrait by him, in the Berlin Gallery,
has the date 1445; and as there is some reason to
believe that it was painted in Italy, the artist may
have quitted Flanders for Venice in 1444. As yet
there is no ground, save the questionable evidence
of this portrait, to conclude that Antonello re-
turned to Italy so early;* but assuming such to
be the case, his first residence in Venice must have
been of long duration. There is nothing impro-
bable in this, as he must have passed a consider-
able number of years either in Venice during his
first stay there, or in Milan. That during those
years he was occupied with his art we cannot
doubt, but it is remarkable that, except the por-
trait referred to, no picture by Antonello has been
hitherto noticed with an earlier date than 1470†:
according to a Sicilian writer, an Ecce Homo,
formerly at Palermo, was so inscribed.‡ The com-
piler of the " Memorie de' Pittori Messinesi,"

* The doubtful evidence alluded to is the fact that the por-
trait is painted on chestnut-wood, a material not commonly
used for such purposes in the North : the authenticity of the
picture has never been called in question. According to a
Flemish MS., quoted by De Bast (*Kunst-Blatt*, 1826, p. 339),
Antonello remained some years in Flanders after Van Eyck's
death.

† The date on Antonello's picture of the Crucifixion, in the
Gallery at Antwerp, is now universally acknowledged to be
1476.

‡ Vincenzo Auria, quoted by the author of the *Memorie de'
Pittori Messinesi.* In Messina, 1821, p. 16.

published also the "Guida per la Città di Messina." * In that compendium, when speaking of the church of S. Gregorio at Messina, the writer describes a picture of the Virgin and Child by Antonello inscribed with the artist's name and the date 1473 :† hence he infers that Antonello remained in Sicily till that year. Antonello's residence in Milan must therefore have preceded his visit to Sicily, where, accordingly, his biographer supposes him to arrive shortly before (verso) 1465. Circumstances are not wanting to support this conjecture; for it is by no means unlikely that his success in Milan was regarded by his competitors there with extreme jealousy: though protected, as we assume, by the Portinari, Antonello appeared among the Milanese artists as a stranger, practising a mode of painting to them unknown, and which had obtained favour with the wealthy.‡ We are also led to conclude that Antonello returned to Venice in 1473, immediately after the completion of the picture in S. Gregorio at Messina. In corroboration of this view, it is to be observed that

* Siracusa, 1826.

† Memorie de' Pittori Messinesi, p. 20. According to the same author, four other pictures, originally forming part of the altar-piece, are now in the sacristy of S. Gregorio. The inscription on the latter is given in the Memorie, p. 15, as follows :—" Anno Dei M°CCCC° septuagesimo tertio Antonellus Messanensis me pinxit."

‡ The expression " Mediolani quoque fuit percelebris " (see Materials, vol. i. p. 194, note) is sufficiently conclusive on this point.

Zanetti, on grounds irrespective of the above
evidence, fixes 1473 as the date of the first oil
picture painted by a Venetian artist.* Antonello,
knowing that the process was gradually becoming
public, would, on his reappearance, naturally be
anxious to assert his claim to be considered the
earliest teacher of the art in Italy: accordingly, he
seems to have lost not a moment, after arriving in
Venice, to impart the knowledge he possessed,†
and the work by Bartolommeo Vivarini, formerly in
S. Giovanni e Paolo, may have been the first,
though as yet the very imperfect, fruits of the
Sicilian artist's teaching. Whether Zanetti was
right or not in judging that this picture was
executed in oil we have now no means of ascer-
taining, as it has disappeared; certain, however,
it is that the earliest date, as yet known, on any
picture painted by Antonello after his return to
Venice is 1474. The Sicilian lived to see him-
self surpassed even in the use of the method which
he had taught; but at the period now referred to,

* Della Pintura Veneziana. In Venezia, 1771, p. 24.

† Ridolfi's story (*Le Meraviglie dell' Arte*, vol. i. p. 48)
respecting a stratagem employed by Giovanni Bellini to
possess himself of Antonello's secret, need not be rejected ; it
would only prove that Giovanni had no personal acquaintance
with the Sicilian, and that he sought to obtain, unobserved, a
better knowledge of the method than, as a stranger, he was
likely to obtain. Antonello's free communication of his pro-
cess would probably be first made to those painters whom he
had known during his former residence in Venice.

his works, in depth and richness of colour at least, were far superior to those of his Venetian followers. The portrait in the collection of Count Pourtalès,* inscribed "1474. Antonellus Messaneus me pinxit," is an excellent specimen of the artist: in force, warmth, and clearness it would bear a comparison with the best Flemish examples; while, although minutely finished (as in the eyes, eyebrows, and beard), it is not without a certain Italian breadth.† Before quitting this painter it may be remarked that after having once acquired the art of oil painting he seems never to have laid it aside for any other method; whereas many of those who adopted the Flemish process wanted inclination or perseverance to practise it on all occasions. We proceed to trace the progress of his earlier successors in the art at Florence.

It does not appear that the Italian artists had as yet any means of acquiring a knowledge of oil painting from foreign professors. The Flemish painters who visited Italy seem to have kept their secret jealously. Justus van Ghent, who was employed by Federigo da Montefeltro at Urbino, and one of whose works in oil, completed there in 1474, still exists, contrived to conceal his method from the painters of the Umbrian school.‡ Antonello da

* Now in the Gallery of the Louvre.—*Ed.*

† This appears to be the portrait which, according to Lanzi (vol. ii. p. 27), was formerly in the Casa Martinengo at Venice.

‡ Sir Charles Eastlake subsequently, on a visit to Urbino,

Messina, while residing at Milan, must have been
equally cautious; for not a single specimen or
record has come to light to show that the art was
taught by him in the north of Italy till 1473,
when he was again in Venice. A celebrated work,
painted in oil by Antonio Pollaiuolo, was com-
pleted, after much study and many previous essays,
in 1475; and we find that this artist long wrought
as a goldsmith before he learnt the art of oil
painting from Piero, his younger brother.

The productions of the Pollaiuoli comprehend
the earliest unquestionable examples of Italian oil
painting now extant. The two brothers at first
worked together, but Antonio, who was the more
accomplished designer, by degrees asserted his
superiority. Vasari notices but one occasion, an
early one, in which Piero painted some works alone.
The remains are still to be seen: they consist of
some single figures of angels and prophets, and
an Annunciation, painted on the walls in the church
of S. Miniato al Monte. The single figures are

Sept. 1858, examined the work by Justus van Ghent here
alluded to, and formed a very low opinion of it, which he thus
summed up in notes taken at the time :—" The painter was
utterly unworthy to be admitted among those in Urbino who
must have been his cotemporaries, and, assuming that this
picture represents his ability and the extent of his qualities,
there is not a single particular, not even architecture or still
life, in which he can be said to have influenced the Italians."
To this cause, perhaps, rather than to any secrecy, may be as-
signed the fact that the method of Justus van Ghent found
no followers in Urbino.—*Ed.*

nearly effaced, and are, moreover, high on the wall; the Annunciation is better preserved and more accessible. The deep colours of the Madonna's dress and certain peculiarities in the surface, hereafter to be noticed, indicate the material with which these figures are painted; the appearance of the work agrees, in short, with the statement of Vasari, who expressly says that Piero executed it in oil. In the same church the brothers painted an altar-piece on wood, and, as Vasari again states, in oil; it represented three saints— St. James, St. Eustace, and St. Vincent. This picture has been removed to the Gallery of the Uffizj, where it now is. Puccini,* who had an opportunity of observing it narrowly, asserts that it is in tempera. The technical question must be left in this case undecided, for even supposing the brothers to have produced works in oil before the date of this picture, there would be nothing extraordinary in their subsequently painting an altar-piece in tempera. With respect to the general merits of the work, it is evident that two hands were concerned in it; the St. Vincent and the St. James are far superior to the St. Eustace: that figure is consequently to be assigned to Piero. Vasari speaks of a work by the Pollaiuoli executed in oil on cloth, in the church of S. Michele in Orto. Some single figures of Virtues, also painted in oil, and which

* Memorie di Antonello degli Antonj, Firenze, 1809, p. 65.

were originally in the Mercatanzia (a tribunal so
called), are now in a corridor annexed to the Uffizj;
they are interesting in a technical point of view,
and will be noticed as we proceed. The two pic-
tures by Antonio in the same gallery, representing
the Labours of Hercules, appear to be repetitions
on a reduced scale of two out of three works of the
kind painted for Lorenzo de' Medici; they are
chiefly remarkable for their boldness of design.

The celebrated picture of St. Sebastian, origi-
nally in the chapel of S. Sebastiano a' Servi, after-
wards in the Palazzo Pucci*, was completed in 1475.
It is painted on wood, and unquestionably in oil; it
has been engraved in the *Etruria Pittrice* and else-
where. The date, which Vasari, in reference to the
general merits of the work, records as an era in art,
its technical qualities, and its excellent preservation,
render this picture especially worthy of attention.
This was the first great example of the application
of the new art to altar-pieces. Oil painting was
thus at last recommended to the Florentines by a
true son of the school. The enterprising genius of
Antonio Pollaiuolo displayed itself in works re-
markable for vigour of drawing, while the hardness
and anatomical precision which even his oil pictures
exhibit would scarcely be looked upon as a defect
at the period when he lived. Soon after the com-
pletion of the St. Sebastian, he was employed to

* Now in the National Gallery.—*Ed.*

paint a figure of St. Christopher on the external wall of the church of S. Miniato fra le Torri. The representations of this saint were always gigantic, not only in accordance with the legend, but because the sight of the picture was supposed to act as a charm in renovating the strength of the labourer and in preventing accidents; hence it was desirable that it should be conspicuous from afar as well as near.* The St. Christopher of Antonio Pollaiuolo was nearly twenty feet high: according to Baldinucci, in whose time it was still visible, there was a tradition that Michael Angelo in his youth was in the habit of making drawings from it by way of study.

The foreground figures in the St. Sebastian are not only as large as life, but their style of design is full, in the taste afterwards carried to its extreme by Michael Angelo, and is thus directly opposed to the meagreness of the early Flemish school. The peculiarities of the execution will be described hereafter.

But notwithstanding the great abilities of Antonio Pollaiuolo, most of the Florentine artists, like Michael Angelo himself at a later period, could appreciate the efforts of their countryman in design without extending their approbation to the method of oil painting which he had adopted. The elder painters, such as Cosimo Rosselli, Sandro Botticelli,

* See L' Osservatore Fiorentino, vol. i. p. 113. Compare Maniago, Storia delle Belle Arti Friulane, 1823, p. 193. For the legend, see Mrs. Jameson's Sacred and Legendary Art, vol. ii. p. 48.

and others, were too much wedded to their early habits to venture much on the novel practice. Even Domenico Ghirlandajo, who was young when Antonio's masterpieces were produced, showed to the last a disinclination for the change. He was in the habit of saying that painting consists in drawing, and that the only method which promised unlimited durability was mosaic—expressions which appear to have had reference to the opinions of others in favour of the new system.

Two pictures ascribed to Ghirlandajo, in the Berlin Gallery, are remarkable for being painted partly in tempera and partly in oil. In one, representing the Madonna in glory adored by saints below, the two kneeling figures of St. Jerome and St. Francis are in oil; all the rest of the work is in tempera. The figures in oil are supposed to be by Francesco Granacci, one of Ghirlandajo's scholars, and the inference is that the picture was left unfinished by the master. In the other—a single figure of St. Anthony—the saint is painted in oil, and the background in tempera. The companion picture, representing S. Vincenzo Ferreri, is entirely in tempera. In the case of the St. Anthony it may be supposed that the figure was completed after the death of Ghirlandajo by his brother David, or by Bastiano Mainardi, both of whom could imitate his manner closely. Vasari does not mention a single oil picture by Domenico Ghirlandajo. It is, however, quite possible that such works by

him may exist. As rare examples, they would merely prove the hesitation and reluctance with which some of the best artists, followers of the earlier methods, made attempts in the novel process.

The opinions or prejudices of Ghirlandajo with regard to a question then so much discussed must have had a powerful influence on his great scholar Michael Angelo—the latest representative of the opponents of oil painting.

NOTE

ON TWO COPIES OF AN INEDITED MANUSCRIPT
BY ANTONIO FILARETE.

THE MS. referred to is a treatise on architecture in twenty-five chapters. Various copies in Italian and various Latin translations exist, but the work has never been deemed worthy to be printed. Two Italian copies are in Florence; one in the Palatine, the other in the Magliabechian Library. Morelli (*Notizia d'Opere di Disegno*, pp. 160, 168) describes a Latin version in the library of St. Mark, at Venice, and enumerates other copies, in both languages, existing elsewhere. Of the two MSS. in Florence, that in the Palatine Library is addressed to Francesco Sforza (who died in 1466) ; many names are not filled in, some chapters or books towards the end are wanting, and the MS. is written in at least two different hands. From these circumstances, as well as from the absence of sufficient decoration, it is evident that this could not be the presentation copy to Sforza. The Magliabechian copy is dedicated to Pietro de' Medici, and was once in the possession of Cosimo, the first Grand Duke : this fact, added to the beauty and regularity of the execution, is a sufficient proof that the volume was really presented to Pietro. Vasari (*Vita di Filarete*) states that it was completed and dedicated

in 1464, and there is internal evidence to show that it was not finished before the autumn of that year. Morelli (*Notizia*, p. 169) and Zani (*Enciclopedia*, vol. ii. p. 336) appear to be wrong in supposing that the Palatine MS., addressed to Sforza, was written in 1460. According to Gaye (*Carteggio d'Artisti*, vol. i. p. 202), that date occurs in both MSS., but only with reference to certain edifices to mark the year when they were built : the same writer concludes that both copies were written about the same time. He remarks that both allude throughout to Cosmo de' Medici as living, but in this he is mistaken; the Magliabechian copy speaks, towards the end, of the "degnia memoria di Cosimo." Cosmo (Pater Patriæ) died August 1st, 1464.* There is also a passage alluding to the death of a younger son of Cosmo, Giovanni de' Medici, who died in 1463. From the difficulty of making a careful inspection of the Palatine MS. when these researches were first undertaken, the author is not prepared to say whether any evidences of so late a date exist in that copy or not; the following facts are, however, not unimportant :—The Palatine MS. speaks at length of the Albergo de' Poveri (built by the writer of the treatise), at Milan, as a completed work, and, according to a medal quoted by Vasari, the first stone was laid by Francesco Sforza in 1457. After that, as appears from both MSS., as well as from other authorities, Filarete planned and partly built the Cathedral of Bergamo, and during the progress of that and other works, as he himself tells us, composed his voluminous treatise.† These labours may fairly be allowed to extend from 1457 to 1464. In the absence of more special evidence, we therefore conclude with Gaye that both copies were written about the same time. The Magliabechian

 * Gaye, by an oversight, speaks of April, 1464, as the date of Cosmo's death.

 † " e [fece] nella città di Milano il glorioso albergho de poveri di Dio sotto Francesco Sforza duca quarto di Milano el quale colla sua mano la prima pietra nel fondamento colloco et altre cose pme inessa [città furono] hordinate, la chiesa maggiore di Bergamo anchora hordinai et inquesto tempo quando aveva alquanto divacazione queste conaltre hoperette compuosi," &c.— *Magliab. MS.*

MS. contains a remarkable description of the process of oil
painting (to be noticed hereafter) which is wanting in the
other, and which was overlooked by Gaye. The passage, oc-
curring towards the end in both MSS., in which Domenico
Veneziano is mentioned, has reference to the proposed decora-
tion of a palace at Milan which had been presented to Cosmo
de' Medici by Francesco Sforza. The discussions often assume
the form of a dialogue, although the interlocutors must be
supposed :—

[*Principe.*] "So, in my opinion, it should be done; it is for
you therefore to find the master, and to make arrangements for
these undertakings."

[*Filarete.*] "I fear, Signore, we must wait ; as there is a
dearth of good masters. The proposed works should by all
means be executed satisfactorily ; but, from whatever cause,
good masters are not to be found. Several who were formerly
in Florence, and who would have come at our call, are dead ; one
called Masaccio, another called Masolino ; one who was a friar,
called Fra Giovanni. Lately, also, among other good painters,
died Domenico da Venezia ; another called Francesco di
Pesello, who was a good master for animals ; another, called
Berto, who died at Lyons on the Rhone ; another, again, who
was very learned and skilful in painting, called Andreino de-
gl' Impiccati: so that I fear there may be some difficulty. We
will, however, do the best we can with those who are to be
had ; we will see whether any good painter can be found in
the North—one there was who was most excellent, called
Giovanni da Bruggia ; he too is dead. I think there is one
Maestro Ruggieri [Roger of Bruges], who is celebrated, and
also one Giachetto, a Frenchman [or Fleming] if indeed he
still lives. He is a clever artist, especially in portraits ; at
Rome he painted Pope Eugenius [IV.] with two of his atten-
dants next him, looking absolutely alive. Those likenesses are
painted on cloth, and the picture was placed in the sacristy of
the church della Minerva. I speak of this work because the
artist painted the portraits in my time.* We will therefore

* Vasari, in his Life of Filarete, and probably quoting from
the MS. here described, speaks of a portrait of Eugenius IV. in

see whether we can have these painters, and if we cannot, we
must employ those who are on the spot." *

Some of the above allusions by Filarete to defunct painters
are by no means complimentary to the existing or rising talents
of his day ; at all events, in regretting that so many good

the Minerva by Giovanni Focchora or (first edition) Fochetta[1]
—intended perhaps for the "Giachetto Francoso" of Filarete.
The portrait may have been executed about 1440.

[1 It is suggested that "Fochetta" may have been the corrup-
tion of Fouquet—Jehan Fouquet de Tours—painter to Louis XI.
of France, and known by his portraits of royal personages.—Ed.]

* The original passage, as written in the Magliabechian
copy, is as follows :—

"A me pare checosi sidebba fare siche avoi sta trova il
maestro a chesidia hordine afar fare queste cose. Io dubito
Signiore abisognera aspettare pche cie carestia dimaestri
chesien buoni pche queste cose vogliono stare bene aogni modo
voglio stieno bene manon situovano maestri buoni non so
pche nemorti una sorte che erano afirenze chesarebbono venuti
iquali erano buoni maestri tutti cioè uno chiamato Masaccio
unaltro chiamato Masolino uno chera frate chiamato fra Gio-
vanni poi ancora nuovamente ne sono morti tra altri buoni uno
chiamato Domenico davenegia unaltro chiamato Francesco
dipesello il quale pesello fu grande maestro danimali unaltro
sichiamava Berto ilquale mori alione sopra Rodano unaltro
ancora ilquale era nella pittura molto dotto e perito ilquale
sichiamava Andreino deglimpicchati siche dubito sara dificolta
averne. Bene faremo conquegli che potremo avere ilmeglio si
potra sivorrebbe vedere senelle parti oltramonti ne fusse nes-
suno buono dove nera uno valentissimo ilquale sichiamava
Giovanni dabruggia e lui ancora emorto parmi cisia uno ma-
estro Ruggiera che e vantaggiato ancora uno giachetto francoso
ancora se vive e buono maestro maximo aritrarre del naturale
ilquale fe aroma papa Eugenio e due altri desuoi appresso
dilui cheveramente parevano vivi proprio iquali dipinse insu
uno panno ilquale fu collocato nella sagrestia della Minerva.
Io dico cosi pche amio tempo glidipinse siche vedremo se-
glipossiamo avere senon faremo conquesti checisono."

The passage in both MSS., in which the date 1460 occurs
in anagrams, and which gave rise to Zani's supposition that
the treatise was completed at that period, is here given litera-
tim from the Palatine copy, as the transcript professed to be
taken from that MS. by Zani's correspondent is incorrect in
some particulars :—

painters were dead, about the year 1464, it was superfluous to
name Masaccio, who died twenty years earlier. Still less
necessary was it to allude to Masolino (if the same as Masolino
da Panicale), since, according to Baldinucci, he died in 1415.
Of the recently deceased, at the head of whom appears
Domenico Veneziano, Francesco Pesello died, according to
the same authority, in 1457. Probably, the expression "nuo-
vamente" in Filarete's loose style, refers chiefly to Domenico,
for, even in speaking of the then certainly recent deaths of
Giovanni and Cosmo de' Medici (1463, 1464), he uses no such
term.

It is remarkable that, in Filarete's judgment, two Northern
painters—Roger of Bruges and " Giachetto Francoso "—were
after all the fittest to execute the proposed works at Milan.
The unknown " Giachetto," * like Roger of Bruges, was pro-
bably an oil painter, and this is not the only instance in which
the architects of that time, aiming at durability in decorations,
and persuaded of the superior recommendations of oil painting
in that respect, showed a preference for the new method. The
omission of Antonello da Messina's name in Filarete's capri-
cious list may be explained by that painter having, in all pro-
bability, quitted Milan for Sicily when the passage was written.
Vincenzo Foppa, a native of Lombardy, and the artist ulti-
mately employed †, is also unnoticed.

" Disse allhora il figliolo del Signore alinterpreto per nostra
fe chiariteci un poco quello dicono le lettere. Io vi chiariro
quello io nintendo di queste pche cie alcuna non ne intendo
bene pche sono lettere in modo intromesse che no sintendono
le quali sono queste—Re zogalea gliofi D. FR. SF. [Re Gale-
azo figlio di Francesco Sforza] i quali hanno p loro magna-
nimita questo porto con tutti questi altri edifitii e la terra
insieme constituita e fondata questo a chi passera fia noto e p
lo architetto nostro ordinati il quale onitoan nolihaver [An-
tonio Haverlino] chiamato p patria notirenflo [Florentino] nel
lemi troqua tocen tasanse [mile quatro cento sesanta]. Questo
non ne intendo altrimenti. Ben basta noi faremo scrivere il
nome el tempo di chi ha fatto fare e fatto si quando sara forniti
questi deficii che restano a fare."
* See p. 24, note by Ed.
† Vasari, Vita di Michelozzo Michelozzi, and Vita di Filarete.

CHAP. II.

RECAPITULATION OF CHARACTERISTICS OF EARLY FLEMISH
SCHOOL—THE VARNISH OF TEMPERA PICTURES—IMPROVE-
MENTS BY VAN EYCK—MIXTURE OF VARNISH WITH COLOURS
—METHODS OF PAINTING.

BEFORE we proceed to inquire into the Italian practice of oil painting, it will be desirable to recapitulate the chief characteristics of the early Flemish school, since to that school Italian oil painting owed its origin.

The details contained in the first volume of this work render it now possible to confine our attention to the conclusions derived from them, without going into the evidence on which such conclusions rest : it will be sufficient to refer to the documents there adduced, occasionally noticing some others which have since come to light, and which either corroborate or correct the former statements.

Tempera pictures, executed before and after the time of Van Eyck, were coated with a varnish composed of sandarac dissolved in linseed oil, generally in the proportion of three parts of oil to one of resin.* This varnish was extremely durable,

* Vol. i. pp. 241, 251, 253. Compare Mrs. Merrifield's Original Treatises, dating from the twelfth to the eighteenth

but it was a substitute for a firmer composition of the kind, still more ancient in date, and in which amber was used instead of sandarac. The word Vernice, or Bernice, was originally appropriated first to amber and then to sandarac, as dry substances.* The sandarac varnish was known in Italy by the name of " vernice liquida ;" the amber

centuries, on the arts of Painting, &c., 1849, Introduction, p. cclxi.

* Vol. i. pp. 230, 237, note. The authority of Eustathius on the early application of the word Bernice is alone conclusive; others will, however, be found in the treatises of Libavius, Salmasius, Butman, and the authors quoted by them. Butman's derivation of Bernice from Bernstein, a northern appellation of amber, is probably correct (*Mythologus*, vol. ii. p. 362). The antiquity of the trade with the North for this substance is established by the following passages from another high authority :—" The amber trade, which was probably first directed to the West Cimbrian coasts, and only subsequently to the Baltic and the country of the Esthonians, owes its first origin to the boldness and perseverance of Phœnician coast navigators. In its subsequent extension it offers a remarkable instance of the influence which may be exerted by a predilection for even one single foreign production in opening an inland trade between nations, and in making known large tracts of country. In the same way that the Phocæan Massilians brought the British tin across France to the Rhone, the amber was conveyed from people to people through Germany, and by the Celts on either declivity of the Alps to the Po." Again :—" A not inconsiderable inland trade with the remote amber countries was carried on by them (the Etruscans), passing through Northern Italy and across the Alps."—Humboldt, *Cosmos*, vol. ii. pp. 128, 134, Sabine's translation. Among the works quoted in support of these statements is Ukert's memoir " Ueber das Electrum, in der Zeitschrift für Alterthumswissenschaft," Jahr. 1838, No. 52–55.

varnish by that of " vernice d' ambra," or " vernice liquida gentile." * Both, in consequence of the great heat required in their preparation, were dark in colour, the amber varnish most so. Both inclined to a warm reddish hue, not merely from the effects of partial carbonisation, but, in the case of the sandarac especially, because the dry substance acquires a russet hue from age. In English account-rolls of the thirteenth and fourteenth centuries, the term " vernisium rubrum" distinguishes the sandarac resin.†

Not only tempera pictures, but painted walls and even implements and armour, were, in the middle ages, commonly varnished with vernice liquida.‡ For ordinary purposes the varnish was less carefully prepared; common resin (" pece Greca," or " pegola") was sometimes mixed with the sandarac, sometimes superseded it; such compositions were called "vernice grossa," and " vernice comune."§

* Vol. i. pp. 238, 241.

† Ib. p. 247.

‡ Ib. pp. 238, 239, 252. Marciana MS., Mrs. Merrifield's Original Treatises, p. 636.

§ Fioraventi, *Compendio dei Secreti Rationali.* Venezia, 1597, p. 116. Marciana MS., 637. The epithet "comune" necessarily changed its application accordingly as any given varnish became common ; the term " grossa" is equally vague. Originally there can be no doubt that the "vernice liquida" was called "comune ; " that the " gemeiner virnis " of the Strassburg MS. was sandarac, as opposed to amber, and even so late as the seventeenth century an English writer (Salmon, *Polygraphices*, l. ii. c. 5) speaks of " common liquid varnish " com-

The warm reddish tint of the sandarac varnish rendered it unfit, in nice operations, for covering greens and blues, and indeed any delicate colours which might be vitiated by its hue. For such purposes a lighter varnish, called by the Italians " vernice chiara," was used, composed of mastic or of bleached fir resin, or sometimes of both, and nut oil* (the commoner kind consisting of the ordinary fir resin and linseed oil). In English records of the thirteenth and following century the " white " as well as the " red " varnish frequently occurs ; the white varnish being generally mentioned together

posed of " linseed oil and gum sandarack." Italians of the sixteenth century, however, understood by " vernice comune " a compound of linseed oil and common resin. Even this, according to Bonanni (*Trattato sopra la Vernice, &c.*, in Bologna, 1786, p. 42), was improperly called " vernice di ambra ; " again, Giambattista Volpata, in a MS. possessed by the author, speaks of " vernice grossa o d' ambra." The red and white varnishes had probably their common substitutes, and in comparing many authorities it appears that in general " vernice grossa" meant a cheap substitute for amber or for sandarac, probably resembling those varnishes in tint, while " vernice comune " was the lighter coarse kind. According to De Mayerne (see Vol. i. pp. 303, 304), the so-called " huile d'ambre de Venise," or " Vernix d'ambre de Venise," sold in the shops in Italy in his time, and no doubt the same as that mentioned by Volpato, inclined, like sandarac, to a red tint. For the rest, the application of the term " amber varnish " to the most ordinary oleo-resinous compounds proves the estimation in which the real medium was held.

* Armenini, De' veri Precetti della Pittura (in Ravenna, 1587, p. 129). Vol. i. pp. 247, 462, note, 552. Marciana MS., Mrs. Merrifield, Original Treatises, p. 632.

with materials for painting surfaces in green or in
blue. For example, in the fabric-rolls of Exeter
Cathedral, under the date 1320, verdigris, azure,
indigo, and white varnish are included in the same
entry :* in that document, the white varnish is one
shilling the pound ; the red was always cheaper.†

The English records, not to 'mention various
other documents before quoted, also show that at
the periods referred to (before 1400), colours
mixed with linseed oil were used for common pur-
poses of decoration. In such cases the painted
surface, if coated with "vernice liquida," would be
very durable: it was, however, durable of itself
and from another cause; the details of Cennini, ‡
the Byzantine MS., § and other authorities prove
that the oil so used with colours was thickened, by
exposure to the air and sun, to the consistence of
honey. These descriptions of the medium agree
with the appearance of certain portions—such as
ornamental patterns and other details—executed
in oil in early tempera pictures. The edges of the
parts so painted are blunt, and the surface is not
merely raised (as tempera itself often is), but the

* "1320. 1 libra de azura empta London per Dominum
Episcopum Walterum de Stapeldon, 1 libra de Ynde bandas,
18d. ; 4 lib. de verdigris, 2s. 4d. ; 4 lib. de vermilloun ; 5 lib.
de verniz alb. 5s. ; ¾ de Sinople, 4s. 9d. . . In 16 lagenis olei pro
pictura, 21s. 6d."
† Vol. i. pp. 247, 248.
‡ Ib. pp. 65-9.
§ Ib. p. 79.

substance is transparent.* The thickened oil was found, from experience, to be much more durable than oil in a fresher state; when so prepared it is, in fact, half resinified, it acquires the nature of a varnish, and, to use a technical term, "locks up" colours more effectually.†

Both the oil and the varnishes used were thus calculated for durability. The perfect gloss which resulted from their semi-resinous state indicated a compactness of the particles which secured the surface from damp and rendered it possible to preserve the work in a clean state, if necessary, even by occasional ablution.‡ But the thick consistence of the oil rendered it unmanageable for finer painting; hence, such portions as required very delicate

* Vol. i. pp. 71, 73. Cicognara (*Storia della Scultura*, Prato, 1823, vol. iii. p. 158) describes a tempera picture by the early Venetian painter Lorenzo, dated 1369. It not only retained the original varnish, but certain portions were executed in oil. "The colour employed in the ornaments and gems on the gold ground, in the nimbus, and on the drapery of the Christ, is not tempera, but appears as if crystallized with another diaphanous and thick substance, strongly adhering to the gold ground, with which tempera would not bind. The tints used in these ornaments were evidently ground and prepared with the same oil or varnish which was spread over the whole work."

† Vol. i. p. 511, note.

‡ Vasari's expressions, " il modo di poterle lavare," and, speaking of Van Eyck's vehicle "secca non temeva l' acqua" (*Vita di Antonello da Messina*), may be compared with Pliny's "custodiretque a pulvere et sordibus," when speaking of an ancient varnish. Vol. i. p. 14.

modelling—for example, the heads and undraped portions of figures in altar-pieces—were executed in tempera.* We are not called upon to explain the reason why oil painting—generally known and practised as it was, for ordinary purposes, before the year 1400—should have been so long despised for works of price and skill. Nothing, apparently, prevented the painters of those days from employing the oil in a thinner state, since, even admitting its more perishable nature in that state, it could always have been protected, like a work in tempera, by the customary varnish. Of the fact of the unwillingness of the painters, and of their persevering to practise tempera for ages after the immixture of colours with oil was known, there is, however, no doubt whatever. It is even certain that long after excellent oil pictures had been produced, such as to excite an admiration which has lasted to our day, some of the best Italian masters still looked upon the art with distrust and dislike.

But, at all events, the practice of decorators in the application of colours with oil, and the long experience of tempera painters in the use of varnishes, before the commencement of the fifteenth century, enable us to form some idea of the nature of the improvements introduced by Hubert Van Eyck.† He was in the habit, like others, of coating

* Vol. i. pp. 72, 175.

† The claims of Hubert Van Eyck as the original inventor of the new method are now universally acknowledged. See

his tempera pictures with "vernice liquida;" like others, he must also have been acquainted with the "white varnish." (We find that in 1353 Lonyn of Bruges furnished some pounds of the substance so called for the use of the painters of St. Stephen's Chapel.*) For a time his habits may have been in all respects those of the painters who had preceded him. Painted and varnished walls in interiors were sometimes dried by means of fire:† the varnished tempera picture, being movable, was always placed in the sun, precisely according to the directions of Eraclius and Theophilus.‡ There is therefore nothing improbable in Vasari's story, that a work of Van Eyck's painted on wood (the material then almost universally employed), when so exposed by him, split from the heat, and induced the artist to think of preparing his "vernice" so that it should dry without the aid of the sun's heat. A similar accident happened to a Flemish painter at a later period §, and may have happened to many. To an Italian, accustomed to the practice of so exposing pictures, and aware of the danger attending it ‖, the explanation would seem quite satisfactory. A northern painter might only suggest that the tediousness of drying, with or without the sun, in a humid climate, might have been a

Carton, *Les trois Frères Van Eyck*, p. 32; compare Passavant, *Kunst-Blatt*, 1850, p. 14. * Vol. i. p. 248, note.

† Ib. p. 53. ‡ Ib. pp. 35, 40. § Ib. 512.

‖ Cennini, Trattato, c. 155.

sufficient reason for devising some means to accelerate the process of desiccation. Yet no sufficient means for this purpose, we may be assured, had been adopted before Hubert Van Eyck's time.

The primary object of Van Eyck, according to Vasari, was thus to make the customary varnish more drying.* His first experiments were with the oils. He found no reason to conclude that linseed oil—the vehicle then generally used—was inferior to any other known oils as regards its siccative quality; but he seems to have revived the use of walnut (nut) oil†, and, as that oil has been supposed to become less yellow than the other with time, he may have employed it for certain colours, and may have appropriated it to the preparation of the "white varnish." We find that, at all events, this practice afterwards obtained.

The chief dryer which he used in preparing the oils or varnishes appears to have been white copperas—a material common in Germany, and which was certainly used in Flanders for the purpose in question in the fifteenth century. The reasons which may have induced Van Eyck to prefer this dryer to lead have been explained in the preceding volume.‡ The records of the time and country

* Vol. i. p. 205; compare Morelli, Notizia, &c., p. 116.

† It had been used as a varnish in, if not before, the fifth century, and had been tried, though without success, apparently as a medium for colours, in the fourteenth. Vol. i. pp. 19, 46.

‡ See Vol. i. pp. 130, 131, 285, the extracts from the Strass-

further show that the oils were then purified and rendered more drying by means of calcined bones.*

In searching for choicer resinous materials, and such as promised the utmost durability, Van Eyck could hardly fail to give a preference to amber. The darkness of the ordinary (and perhaps very ancient) solutions of amber was an objection to them as varnishes, and this appearance he may have corrected, as it is corrected now, by great care in the preparation.† Another substance, often, like sandarac, confounded with amber in the middle

burg MS., and from that of De Ketham, also p. 366. It should be further observed that white copperas is perfectly safe as a dryer when boiled with oil or varnishes, since it only parts with its sulphuric acid at a much higher temperature than in such boiling it can be subjected to. When calcined, it is also harmless, having then parted with its sulphuric acid; but in this state it is a white pigment merely (flowers of zinc), and as such is unfit for the darks, and superfluous (as a dryer) in the lights. Mixed with colours when it is dried only, not calcined, it may be sometimes injurious, "on account of the extreme tendency of the vitriolic acid to become dark." On this defect see the *Traité de la Peinture au Pastel.* Paris, 1788, p. 69.

* Vol. i. pp. 130, 143.

† See the description of Lewis's method in his *Commercium Philosophico-Technicum.* London, 1763, p. 366. It is quoted in Mrs. Merrifield's *Ancient Treatises,* &c., Introduction, p. cclxxiv., note. Lewis's solution of amber was "in linseed oil, gold coloured; in oil of poppy-seeds, yellowish red ; in oil of nuts, deeper coloured." From these experiments it would appear that the ancient medium, linseed oil, is fittest for the amber varnish.

ages*, may also have invited the Flemish artists'
attention; this was copal, which forms a varnish
quite as eligible for painting†, and which can be pre-

* Vol. i. p. 233.

† See the interesting account of Sheldrake's experiments
with amber and copal, *Transactions of the Society of Arts,*
1801, vol. xix. " These colours (mixed with amber) were not
acted upon," he observes, " by spirit of wine and spirit of
turpentine united. They were washed with spirit of sal am-
moniac and solutions of potash for a longer time than would
destroy common oil-colours, without being injured." The
result of his experiments with copal was the same, "except
that with copal the colours were something brighter than with
amber." He concludes :—" If my experiments have not mis-
led me, I am entitled to draw the following conclusions from
them :—Wherever a picture was found possessing evidently
superior brilliancy of colour, independent of what is produced
by the painter's skill in colouring, that brilliancy is derived
from the admixture of some resinous substance in the vehicle.
If it does not yield on the application of spirit of turpentine
and spirit of wine, separately or together, nor to such alkalies
as are known to dissolve oils in the same time, it is to be pre-
sumed that vehicle contains amber or copal, because they are
the only substances known to resist those menstrua."

With regard to the superior brilliancy of the tints mixed
with copal, this, it seems, is only the case at first. Dreme
(*Der Firniss- und Kittmacher,* Brünn, 1821, p. 129) observes,
that when the two compounds are employed in coach-varnish-
ing, the copal is the more brilliant for a time only, but that in
the end, and after long exposure to sun and rain, the amber is
far superior. For the purposes which we are now considering,
the difference in the relative durability of the two substances
is unimportant. The tendency of copal to become yellow, and
the darker hue of the amber varnish, are no objections to
painters who are not afraid of depth. The never-failing force
of the early oil pictures is among the proofs that the vehicles
then used were not light in colour. Intensity, either in chiar-

pared less coloured even than that of sandarac. In an historical point of view, in which we profess chiefly to consider these questions, it is, however, more probable that Van Eyck used amber than copal, because, as we have seen, the former substance was certainly employed in Flanders in the fifteenth century, and because it was at hand. The oriental or African copal could, doubtless, have been imported in the North, just as amber found its way, in the remotest times, from the Baltic to the Mediterranean; but there is no documentary evidence to prove that it was used in painting so early. These doubts are of little consequence, as both materials possess nearly the same recommendations; we shall even find that most Italian painters were satisfied with the sandarac varnish. The great point is, that the early painters used resins dissolved in fixed oils, not in essential oils; and it appears that even the weakest of the former class of varnishes—the compound of linseed oil and common resin—was considered adapted to protect surfaces in the open air.*

It was before observed that the early practice of using the red or white varnish, according to the colours over which they were passed, or according to the transparent colours with which they were

oscuro or in local hues, was considered indispensable, and implies a more or less tinted medium.

* Smith, Art of Painting in Oil, 1687, p. 86. Salmon. Polygraphices, l. ii. c. 5.

mixed, may have given Van Eyck the first idea of
assisting the effect of tempera with variously tinted
oleo-resinous lackers—compositions which had been
used for certain ornamental purposes for centuries
before his time.* Whether this was the inter-
mediate step or not is of little importance, a great
improvement gradually arose out of his first ex-
periments. The design being carefully drawn and
shaded, he ground the colours in clarified, but not
thickened oil† (using, we may presume, the lighter
coloured oil with the more delicate tints), and then
adding to each tint a certain quantity of the red or
white varnish, in greater or less proportions, and
also according to the tint.‡ The shadows, darks,
and warm tints generally might be safely fortified
with the amber varnish; but the sky, and certain

* Vol. i. pp. 38, 263, 264, 272. It has been seen (Vol. i.
p. 270) that the early painters were so accustomed to the reddish
hue of the sandarac varnish that other compositions intended to
represent it were sometimes tinged with a red colour. The
following extracts confirm this. In a Venetian MS., dated 1466,
in the possession of Mr. Seymour Kirkup, we read:—"Da
fare la sustantia si pone ī luogo dela V̄nixe liquida, quando
quella nō si trovasse." The ingredients are "oleo de semente
de lino, mastexe, *minio*, incenso" and "pegola biancha." In a
Bolognese MS., also of the fifteenth century, published by Mrs.
Merrifield (*Original Treatises*, p. 489), we find the following
receipt:—"A fare vernice liquida per altro modo. Recipe
libre 1 de olio de seme de lino . . . poi tolli mezo quarto de
alume de rocho spolverizato et altratanto *minio* o *cinabrio*."
The yellow and green varnishes were no less common.

† See Vol. i. pp. 130, 278, the extracts from the Strassburg
MS. ‡ Ib. p. 279.

colours—such as greens and blues—would, precisely
according to the earlier practice of the decorators,
require to be mixed with the white varnish. The
work executed with such materials was already
sufficiently protected; the final varnish, in search
of which all the experiments had been undertaken,
was now no longer necessary. The materials in-
tended to be used for that purpose had been incor-
porated, to a sufficient extent, with the colours,
and left them glossy, transparent, and firm.*

Meanwhile the tempera picture had been gradu-
ally reduced to a carefully shaded drawing, or, at
most, to a very light chiaroscuro painting, as, on
the other hand, what might be compared to the
former ultimate varnishing had become a compli-
cated work, in which opaque as well as transparent
colours were used.

As this system had been gradually developed
from the previous mode of varnishing, so, however
long the process might be, it was a single and final
operation. The work was essentially executed at
once †, or, as the Italians express it, " alla prima."
This system is quite compatible with utmost care
and precision. It supposes the design to be per-
fectly settled, and the drawing to be finished
beforehand, and enables the painter to leave his
ground (that is, the tint of the priming) when and
where he pleases—a power of which the later

* Vol. i. p. 205. † Ib. pp. 393, 394.

Flemish painters took great advantage. A recent example in our own school may here be quoted: Wilkie's celebrated picture of the "Preaching of John Knox," though long in hand, was executed in the sense explained, at once, on the white ground, patches of which were to be seen next finished portions of the work till the whole was completed. This general characteristic of the early Flemish painters (the exceptions and modifications we need not stay to consider) was adhered to and carried to perfection by Rubens, who arrested his design in finished sketches, in order that the picture itself might be executed as much as possible "alla prima." * We shall find, in the course of our investigations, that the Italian, and especially the Venetian practice differed essentially in this respect from the practice of the Flemish school.

To return to the earlier methods. The varnishes that have been described were thick in consistence. Experience taught that the resinous ingredient, on which their compactness and their hydrofuge quality mainly depended, should be as copious as was compatible with the toughness of the composition. Such a consistence in the red varnish, which was freely used with transparent darks, not only insured (at least for a considerable time) an effect of

* Vol. i. pp. 492, 429. Latterly, as is well known, Rubens' sketches were partly intended to enable his scholars to prepare his pictures.

depth by its lucid clearness*—a quality more or less common to all these preparations,—but was further necessary on the principle that in proportion as the pigment has less body the vehicle requires to be substantial. The white varnishes were even thicker, but for other reasons: they were employed with the paler fugitive colours, such as yellow lakes, which, if unprotected, soon disappear;† with verdigris, which, in order to remain unchanged, requires to be well guarded from damp by a medium which, though abundant, cannot vitiate its tint.‡ Lastly, they were employed especially with blues, which, consisting chiefly of carbonates of copper, were found to become partially green and otherwise altered in time, if not effectually "locked up."§ An Italian writer accordingly intimates that blue requires more gum than any other colour.‖ The " vernice liquida," whether prepared with sandarac or amber, was com-

* Compare the passage from Cicognara before quoted (p. 31.)

† On the superior effect of resinous compounds, as compared with mere oils, in preserving fugitive colours, see the experiments quoted in Vol. i. p. 444.

‡ Ib. pp. 458, 468.

§ The colour called " azurro della Magna " (d' Allemagna) was, with the exception of ultramarine, almost the only blue used by the early painters. See the observations of Petrini, in the Antologia (Firenze), August, 1821.

‖ " Fa bisogno a voler temperar bene i colori d' osservar che l' azurro da campo vuole assai gomma, in discrezione ; il verde . . . a bel modo, ma la biacca ne vuol puochissima."—Birelli, *Opere.* In Fiorenza, 1601, p. 346.

posed, as already stated, of three parts of linseed oil to one of resin; the quantity of oil being necessarily reduced in the preparation by fire. But the white varnish, when composed of fir resin and nut oil, consisted of two parts only of oil to one of resin.* The light varnish of mastic and nut oil was at least as thick, for Armenini directs that the resin should be merely well covered with oil in the vessel in which it was to be dissolved.† The safe proportion, combining toughness, by means of the oil, with the lustre and firmness which the resin imparted, was, in these lighter varnishes especially, sometimes overpassed. Accordingly, in the early oil pictures, the white varnishes have, in most cases, become more extensively cracked than the dark ones, although the latter, from another cause, often exhibit a rougher appearance. The white and red varnishes are easily distinguished in pictures, not only by the colours to which they were respectively appropriated, but by their effects. The cracks of the sandarac varnish or ordinary "vernice liquida," when that compound has been used moderately, are short, and sooner or later become abraded at the edges. When used in quantity, the substance acquires in time, and especially if exposed to the sun's rays, a corroded and

* Boltzen, Illumirbuch, 1566, p. 5. Strassburg MS., quoted Vol. i. p. 278. Fioravanti, *Compendio*, &c., p. 116, gives even three parts of resin to one of oil.

† De' veri Precetti, &c., p. 129.

blistered appearance. The white varnish, on the other hand, has long continuous cracks, and yet retains a smoother surface. The characteristics of the two may be seen together in the portrait of Julius II., ascribed to Raphael, in the National Gallery. The green colour is protected by the usual white varnish, the "vernice liquida" being used elsewhere in the picture. A specimen of the excessive corroded appearance which the latter varnish sometimes presents is to be seen in the shadows of the drapery of the St. Peter in the picture by Annibale Carracci, No. 9 in the same collection. This apparently blistered effect is the never-failing mark of sandarac as distinguished also from the amber varnish, which never exhibits such extreme results; although, like copal, it cracks (if at all) in the same short manner. The long glassy crack distinguishes mastic and fir resin when they are used abundantly.*

* The oil varnishes, which afforded, and which often still afford, such effectual protection to the paintings of the early masters, require to be themselves protected after the lapse of years. For this purpose the essential-oil varnishes (which were first used by the Italians) are quite sufficient. Had these been applied in time, so as merely to exclude the air from the surface of the painting—the action of the sun's rays being always supposed to be guarded against—the cracked and corroded appearances above described might have been arrested.

If, on the one hand, the effects of time may be prevented by these expedients, they may, on the other, be accelerated (for the sake of experiment) by exposing varnished surfaces in the open air. A good copal varnish (somewhat diluted, however,

There were some apparent exceptions to the system above described in the treatment both of lights and darks. All dark shadows, those even of blues and greens, inasmuch as such darks are comparatively colourless, were commonly inserted with the " vernice liquida." When, in the early oil pictures, blues which have retained their colour are not prominent, that is, when they are not protected by a superabundance of (the white) varnish,, it may be inferred that the colour used was ultramarine. Opaque colours of whatever tint, especially if durable, required to be mixed with no more varnish than was requisite to give them a gloss like the rest of the work. Black, for example, was so treated; it was thus distinguished, as a local colour, from mere darkness, and had less transparency than the shadows: moreover, it required no especial protection from the atmosphere, since, as a colour, it is not affected by the ordinary causes of change. On the same principle, and still more obviously, white, as well as all solid, light, permanent colours, required less vehicle: their apparent substance would have become inconveniently prominent (as compared with the ordinary surface

according to the modern system, with spirit of turpentine), after being so exposed for two years, has become minutely cracked like (thin) sandarac, and threatens further decay. With regard to the complicated effects of certain ingredients, such as wax, asphaltum, glass, &c., in varnishes, no attempt will be here made to trace or explain them.

preferred by the early masters) if a varnish, of the consistence above described, had been mixed with them in great quantity: but they do not even require such protection, and on this account also they were applied with less of the fortifying vehicle. In the early oil pictures the most solid painting, on a comparatively large scale, and chiefly produced by the thickness of the pigment, occurs in light skies. Even these contain a proportion of varnish; for it was necessary that a sufficient quantity of it should be mixed with *all* the colours to insure a uniform gloss, and to render a final varnish superfluous, at least for many years. The presence of the oleo-resinous medium even in the opaque colours is to be detected, among other indications, by the prominence of small ornaments and of all details where the touch was unavoidably minute. In such portions, where it was impossible to spread the colour, the substance which it derives from the varnish gives· it an embossed appearance.

It is to be remembered that there were no other ingredients in these varnishes than fixed oils, resins, and dryers, such as have been described.* No essential oils entered into their composition. We find that in the seventeenth century the cabinet-makers of Amsterdam introduced spike oil into the

* The ingredients sometimes introduced for absorbing the aqueous particles and for mechanically clarifying the composition, are of course excepted.

"vernice liquida," to render it more drying without impairing its clearness.* There are evidences of a similar practice in Italy at the close of the sixteenth century; but we meet with nothing of the kind in the earliest records of the Flemish method. According to that method, when, in the course of painting, the varnishes or the tints mixed with them were found to be too thick, they were diluted not with an essential oil but with a fixed oil—with the same fluid in which the resin was dissolved.† There may thus, after all, be some truth in Ridolfi's statement that Antonello da Messina was seen to dilute his tints from time to time as he worked, with linseed oil.‡ In the original process, the admixture of essential oils would hardly have been compatible with durability; the strength even of the amber varnish is impaired if the composition be diluted with an evaporable ingredient; the compactness of the substance is thus necessarily diminished, and the result is apparent, in extreme cases, by the dulness of the surface. In the later Italian practice, on the other hand, the colours, often copiously diluted with an essential oil, and mixed only in certain cases with varnish, required to be coated with a protecting varnish as soon as the work was completed. It is

* Vol. i. p. 507, note.

† An indication of this practice will be found in an early Dutch or Flemish MS. quoted Vol. i. p. 286, note.

‡ Le Meraviglie dell' Arte. In Venezia, 1648. Vol. i. p. 49.

unnecessary to decide between the two methods; the choice, in either case, was first dictated by the experience of climate.*

The practice of the early Flemish masters in preparing the ground, and in carefully drawing the design upon it, has been described at length in the preceding volume. It may only be necessary to add, in reference to that subject, that the shading of the design (to be painted upon) was carried so far, with the point, or with a tint in water-colour, that the light ground was in a great measure excluded by it, and, consequently, more excluded in the darks than in the lights of the picture. This was one of the defects of the original Flemish process; it was remedied by subsequent painters, and more especially by Rubens, who was careful to preserve brightness within the transparent shadows, while his solid lights exclude the ground.† The older Flemish painters kept their lights thin, and as the opaque colours had less of the varnish mixed with them, their surface is generally but little raised, while that of the shadows, and of those colours which required much vehicle, projects beyond the surface of the lights.

Various Flemish pictures of the fifteenth century

* Vol. i. p. 434. In Vol. i. p. 313, it is conjectured that the sharpness of execution observable in some works of the early oil painters indicates the admixture of essential oils : the same precision is however quite attainable with fixed oils, even when somewhat thickened by a resinous ingredient.

† Ib. pp. 492, 499.

might be referred to in illustration of the general
practice which has been described, the system
being, of course, more apparent in large works.
The following are among the technical character-
istics which will generally be recognised:—The sur-
face of the flesh tints is seldom prominent; black
is little prominent; rich shadows, and, above all,
greens and blues, are, in a manner, embossed, and,
for the reasons before given, are often more cracked
than the rest of the work. Two pictures by
Mabuse at Hampton Court—No. 509, representing
James IV. of Scotland, with other figures, and No.
510, his Queen—are remarkable examples. On
looking at the mere surface of the first (which may
be best contrived by viewing it from an angle with
the light in which it shines), it will be seen that the
face and the black cap of the principal figure are
quite embedded within the prominent green drapery
round it; the blue is in like manner prominent, and
the shadows, even when small in quantity, are gene-
rally more raised than the lights. This is one of
innumerable examples of the kind, and the observer
who is interested in such particulars may easily
detect the same system in smaller works of the
school: the green drapery, for example, in the Van
Eyck in the National Gallery, is more prominent
and more cracked than any other part of the
picture; the blue, which is less thick than usual,
is probably in this case ultramarine. By such
observation it will also become apparent that the

methods of the Flemish painters were in many respects allied to the habits of preceding ages, and the humble records of the decoration of St. Stephen's Chapel, and of English cathedrals, verified and explained as those records are by later documents, throw no inconsiderable light on the original practice of oil painting.

The leading peculiarities above described are to be traced in the early Italian oil pictures, proving the Flemish origin of the mode in which they were executed; the effects of time on some of these works tend further to show what was the nature and consistence of the varnishes used. In some half-decayed pictures, the darks, where the " vernice liquida " has been copiously employed, are frequently blistered in the mode before described ; the greens and blues, in which the white varnish has been freely used, causing their surface to be prominent, are cracked only, but to a great extent; the blacks, the flesh tints, and the sky (though the latter is often painted with considerable body) are cracked least.*

Such appear to have been the vehicles of the early oil painters. Those who are interested in such investigations will perhaps be curious to

* In the practice of oil painting here considered, the tendency to crack is generally in proportion to the quantity or quality of the resinous ingredient employed. Some of the later Flemish painters seem to have used thickened oil only in their rich shadows to obviate the defect.

know whether such materials can now be satisfactorily prepared. The " vernice liquida," and the amber varnish, after having become obsolete in practice, and after their very designations had, unaccountably enough, become a mystery, have been lately revived in consequence of these researches; and we are now enabled to verify the descriptions of the oldest writers on art from actual observation and experiment. The solution of the light resins in the fixed oils (forming the " white varnish ") is easily accomplished : the solution of sandarac and amber in those oils is, on the other hand, difficult and dangerous, as the operation, to be successful, requires to be undertaken on a large scale. The English varnish-makers, who are surpassed by none, were at first reluctant to make these solutions with so small a quantity in proportion to the " gums," as the old formulæ prescribe, and without the usual ingredient of an essential oil, which latter not only thins the composition, but renders it more drying. It was, however, considered of importance, with a view to making the experiment fairly, that the ancient method should be strictly followed. The employment of a perfectly purified linseed oil was by no means a new condition : the prescribed quantity of oil in proportion to the resin, the use of copperas as a dryer, and the omission of spirit of turpentine were, by degrees, attended to. The " vernice liquida " and the amber varnish have thus been made, resembling

the vehicles which the painters of the fifteenth century used. A copal varnish was prepared in the same way. The "vernice liquida," or sandarac varnish, corresponds in tint with the descriptions of Italian and other writers: the amber varnish is darker, but either may be mixed with good results even with light tints; greens and blues perhaps excepted. De Mayerne observes that the amber varnish used by Gentileschi, though coloured, did not spoil white.*

He might have added, that the first effect of the vehicle, which is slightly to warm the tints with which it is mixed, is permanent, and does not degenerate to what painters call a horny surface. Such effects agree with the result of Sheldrake's experiments; he remarks that "colours mixed with amber, after having been shut up in a drawer for several years, lost nothing of their original brilliancy. The same colours tempered with oils, and excluded from the air, were so much altered that they could scarcely be recognised."† The oil varnishes generally, when well prepared, and with sufficient body, have all more or less this preserving

* Vol. i. p. 304, note. The effect of materials of all kinds may be counteracted by a peculiar taste and practice. Gentileschi was no colourist, and none would imagine, from the coldness of his works, that he was in the habit of using a coloured vehicle. In the general appearance of his pictures we have at least a proof that the amber varnish does not necessarily produce either a " foxy " colouring or a horny surface.

† Transactions of the Society of Arts, before quoted, (p. 36.)

quality: the different effects of such vehicles, as compared with those of the common drying oils (which some of them certainly resemble in colour), seem to be that the thick consistence of the former, in consequence of the resinous ingredient, when once dry, tends to fix the particles so that they undergo no further change; whereas the ordinary thin oils long continue to rise to the surface.

The colours with which these varnishes are, in greater or less proportions, incorporated, should be first well ground in the oils before described, using the clarified drying oil when necessary ; but, in order to reduce the quantity of the oil before adding the varnish, it is advisable to place the colour on compact blotting-paper, or on a smooth piece of plaster-cast; the superfluous oil is thus absorbed, and the varnish may then be mixed with the tint in the proportions required. The colours may occasionally be ground at once in the varnish, but the thickness of the medium renders the operation troublesome.

It is not pretended that there is much of novelty in these materials. All who are acquainted with the nature of an oil varnish can judge of the properties of the more substantial compounds above described, and will also be aware of the inconveniences attending their use. To those less familiar with preparations of the kind it may be necessary to remark that such materials are adapted to a particular practice, and that they were em-

ployed by the early painters in final operations only. Their effect is to produce a glossy surface, which, as painters well know, is ill calculated for a second operation. Yet certain effects in Rembrandt's works were probably the result of skilfully-repeated applications of such thick and transparent vehicles on a surface not too smooth.

All oil varnishes have a tendency to flow. In marking forms with the brush in transparent darks laid in with a copious admixture of amber, sandarac, or copal varnish, it is found that such forms soon become indistinct, and flow more or less into a mass. The defect is best remedied by inserting or repeating the markings when the surface begins to dry; they then keep their due sharpness. The tendency to flow is more easily counteracted in the lights where the substance of the pigment tends to arrest and fix the vehicle; indeed, the sharpest pencilling remains distinct after a very short time if the colour be used in sufficient body. It has been seen that the early oil painters applied their lights thinly, and in this case the colours would of themselves for a longer time easily flow and blend together. This may account for the general absence of "hatching" (or working with lines, as in a drawing) which is characteristic of the older Flemish masters even in small works. It is not so generally avoided in early Italian oil pictures—a circumstance which will be considered as we proceed. What would now be considered an

inconvenience must have been looked upon as an advantage by painters who were accustomed to tempera, in which, according to Vasari *, hatching with the point of the brush was the ordinary mode of finishing. The extreme facility of blending the mere substance of the pigments, even when thin, in the new method, appears to be alluded to by the same writer when, in describing the Flemish vehicle, he says, " what appeared to him most admirable was that the varnish had the effect of blending the colours," &c. †

The tendency to flow which is peculiar to oil varnishes (and which, after all, is an evidence of their homogeneous consistence) cannot be conveniently corrected by ground glass — a material which was used with certain colours by the Italians — for that ingredient, when finely pulverised, is equivalent to a white pigment, and would altogether destroy the transparency of the darks, for which the vehicle is chiefly required. The immixture of wax answers better, but this ingredient has the effect of rendering the varnish comparatively dull, and, to say nothing of the consequent necessity of a final varnish, diminishes to a certain extent, perhaps permanently, the lucid depths of the shadows. In order to correct the inconvenience adverted to, it is advisable to use

* Vita di Antonello da Messina. Also Vita di Andrea Mantegna, vol. i. p. 401 ; Vita di Niccolo Soggi, vol. ii. p. 754.
† Ib.

the pigment itself in due quantity in proportion to
the varnish: the tendency is arrested by incipient
desiccation, and the glassy smoothness of the sur-
face which would be the result of leaving the work
to itself may be prevented, without impairing its
gloss.* As one of Van Eyck's principal improve-
ments was the drying property of his varnish, this
remedy must have been everywhere rendered effec-
tual according to the exigencies of climate: accord-
ingly we find that the oil varnishes used in Italy
were employed partly to assist the drying of the
dark colours.†

The defect above pointed out was certainly cor-
rected by the Italian painters: it is very rare that
the *drop*, indicating the tendency to *flow*, is to be
detected in their works. In a picture of St. Paul

* It appears from the directions of Cennini (*Trattato*,
c. 155), and also from the Romaic MS. (Didron et Durand,
Manuel d'Iconographie chrétienne, Paris, 1845, p. 42), that the
tempera painters were in the habit of laying their pictures flat
when they applied the " vernice liquida." This certainly pre-
vents the varnish from flowing down, but the surface becomes
like glass—an appearance which, however desirable in a final
varnish, is not so agreeable in glazings. It may be obviated
after such an operation in two modes: either by exposing the
picture in a horizontal position to the sun, or, more certainly
and infallibly, by passing an essential oil over the smooth sur-
face: this has the effect of *shrivelling* the oleo-resinous coat.
(See Vol. i. p. 37.) This appearance in a varnish is a defect,
but the artifice may have been resorted to by painters with a
view to certain effects in glazing: the result in pictures will
be again noticed hereafter.

† Vol. i. p. 304. Armenini, De' veri Precetti, pp. 124, 129.

by Perugino (No. 1355 in the Gallery of the Louvre) it is slightly apparent where the green drapery meets the red, and on the under side of the right arm. Some indications of the kind are also to be seen in portions of the blue drapery in Raphael's " Belle Jardinière" (No. 1185 in the same collection). On the other hand, in pictures where the shadows are painted with much vehicle, the marks of the brush are sometimes visible in the transparent mass.

It is only possible, we repeat, to leave such traces in an oil varnish, however thick (if unmixed with wax), when the surface is nearly dry. Whether the older painters had any other special means of arresting the flow of the colour in the cases referred to may be a question: the advantage of *meguilp* in this respect will always render it a favourite vehicle, notwithstanding its defects; but there is no evidence whatever that the old masters used it.*

Whatever limitations may have been observed in the immixture, with certain colours, of what was

* The most remarkable instance of the copious use of meguilp, with which the author is acquainted, is Wilkie's picture of the " Preaching of John Knox." The effect of the ordinary mastic varnish on pictures so painted is well known ; see Cunningham's *Life of Sir David Wilkie*, 1834, vol. iii. p. 298. A middle course between the old and the modern practice, which artists might now adopt, would be, after using meguilp freely, to secure it, in finishing the picture, with an oil varnish.

called the red varnish, that varnish was by no
means excluded from the flesh tints; on the con-
trary, the early painters evidently considered that
the glow which it could impart to such tints was
not among the least of its recommendations: its
presence in any colour to which its tint is not
directly opposed may, in fact, be said to be equiva-
lent to sunshine. This, again, may explain an
expression in Vasari's description of the Flemish
method—a description which, though apparently
misunderstood by that writer himself, must have
been furnished by a good authority—when he says
that the varnish which Van Eyck mixed with the
tints not only gave them a firm consistence, but
" kindled the colour to such a degree that it had a
lustre of its own without the addition of 'vernice.' " *
Armenini, after recommending that a little " ver-
nice comune " should be mixed with a light reddish
ground-tint which he proposes, says that the in-
gredient gives the tint " a certain flame-coloured
appearance." †

* Vita di Antonello da Messina.
† De' veri Precetti, p. 125. When Armenini, shortly be-
fore, directs that verdigris should be fortified with " vernice
comune," we are to understand the substance properly so called
in his time—a compound of linseed oil and common resin.
This varnish was evidently a mellow golden colour, otherwise
it could scarcely give to the light reddish ground " a flame-
coloured appearance;" such a tint would by no means render it
unfit for greens. For the blues, however, Armenini prescribes
the whiter varnish of mastic and clear nut oil. Ib. p. 129.

If, as we have had reason to conclude, Van Eyck used a durable varnish with his flesh tints, this may account for a greater apparent thickness in such portions of his work than perhaps they really possess. It is seldom possible to see the outline under his lights—a circumstance which may be explained by the fact that the amber varnish preserves the surface from the effects of the atmosphere far more effectually than any other vehicle. Cennini calls "vernice liquida" the firmest of vehicles*, and this would be more literally true if he had intended to speak of the amber varnish ("vernice liquida gentile"). The apparent solidity of the lights in Van Eyck's pictures appears to be referable to the power of this last medium. Experience has long shown that white lead, when not sufficiently protected, has a tendency to become semi-transparent. If painted even thickly over darks, such darks will, after a time—sometimes after a few months only—become visible through it, giving the once white external colour a grey hue. The experiment may be easily made by painting over a chess-board uniformly with white: at first nothing is visible through the pigment, but sooner or later the black squares will reappear, showing, in the superior brilliancy of the colour occupying the white squares, the advantage of a light ground. Such experiments exemplify the changes that take

* Trattato, c. 161.

place in pictures when lights are painted with insufficient body over darks, as in making corrections known by the name of " pentimenti." In the usual language of painters, the darks are said to " come up," or, as the French express it, " pousser." There may be cases where such effects really take place*, but the usual cause is that above noticed— the tendency of the white lead to become transparent.

When, therefore, white and the tints which partake of it are not applied in great body, more especially when there is a ground at all darker underneath them, such tints are more likely to retain their solidity when duly protected by a resinous medium. As an example of another practice, the St. Catherine by Raphael, in the National Gallery, may be referred to. On examining the neck of that figure the lines of the first drawing on the white ground will be easily perceived. It is not to be supposed that the flesh tint was originally painted so thin as not to exclude those lines, it is far more probable that it has gradually become transparent in consequence of being painted with a vehicle not sufficiently binding.

The material or mechanical advantages of Van Eyck's medium as described by Vasari †—the drying property of the varnish, its perfectly hydrofuge surface, the firm consistence which its immixture

* Vol. i. p. 447, note. † Vita di Antonello da Messina.

with the pigments insured, its effect in kindling
the colours, its permanent lustre, its tendency to
promote the fusion of the tints—are all applicable to
the amber varnish, and, in various degrees, to the
oil-varnishes generally when duly prepared; but,
in most of the above respects, to no medium with-
out either a resinous ingredient or a resinous prin-
ciple. The vehicle was the vehicle of a colourist,
and in the hands of the Flemish artist and his best
followers it produced warmth, force, and transpa-
rency. The chief peculiarity of the method which
it involved was that the picture, properly so called,
required to be executed " alla prima; " the colours
which needed no varnish at last were themselves
equivalent to a varnish; and the painting, however
gradually and exquisitely wrought, was only a
final process applied to a carefully finished design,
prepared like a drawing, or, when dead coloured, in
little more than chiaroscuro.*

Making every allowance for the facilities which
Van Eyck's system afforded to painters even mode-
rately gifted as colourists, it would be absurd to
suppose that all were qualified to take advantage of
that system. Of the painters who first adopted
the method, many saw in it only the recommenda-
tion of durability, or a novelty which had attracted
the attention of the rich. Antonello da Messina,
though constant to the method, himself compre-

* Vol. i. pp. 380, 381, 395.

hended but little of its power; and the allusion, in his epitaph, to the "splendour as well as durability" which he had been the means of imparting to Italian painting, rather points him out as the cause than the example of the excellence which followed.

We now resume the history of the method, and of the modifications which it underwent in Italy.

Resistance to humidity was the original recommendation of oil painting in its rudest form, and dictated its applications.* The method, both in its early state and with the improvements which Van Eyck had introduced, was employed in Italy, from first to last, and at first exclusively, for standards carried in religious processions in the open air; for canopies (*baldacchini*), also so used; for caparisons (*barde*) of horses; and for similar purposes.† For a long period after the new pro-

* A receipt for protecting (tempera) painting with thickened oil "ut aqua deleri non possit," occurs in a MS. of the 12th century. See Vol. i. p. 19.

† The instances in Vasari are numerous. See the Lives of Luca Signorelli, Domenico Pecori, Girolamo Genga, &c. It was reserved for the biographer to assert that oil pictures are spared by the lightning. At a time when amber (elektron) entered into the materials of painting, he might have carried his theory farther. The following passage occurs in his Life of Raffaellino del Garbo : " una saetta cascò vicino a questa tavola, la quale per essere lavorato a olio, non offese niente, ma dove ella passò accanto all' ornamento messo d' oro, lo consumò quel vapore, lasciando il semplice bolo senza oro. Mi è parso scrivere questo a proposito del dipignere a olio,

cess was known, the higher aims of art found their
expression chiefly in tempera—a method which,
however defective in some respects, was at least
not open to objection, south of the Alps, on ac-
count of its liability to decay. In Flanders, on the
contrary, tempera was soon acted on by damp;*
and hence oil painting, for fine works of art as well
as for common purposes, was there the result of
necessity. These different conditions of climate
explain both the earlier demand for oil painting in
the North, and the long indifference of the Italians
even to the improved method of Van Eyck, when
it was proposed to apply it to purposes for which it
was not absolutely necessary.

It might, at that time, be concluded that a
method of painting which was proof against ex-
ternal damp would be best adapted for walls; at
all events, it was at once resolved to try it in that
mode. There were sufficient grounds, as we have
seen, for not, at first, employing it for movable
pictures on wood; it must have appeared inju-
dicious, in the state of opinion at the time, to
attempt to introduce it for such purposes: the
customary method adopted for altar-pieces—that of
tempera—was not only found to be sufficiently
durable, but was perhaps better fitted for the partial

acciò si veda quanto importi sapere difendersi da simile in-
giuria ; e non solo a questa opera l' ha fatto, ma a molte
altre."
* Vol. i. p. 550.

gilding sometimes added to such works. The decay of paintings on walls was, on the other hand, much more common*, and hence any method which promised a greater durability on such surfaces would, it might be presumed, be welcomed at once. There were reasons—then not suspected, and indeed, as will hereafter appear, not rightly understood even by the later Italians—why oil paintings on solid walls could not preserve the brilliancy of their tints for any length of time, though the works themselves might last for ages; but if this had been noticed in examples of the coarse oil painting before practised, it might still be supposed that the new method would be free from such defects.

Among the different methods employed by the Flemish painters in beginning their works on panel, and which have already been described at length, the most usual was that corresponding with the process recommended by Cennini in commencing wall paintings in oil. The design being carefully completed on the ground, a coat of size (and afterwards, generally, a thin warm tint in oil which did not conceal the outline) was passed over it.† Another mode was to apply an oil priming first, and to draw in the subject upon it.‡

The opinion of Leon Battista Alberti respecting

* Vasari, Vita di Simone e Lippo Memmi; Vita di Tommaso detto Il Giottino ; Vita di Antonio Veneziano, &c.

† Vol. i. pp. 384, 386. ‡ Ib. p. 390.

oil painting on walls may have been recorded about this time; he died in 1472. His words are:—" There is a new invention, in which all kinds of colours applied with linseed oil are proof against all effects of the atmosphere; provided the wall on which they are spread be dry and perfectly free from moisture [within]." * This notice, imperfect as it is, of a then recently practised method (for Alberti cannot allude to the common oil painting which had been in use for centuries) is important.

Another contemporary writer already quoted— Antonio Filarete, sculptor and architect—gives a more detailed account of the new method. His manuscript treatise was completed, as we have had reason to conclude, in 1464.

After briefly noticing the process of fresco and the mode of rounding forms by light and shade, he thus proceeds:—" And you are to follow the same system in tempera; in oil, also, all these colours may be applied, but this is a different labour and a different process—a process which is certainly beautiful in the hands of those who dare to practise it. In Germany they work well in this method: Maestro Giovanni [Van Eyck] of Bruges especially [excelled in it], and Maestro Ruggieri;

* "Novum inventum oleo linaceo colores quos velis inducere contra omnes aëris et cœli injurias eternos : modo siccus et minime uliginosus sit paries ubi inducantur."—Leonis Baptistæ Alberti Florentini, *Libri de re ædificatoria decem.*—Parrhisiis, 1512, l. b. c. 9.

(Rogier van der Weyde) both of whom employed
these colours admirably. *Q.* Tell me in what mode
painters work with this oil, and what oil they use: if
that of linseed, is it not very dark for the purpose?
A. Yes; but the dark colour may be removed. I
am not acquainted with the mode, unless it be to
place the oil in a vase, and suffer it to remain un-
disturbed a long time; it thus becomes lighter in
tint: some, indeed, say there is a quicker mode.
Q. Let that pass; what is the mode of working?
A. The gesso with which your panel is prepared, or
the mortar (if you work on a wall) being dry, you
give a coat of colour ground in oil. White answers
for this purpose, and if any other tint [be mixed
with it] it is of no importance what colour is used.
This ground being prepared, draw your design upon
it with very fine lines and in the manner which I
before described, and then paint the sky upon it.*
Then, with white, paint everything which you have
to represent with a sort of shade of white, whether
you have to represent figures, buildings, animals,
or trees, whatever you have to execute, express its
form with this white. It should be well ground
(indeed all colours should be well ground; and
every time let them dry well, in order that each
[layer] may incorporate well with the other).

* The painting of the sky, apparently in its own colour,
while the rest was to be prepared in chiaroscuro, reminds us
of the unfinished Van Eyck—the St. Barbara—in the museum
at Antwerp. Vol. i. p. 414.

And thus, having with this white defined all the forms for what is to come upon them, prepare the shadows with the tint you prefer, and then when all is dry give a thin coat of the colour which is to clothe the preparation, and round the forms more completely, heightening with white or with any other tint that will harmonise with that which you have given to the object ; and thus you will treat all the objects which you wish to represent. And on walls also you must proceed in this same manner." *

* " . . . et cosi sea afare a tempa et anche aoglio sipossono mettere tutti questi colori ma questa e altra fatica et altro modo il quale e bello chi losa fare. Nellamagna silavora bene inquesta forma maxime dacquello maestro giovanni dabruggia et Maestro Ruggieri iquali anno adopato optimamente questi colori aolio. dimi inche modo silavora con questo olio e che olio e questo olio sie diseme dilino none egli molto obscuro. si maseglitoglie ilmodo nonso senon mettilo intro una amoretta et lasciarvelo stare uno buono tempo eglisischiarisce vero e che dice chece elmodo affare piu presto. lasciamo andare il lavorare come sifa. prima sulatua tavola ingessata overamente imuro che sia lacalcina vuole essere seccha et poi una mano di colore macinato aolio sella biaccha e buona et anche fosse altro colore non monta niente che colore sisia et fatto questo disegnia il tuo piano colinie sottilissime e conquelmodo chedinanzi tidissi poi fa laere insuquesto poi colbianco ditutto quello che vuoi fare da come dire una ombra dibianco cioe che tu o figure ocasamenti o animali o arbori o qualche cosa chetu abbi afare da laforma con questa biaccha et chesia bene macinata et cosi tutti glialtri colori sieno bene macinati et ogni volta glilascia ben secchare pche sincorpori bene luno collaltro et cosi data questa mano dibiaccha alle forme di tutto quello chevuoi fare suvi et tu conquegli colori conche tu vuoi fare

There can be little doubt that this account was derived from a personal examination of the first oil paintings executed by Italians, according to the improved method, in Florence. The passage occurs in book xxiv. (consequently very near the end) of the Magliabechian copy of the MS., and is not in the Palatine copy. The completion of the former in the autumn of 1464 appears to be a sufficient ground for fixing the date of the memorandum in that year.

The only other hypothesis at all admissible is, that Filarete, who had been employed as an architect at Milan, may there have become acquainted with Antonello da Messina, and may have obtained some imperfect information from him. This, however, is not very probable, as the writer (as we have seen, p. 23) omits to mention that painter in a list of the worthies of his day who were known to him. At all events, this is the earliest Italian description of oil painting which can be supposed to have any reference to Van Eyck's method.

l' ombra * poi conuna mano sotile di quello colore che tu lai avestire dagliene una coperta sottile quando latua ombra e seccha et tu poi lameni rilevando colbianco o conaltro colore chesiconfaccia conquello che dato ai alla tua figura et cosi farai atutte letue cose chedipingere insuquesto vuoi et anche insulmuro acquesto medesimo modo bisognia fare."

* In order to give a passable construction to this passage, it is necessary either to read "fane" or "farai" for "fare," or, without altering anything, to consider "ombra" as the imperative of *ombrare*: "l' ombra" for *ombralo*.

The reason, in this instance, for *painting* as well as *drawing* the chiaroscuro design has been already explained. Such an under-painting (representing the finished and shaded drawing then commonly preferred on panels) required to be executed with a thin vehicle, and, if possible, without gloss, the more fitly to receive the oil varnishes with which the colours, properly so called, were applied.

Filarete was evidently ignorant of the nature of the vehicles employed in the final process; but the information which he wanted is supplied in a description of wall painting which is given by Vasari, and repeated by Borghini. The former says:—
"When it is proposed to paint in oil on the dry wall, two modes [of preparing the wall may be adopted]. One is as follows:—If the wall has been whitened, either in fresco or in any other mode, it is scraped; or if, being covered with mortar only, it have a smooth surface, boiled oil is passed over it two or three times, or till it will absorb no more. When this is dry, a priming should be spread over the surface, as explained in the preceding chapter. This being dry, the design may be either traced or drawn upon it; after which the work may be completed as in painting on wood, always using a little 'vernice' mixed with the tints, because by this means there is no necessity for varnishing the work at last." *

* "Quando gli artefici vogliono lavorare a olio in sul muro secco, due maniere possono tenere : una con fare che il muro,

The description of the other mode of preparing the wall is here unimportant.

Borghini's directions are nearly the same. He merely observes, as Vasari does elsewhere, that the colours had better be ground in nut oil, as it yellows less than that of linseed. He then directs that a little "vernice" should be mixed with the tints.*

Thus, in and after the middle of the sixteenth century (the date of the two writers last quoted), the Flemish process survived at Florence in the application of oil painting to peculiar purposes only. Had those writers left no details of the method of painting on wood or on cloth, it might be inferred from the passages cited that the oil varnish was also commonly employed in works of that kind; but, in descriptions of such applications of oil painting, they say nothing whatever of mix-

se vi è dato su il bianco o a fresco o in altro modo, si raschi, o, se egli è restato liscio senza bianco ma intonacato, vi si dia su due o tre mani di olio bollito e cotto, continuando a ridarvelo su, sino a tanto che non voglia più bere ; e poi secco, se gli da di mestica o imprimitura, come si disse nel capitolo avanti a questo. Ciò fatto e secco, possono gli artefici calcare o disegnare, e tale opera come la tavola condurre al fine, tenendo mescolato continuo nei colori un poco di vernice, perchè facendo questo non accade poi verniciarla."— *Introduzione*, c. xxii.

* "Dando i colori, temperato con olio di noce o di linseme (ma meglio fia di noce, perchè è più sottile, e non ingialla i colori, ne' quali fia bene mescolare un poco di vernice), conducerte con diligenza a fine l' opera vostra, laquale non accaderà verniciarla."—*Il Reposo*, Milano, 1807, vol. i. p. 202. The first edition is dated 1584.

ing varnish with the colours.* It appears, there-
fore, that the Florentine contemporaries of Vasari,
looking merely at the quality of durability, had by
degrees considered such a use of varnish to be un-
necessary, except when, as in the case specified,
the work was exposed to damp. In this gradual
restriction, in Florence, of the Flemish method
(when employed on the higher objects of art) to
wall painting, we recognise a proof of the general
fitness of that method for a severer climate. Under
circumstances which, in certain seasons, approxi-
mated to the conditions of a northern atmosphere,
the art of the North was retained without change.
It is only remarkable that the origin and intention
of its technical peculiarities were so far lost sight
of at the period referred to, that Vasari explains
the admixture of varnish with the colours merely
by observing that it rendered a final varnish un-
necessary. Meanwhile, the advantages of the pro-
cess in a higher sense—the richness of shadows
and low tones, the general glow which it could
impart, and the force which it at once compelled
and assisted—were in danger of being forgotten.

Though accepted at first by few, the art began
with a fairer promise. The original method ap-
pears to have been implicitly followed in Florence

* Borghini expressly prohibits any vehicles in addition to
nut oil :—" Chi volesse dipingere a olio in tavola . . . colorisca
co' colori temperati con olio di noce, senza più."—*Il Reposo,*
vol. i. p. 203.

and the neighbouring schools for a considerable time by several painters. The first whom we have to notice is Antonio Pollaiuolo; of his surviving works the picture which most invites attention is the celebrated St. Sebastian, of which we have spoken (p. 18). This early specimen of Florentine oil painting is still in excellent preservation. Its surface has, at some not very recent period, been indented but scarcely perforated, by what appear to be small shot-marks. These, with the usual warping of the planks of which the "tavola" is composed, and a few scratches, are the only injuries. The minute pits or bruises have here and there been filled up, but the picture exhibits little appearance of repainting.

It is quite evident that this work was painted at once on a warm light ground. There was no solid chiaroscuro preparation, and there is no indication of a dead colour. With the exception of a slight change in an outline, no part appears to have been retouched. There is no appearance of "hatching;" the generally thin substance of the pigments is blended, the tints fused. Certain portions are, however, painted with great precision, as, for example, the wrinkles on the older figures, and even the grain of the skin on the back of one of their hands. The darks are, almost without exception, more prominent than the lights, and, from the effects of time, are now rough and blistered. Even the dark trees in the distant landscape are all, as it were,

embossed, in consequence of being painted with a thick medium. The lights have remained smooth, and free from cracks; the minuter lights only are raised; the minute darks have the same appearance; the drops of blood, for instance, on the martyr have the relief of real drops.

The "Virtues" by Pollaiuolo, before mentioned (p. 17), are inferior specimens of the master, but they have the same general characteristics. The darks are prominent and are now corroded. The flesh is thinly painted: this last peculiarity is almost universal in the early Italian as in the early Flemish pictures, and indicates the careful completion of such portions, at once, on the light ground. Light skies are often more loaded; in them the thicker "vernice chiara" was commonly used, which increased their apparent body; they appear, however, to have been really painted with more substance to insure their luminous effect, and this must have been more necessary when the ground was tinted. In the flesh, on the contrary, the tint which was sometimes used for the ground was calculated to assist the colour *, while the warmer and somewhat thinner varnish was used. In the two pictures by Pollaiuolo representing the " Acts of Hercules," the flesh is as usual thin, while the light sky and all the darks are raised.

The examples that have been adduced are sufficient to show that the earliest specimens of oil

* Vol. i. p. 393.

painting produced in Florence were executed strictly according to the Flemish process, and, if not in every case with the same vehicle, with a nearly equivalent one, employed partly from choice and certainly on the same principles. Those principles contained the germ of the best practice: the thin painting of the flesh may be reckoned among the defects; but even this habit was partly a consequence of looking upon such portions of the work as belonging to the class of low tones, and requiring, like all such tones, to be more or less transparent. The defect was sooner remedied in Italy than in the North: there, we seldom find the lighter flesh-tints solidly painted till the age of Rubens and Rembrandt. Another occasional defect, before adverted to, common to the early Flemish masters and their Italian followers, was that of shading the preparatory drawing to the exclusion of the light ground where it was wanted most: but this is a question of degree; a shade tint which is sufficient to indicate the chiaroscuro of a work, before the actual painting is begun, may still be light enough to give value to the transparent shadows afterwards inserted.* In other

* Internal light in the obscurer portions of a picture, by whatever means that transparency is obtained or represented, is indispensable to richness of effect. Without it, force degenerates to blackness, and darkness is no longer equivalent to depth. Vasari justly remarks that no ultimate varnish could give depth to the black shadows of Giulio Romano :—" Questo nero fa perdere e smarrire la maggior parte delle fatiche che

respects Antonio Pollaiuolo followed with advantage the Flemish system, and transmitted it unimpaired to the great artists who succeeded him.

One great peculiarity of the system, and of which he felt the value, was the abundant use of the thick yet lucid vehicle in the darks: while these retained their surface and gloss they must have given to his works a richness then new in the art.* The appearances of this kind above noticed in his works now enable us to pronounce that an oil varnish of the ordinary kind (sandarac and linseed oil, called

vi sono dentro, conciossiachè il nero, ancorchè sia verniciato, fa perdere il buono," &c.— *Vita di Giulio Romano.*

* The early oil painters saw in the method the qualities opposed to tempera; when portions executed in oil had been introduced in tempera pictures (ornaments, gems, &c.), the quality aimed at and attained in those portions was that of depth—depth, in the positive and real sense of seeing colour or light in and through a lustrous, transparent, but thick substance, for the oils and varnishes then used had an almost honey-like body. This actual representation of depth (as distinguished from the imitation of atmosphere, distance, and roundness) is the essential and original characteristic of oil painting. By later masters it was applied to assist the expression of space, as in shadow, but it was also used to give the charm of depth to all colours, to flesh, and even to stone and to wood. Among the masters who felt this most, so as sometimes to carry it to excess, may be named Correggio, Rembrandt, and Reynolds (the latter here named with reference solely to this quality, and irrespective of any merits or defects of other kinds). The " Annunciation " by Pollaiuolo at Berlin, with all its defects, has the richness and depth of the most consummate oil painters : not from the expression of distance and space, for in this perhaps it fails, but from the mechanical real effect of a transparent vehicle used over light with all the colours.

" vernice liquida ") was used probably in all the colours except the sky, but especially in the darks. Had the firmer amber varnish been employed, the surface of the raised shadows would not have been affected in the mode described; or at least not to that extent. The known durability even of the "vernice liquida" appears to have given it an almost equal reputation in the eyes of the Italians, and a Florentine had pronounced it to be "the strongest vehicle there is." For works not likely to be exposed to any extraordinary trials—such trials as being kept at all seasons and for ages within churches—this sandarac oil varnish (greatly to be recommended for its tint and lustre) may be considered an all-sufficient vehicle; but as regards the question of actual durability, there is no doubt that the amber varnish is unsurpassed. With regard to the estimation in which its rival was held in Italy it must be remembered that while used only as a varnish for tempera pictures it was not applied in much body; and when, as must have happened in the lapse of time or from unusual exposure to the vicissitudes of heat and cold, the oleo-resinous coating cracked, such a result produced no serious change in the effect of the work, which, in extreme cases, could be cleaned and then varnished afresh.* In the course of our investigations we shall, however, have abundant proof,

* Didron et Durand, Manuel, &c., p. 43. The words translated "eau forte" are explained (Introduction, p. xxxiv.) to mean the "eau seconde de potasse."

from the decay that has taken place in the rich shadows of excellent pictures, that the Italians placed too much confidence in this favourite vehicle: the lavish use of a semi-resinous medium where, certainly, it was most required—in the transparent darks, and, in another form, to protect certain colours—was ill calculated to resist the Italian summer atmosphere, still less the occasional action of the sun's rays.* The question of the influence of climate on the technical peculiarities of the arts would lead to deeper inquiries than we can here indulge in; thus much, however, may be confidently affirmed, that the richness of texture

* Such effects of the sun's rays are not confined to Italy ; the fine picture of Rubens with his wife and child at Blenheim is remarkable for the quantity of vehicle with which the mass of shade in the drapery is painted. This portion is now *riddled* with cracks, in consequence of the picture having been formerly in a situation where it was partially exposed to the sun.

The influence of heat on resinous compounds is too often exemplified in church pictures by the effect of the altar candles on portions of the work that have been nearest to them. The lower portion of Titian's picture of the Assumption, formerly in the Frari at Venice, was seriously injured in the centre from this cause, and the figure seated on the sarcophagus required to be in a great measure repainted in consequence. Richardson (*Works*, vol. ii. p. 34) says that Raphael's St. Cecilia was "fried" in the parts nearest to the candles. Vasari informs us that the doors painted by Liberale Veronese to protect an early picture of the Madonna in S. Maria della Scala, at Verona, were injured from the same cause, and the triptych was placed in the sacristy for safety. Lastly, a work by Granacci was burnt by the candles inadvertently left on an altar.—*Vita di Fra Giocondo; Vita di Francesco Granacci.*

which, as a result of firm yet transparent vehicles, a Rembrandt could produce with safety, and even, in a material sense, with advantage, in the climate of the Netherlands, often led to premature decay in the works of some of the best Italian colourists. Undoubtedly, the evil might have been arrested by ordinary care on the part of those to whom the conservation of such works was entrusted; and as this is, or should be, an easy condition, we conclude that the later Italian painters had no just ground, in the experience of their climate and its effects, for abandoning the technical characteristics of the Flemish method. Such objectors, nevertheless, there were: not only was oil painting denuded of its best attributes by those later Florentines who suggested or adopted the precepts of Borghini, but examples were not wanting of painters who altogether condemned and abandoned the method. At a period in the sixteenth century, when the finest examples of oil painting had been produced, Domenico Beccafumi returned to tempera, from a persuasion that the more modern process was not durable.*

* " E perchè aveva Domenico opinione che le cose colorite a tempera si mantenessero meglio chè quelle colorite a olio, dicendo che gli pareva, che più fussero invecchiate le cose di Luca da Cortona, de' Pollaiuolo, e degli altri maestri che in quel tempo lavorarono a olio, che quelle di Fra Filippo, di Benozzo, e degli altri che colorirono a tempera innanzi a questi, per questo, dico, si risolvè, avendo a fare una tavola per la compagnia di S. Bernardino in su la piazza di S. Francesco, di farla a tempera."—Vasari, *Vita di Domenico Beccafumi.*

CHAP. III.

LORENZO DI CREDI—LEONARDO DA VINCI—PIETRO PERUGINO—
FRANCESCO FRANCIA.

THE works of Antonio Pollaiuolo, considered as oil
paintings, and independently of their merit in
design, were far from exciting universal admiration
among the artists of Florence, or of the neigh-
bouring schools, but there were some of the then
rising generation who looked at these works with
deeper interest, and who were at once attracted by
the new method.

About the year 1475, when the St. Sebastian by
Pollaiuolo was completed, three young men, after-
wards celebrated, were studying with Andrea
Verocchio. These were Pietro Perugino (born
about 1446)*, Leonardo da Vinci (born 1452), and

* Vasari's statement that Perugino studied for a time with
Verocchio has been doubted by some modern historians, partly
on account of the very little resemblance to be traced between
the style and aim of the two artists; but the authority of an
interesting contemporary writer—Giovanni Sanzio, the father
of Raphael—may be considered a corroboration of Vasari's
assertion. In a poem on the Acts of Federigo da Montefeltro,

Lorenzo di Credi (born 1453). The first-named was then twenty-nine years of age; Leonardo da Vinci was twenty-three, and Lorenzo di Credi was a year younger than Leonardo. Their instructor, Andrea Verocchio, was a sculptor, who handled the brush only occasionally, and not even very successfully; in other respects, and especially as a designer, his influence on the subsequent direction of the Florentine school was both marked and beneficial. His well-studied contours for a battle, in which the combatants were naked, probably suggested the idea of the celebrated cartoon by Michael Angelo of the " Bathing Soldiers " suddenly called to the field. Verocchio is said to have been one of the first who took casts from nature, and the practice indicates a desire to master the difficulties of modelling. He was, in short, well qualified to teach the knowledge of form and anatomy—studies no less essential to a painter than to those of his own profession. To all appearance the first ardent admirers and successful cultivators of the new art of oil painting were thus, at the time when their predilections were manifested, qualifying themselves to be skilful designers; but their subsequent practice does not altogether confirm this. Of the three

which is preserved in the Vatican Library, Giovanni alludes to the friendship between Leonardo da Vinci and Perugino when young men, and, as we may conclude, fellow-students in Florence :—" Due giovin par d' etate e par d' amori, Leonardo da Vinci e 'l Perusino, Pier della Pieve, che son divin pittori."

painters above named, Leonardo was the only one
who, partly by Verocchio's instructions and ex-
ample, had acquired a thorough knowledge of the
human figure and great skill in modelling. If he
equalled his teacher in these respects, he soon sur-
passed him as a painter. An altar-piece in which,
while yet a youth, he assisted Verocchio, is preserved
in the gallery of the Academy at Florence, and it is
related that the figure of an attendant angel, added
by the scholar, was considered so superior to the
rest of the work, that Andrea, in his mortification,
determined to abandon the pencil for ever.

It is, indeed, on many grounds probable that
whatever Perugino and Lorenzo di Credi learnt of
painting while they were in the school of Verocchio
was chiefly derived from Leonardo. As regards
Lorenzo especially, this is confirmed by the cha-
racter of his works. At an early period he copied
a picture by Leonardo so closely that the original
could not be distinguished; the predilection was
lasting, and his style, from first to last, was formed
on that of his fellow-student. The friendship of
Leonardo and Perugino during their youth has
been already adverted to (see note, p. 78), but
the elder artist seems to have borrowed little from
Leonardo except a more refined taste in expression.
The secret of the intimacy is however sufficiently
explained by their common study of oil painting
at a time when that method had been adopted
by few.

Lorenzo di Credi's style and practice, in imita-
tion of Leonardo, must have been formed previous
to 1480, about which time Leonardo quitted Flo-
rence for Milan, where he remained till near the
close of the century. The eight or ten years
immediately preceding 1480, therefore, define the
period when the Flemish method of oil painting
was first studied by the scholars of Verocchio.
The process was gradually modified by each of
them, but, as will appear, most so by Leonardo.
That enterprising spirit, far from looking coldly on
the new art, eagerly and early adopted it; and it
was apparently through his example that his com-
panions forgot their prejudices, and became warmly
interested in the pursuit. Each, however, according
to his character and views, recognised in it peculiar
advantages. In the eyes of Leonardo the method
had two great recommendations—that of enabling
him to correct his forms and expressions to the last
degree of accuracy and truth, and that of furnishing
the means of closely imitating the relief and force
of nature. Lorenzo di Credi, if attracted also by
these qualities, was still more smitten with the
fusion of tints and the finish which the method
promised; while Perugino was more alive than
either to the transparency and warmth which it
could command. The tradition of the mere art
could no longer be a secret; Antonio Pollaiuolo
had many disciples, and the process was now in the
hands of too many to continue to be monopolised.

Lorenzo di Credi, who, in the practice of painting, could have felt little in common with Verocchio, was, nevertheless, sincerely attached to him; he remained with him assisting in the direction of his affairs after the departure of Leonardo and Perugino, and when Verocchio died in Venice in 1488, from the fatigue he underwent in casting his equestrian statue of Bartolommeo da Bergamo, Lorenzo hastened thither, and brought back his remains to Florence.

Though the occasion of his short stay in Venice must have allowed but little opportunity for observation, Lorenzo could not, as a painter, be insensible to the interest of the place. At that time Antonello da Messina was in full employment there, and had produced his masterwork—the altar-piece of S. Cassiano. The very year (1488) of Lorenzo's visit was marked by the completion of two celebrated works (hereafter to be described) by Giovanni Bellini, in which the first promise was given of that powerful and glowing colour afterwards carried to perfection in the works of Giorgione—then only eleven years of age. Lorenzo's practice was formed, and it does not appear that it was essentially altered in consequence of this experience, but the enthusiasm which now began to prevail in Venice for the new method must have confirmed his predilection for it.

The early pictures in tempera by Lorenzo di Credi are seldom interesting; he was an example

of those to whom Vasari may be supposed to allude
in his general notice of the introduction of oil paint-
ing—tempera painters who longed for a method
which should supersede the necessity of finishing
with the point, and which, with the requisite preci-
sion, should command an imperceptible blending
of the tints. The qualities which recommended
the new process to Lorenzo may be said to charac-
terise all his oil pictures. One of the best, repre-
senting St. Julian and St. Nicholas standing beside
the enthroned Madonna, is now in the Louvre; and
of this Vasari says, "Whoever would be convinced
that careful processes in oil painting are essential
to the durability of the work, should look at this
picture." Two excellent specimens, both repre-
senting the Nativity, are in the gallery of the
Uffizj at Florence. All these works have the same
technical characteristics: there is no "hatching"
in any part; the flesh tints, though quite as smooth
as those of the earlier masters, are much more
solid, but notwithstanding this solidity the darks
are more raised than the lights. In the Louvre
picture above mentioned (the only specimen of the
master in the collection), the blues and greens are,
as usual, prominent; the left hand of St. Nicholas,
for example, is quite embedded in the blue cover
of the book he holds. In some cases the prominent
shadows, like those in Pollaiuolo's St. Sebastian,
and in his single figures of "Virtues," are blistered
and corroded, and consequently rough.

Lorenzo's system of dead colouring, as distinguished from the original Flemish practice, may be inferred from the appearance of his pictures, in which the ground is almost entirely excluded, and from the fact of his having left many half-finished works at his death. A certain conscientious feeling, agreeing with his character in other respects (for he was among the followers of Savonarola), influenced even his practice in art; and his love of finish was rather encouraged than checked by Leonardo da Vinci, though that great artist, in his own elaborate works, was fastidious with a higher aim. The extreme care and delicacy of Lorenzo's execution are, however, not to be regarded as an imitation of the earlier Italian examples of oil painting which he had seen. The works of Antonio Pollaiuolo are so far bold and decided that, even when of large dimensions, they are painted at once and without retouching; the pictures of Lorenzo were the result of repeated and slow processes.

With this explanation the remarkable description of this painter's habits which Vasari has left may not be uninteresting:—" He was so finished and delicate in his works," says that writer, " that every other picture compared with his will always appear a sketch, and coarsely executed. . . . He was not desirous of undertaking many large works, as he took infinite pains in bringing such to completion. The colours which he employed were ground to the

last degree of fineness; he purified and distilled his oils, prepared from walnuts; the tints on his palette were very numerous, so much so that they extended through all gradations from the first light tint to the deepest dark with a needless regularity: the consequence was that sometimes he had five and twenty or thirty tints on a palette, and for each tint he kept a different pencil. When he was at work he would not suffer the least movement which could stir any dust. Such an extreme nicety is no more to be commended," gravely adds the biographer, " than an extreme negligence."

In his preference of nut oil to the exclusion, it seems, of that of linseed, Lorenzo di Credi resembled Leonardo: the expression "he distilled" ("stillava") may only relate to the process of filtering, which was not uncommon; but as Leonardo certainly distilled the oils, including even the fixed oil he used, by means of fire, the word is perhaps in the above passage to be taken in its literal sense. It is scarcely necessary to observe that, as regards the fixed oils, it was a useless refinement. But wherever modifications of the Flemish process may have been introduced or adopted by Lorenzo di Credi, he preserved one peculiarity unaltered: this was the abundant use of the "vernice" in his darks. As already observed, the common "vernice liquida" was considered by the Italians extremely durable, and no less so than the amber varnish (though this was certainly a mistake). This can

alone account for the circumstance that so scrupulous a workman did not on all occasions prefer the latter.

As the more innovating technical habits of Lorenzo di Credi appear to have been derived from his fellow-scholar, it is to be regretted that so few certain works by Leonardo da Vinci, belonging to the period of his first residence in Florence, should be preserved. The earliest example is the angel before mentioned in Verocchio's altar-piece, representing the Baptism of Christ, now in the gallery of the Florentine Academy. But for the addition by the scholar, it would not be easy to determine whether the work is in tempera or in oil, as portions only exhibit the peculiarities of the latter method. The figure of Leonardo's angel has, however, more body than the rest of the picture, and is free from "hatching," while the portions executed by Verocchio frequently betray the use of the point. In the figure in question, again, the darks are prominent, and some blue drapery is, as usual, more raised than any other part. This picture long remained forgotten in a church near Vallombrosa, and was only brought to light in 1812: it has therefore suffered considerably.

The celebrated Medusa's head in the gallery of the Uffizj has been doubted by a writer of no

ordinary authority*, but his opinion has not been confirmed by that of any other connoisseur. Technically considered, the work corresponds sufficiently with the accredited specimens of the master, and is painted with an equal body of colour. In the same gallery, and underneath the Medusa, is a portrait of a young man also attributed, but hardly on sufficient grounds, to Leonardo. It is solid, like the works of Lorenzo di Credi, yet there is evidence of its being painted on a light ground. The darks are, as usual, much more raised than the lights, and the green background is more prominent than the black cap which it surrounds, precisely as those colours are treated in the early Flemish pictures. Leonardo's portrait of himself (belonging to a different period), in the same gallery, has the same general characteristics; solid throughout, but with the darks most raised, in consequence of the greater proportion of thick varnish used with them.

The editors of one of the earlier works on the Florence Gallery† are of opinion that Leonardo's unfinished picture of the Adoration of the Magi belongs to his second residence in Florence (1499–1513), and adduce some not unimportant reasons for their conclusions; Vasari, on the other hand, includes it among the master's earlier works.

* Rumohr, Italiänische Forschungen, vol. ii. p. 307.
† Reale Galleria di Firenze.

Whenever it was executed, it is plain that the artist got into difficulty with it, and he may have thrown it aside in consequence. The work exhibits two different stages, or rather experiments: in one portion the composition is laid in, in chiaroscuro, on a cream-coloured ground; the very pale outlines and shadows of this preparation are greenish. A second process is apparent upon this in the remaining portion; the shadows are inserted without care, so as to encroach in many places on the outline, and are sometimes violently dark. The fainter greenish shades have, at a distance, the appearance of white scumbled over the intenser darks, but on near inspection this is found not to be the case, although some white was used. All this cannot be said to belong to any regular system, but some other circumstances merit attention. The chiaroscuro preparation agrees in principle with Filarete's description of the method of oil painting. The greenish shadows correspond with the practice of the earlier tempera and fresco painters, and, as we shall see, were an exception to Leonardo's general method. The darker shadows were evidently inserted with " vernice," and though often prominent, are not blistered or corroded like those of some specimens before noticed.

A small picture of St. Jerome, by Leonardo, which was sold with the Fesch collection, is another and a more careful example of this chiaroscuro preparation. In this instance no white is added;

the ground is left for the lights, and a brown colour, varying in depth, but never intensely dark, is alone employed to define the masses and round the forms. The head of the saint is highly finished in this mode; the rest of the work is not carried so far. To the two last-mentioned specimens may be added various studies of heads in chiaroscuro, which are sometimes to be met with in public and private collections; one is in the gallery at Parma, another, a study for the head of the " Vierge aux Rochers," was once in the possession of Messrs. Woodburn.

The manner in which these preparations are executed shows that Leonardo did not follow the original Flemish method in this stage of his work so closely as Giovanni Bellini and other early Italian oil painters. The Florentine, it may be gathered, both from his writings and his works, seems to have thought that each process of art, as well as each quality in nature, has its characteristic and corresponding means of expression. While employed in drawing, for example, he aimed at the last degree of exquisite precision, as if accuracy of mere form were, by means of a pointed instrument, the proper object of imitation. But when he dealt with light and shade—and especially by means of the brush —his attention was directed to the attainment of roundness by imperceptible gradations, and the softer instrument was employed to express, by such gradations, the thorough *modelling* of the object. In unfinished works by Van Eyck and Giovanni

Bellini, on the contrary, the light and shade of the future picture is expressed with the point; the work is finished as a drawing, although all was to be covered and obliterated by more or less solid painting. The later Flemish painters adopted the Leonardesque process: the earlier method was that of the tempera painters, who always completed their compositions as drawings before they began to paint. The preparation with the brush instead of the point (after the outline was defined) may be considered one of Leonardo's improvements on the older system, and the practice seems to have been adopted by him as much from the capabilities of the instrument and materials of oil painting as from a desire to combine breadth with finish in the treatment of shade.

Various pictures which are described as early works of the master exhibit his characteristic merits too imperfectly to be considered really his. The so-called " Monaca," in the Pitti Gallery, appears to belong to another school and period. The Madonna with the vase of flowers, in the Borghese Gallery at Rome, corresponds in its subject and accessories with a picture described by Vasari, but is hardly equal to Leonardo's reputation.

The later and more consummate productions of the master may be classed according to his places of residence. At the head of his works executed at Milan stands the celebrated Last Supper: of his movable pictures, probably done at the same

period (1480–1499), some are preserved in the
Louvre. Among them is the portrait called " La
Belle Ferronière," but supposed to be that of
Lucrezia Crivelli. The St. John and the Bacchus
in the same gallery, may perhaps belong to Leo-
nardo's second residence in Florence; on this point
it is difficult, and not very important, to decide.
The " Vierge aux Balances" has been considered the
work of Oggione, and is certainly not by Leonardo.
The " Vierge aux Rochers " is also by a scholar: the
original is in the possession of the Earl of Suffolk at
Charlton Park. The picture was once in the chapel
" della Concezione " in the church of S. Francesco
at Milan: two angels, originally forming the side
pictures or doors to the work, are still in the col-
lection of Duke Melzi in that city. To these speci-
mens are to be added the portraits of Lodovico
Sforza and his consort, and the head of St. John in
the Ambrosian Library at Milan; the Holy Family,
now in the possession of the Countess of Warwick
at Gatton Park; and the Holy Family in the gallery
of the Hermitage at Petersburg. The unfinished
picture in the Brera at Milan, the Virgin and Child
with a lamb, is supposed to be the production of a
scholar: some critics see in it the work of two
hands. The finished portions are executed at
once on the light ground, as in the early Flemish
system, and as in Pollaiuolo's St. Sebastian : the
process is more apparent in this specimen, as con-
siderable portions of the white ground are still

untouched. Admitting this to be the work of a less practised hand than Leonardo's, or, at all events, to be not entirely by himself, it is to be remembered that he was ever making experiments, and that he may sometimes have returned to the earlier practice, which must have been first familiar to him.

To the period of Leonardo's second residence in Florence (1499–1513) belong the Battle of Anghiara, commonly called, from the portion of the composition which has been copied and preserved, the Battle of the Standard; the celebrated portrait of Mona Lisa in the Louvre; a young man's head in the Belvedere Gallery at Vienna; and the cartoon in the Royal Academy in London. To this period may also belong some Madonnas which are perhaps to be found among the pictures ascribed to Leonardo in Spain.*

No work of importance can with certainty be referred to as marking Leonardo's short stay in Rome. The Madonna and the portrait mentioned by Vasari are not to be traced. The fresco in S. Onofrio either proves that the method induced the artist to alter his style, or, as Rumohr supposes,

* Of the three pictures, so called, by Leonardo da Vinci, since seen by Sir Charles Eastlake in the Madrid Gallery, he describes No. 666, Retrato de Mona Lisa, as a "poor copy;" No. 778, Sacra Familia, as "a Luini—rather blackened;" and No. 917, Jesus, Santa Ana y la Virgen, as "an indifferent picture."—Ed.

that he painted it during an earlier visit to Rome. The picture called Modesty and Vanity, in the Sciarra Palace, is now generally acknowledged to be a work by Luini, as is also the Christ and the Doctors in the National Gallery in London.

Between the date of Leonardo's last departure from Florence to reside in France (1516) to 1519, when he died, the only works which can with probability be ascribed to him are, the unfinished Holy Family (a picture in which the Madonna sits on the lap of St. Anna) in the Louvre; and the Flora, or Diane de Poictiers, called when in the Orleans Gallery " La Colombine," afterwards at the Hague.*

Many other pictures which formerly passed for Leonardo's productions, executed before as well as during his residence in France, have, with increased knowledge of the manner of his imitators, and a more accurate acquaintance with his own style and method, been attributed to his scholars. The Pomona in the Berlin Gallery is, on good grounds, assigned in the catalogue of that museum to Francesco Melzi; the Judith at Vienna is by Cesare da Sesto; the Leda (miscalled a Charity), formerly at Cassel and since at the Hague, is also a school picture. The Christ with the Globe in the Miles collection, the Magdalen in that of Hofrath Adamo-

* Now in the Gallery of the Hermitage, Petersburg. See *Gemälde-Sammlung in der Kaiserlichen Ermitage zu St. Petersburg*, von Dr. G. F. Waagen, 1864.

vitsch in Vienna, the Daughter of Herodias in the Tribune at Florence, and the St. Catherine at Copenhagen—pictures of which there are numerous repetitions—are by, or after, Luini. The Christ bearing his Cross, a half-figure, at Vienna, is also of Leonardo's school. It will not be necessary to consider all even of the genuine works of the master above enumerated; a few will be sufficient to illustrate his technical peculiarities and the changes which he introduced in the Flemish system of oil painting.

Leonardo's refined taste and fastidious habits may be traced in opposite effects—in untiring labour, and in apparently causeless dissatisfaction. From a real love of excellence, and by no means from indolence, he was averse to methods which require decision and dispatch, and this temper of mind may be supposed to have influenced his adoption of a process which left improvement always in his power. This cannot be literally said of the Flemish system of oil painting, in which, when once the design was completed on the ground of the intended picture, that design was looked upon as nearly as unalterable as an outlined fresco. To what extent Leonardo used and abused the facilities which he found the new process afforded may be gathered from the state of the unfinished picture in the Brera, above noticed, p. 87, of the Adoration of the Magi. But the more judicious employment of the controllable means of oil painting is to be recog-

nised in many of his works, in successive opera-
tions, in the most exquisite " modelling," and in
the preservation, notwithstanding such repainting,
of a uniform surface. This power of still making
corrections, and superadding refinements in form,
expression, and effect, was analogous to the advan-
tage which he possessed as a sculptor. It appears
that the model for the equestrian statue of Fran-
cesco Sforza was kept in the clay for sixteen years;
during the greater part of that time Leonardo was
also employed on his noblest work, the Last Supper,
in S. Maria delle Grazie, and a contemporary
writer gives the following account of his habits in
Milan:—

" He was wont to go early in the morning—I
have often seen and watched him—and ascend the
scaffolding (for the picture of the Last Supper is
somewhat high from the ground); he would con-
tinue painting there from sunrise to twilight, for-
getting his meals and never laying aside his pencil.
Then, perhaps, for two, three, or four days he would
not touch the work; yet he sometimes stood for an
hour or two in the day, merely looking at it, and
as if passing judgment on his figures. I have also
seen him (as caprice or impulse moved him) set
out at noon, under a July sun, from the Corte
Vecchia, where he was modelling that stupendous
horse in clay, and hasten to the Madonna delle
Grazie; there, having ascended the scaffolding, he
would take his pencil, and, after giving one or two

touches to a figure, he would all at once quit the convent."*

The habit, here so clearly indicated, of yielding to impulses, and taking advantage of the facilities which oil painting afforded, without the necessity (at least at the moment) of cumbrous mechanical preparations, implies a certain simplicity in the materials employed, and agrees with the system of the artist as exhibited in his pictures—the system of carrying his work nearly to completion with very few colours, in order to confine his attention at first to form and light and shade. The portrait of Mona Lisa was, according to Vasari, a labour of four years, though declared unfinished at last: this is quite intelligible if we suppose it to have been taken up occasionally in the mode above described.

The first characteristic, therefore, which we notice as distinguishing the finished works of Leonardo from the contemporary or earlier examples of Flemish oil painting, is the solidity of the work, generally produced by frequent repaintings. This practice involved a certain modification of the materials. A thick semi-resinous vehicle is fitted for final *sealing* operations only; it is quite possible, by means of preparatory sketches and a completed design, to reduce this final work to one "alla prima" painting, as was often the practice of the

* Novelle del Bandello, Parte 1, p. 363.

Flemish masters; but it is hardly practicable, at all events, it is not convenient or agreeable, to cover a work repeatedly with such a medium—producing a shining surface, and rendering it difficult, after frequent operations, to express the minuter forms with precision. In order to return again and again to the work, as was the practice of Leonardo, a less glossy and a less substantial vehicle was necessary: the changes thus induced gradually defined the Italian, as distinguished from the Flemish, method of oil painting.

With all his sense of the advantages of the new process, Leonardo participated in the dread of oil which was so common among the Florentines. He preferred nut oil, as less coloured than that of linseed, and took infinite pains to extract it in the purest state. He appears at one time to have believed that not only this but all the fixed oils could be rendered perfectly colourless; but he must have found that, after all such precautions, time ultimately deepened their hue. He distilled these oils in the hope of obtaining a less changeable vehicle, with no greater success. With better promise of attaining his object, he confined himself to certain colours in the earlier stages of his pictures, with a view to counteract the subsequent yellowing of the oil. He prepared, and even completed them (their final glazings excepted), in a purplish tone, and thus provided by anticipation a remedy for the evil which he dreaded. With the exception of the

Adoration of the Magi, in which the fainter sha-
dows are greenish, there is scarcely a picture by
Leonardo, whatever stage of completion it may have
reached, which does not exhibit this more or less
solid purplish preparation, varying from an ink-
colour scarcely removed from grey—as in the Mona
Lisa, as in the "Vierge aux Rochers" at Charlton,
and as in an unfinished head in the gallery at Parma
—to the almost violet hue of the Holy Family in
the gallery of the Hermitage at Petersburg. De
Piles remarks that the carnations of Leonardo in-
cline for the most part to the colour of wine-lees,
and that a violet colour predominates in his pic-
tures; Rumohr notices the same tints in the head
of Ludovico Sforza in the Ambrosian Library at
Milan, and in other examples. Leonardo himself,
describing a mode of painting with gum-water, re-
commends the use of lake and black among the
colours for painting the shadows of flesh, the darker
shades being strengthened with lake and ink.

It appears, both from the unfinished Adoration
of the Magi, and from Leonardo's writings, that
he preferred a yellowish ground or priming. This
was the opposite hue to his dead colour, as his dead
colour was again the opposite to the mellow tone
which glazing and time would give. On the same
principle the tempera painters dead-coloured their
flesh green, that the carnations might look fresher,
and the Venetians prepared a sky with cream colour
as a ground for blue.

The importance which Leonardo attached to the purity and whiteness of the oils in the preparation of his pictures led to other changes in the vehicle. The yellow film which, notwithstanding all his precautions, gathered upon the surface of his work, often long in hand, was still an objection. It was remedied by the partial use of the essential oils; he distilled these himself, and, not impossibly, may have been the first who employed them in painting. A remedy, applicable at least to pictures in an unfinished state, was thus at length found, and, as we shall hereafter have occasion to refer to this strictly Italian practice, its general conditions and results may be at once described.

When the colours are ground in a purified fixed oil, diluted with an essential oil, they dry partly by evaporation, they are covered with no skin, and, if the essential oil be properly rectified, have no gloss on the surface. A picture so painted, even if turned to the wall and left for months deprived of light and almost of air, undergoes scarcely any change. The experiment may be easily made by covering one portion of the surface with white, ground with a fixed oil, and another next it with white, ground with less of the fixed oil (or from which much of the oil has been extracted), and diluted with an essential oil: the latter mode of mixing and applying the colour corresponds with the well-known process termed by the house-painters

" flatting," because the surface is free from shine.*
A picture executed with tints thus prepared may
be retouched and repainted to any extent without
turning immoderately yellow; and when to this pre-
caution, as adopted by Leonardo, was added that
of painting the work throughout in a purplish tone,
the apprehended evil was as far as possible prevented
or neutralised.

The essential oil which Leonardo employed ap-
pears to have been that known by the name of spike
oil. Here the practice of the Milanese school in
the sixteenth century throws light on an incidental
expression in Vasari. The biographer states that
while Leonardo was in Rome, having been com-
missioned by Leo X. to paint a picture, he imme-
diately began to distil oils and herbs for the purpose
of making varnishes, upon which the Pope observed,
" Alas ! this man will do nothing, for he is thinking
of the end before the beginning of the work."
" The herbs" which the artist placed in the alembic
could be no other than lavender, from which spike
oil, afterwards so commonly used in painting, is
extracted. The Milanese writer, Lomazzo, in his
Idea del Tempio della Pittura, says, " The colours
are ground with the oil of walnuts, of lavender, and

* In painting with gum-water, Leonardo was also careful to
prevent a glossy surface:—" Sfumato che tu hai, lascia sec-
care, poi ritocca a secca con lacca e gomma, stata assai tempo
con l' acqua gommata insieme liquida, che è migliore, perchè
fa l' uffizio suo senza lustrare."— *Trattato della Pittura*, p. 256.

of other things." The other essential oils used
by the Italian painters were spirit of turpentine, and
petroleum ("oglio di sasso") or naphtha—the first
common in the neighbourhood of Venice, the latter
abounding in the territory of Parma; but Lomazzo,
true to the practice of Leonardo, lays the greatest
stress on nut oil and spike oil. The Florentines seem
to have inherited the same predilections. A Spanish
writer, born in Florence in the sixteenth century[*],
thus describes the vehicles used in painting:—
"The colours for painting in oil are employed and
ground with nut oil, spike oil, petroleum, linseed
oil, and spirit of turpentine." It was before shown
that some Spanish painters were contented with
linseed oil, and rather ridiculed the preference given
by some Italians to nut oil; the prominent place
which the latter occupies in Carducho's list may
tend to prove that, though he left Florence when
young, his technical instructions were derived from
Italian rather than from Spanish authorities.
Pacheco boasts of being able to use linseed even
with blues and whites, his secret to prevent its
yellowing being still the oil of lavender. According
to the words of Vasari, if taken literally, both the
essential oil and the (distilled) fixed oil were
intended by Leonardo for the composition of
varnishes: this is quite possible; but the prepara-

* Carducho, Dialogo de la Pintura, su defensa, origen,
essencia, definicion, modos y diferencias. 4to. Madrid, 1633.

tion of the essential oil at all sufficiently implies its use as a diluent in painting, and the testimony of Lomazzo, confirmed by that of Carducho, is conclusive on this point.

The appearance of the surface in Leonardo's well-preserved pictures and in those of his followers, corroborates the evidence which is to be gathered from the above writers. The solid light parts (with which thin vehicles are most fitly used) are covered with innumerable fine cracks, not at all disturbing the effect: these indicate the use of a medium not very binding, yet not capable of violent contraction, inasmuch as the particles of colour subside in a thin medium into their most compact form; on the other hand the evaporation being checked, to a certain extent, by the presence of a fixed oil and a slight resinous ingredient, is not so complete as to occasion any considerable contraction and consequent disruption. When the latter results take place in pictures so executed, it is to be presumed that the essential oil was too abundantly used.* These effects may be easily proved by experiment; for which purpose the painted surface should be exposed to the changes of temperature in the open air.†

* In examining the surface of pictures painted on panel, it is necessary to distinguish between the cracks on the painting which follow the fibres of the wood from those which arise from the state of the pigment, or the nature of the vehicles used.

† Under such circumstances white lead, applied in body,

To return to Leonardo, a solid painting was now prepared, calculated by the vehicles which had been employed to undergo little change of tint, and fitted to counteract even that change by a purposed tendency to the opposite hue. All this was, however, only a preparation. When all was done, the painter had conducted his work to a stage corresponding with the shaded outline, without body, of the early Flemish masters. The chief difference, besides the solidity of the preparation, was that the delicate gradations of light and shade were carried much farther in Leonardo's process, and that, therefore, in this respect, little remained to be done in the process of colouring. Some other peculiarities in the treatment of the shadows (which rarely exhibited the ground through them) will be presently considered. Such being the under-painting, the remaining part of the work was necessarily modified accordingly; the tinting of the lights might now be accomplished with the thinnest applications of warm, opaque colours, and the whole of this final operation required a treatment more approaching to glazing (that is, the employment of literally transparent colours) than was practised in the Flemish school. This thinner use of the opaque

remains longest without cracks when used with oil alone ; with the ordinary semi-resinous vehicles, now commonly used, it becomes cracked in long lines ; with a due admixture of essential oil the cracks are finer and shorter, or with inspissated oil the surface, instead of cracking, becomes shrivelled.

colours was still more requisite in the half lights, the varieties of which in chiaroscuro had been already expressed in the grey or purple preparation with the utmost nicety: on these, therefore, the scumbling colours, tending to harmonise the sub-dued lights with the rest of the work, were spread with a sparing hand, softening still more the finer markings and rounding the forms by almost im-perceptible gradations, or, as Lomazzo expresses, " with tinted film upon film." This treatment is what the Italians distinguished by the term " sfumato."

The perfection of the system was afterwards attained in the Lombard and Venetian schools, for Leonardo, though its worthy inventor, was far from succeeding in it uniformly. His preparation was in one sense too perfect. The scumbling which he could venture to pass over his exquisite " dead colour " sometimes wanted power to neu-tralise its exaggerated inky hue. Sometimes, again, the completeness and beauty of the preparation, in all but colour, tempted him to dispense entirely with that last glow, for which, after all, the previous work had been calculated. Vasari states that the Mona Lisa was left unfinished: modern critics have often assumed that its present grey, though in other respects perfect, state, is a consequence of cleaning; but the hands have the full carnation tone, and, as a proof that the picture is not ma-terially different from its original hue (in whatever

other respects it may have suffered), it may be mentioned that very old copies have the same appearance.*

There was another reason why, in Leonardo's process, a nearer approach to the Flemish system in his ultimate operations was impossible. From an ambition to produce on a flat surface the apparent relief and roundness of sculpture, he was in the habit of gradually painting the shadows of his preparation, or dead colour, to their strongest effect. His fine feeling for light and shade had been cultivated to the prejudice, as is often the case, of colour. He saw in darkness its force rather than its depth; in light its brilliancy rather than its warmth; in half light the delicacy of gradations rather than the breadth of local tint. His precepts agree with his practice: he considered light and shade the essence of painting, and more difficult of attainment than drawing. His position, that shade destroys colour, betrayed him, while he aimed at strength, into blackness. On one occasion he observes that, as greens become dark they become bluer, and perhaps there is no instance in his works of a transparent brown shadow to green. This force, or rather blackness of his shadows in pictures merely prepared for glazing, rendered the warming effect of those glazings powerless, for it is essential to such operations that the superadded colour

* See Leonardo da Vinci-Album, von G. F. Waagen. Berlin.

should always be the darker. Vasari speaks of Leonardo's endeavours to approach the force of nature in the following terms:—" It is curious to trace the efforts of this extraordinary genius in his desire to give utmost relief to the objects which he painted. In trying to increase the intensity of shade by darkness within darkness, he sought for blacks deeper than other blacks, in order that the light should, by opposition, be more brilliant. The result, however, was that scarcely any light remained in the picture; such effects rather resembling night scenes than a gradually mitigated daylight. But all this was in consequence of his aiming at utmost relief, and indicated an ambition to attain the end and perfection of imitation." The biographer afterwards again refers to this love of intense shade:—" This painter added a certain obscurity to the art of colouring in oil, in consequence of which the moderns have given great force and relief to their figures." Succeeding colourists may have adopted a greater force in consequence of this practice, but certainly not in exact imitation of it, for the darker shadows of Leonardo are for the most part opaque. The St. John in the Louvre is one of many examples: in that work the darks, while they exclude every vestige of the internal light ground, must have been too intense themselves to be a fit preparation for subsequent glazings. In the directions which Leonardo has left for painting (in gum-water) the

shadows of flesh, he recommends that the first colour, composed of blacks and reds, should be retouched with lake alone. The same system appears to have been followed in his oil painting (for which indeed the method he describes may have been sometimes a preparation), but the inky shadows were in many instances too dark to be corrected by lake or by transparent browns.

The painting executed in the mode described, with thinned oils, required not only the warmth which the ultimate glazings could give, but the protection which the more substantial vehicle used with these glazings insured. The "flatting" process in common painting is unfit, as is well known, for the open air. The absence of gloss indicates a more or less porous surface, which is too readily susceptible of damp, before it hardens, to last, when so exposed, even for a short period; a picture somewhat thinly executed with drying oil disappeared entirely, under such circumstances, in a few months. Without supposing extraordinary trials, experience shows that the alternating effects of moisture and aridity are soon destructive to pictures when the substance or surface of the work is imperfectly defended. In Italy the protection, as such, which a hydrofuge coating can give was indeed less essential than in the North, and carefully kept small works, in which it was omitted, do not appear to have suffered much in a mechanical sense, except as regards the fine and minute cracks

before mentioned, with which the surface of Leo-
nardo's best works is covered: the Mona Lisa is a
remarkable example.

Leonardo, like other painters, had his dark and
light oil varnish: the first was composed of amber
and nut oil, the nut oil being sometimes distilled;
the light varnish consisted of nut oil thickened in
the sun. Whether the solution of amber with nut
oil instead of the customary linseed oil was a need-
less refinement or not, his mention of an amber oil
varnish shows that the choicer composition prepared
in the North ("vernix Germanorum") was now
employed in Italy. On one occasion, when Leo-
nardo speaks of varnish, the lighter of the above
vehicles is perhaps to be understood; he observes
that verdigris, "even if applied with oil, will soon
disappear unless it be immediately varnished." A
half resinified fixed oil is quite as efficacious as the
"white varnish" in locking up this colour, and
certainly more so than an essential-oil varnish: the
effect of balsams employed for the same purpose
has been before adverted to.*

In the passages which have been quoted Leo-
nardo speaks of oil varnishes only, but the same
reasons which made him reluctant to cover his
highly-wrought "dead colour" with mellower tints
which would have rendered further alteration in-

* See Vol. i. p. 459. Also Sir Joshua Reynolds's experi-
ment, ibid. pp. 540, 541.

convenient, induced him to seek for thinner compositions to protect his work. Vasari observes that " he undertook extraordinary experiments in seeking for oils to paint with, and varnishes to preserve the finished pictures." Such a varnish, the result of " extraordinary experiments," could not have been the well-known oil varnishes, and if Leo X. found him " distilling herbs for the purpose of making varnishes," an essential-oil varnish must have been in that instance proposed.

Next in estimation to amber, the customary resinous ingredient in the oil varnishes was sandarac. The latter can be dissolved in no essential oil except spike oil, and this composition, which in Italy lasts for a considerable time, appears to have been the thinner varnish of Leonardo. Its employment by him is the more probable since we find it in use in the Florentine school in the sixteenth century, and its introduction agrees with the prevailing tendency of that school to shun the fixed oils as much as possible, using them sparingly in painting, and rarely in varnishing. Borghini thus describes a composition for the latter purpose, intended to dry in the shade—a precaution again corresponding with Leonardo's habits :—" Take an ounce of spike oil and an ounce of sandarac in powder; these being mixed together are to be boiled in a new glazed pipkin, and if the varnish is required to be more lustrous, more sandarac should be added. It should be well stirrèd in boiling;

when the solution is completed the varnish should be removed from the fire—it should be carefully applied while tepid to the picture, and this varnish is very delicate and of an agreeable smell." Leonardo's experience must have convinced him that no varnish is durable: this may be gathered from his proposing what he calls "an eternal varnish," consisting of a very thin sheet of glass, which was to be attached to the surface of the picture.* On the whole, perhaps, the composition called the varnish of Correggio is, in an Italian atmosphere, the least objectionable of the thinner varnishes.

Among Leonardo's "extraordinary experiments" with oils may be reckoned his method, noticed by Lomazzo, of reducing the substance of the fixed oils by distillation. As the practice was condemned even by his immediate followers (represented by that writer), and as we find no trace of the employment of such oils in painting, except by Lorenzo di Credi, it may be concluded that the invention was short-lived. From the records of Florentine investigators, it appears not unlikely that Leonardo made use of the same oil in the composition of his amber varnish; at all events, we find such a preparation described by the Padre Gesuato, whose "Secreti" were appended to an edition of Alexius published at Lucca in the middle of the sixteenth

* Trattato della Pittura, p. 255.

century. The receipt was copied by later writers, but the process itself, if introduced by Leonardo, appears after his time to have survived only in description.

The equal substance with which most of the works of Leonardo are painted; the force, approaching to blackness, in the shadows of some of his preparations; and his reluctance to adopt the thick rich glazings which, according to the practice of his time, precluded all further retouching, sufficiently account for the want of that prominence of surface in the darks which is characteristic of the early oil pictures. Leonardo's flesh tints are generally as solid as any other portion: in the picture in the Louvre in which the Virgin is sitting on the lap of St. Anna, the flesh is unusually thin—a circumstance explained by the unfinished state of the work. A slight prominence in the dark is only partially to be traced in that picture, in the St. John, in the Bacchus, and in some other examples, which will be noticed as we proceed. Leonardo's greens and blues are, in like manner, scarcely more raised than the surface of the other colours; the use of ultramarine, which, unlike the " Azzurro della Magna," requires no thick vehicle to protect it, would partly explain this, and the changes which have sometimes taken place where transparent tints were not sufficiently " locked up," not only as regards greens but other colours, prove that the artist's deviations from the traditional practice were not always improvements.

Leonardo seems to have been averse to expose his pictures to the sun; the use of an evaporable ingredient (spike oil) might undoubtedly render the surface so exposed too arid, and too liable to crack. On one occasion he directs a painting, prepared for varnishing, to be dried in a dark oven:* he nowhere mentions dryers.

The dryers used at an early period in Italy are to be detected in descriptions of mordants for gildings. Cennini directs linseed oil to be slowly boiled till it be reduced one half; this drying oil, he observes, is good for painting, and when further thickened with a certain proportion of " vernice liquida " is fit for mordants. Elsewhere he speaks of white lead and verdigris mixed with oil and " vernice " for mordants. The later Florentine preparations of this kind were fitter for occasional use in painting, and the best was evidently of northern origin. A composition which must have resembled japanners' gold-size in colour and siccative power is described by Borghini: it consisted of umber, massicot, minium, calcined bones, and calcined vitriol; these materials being finely ground were boiled in linseed or nut oil, and the preparation was used as a mordant when cold—that is, in a clarified state. Borghini, after directing how the vitriol was to be calcined, observes:—" This vitriol makes all slow-drying colours dry, but it spots

* Trattato della Pittura, p. 256.

them." There can be little doubt that white cop-
peras or sulphate of zinc is here meant, since no
other "vitriol" is known to have been used as a
dryer; as already explained (p. 35 note), it is per-
fectly harmless when boiled with oils according to
the Flemish method, and when calcined would also
be harmless if mixed in substance with the colours,
but being then opaque, it would be unfit to mix
with darks. The composition described by Borghini
might perhaps be improved for the uses of painting
by omitting the preparations of lead, which are
more or less soluble in oil, while the sulphate of
zinc is not so. Another mordant described by the
same writer, and which is applicable as a siccific,
was composed of the remains of colours which had
dried with a pellicle. These were boiled in nut
oil till they were dissolved; the preparation was
then strained and clarified.

The paintings which Leonardo executed in oil
on walls were ill calculated for durability. Three
works of the kind were undertaken by him: the
celebrated Last Supper in the refectory of S.
Maria delle Grazie at Milan; the portraits of Lodo-
vico and Beatrice Sforza in the same hall, opposite
the Last Supper and next the Crucifixion in fresco,
by Giovanni Donato Montorfani; and the Battle
of Anghiara (called, from the portion which is
known from copies, the Battle of the Standard) in
the council-chamber at Florence. The Madonna
and Child in the convent of S. Onofrio at Rome,

painted, according to Titi and others, in oil, is certainly in fresco.*

In preparing to paint on the walls of the refectory in S. Maria delle Grazie, it is evident that, mindful perhaps of the suggestion before quoted of Leon Battista Alberti, he proposed to take additional precautions at the outset of the work. The portraits of Lodovico Sforza and his consort were painted on the smooth intonaco corresponding with that on which Montorfani's fresco was executed, the surface having been perhaps prepared with size for Leonardo's oil pictures: parts of the white wall are now exposed, and the portions of those pictures which remain are so blackened that the forms are scarcely distinguishable. These works are, however, comparatively unimportant, and the artist is said to have undertaken them with reluctance. But the wall on which the Last Supper was painted was first covered with a mixture of common resin, mastic, gesso, and other materials. This coating, however, proved insufficient for an unusually damp wall, which, in consequence of the low site of the building, was exposed even to the effects of inundations. The wall of the council-chamber at Florence was defended by a similar composition, apparently including linseed oil; in this case an evil of a different kind occurred—the hydrofuge coating began to flow down, and after Leonardo

* See Bunsen, Beschreibung der Stadt Rom, vol. iii. Part III. p. 585.

had abandoned the painting the surface required to be supported with woodwork.

With the exception of the hydrofuge preparation, Leonardo appears to have made no change in his system of painting on walls as compared with his ordinary process: he reckoned on his first and last operations (the last having been unfortunately omitted) for the preservation of the work. In the painting itself his chief object was to reserve the power of retouching till he was satisfied, and, keeping this in view, to prevent a glossy surface and the yellowing of the oil. Paolo Giovio, a contemporary of Leonardo, and perhaps personally known to him, says that the Battle of Anghiara was painted with nut oil, and Lomazzo attributes the early decay of the Last Supper to the artist having used it thinned by distillation; but neither the practice nor the further dilution of the vehicle with spike oil would have been injurious had these paintings been completed with oil varnishes. Leonardo's deviation from the Flemish process is especially evident in his mode of painting upon walls: we have seen that the Florentine artists who succeeded him retained, in that case only, the Flemish method of using varnish with all the colours. Leonardo undoubtedly contemplated the ultimate toning, and, which was no less important, the protection of the surface by means of substantial vehicles; but in this as in many other instances the final operation was for ever postponed.

That the protection of the surface of the wall from internal damp is essential to the preservation of pictures executed upon that surface there can be no question, but one cause of the blackening of oil pictures on walls has been generally overlooked. Vasari remarks that Andrea dal Castagno, the Pollaiuoli, and others, had never been able to prevent their oil paintings on walls from turning black; he then expresses his conviction that the difficulty had been entirely surmounted by Sebastian del Piombo, who, not content with a hydrofuge preparation as a ground for the picture, mixed the very mortar with resin, and spread the first rough coat with a hot iron, "in consequence of which," continues the biographer, "his paintings on walls have effectually resisted moisture, and have preserved their colours without the slightest change." He instances the picture by Sebastian of the Flagellation of Christ, in S. Pietro in Montorio at Rome. When Vasari wrote, that picture might have retained its freshness, but now, from its blackened surface, it is scarcely visible. Such is, indeed, a common if not a universal defect of wall paintings in oil.

The cause of this change is not merely internal. Borghini, though he expresses himself incorrectly, hints at another source of the evil: " Whoever," he observes, " wishes their oil painting on walls to last long, should paint on walls of brick, and not on walls of stone; for the latter, in humid weather,

give forth moisture and stain the picture, whereas bricks are less susceptible of damp." The colder the surface, the more the moisture of the atmosphere will be condensed upon it, and when a painting is executed on stone, its surface will necessarily be wet in damp weather. The decay of the picture, if executed with thin oil alone, would be the speedy result: even if it were painted with firm vehicles, as was usually the practice, still the moist surface would attract dust and smoke, and gradually become blackened. On the same principle an oil painting would retain its original appearance longer on plaster upon laths than on the colder surface of plaster upon bricks. The same conditions affect fresco painting to a certain extent, but much less so, from the constant tendency of lime to a redisintegration, from the surface inwards, of the original carbonate; that process requires moisture, and thus, for a considerable time at least, prevents its accumulation in damp weather on the mere surface.

The epitaph on Leonardo which appears in the first edition of Vasari's *Lives*, might be understood to attribute to him the invention of oil painting, thus pointing to the many changes which he introduced in the process: if the eulogy is exaggerated in this respect, it is no less so in alluding to his "transparent shadows." The writer, having assumed that Leonardo was the first who practised oil painting, ascribes to him,

without further enquiry, the characteristic excellence of the method.

Two interesting specimens of the master, further illustrating his technical predilections and his versatility, may be noticed in conclusion. The picture called the " Vierge aux Rochers," in the possession of the Earl of Suffolk, was probably one of the first works painted by Leonardo in Milan. The shades and obscurer colours are now become intensely dark, and this peculiarity is observable in the two pictures of angels, originally forming part of the altar-piece, which are still at Milan. The system adopted in this picture may have been the same, carried farther, as that of the unfinished Adoration of the Magi in Florence; the brown darks appear to have been inserted at first, time having rendered them more opaque. The flesh tints are painted with the usual purplish greyish tint, but not with so much body as in some of his later works. As the picture was long in a church, it is hardly to be supposed that it was left unfinished; the more probable conclusion is that the present colourless state of the flesh is in consequence of the glazings having disappeared. The surface of the darks, though rarely prominent, is here and there cracked, and in a mode which indicates the use of sandarac.

The Holy Family in the possession of the Countess of Warwick at Gatton Park, is an exception, in a technical point of view, to the usual system of Leonardo. The excellence of the com-

position, and the thoroughly studied drawing and modelling of the heads and hands, are sufficient evidences of the master, while the remarkable preservation of the picture gives it a more than common interest and value. The peculiarities of the execution, as compared with Leonardo's other works, are to be considered as proofs of his studious and investigating character, and perhaps in this case admit of more direct explanation. Lomazzo's statement that no work of the master is to be considered finished can hardly apply to this example, which is completed in every part. The colouring of the flesh is warm, and although there is evidence here and there—for example, in the children—of a cool preparation in the lower half-tints and lighter shadows, that preparation was so far calculated for the mellower tones with which it is clothed that no unpleasant grey or inky colour predominates. The heads and hands of the Joseph and Zacharias are even golden in tone. The flesh, though as usual free from "hatching," is thinner than in most works of the master; and the shadows, especially the darker parts of the blue drapery, decidedly prominent in comparison with the portions in which white was used. Some dark green drapery behind the heads of the Madonna and Joseph, and elsewhere, is cracked in a manner which shows that the ordinary "white varnish" was used, but the raised shadows generally are not cracked at all, and their perfect preservation, notwithstanding the quantity of

vehicle used in them, indicates the use of the amber varnish. No essential oil appears to have been employed in this picture; the cracks in the flesh are not numerous (as in the portrait of Lucrezia Crivelli, that of Mona Lisa, and the St. John), and are apparently the consequence of a slight expansion in the fibres of the wood, the grain of which they generally follow. On minute inspection, a light ground is to be detected through the shadows of the flesh.

All the above peculiarities—the prominence of the shadows as compared with the light, the firmness of the vehicle both in lights and darks, the use of the white varnish in the deeper greens, the general warmth of tone, and the comparative transparency of the shadows of the flesh—are characteristic of the early Flemish system, and there is perhaps no other work of Leonardo's in which that system is so closely followed. The picture belongs to the middle period of the master's practice, and may have been executed in Milan. The probability is that Leonardo may there have studied some specimens of the Flemish process: none were more likely to come under his observation, from their novelty and celebrity at the time, than the works of Antonello da Messina. That painter had returned to Venice; but, as we have seen, he had resided for some years in Milan, and must have left numerous pictures there—perhaps chiefly portraits. Whatever may have been the cause of Leonardo's adoption of the Flemish method during

part of his stay in Milan, his fastidious and pro-
crastinating habits (apparent at that time in the
prosecution of his great work in S. Maria delle
Grazie) ultimately determined his executive me-
thod, and the style which is more peculiarly his
own is best represented by a subsequent work at
Florence—the portrait of Mona Lisa.

The foregoing description of Leonardo's works
and method has been purposely minute, because
he is to be regarded as the founder, strictly speak-
ing, of the Italian process of oil painting. The more
important characteristics of his mere practice may
be shortly defined as follows. The system of re-
touching to any extent the preparation or *abbozzo*
may be said to date from him; and the technical ex-
pedients and materials which rendered this system
possible and convenient were also his invention.
In securing the means of painting and repainting
without prematurely coating the surface with semi-
resinous and glossy vehicles, his object seems to
have been to retain the power of improving his
works in form and expression, and of imitating
with completeness the roundness and relief of
natural objects. The application of mellower tints
and glazings with substantial varnishes was re-
served for final operations, or till the artist was
satisfied. In this respect Leonardo differed not, in
principle, from the Flemish masters: they too,
though using varnish (in greater or less propor-
tions) with all the colours, may be said to have

employed it only in final operations; but their final
painting was, in many cases, the only painting—the
work being executed, like a fresco or tempera
picture, from finished sketches, portion by portion.
The progress of the art from tempera was indeed
gradual and consistent: the tempera picture was
varnished; the first oil painters, in the course of
experiments to improve this varnish, ended by
mixing it with the colours, and assuming or finding
that the application of tints with so glossy a vehicle
could not conveniently be repeated, they thoroughly
drew and shaded their design before the colours
were applied, and then often painted " alla prima."
A literally unchangeable design and the decision of
the subsequent operations were not to Leonardo's
taste. In order to reserve the power of correcting
his work he invented a mode of painting with
diluted oil, calculated to prevent gloss on the sur-
face, postponing the use of thick varnishes, at least
in the lights, till his picture was all but completed.
That picture, purposely kept cool and grey in
colour, but with every form, half-tint, and shadow
defined, was equivalent to the Flemish painter's
finished drawing, since, in both cases, a single opera-
tion only with varnish-colours was required to
complete the work, or, at all events, the portion so
treated. One consequence of Leonardo's repaint-
ings, perhaps not at first contemplated by him, was
a greater solidity or body of colour (*impasto*) than
had previously been attempted, or than was by

some contemporary artists thought desirable. It will be seen as we proceed, that, with the exception of Lorenzo di Credi, the immediate followers of Leonardo preferred a thinner substance in the lights, and especially in the flesh tints, and thus adhered more closely to the Flemish system. The solid preparation was, however, subsequently adopted by many (especially when painting on cloth instead of wood), as a means of preserving the work, and was gradually considered indispensable in larger pictures as forming a needful substratum for the semi-transparent and transparent tintings called scumbling and glazing. The judicious use, by the Venetian painters, of these various methods, including a lighter preparation of the shadows, soon opened the way to excellences never contemplated by Leonardo.

In enumerating the actual changes which this inventive and fastidious painter introduced, and which were sooner or later adopted, not only in Italy, but, by a natural reaction, sometimes in the schools of the North, we may thus reckon:—1. The exclusion of the light ground by a solid prepara tory painting. 2. The use of essential oils together with nut oil in that preparation. 3. The practice of thinly painting and ultimately scumbling and glazing over the carefully prepared dead colour, as opposed to the simpler and more decided processes, or sometimes the single "alla prima" operation of the Flemish masters. 4. The reservation of thick

resinous vehicles (when employed to cover the lights) for final operations, so as to avoid as much as possible a glossy surface during the earlier stages of the work. 5. The use of essential oil varnishes.

The defects into which Leonardo was often betrayed—on the one hand by his exclusive study of chiaroscuro, and, on the other, by his endeavours to guard against the yellowing of oil—were, want of transparency in his shadows, and want of warmth in his flesh tints. The chief practice, characteristic of the school of Van Eyck, which he retained, was the use of the amber varnish, substituting nut oil (sometimes even distilled) for the customary linseed oil. Instead of the " white varnish," composed of nut oil and mastic, or nut oil and fir resin, he, at least occasionally, used the thickened nut oil alone.

We now come to the third member of the trium-virate before mentioned—Pietro Vanucci, called Perugino. Some of the writers who have traced the progress of this painter are unwilling, as already stated, to believe that with his habits in a great measure formed at Perugia, and probably no longer a youth when he first visited Florence, he could have entered the school of Verocchio as a student. But in Italy, and at that time, such a circumstance would excite no surprise; the thirst for knowledge was the great stimulus—the readiest means of ac-

quiring it the chief consideration. In any view of this question, the early friendship of Perugino and Leonardo, whether as fellow-students or not, is established on the safest authority.

Supposing Perugino to have arrived at Florence at the age of twenty-five (1471)—to allow time for his previous studies at Perugia with his first master, Bonfigli, and for some works of his own there—it is plain that the improved method of oil painting must have been then unknown to him. He could only acquire that knowledge in Florence, and probably not till a year or two later. One of his early pictures—the Adoration of the Magi*, formerly in the Chiesa de' Servi (formerly called S. Maria Nuova) at Perugia†—is, according to Mezzanotte, painted in oil. The style of this picture indicates little influence of Florentine studies; but if, as Rumohr on good grounds supposes, the work was executed in 1475, it may, quite possibly, be an attempt in the new method. It matters little

* Cavalcaselle attributes this picture to Fiorenzo di Lorenzo. It is now in the Perugia Gallery, No. 39, under the name of Dom. Ghirlandajo! See Cavalcaselle, vol. iii. p. 158, and note.—*Ed.*

† A picture of the Transfiguration, once in the same church, now in the gallery at Perugia, is placed by Orsini (*Vita, Elogio e Memorie di Pietro Perugino*, p. 20) among the early works of the master. It has, however, suffered so much, and is so repainted, that it will hardly be safe to draw any conclusions from it. The altar-piece in S. Simone at Perugia, which Orsini (p. 24) inclines to place among the early works of Pietro Perugino, indicates rather the weakness of age.

whether this work was painted in Florence or in Perugia; Florence may be considered the head-quarters of the artist about that time, and 1475 is the date of Antonio Pollaiuolo's St. Sebastian. The earliest work which Perugino is known to have executed in Florence is a fresco formerly in S. Piero Maggiore, and which, on the demolition of that church, was removed to the Palazzo Albizzi, where it now is.* From a document obligingly communicated by the present inheritor of the picture, it appears that the artist received a hundred gold crowns for it from Luca degl' Albizzi. That individual, having been concerned in the conspiracy of the Pazzi, was exiled in 1478, and did not return to Florence till after twenty-five years. The work in question may have been executed about 1476–7. A fresco by Perugino at Cerqueto, near his native city, had the date 1478. In 1480 Perugino left Florence for Rome†, where he was employed by Sixtus IV., and, after that pontiff's death, by others for some years, occasionally visiting Perugia. Leonardo quitted Tuscany for Milan about the same time: it is therefore sufficiently evident that, if Perugino gave his attention to oil painting in company with Leonardo and Lorenzo di Credi, the time

 * Vasari (vol. i. p. 420) speaks of the resistance of this fresco to rain and wind. See also Bocchi, Bellezze di Firenze, p. 176, quoted in Orsini, p. 120.

 † According to Orsini (p. 137, note), Perugino was in Perugia in 1483.

when such studies were prosecuted must have been anterior to 1480. In the absence of dates on many of Perugino's works it is not possible to determine what pictures by him, now extant, were painted before that period. Many circumstances concur to prove that he had then attained great practice in the method; and perhaps a writer before quoted is correct in assigning the works executed for the Gesuati in the church of S. Giusto alle Mura to the period of the artist's first residence in Florence. The church, with its frescoes by Pietro, was destroyed in 1529 during the siege of Florence, but the three altar-pieces in oil by him were removed, and are still preserved: in one of them (a Crucifixion, with the Magdalen), now in the church of S. Giovanni della Calza, some critics have traced an imitation of Luca Signorelli; if they are correct*, this is an additional reason for concluding that the picture, and consequently its companions, were executed about the time above supposed. Signorelli painted several pictures in Florence for Lorenzo de' Medici, some of which are now in the Uffizj. Perugino again met Signorelli, and must have seen a fresco by him (afterwards destroyed) in Rome; but there is no trace of the imitation above alluded to after Pietro's first residence in Florence.

In Rome Perugino found few disposed to employ

* See Passavant's Life of Raphael (German), p. 489. Also Borghini, Il Riposo, vol. ii. p. 150, note, and Baldinucci, vol. v. p. 491.

him as an oil painter: his works in the Sistine
Chapel, as well as those begun in the Vatican, were
necessarily in fresco. A round picture, formerly
in the Corsini Palace, and lately in the Royal
Gallery at the Hague, is a beautiful example of
tempera.* Another work in tempera, with the
date 1491, probably executed at Perugia for a
Roman employer, is now in the Albani Palace at
Rome. The altar-piece formerly in the church of
St. Mark in Rome has disappeared.†

Soon after 1490 the artist was again in Perugia
and Florence; his time was divided between those
and other cities (including Rome, which he more
than once revisited) till about 1515‡, when he
retired to Perugia, chiefly on account of the severity
with which the followers of Michael Angelo in
Florence treated his latter works. He died at
Frontignano, between Città della Pieve and Perugia,
at the age of seventy-eight, in 1524.

The best works of Perugino were executed be-
tween 1490 and 1505. The following are among
the most celebrated:—The altar-piece painted for
the church of S. Domenico at Fiesole, and dated
1493, representing the Madonna and Child en-

* Now in the Louvre.

† Bunsen (vol. iii. Part III. p. 536) mentions a picture of
St. Mark ascribed to Perugino, but more like a Venetian picture.

‡ As he purchased a burial-place in the Servi at Florence
in July, 1515, he can hardly have abandoned the idea of
ending his days in that city until after that date. See Vasari,
note 50 to *Life*.

throned, with St. John the Baptist and St. Sebastian standing beside them, is now in the gallery of the Uffizj. This picture is remarkable for a very refined character and expression in the Madonna. Another, with the same date, somewhat similar in subject, is in the Belvedere Gallery at Vienna. A picture of the Madonna with two saints, SS. Augustin and James, dated 1494, is in the church of S. Agostino at Cremona.* Four excellent works of the master were painted, or completed, in the following year (1495): the Dead Christ mourned by the Marys and Disciples, originally in the church of S. Chiara, and now in the Pitti Gallery at Florence; the enthroned Madonna and Child surrounded by the patron saints of Perugia, painted for and formerly in the Cappella del Magistrato at Perugia, and now in the gallery of the Vatican;† the Ascension, painted

* This picture was among those taken to Paris.

† Mariotti gives a curious and amusing history of this picture. In 1479 a painter of Perugia, Pietro di Maestro Galeotto, was commissioned to paint an altar-piece for the Cappella del Magistrato within the space of two years. The picture was to represent the Madonna and Child with the four patron saints of Perugia — SS. Lorenzo, Ludovico, Ercolano, and Costanzo. Galeotto was not a man of punctual habits. Three years elapsed, and the work was not complete ; and, for fear of the plague, which was increasing in Perugia, he obtained another year's grace. In that year he died, leaving the picture unfinished. Then the magistracy applied to their fellow-townsman, Pietro Perugino, and a contract was drawn up with him, stipulating that the picture should be completed in four months' time from that date, November, 1483. "But,"

for S. Pietro Maggiore at Perugia, and now in the
gallery at Lyons; and the Sposalizio, or Marriage
of the Virgin, once in the Duomo at Perugia, and
now at the Museum of Caen, in Normandy. A
picture of the Nativity, originally in the church
of S. Antonio Abbate in Perugia, is now in the
Louvre ; it was painted about 1497. An altar-
piece with the same date, representing the enthroned
Madonna and Child surrounded by six saints, is in
the church of S. Maria Nuova at Fano. The pic-
ture of the Madonna and Child, round whom kneel
six figures while angels hover above, painted in
1498 for the confraternity " Della Consolazione,"

says the author, "what availed the promises of the old
painters ? " Within a few days of the signing of the contract
Perugino was on his way elsewhere, and the picture remained
in statu quo. The magistracy waited for his return till the
December of the same year, 1483, and then they signed an
agreement with another painter and fellow-townsman, Santi
di Apollonio, binding him to complete the work within one
year. But the third labourer in this field was as little con-
scientious as the two first. Seven years passed away, and
he never set a stroke. All this while the picture remained at
the house of Galeotto's father, who, tired of keeping it, con-
signed it, in 1791, along with some unused colours, to the
magistracy. Four years longer the unfinished work sent up
its mute protest. Then the magistracy bethought themselves
again of Pietro Perugino, whose growing fame wiped out his
past delinquencies ; and in March, 1495, a fresh contract
bound the painter to complete this and other labours within
six months. Whether he was more punctual this time is not
known, but Mariotti adds : "il quadro però noi lo vediam
fatto."—*Lettere pittoriche Perugine,* pp. 146–152. This picture
was among those taken to Paris.

in Perugia, is in the church of S. Domenico in
that city. About the same time was painted the
altar-piece called the Family of St. Anna, formerly
in the church of S. Maria de' Fossi at Perugia, and
now in the museum at Marseilles. Two children
(St. James Major and St. James Minor*) in the
picture were copied by Raphael in tempera on a
gold ground : (this, perhaps the earliest existing
work of Perugino's distinguished scholar, is pre-
served in the sacristy of S. Pietro Maggiore at
Perugia). The Assumption of the Virgin, painted
for the convent of Vallombrosa in 1500, is now in
the gallery of the Academy at Florence. The
great work of Perugino—the series of frescoes in
the " Sala del Cambio " at Perugia—was executed
about 1500 : these paintings bear the same relation to
the artist's fame as those of the Vatican do to that of
Raphael. The picture of the Resurrection, painted
in 1502 for the church of S. Francesco at Perugia,
is now in the gallery of the Vatican : in this work
the assistance of Raphael is apparent. To the years
1504–1505 belong the wall paintings at Città della
Pieve (Perugino's birthplace) and at Panicale ; the
first representing the Adoration of the Kings, the
latter the Martyrdom of St. Sebastian. These
works are interesting in a technical point of view,

* Passavant describes the children as the Infant Christ and
St. John, but in the original picture the name of each is
inscribed in the nimbus.

having been apparently painted on the dry wall, in the method called " secco."* An altar-piece representing the Virgin and Child enthroned surrounded by saints, painted in 1507 for Montone, near Città di Castello, was, in the last century and probably still is, in a private collection at Ascoli: it differs in one respect from the generality of Pietro's works, as the upper part consists of a gold ground on which some figures of angels are relieved.

Some excellent pictures of the master which are preserved in various galleries are here omitted, as they are of uncertain dates. The later works of Perugino are generally inferior to those that have been named: intent latterly, as it appears, on amassing wealth, he often adapted his former compositions to new subjects, and, while his powers of invention declined, his colouring, which constitutes so great a part of the merit of his best productions, also became weak. This is observable in an altar decoration of considerable extent, painted (probably in 1512) for the church of S. Agostino in Perugia. The insulated altar exhibited a picture on each side, besides smaller accessory subjects; the two principal portions are still in the church, though not in their original place. Perugino's last works were wall paintings: a Nativity and some other subjects at Frontignano (between Città della Pieve and Perugia) were

* See Vol. i. p. 142.

painted in and after 1522. These, like some earlier specimens of the kind, are executed on the dry wall.

Many of the altar-pieces here enumerated were adorned with other pictures. The principal subject was commonly surmounted by another, forming an apex to the decoration: the upper and smaller picture was often of the lunette form (like the Francia of that shape in the National Gallery); the pilasters or lateral portions of the frame were sometimes filled with single figures or half-figures of saints, and a narrow compartment below (the predella) was occupied with small Scripture subjects, and sometimes with figures of saints as well. Most of such smaller figures by Perugino, originally belonging to larger works, are now scattered in galleries, and are not unfrequently attributed to Raphael. The three predella pictures of the altar-piece of the Ascension, now at Lyons, which are in the museum at Rouen, are examples. At the period when these works were executed, Raphael was but twelve years old. One of the works of the master in which the hand of the scholar is really apparent is (as we have said) in the picture of the Resurrection in the Vatican Gallery (1502). Another in the same gallery, representing the Nativity, appears to have been chiefly the work of Perugino's scholars, and the head of Joseph is, on good grounds, ascribed to Raphael. On the other hand, predella pictures, or larger subjects executed

in the manner of Perugino, and which belong to a later date than 1505, cannot be the work of the great scholar, who about that period began to emancipate himself from the style of his master.

The three altar-pieces painted for S. Giusto alle Mura, and which are all preserved in Florence, merit especial attention, not only because they appear to be among the earlier works of the master, but because Vasari has undertaken to describe the mode in which they were painted. His words are: " These three pictures have suffered much, and are cracked throughout the darks and in the shadows; this happens when the first coat of colour which is laid on the priming is not quite dry (for three layers of colour are applied one over the other). Hence, these, as they gradually dry, contract in consequence of their thickness, and have force enough to cause these cracks—an effect which Pietro could not foresee, since it was only in his time that painters began to colour well in oil."

It is true that these works have suffered partially in the mode described, but not more so than other pictures of the time. It is remarkable that Vasari should notice the cracks as existing only in the darks and in the shadows, for this at once contradicts his explanation; it was in those parts that the oleo-resinous vehicle was used in greatest abundance, and the somewhat premature effects above noticed, taking place perhaps fifty years after the pictures were executed, may have been occasioned

by using the vehicle with too great a proportion of resin, or by the insufficient protection of the works from the sun's rays, or from the heat. Had the thickness of the pigment and the circumstance of the under layer not being dry been the sole cause of the defects in question, the light portions would have been cracked as well as the dark. In Perugino's works the flesh tint is generally thin, and sometimes extremely so. Vasari's explanation is thus inconsistent with the master's practice. In other respects his observation is just; when a picture is repeatedly covered it is important that the under layer, if thick, should be quite dry before another is superadded. This precaution appears even in the directions of Eraclius, and that it was observed by the first oil painters in the improved method is apparent from the passage before given from the manuscript of Filarete. For the rest the methodical application of three successive layers belongs rather to the practice of Vasari's time than to that of Perugino. In his life of Fra Bartolommeo, the biographer, in speaking of similar defects in one of that painter's works, again alludes to those altar-pieces by Perugino, and attributes the evil in both cases to the application of " fresh colours to a fresh size " (the size and gesso priming). The precaution of painting on a perfectly dry priming is also important, but it was not necessary to assign such a cause for the cracks in transparent darks.

Of the three altar-pieces referred to, that in the church " della Calza " is a very fine specimen of the master; it represents the Crucifixion, with the Magdalen, St. John, St. Jerome, and St. Colombino (founder of the Gesuati).* The picture is not in bad preservation, but has been neglected, and much needs a coat of varnish, having now almost the appearance of a fresco. On nearer inspection, the darks, which are more or less cracked and blistered throughout, are found to be thicker than the lights, which, however, appear to have lost none of their original body; minute darks, such as the foliage even of distant trees, are, as it were, embossed; both flesh and draperies, here and there, exhibit hatching. The surface of the green drapery of the Magdalen is remarkably prominent; the shadows of the crimson drapery are also thick, and are much cracked and corroded; some parts of this drapery, and others that have chipped, show the white ground underneath. The other two pictures, the Pietà and the Gethsemane†, are in the gallery of the Florentine Academy. In the latter the shadows are raised, even those

* The likeness of this picture to Luca Signorelli has, as we have seen (p. 127), been suggested. Cavalcaselle (vol. iii. p. 247) says: "It is difficult to ascribe this piece either to Perugino or Signorelli."—*Ed.*

† Of this picture Sir Charles Eastlake says in a note, dated 1856 :—"Colour of dead Christ and of standing figure behind St. John—yellow and brown—like an approach to Signorelli; none of the heads *quite* like Perugino, perhaps the Christ and Nicodemus most."—*Ed.*

under the features; the darks of the draperies are also prominent, and are now blistered and roughened. The flesh, on the contrary, is thinly painted, so as to show the light ground within it. In the Pietà the flesh is somewhat more solid, but in this picture also the darks are thick, cracked, and corroded.

The altar-piece painted in 1493 for St. Domenico at Fiesole, and now in the tribune of the Uffizj, has the same general peculiarities; the darks especially are thick, and have suffered to a certain extent in the usual way.

The once beautiful S. Chiara picture, now in the Pitti Gallery, is said to have suffered from the sun's rays in its original situation; it is now in a very ruined state, and has been much repaired. It is, however, to be observed that the darks are all raised, and the greens and blues especially so: the cracks in these colours indicate the use of the white varnish; the shadows of red drapery, rough and blistered, indicate that of sandarac. The flesh, though not without body, is so relatively thin as to be often embedded in the surrounding darks, and in some places it exhibits hatching.

The enthroned Madonna and Child surrounded by the patron saints of Perugia, now in the Vatican, is a fine and well-preserved specimen of the master. The usual prominence of the darks, and the usual difference in substance between the flesh and the draperies, are again observable. The blue drapery

of the Madonna, and the green of the saint reading, are both thick — the blue extremely so. The sur- face has suffered but little from cracks, but where they appear the varieties follow the conditions before noticed. The minute cracks of the lake drapery of the bishop with the crozier show the white ground within, now varnished to a cream colour. The substantial shadows of the blue drapery show marks of the brush, not to be con- founded with hatching.

Some other pictures of the master in the same gallery (the Vatican) may be here noticed. A Nativity (from Spinola, near Todi), painted about 1500, exhibits the same qualities. The hands of the Madonna are embedded in the surrounding draperies; the blue is extremely thick and cracked, but has been much restored; the red drapery is hatched in the shadows. The flesh is so thin as sometimes to show the outline underneath—a dark single line; the shadows of the flesh are a little hatched; this is also observable in the head of Joseph ascribed to Raphael.

In the picture of the Resurrection (1502) in the Vatican the flesh is very thinly painted, the boun- daries of the surrounding colours, of whatever kind, being much more prominent; the flesh is in this case free from hatching.

The celebrated Ascension, now at Lyons, has been transferred from wood to cloth. After a picture has undergone this process, however safe that pro-

cess may sometimes be, the finer inequalities of the original surface, the relative prominence of darks and lights, are less distinguishable. In this case either the operation or the subsequent cleaning has considerably injured the effect of this once finely-coloured work ; still, the peculiarities already noticed are plainly to be traced. The surface of three predella pictures which are in the public gallery at Rouen (and there erroneously ascribed to Raphael) is sufficiently well preserved. They represent the Adoration of the Magi, the Baptism, and the Resurrection : of these the Baptism is the best. In the Adoration of the Magi a figure occurs on the left (with the drapery hanging from the shoulders behind, free of the figure), which is repeated in the Città della Pieve wall painting, and appears to have suggested the St. John in Raphael's picture at Blenheim.* In these predella pic-tures the flesh is thinly painted, and, as in the former specimens described, is embedded in the surrounding colours—the darks, and especially the blues and greens, having the usual relative thickness. The sky is somewhat more solidly painted than the flesh, the substance of the trees, whether blue or green, relieved on the sky, is prominent.

Of the figures of saints which also adorned the

* Two small pictures, replicas by Raphael of the Baptism and Resurrection, in the possession of the King of Bavaria, are copies from the corresponding subjects at Rouen.

altar-piece of the Ascension, six returned to Perugia, and three are in the Vatican Gallery. In the latter more or less hatching is observable; the shadows only in the flesh of the S. Benedetto are cracked, the lights not being at all so. This last peculiarity is indeed almost universally the case in Perugino's works, and is a consequence of the thinness with which the flesh was painted. The hands of the aged S. Placido show white lights like a chalk drawing, and the flesh of the S. Flavia is hatched throughout. The backgrounds of these heads appear to be repainted, for in Orsini's time they were all, according to him, of the colour of indigo.*

The interesting picture of the Sposalizio, which was followed so closely by Raphael in his celebrated small picture of that subject, is now the chief ornament of the museum at Caen, in Normandy. The picture had suffered in the last century by over-cleaning, and the original thinness of the flesh is here so much reduced that the white ground is in some places scarcely covered; the flesh does not appear to be hatched. The blues, even of distant figures, and the green drapery of the high priest, are prominent; the glazing colour in the green drapery above the hand of Joseph which the high priest holds, has accumulated there, indicating the

* Orsini, Vita di P. Perugino, p. 160. These pictures, with others now in Perugia, were copied by Sassoferrato.—*Ib.*, p. 160, and note.

flow or drop of the vehicle. The darks in the blue
drapery of the Virgin are blistered and rough. A
small picture of St. Jerome by Perugino, in the
same gallery (Caen), probably part of an altar
decoration, is thinly painted, and here and there
exhibits hatching.

The picture of the Nativity painted for S.
Antonio Abbate at Perugia, and now in the Louvre,
is in excellent preservation, and clearly exhibits
the peculiarities of the master's practice. The
kings or magi are represented arriving in the
middle distance. All the darks, in distant as well
as in near objects, are more prominent than the
lights. The blues and greens, the former especially,
have the greatest apparent body; minute darks,
such as stems of trees, appear embossed. The flesh
is throughout embedded in the surrounding colours,
but is blended and free from hatching. This pic-
ture was not numbered in the catalogue of the
contents of the Louvre in 1815. A Holy Family
by the master, No. 1161, exhibits partial hatch-
ings, the raised darks have in this case suffered
more; the thick vehicle used with the shadow is
betrayed by the minute darks, such as the divisions
of fingers, where they appear as projecting ridges
opposed to the thin flesh. In a figure of St. Paul,
by Perugino, No. 1355, the transparent colour in
the green drapery appears to have flowed where
the green meets the red, and again on the under
side of the right arm.

A picture of the Assumption painted in 1500 for the monks of Vallombrosa, and now in the gallery of the Florentine Academy, exhibits the same general qualities as the former specimens described. In this and in some other pictures by the master, the thick vehicle with which the glazing colours were applied is sometimes grained by the hairs of a larger brush. The flesh is thin, and in this instance both flesh and draperies are hatched. A small Madonna in the Pitti Gallery may close this sufficiently numerous list of examples; in it all the darks are raised, those even in the features and extremities, as in the dark line of separation, before noticed, between the fingers. The flesh is thin, and, as well as other portions, is partially hatched.

Referring to the Vallombrosa picture (the date of which is unquestionable) and to other examples, it thus appears that the system of hatching in oil pictures was more or less retained by Perugino in the best period of his practice. As this mode of execution was not derived from his fellow-students, the scholars of Verocchio, nor from the best examples of the Flemish process, it is only to be explained by his habits in tempera painting—a process which he practised to the last, and which may have influenced his hand. In the Città della Pieve wall painting (1504), and in the single figures in fresco in S. Severo at Perugia (1521), Gaye*

* See contribution to the *Kunst-Blatt*, 1837, p. 271, by this writer.

remarks an excess of this hatching, and a want of due finish in consequence. It is seldom employed to excess or so as to impair the effect of his oil paintings, and in some of them is hardly introduced at all. Such a system, designs being ready, was favourable to the rapidity with which Perugino's later works were executed, but in those later works it was mechanical rapidity only, and no longer accompanied by vigour or depth. It is remarkable that with such a feeling for force and richness of colour as his best works exhibit—qualities in which he surpassed most of his contemporaries—he should in many cases retain a mode of execution not only not required in oil painting, but which its means enabled the artist to dispense with. Whatever may be said in favour of such a method, it must be admitted that it is not characteristic of oil painters, and that it is not to be found as a systematic mode of execution in the works of the best masters.

With such powers as a colourist in oil as the Vatican picture, the Ascension, and other specimens exhibit, it is not to be supposed that Perugino leaned rather to tempera than to the new method ; but it has been sometimes a question whether certain of his works—not, it is true, the most celebrated—are in tempera or in oil. It is known that the Italian painters towards the close of the fifteenth century, in their transition from the one method to the other, frequently completed tempera pictures with oleo-resinous colours. A Madonna

by Ingegno, a few years since in the Metzger collection in Florence, may be cited as an example.*
Long before the introduction of the Flemish method, portions of tempera pictures, as we have seen, were covered with transparent oleo-resinous glazings, and as the whole work was finally varnished with "vernice liquida," such partial tintings were not inharmonious. In the more extensive subsequent use of this system, the flesh and sky were always covered least, and many a work in which the process now seems ambiguous has more or less the qualities of an oil painting throughout, except in those parts, which are sometimes only slightly toned by the final general varnish. When the oleo-resinous tinting is carried still farther, the work is to all intents an oil picture.

The practice of the Italians, at first reluctant to quit tempera for the new mode, and adopting half measures, explains the origin of oil painting and the peculiarities of its early process; the use of tinted oil varnishes being of very ancient date. Even in the Venetian school early works of Bellini, assumed to be in oil, have been sometimes discovered, too late, to be in tempera—the surface, after the removal of the varnish, having yielded to the application of moisture.†

As the apparently capricious treatment of pic-

* See Passavant, vol. i. p. 503.
† See Zanetti, Della Pittura Veneziana, pp. 47–48.

tures, in regard to their subjects, has been some-
times traced to the will of the employer rather than
to that of the painter, so the method or process to
be adopted was not always decided by the latter;
but, however this may be, the occasional union of
tempera and oil painting by Perugino may be con-
sidered an attempt on his part to introduce the
new mode rather than to cling to the old.

From the examples adduced it appears that the
practice of Perugino as an oil painter differed from
that of Leonardo and Lorenzo di Credi chiefly in
the treatment of the flesh. In Perugino it is almost
invariably thin, and not unfrequently exhibits the
white ground underneath. In the works of his
two fellow-students this indication of want of body
is scarcely ever to be remarked, and tracings of
hatching are equally rare. As a colourist, Perugino
in his best time was superior to both. In the
tinting of his pictures, he fearlessly employed the
rich varnishes of the Flemish masters, and his use
of them appears, with few exceptions, to have been
according to the original methods before described.
His blues and greens are thickly protected with the
" white varnish;" his flesh tints, transparent reds,
and glowing colours are applied with the warmer
sandarac varnish, which is profusely used in the
shadows and deeper local colours. In the use of
this—the " red varnish"—Perugino seems to have
contented himself with the " vernice liquida" (san-

darac and linseed oil); his shadows, if painted
with the firmer amber varnish, would hardly have
exhibited the cracked appearance which Vasari
noticed so soon after the date of the artist, and
which is still apparent. For a considerable time,
if not exposed to violent changes of tempera-
ture, the sandarac oil varnish, as already observed,
is quite equal in its effects to the finer composi-
tion, and is unsurpassed in gloss. The parsimo-
nious habits which were attributed to Perugino
may explain his preference of the least costly
materials, and may account for his common use in
draperies of the "azurro della Magna"—indicated
by the abundant protecting varnish which ultrama-
rine did not require. In some cases—for example,
in the Montone altar-piece—according to Orsini, he
used smalt in tempera on a black preparation.* In
fresco painting, in which ultramarine is indispen-
sable, he however employed it freely; and Vasari
records an anecdote of his dealings with the Prior
of the Gesuati at S. Giusto alle Mura, from whom
the painter obtained this colour.† It is supposed,
and not unreasonably, that Perugino learnt much
relating to pigments from the friars of that convent,
who were excellent chemists. The " Secreti" of a
Gesuato, including various recipes for preparing

* The practice, according to some, of using smalt in tempera
was sometimes resorted to by Paul Veronese. See Orsini,
Descrizione della Pittura, &c., della Città di Ascoli, 1790, p. 73.
† Vasari, vol. i. p. 420.

colours, and one for purifying linseed oil*, were published at Lucca about thirty years after Perugino's death. If the three oil pictures above noticed, originally painted for S. Giusto alle Mura, were, as we have supposed, executed before 1480, then the honour of being the first in Italy to display the resources of the Flemish system, as a means of insuring warmth and transparency, may be awarded to Perugino, as Giovanni Bellini cannot be said to have approached those qualities in oil painting till 1488. The first works of Perugino, as a colourist, were executed about 1495, and of these the altar-piece in the Vatican, representing the Madonna and Child, surrounded by the patron saints of Perugia, is a remarkable example. The sunny glow, considered apart from a certain dryness in the forms, and certain mannerisms which the painter never entirely got rid of, may stand beside the richest works of the Venetians. This is the least important picture, as to subject and dimensions, which bears that date†, but neither of the others—neither the Pitti altar-piece, once in S. Chiara, nor the Sposalizio at Caen, nor the Ascension at Lyons—are so well preserved.

———————

* Vol. i. p. 321, note.

† The date generally indicates that the picture was completed in the year inscribed, but when begun is not always so certain. It is hardly to be supposed that the three or four large altar-pieces, with the date 1495, were the labour of one year only.

The name and works of Francesco Francia are
readily associated in the memory with those of
Perugino. In point of time the Bolognese artist
cannot indeed be classed with the earliest oil
painters, his first known work being dated 1490.
Little is known of his education in art; originally
a die-engraver, he is said to have first practised
painting at nearly the age of forty. It has been
supposed that the works of Perugino, three of
which adorned churches in Bologna, first inspired
him with a love of oil painting. His practice, like
his general taste, has a close affinity with that of
the Umbrian master, but a comparison of the works
of both shows that they differed even in some tech-
nical respects. The best of the altar-pieces which
Perugino sent to Bologna—that of S. Giovanni in
Monte—is now in the Bolognese Gallery, where it
may be compared with several examples of Francia.

The occasional fondness of the Bolognese painter
for heightening certain portions of his pictures—
not only ornaments and rays, but the lights of
distant trees — with gold, can hardly have been
derived from Perugino. With the exception of
the gold ground of the Montone altar-piece one
instance only is cited in the works of Perugino—
an early picture of the Transfiguration in the
Chiesa de' Servi at Perugia, in which gilded rays
were introduced.* In the treatment of the darker

* The gold rays in question were effaced by an inexpert
cleaner even in Orsini's time.—See Vita di P. Perugino, p. 21,
note.

colours and deep shadows Francia closely followed the then customary methods. Such portions are inserted with a thick oleo-resinous vehicle, but, as the extreme darks seldom exhibit the corroded appearance which is so common in the oil pictures of Perugino, it is to be presumed that the material used was not always the sandarac varnish. In the lighter vehicles (white varnishes) employed with blues and greens there was less choice, and accordingly, in them (in the blues especially) the effects of time betray themselves in the works of Francia, as in other oil pictures of the period. But the chief difference in the practice of this painter, as compared with that of Perugino, is the greater solidity and the fusion of his flesh tints. In his first known work, dated 1490, above noted; in that representing the Angel of the Annunciation appearing to the Virgin in the presence of St. John the Baptist and St. Jerome; and in that of the Nativity—all in the gallery at Bologna—the flesh, though in every case less prominent in surface than the darks, has considerable substance, and frequently exhibits the fine hair cracks common in Leonardo's works, but scarcely ever to be seen in those of Perugino. These general peculiarities will be recognised in the Francias in the National Gallery, and in a picture of the Baptism by the same master at Hampton Court. In these examples, besides the common characteristics of apparent substance in the transparent colours and darks, and of greater prominence

in the blues, and occasionally in the greens, it will be seen that the more solid parts of the flesh are here and there minutely cracked. Another attribute of Francia, again differing from Perugino, is the blended surface of his flesh, which never exhibits hatching, or, if ever, only in the fainter shadows. It is doubtful even whether such appearances may not be the hatching of the drawing underneath, seen through the thinnest portions of the flesh tint. The gallery of the Louvre has no specimen of Francia.* In the collection of Count Pourtalés in Paris† there are two specimens; in both, the flesh, though less prominent than the surrounding colours, is solid and fused, and exhibits (in the larger specimen chiefly) the fine hair cracks before described.

It has been sometimes said that the manner of Francia holds a middle place between that of Perugino and Giovanni Bellini. This is hardly correct. The practice of Francia is rather composed of the manner of Leonardo, Lorenzo di Credi, and Perugino. The superior solidity of his flesh is attained at the cost of some of Perugino's glow, and there is scarcely a particular, except perhaps the taste of his backgrounds, in which he can be said to approach the

* At the time this was written there was no Francia in the Louvre; now that gallery possesses a rather inferior specimen. It is remarkable that no specimen of this great painter was carried off from Italy by the French.—*Ed.*

† Sold in 1865.—*Ed.*

Venetians more nearly than the Umbrian master.
Vasari classes the two masters together, and appears
to consider them the first who, in Central Italy, dis-
played the resources and the charm of oil painting.
He tells us that "people crowded with enthusiasm to
see this new and more real perfection, deeming ab-
solutely that nothing could ever surpass it." Part of
the attraction was, or deserved to be, the unaffected
religious feeling which pervaded their works; these
merits, at all events, are such as still to command
the homage of a large section of the tasteful world.
Still, looking at their claims in relation to their
own age, it must be admitted that, in technical
respects, this almost exclusive attention to the
novel excellence which they recommended, ren-
dered them inattentive to the rapid progress which
others around them were then making in design.
Michael Angelo, who had no partiality for oil
painting, ridiculed them both; and Vasari, after
the above eulogy, intimates that the ampler style
of Leonardo da Vinci (the type of which, he might
have added, was the Last Supper, at Milan) again
enlarged the boundaries of the art beyond all anti-
cipations, and gave a new direction to the public
taste.

CHAP. IV.

RAPHAEL—FRA BARTOLOMMEO—MARIOTTO ALBERTINELLI—RIDOLFO
GHIRLANDAJO—GRANACCI—BUGIARDINI—ANDREA DEL SARTO.

IN pursuing an enquiry into the Italian practice of
oil painting, it will often be necessary to refer to
pictures remarkable for their invention and ex-
pression. That the mere technical peculiarities of
such works should hitherto have been scarcely
noticed can excite no surprise. The impressions
which such productions excite so entirely supersede
the consideration of the mere art, that we seldom
feel disposed to enquire what are even their merits
in the mechanical parts of painting. For the pre-
sent, however, our attention is professedly confined
to those outward qualities, and while the subordi-
nate nature of such researches is admitted, it must
be evident that examples which are well known,
and which are remarkable for their preservation
and general excellence, must be the fittest for our
purpose. The apology here offered may require
to be remembered throughout these volumes, but
it appears to be more especially necessary in ap-
proaching the consideration of works which, from

their chiefly addressing the feelings and imagination, generally compel us to overlook their mechanical and material conditions.

In all technical particulars the early works of Raphael, as might be expected, closely resemble those of Perugino. His first style was even confirmed for a time in Florence by the example of Fra Bartolommeo, who, it will appear, in many points closely adhered to the original method of oil painting. It was not till the year 1508, and immediately before he removed to Rome, that the great painter began to adopt the more solid manner of Leonardo da Vinci and his followers. In Rome that manner was still preferred by him, and if, in his later works, some characteristics of the older method are to be recognised, this is rather to be attributed to certain of his scholars who prepared his pictures than to any further change in his own practice.

The method of hatching which the earlier pictures of Raphael exhibit is rarely apparent in his more mature works. His first essays were probably in tempera, like the copy by him, still at Perugia, of the two children in the picture by Perugino at Marseilles, before mentioned.* The two predella pictures of the Baptism and Resurrection in the possession of the King of Bavaria, which appear to be copied from those by

* See p. 131.

Perugino now at Rouen, are either in tempera or, if in oil, are hatched according to the habits of a tempera painter. Some of the earliest examples of Raphael's execution—pictures by Perugino in which he assisted—are now in the gallery of the Vatican. The picture of the Resurrection has been already noticed among the works of Perugino. A Nativity, called "Il Presepe della Spineta," from the church near Todi whence it came, is supposed to have been partly painted by Raphael at a very early age. This is corroborated by the existence of a study by him in black chalk, now in the British Museum, for the head of Joseph—the portion of the picture (otherwise weak) which is most worthy of him. In some parts of that figure hatchings are observable in the shadows of the flesh; the flesh throughout is very thin, and shows the delicate outline like a pencil line through it: the blue drapery next the hands of the Madonna forms a thick raised boundary round them; the red drapery is hatched in the shadows.

The first altar-piece, and the only Crucifixion known to have been painted by Raphael, is now in England, in the possession of Earl Dudley. It was painted for the church of S. Domenico at Città di Castello, whence it was removed during the French occupation of Italy at the close of the last century; it afterwards formed part of the collection of Cardinal Fesch. This interesting work appears to have been completed about the year 1500, when

Raphael was only seventeen years of age; in its general treatment, and in certain peculiarities of form and action, it closely resembles the style of his master, and Vasari remarks that if the name of the artist were not inscribed on it, it would be supposed to be by the hand of Perugino. It has been observed that the expression of the head, and particularly that of the Magdalen, already evince the finer feeling of Raphael; indeed Vasari, even on another ground, is hardly correct in the observation referred to, since Perugino was at the zenith of his practice at the period when this altar-piece was executed, and, as regards mere completeness of execution and richness of colouring, would undoubtedly have produced a very different work. Still, the picture, which is remarkably well preserved, affords the clearest evidence of the adoption of Perugino's practice. The outline, which is often visible through the thinner portions of the work, is drawn on a white ground. The flesh is thin, so much so that the hands and other portions appear less prominent than the surrounding darker colours of draperies; both flesh and draperies are sometimes hatched. The darks in general are raised; this is even apparent in the minute darks of the features, showing that a very thick vehicle was used with the transparent browns; it is also remarkable in the shadows of the blue drapery, and in the greens generally. The sky is, as usual, somewhat more solid than the flesh, and, like some other

portions, has the appearance of having been painted in tempera, but this is a question always difficult to determine.

That the light parts should be almost free from cracks is partly explained, as in Perugino's works, by the thinness of the pigment; yet the darks, often prominent with a rich vehicle, are nearly as sound. When it is considered that this altar-piece remained for nearly three hundred years in the church for which it was painted, its fine state of preservation, as compared with that of pictures which have, under similar circumstances, gone to decay, appears to indicate the use of the firmer medium then employed, namely, the amber varnish. With respect to the prominence of the minute darks, it has already been explained that such portions, executed with a thick oil varnish, remained of necessity more raised than larger surfaces so covered, simply because there was less room to spread the tint. The same peculiarity is often observable in early Italian, as well as Flemish oil pictures, in minute lights, such as embossed ornaments. These are prominent, not so much by the thickness of the colour as by that of the vehicle. In such instances, the edges of the touch are blunt, and are easily distinguished from the dry crisp touch of the solid pigment (with the least possible quantity of vehicle), observable in the works of some Venetian masters.

The prominence of the transparent colours gene-

rally, and of the minuter darks in the features, is to be regarded as a test of the good preservation of an early oil picture. The inequality of surface is less observable on such pictures when painted on cloth, as the artists appear to have taken the precaution not to load the semi-resinous vehicle so abundantly on a flexible material, for fear of its cracking; but the smoother appearance in question is sometimes to be attributed to the operation of lining, in which, in order to secure the adhesion of the additional cloth at the back, the picture is submitted to great pressure. The same flattening result is also likely to take place when pictures are transferred from wood to cloth. Raphael's Coronation of the Virgin, painted in 1502 for the church of S. Francesco in Perugia, and now in the Vatican, was, in consequence of the decay of the wood, necessarily thus treated in Paris, whither it was conveyed in 1797 from its original place. The operation appears to have been better performed than that of restoration, the effects of which are traceable here and there in darkened spots. The flesh, in this work, is extremely thin, appearing, as usual, embedded in the surrounding colours; the outlines, as in the feet of the Apostles, are visible here and there through the pigment. The blue drapery of the Madonna is corroded, and has a dull surface in consequence of that gritty appearance of the colour before described; a similar appearance is observable in the darks. The brilliant green

drapery is extremely thick, and is now covered with horizontal, slightly projecting ridges (probably following the fibres of the wood, and occasioned by its contraction); it is cracked in the shadows, where the vehicle is still more abundant. The corroded effect in some darks is here to be attributed to the use of the sandarac oil varnish ("vernice liquida "), while the mastic oil varnish ("vernice chiara") is clearly indicated in the green.

The three predella pictures belonging to this altar-piece are also in the Vatican Gallery; the subjects are, on the left, the Annunciation; on the right, the Presentation in the Temple; in the centre, the Adoration of the Kings. The same general peculiarities as regards execution and materials are here observable: the angels' dark wings in the Annunciation are very prominent in surface; the flesh, which is remarkably thin, is not at all hatched (the figures being small), but is highly finished and fused—its surface is very perceptibly lower than that of the surrounding colours. A portion of the blue distance in the centre picture is more raised than any other part; the darks of the lake draperies are also very prominent. In the third picture, the Presentation, the shadows of the yellow drapery are hatched; a green drapery has much less vehicle than usual, and has faded in consequence: the effects of the protecting "vernice chiara," and of the want of it, may here be compared in the same altar-piece, the greens in the

large picture being remarkably fresh. The gesso ground of these predella pictures is visible at the edge, showing that it is as thick as in the early Flemish pictures.

The Vision of a Knight, in the National Gallery, is placed by Passavant in chronological order after the last: it may have been painted about the year 1503. The finish of the flesh in this small work resembles that of the predella pictures last described; here, too, the minuteness of the size renders the thinness of the flesh less remarkable, but its relative thinness as compared with the darks is immediately observable. The purplish dress of the figure with the sword, the greens and blues, are all much raised; the lakes, as usual, more in the shadows: the minute darks, as in the nearer tree, and the small tree in the landscape also project. The sky has considerable body, but not more than the distant mountains: the most prominent portions of the picture are, as usual, the darks. The gesso ground is visible at the edges; some indications of gilding on the ground next the border are probably derived from the frame.

The same general appearances are to be traced in the celebrated Sposalizio at Milan, painted in 1504. In that work the opaque colours are sometimes so thin that the outlines, especially of the architecture, are visible through them; the darks, some of which appear to have increased, are, as usual, prominent.

From 1505 to 1508 the gradual influence of Florentine examples is to be traced in the works of Raphael; yet less, for a time, in modes of execution than in general taste. The smaller picture of a Madonna and Child, in the possession of Earl Cowper at Panshanger, belongs to the earlier date, and, from its excellent preservation, is a remarkable example of the methods hitherto described. The flesh is extremely thin, and is highly hatched here and there in the half-shadows; the sky is somewhat thicker; the darks are prominent, especially the green and blue draperies: the blue drapery is so thick, that where the colour is inserted between the fingers of the Madonna's hand it has the appearance of a solid wedge. In this instance the "vernice chiara," or mastic oil varnish, must have been used: the cracks are large or continuous, having the usual appearance of mastic cracks. The varnish was probably made extremely thick, to correct its tendency to flow; it has also answered the intended effect of preserving the "azurro della Magna."

The Ansidei altar-piece, now at Blenheim, has the date 1505—or 1506.* The picture is in excellent preservation: the broader shadows in most of the heads and necks are a little hatched; the Madonna's head is more thinly painted than the rest, but the flesh is nowhere cracked; the sky is

* Mr. Gruner, the well-known engraver, reads 1506 ; Passavant, 1505.

more solid, but still is not so prominent as the
darks, immediately next it, of the baldachin or
throne behind the Madonna: the darks are always
prominent, the edges often appearing in ridges. The
green drapery of St. Nicholas, which has the same
peculiarity, is rough, as if painted with ill-ground
colour; the blue drapery of the Madonna is much
raised in the shadows, and is roughened by cracks
of the " vernice chiara." The lights on the blue
drapery are hatched; the red drapery of St. John
was prepared for glazing by a more solid prepara-
tion than usual; the shadows are, however, still
comparatively raised. Some lines, as in the archi-
tecture of the Sposalizio, are indented; the cross
held by St. Nicholas has this appearance. The
ground was white; it is seen through some rubbed
parts, as in the left leg of the child. The com-
parative solidity of the lights in this picture may
be an additional reason for reading the date 1506
rather than 1505; at the same time it is certain
that other works by Raphael, executed at a some-
what later period in Florence, are again thinner in
the opaque colours, as if the artist fluctuated
between the influence of Fra Bartolommeo and
Leonardo da Vinci. The rapidity with which some
of these works were executed, when once the
design was completed, may, however, sufficiently
account for such apparent varieties.

To the same period (about 1506) belongs the
St. Catherine in the National Gallery. Various

studies for this figure exist, and the cartoon of the size of the picture is in the Louvre. In the flesh, the painting is so thin that the hatched outline on the white ground—for example, in the neck—is distinctly seen through the colour. The sky, though still thin, is somewhat more raised than the flesh. The darks are all prominent, even to the shadows of the features. The hands are embedded in the darks immediately round them. The toned green of the sleeve, glazed over a light preparation, is, as usual, prominent. The lake drapery appears to have been prepared with bright lights; still the comparative prominence of the shadows is apparent; the same peculiarity is observable in the trees and near leaves in the landscape. The picture is in excellent preservation; the lights are free from cracks, and there is only a slight tendency to the corroded effect, so often described, of the sandarac varnish in some unimportant parts of the lake drapery.

The picture of the Entombment of Christ, now in the Borghese Gallery at Rome, has the date 1507. The outlines on the white ground are, in this instance, much thicker than usual, as if inserted with a brush; they are visible in many parts of the figure carrying the body (at the head), in the left arm of the opposite supporting figure (at the feet), and in the Madonna's head. The flesh in the figure of the Christ is much more finished than in the others; it is more solid, and,

except in some shadows, is free from hatching. In other portions—as in the Madonna's head, in the hands of the female clasped round her, and in those of the other holding her up—hatching is very perceptible. The hair of the supporting figure at the feet of the Christ is also expressed by lines, as is the yellow hair of the kneeling female. Notwithstanding the comparative solidity of the figure of the Christ, the whole mass with its accompanying drapery is embedded in the surrounding darks. This is the appearance of the flesh throughout, with the single exception of the profile of the man holding the legs, the surface of which is somewhat more raised than the dark landscape background on which it is relieved. The green and blue draperies are much the thickest parts of the picture, the green being uniformly raised, the blue most in the shadows. Both are cracked; the green indicating the use of the "vernice chiara," and exhibiting cracks and ridges following the fibre of the wood (in this case placed vertically). Some cracks in the light portions are traceable to the same cause, as distinguished from cracks in the pigment itself. These latter are nowhere apparent.

Of the last works executed by Raphael in Florence, it will be sufficient to mention two—the larger Madonna at Panshanger, which has the date 1508, and the "Belle Jardinière" in the Louvre, supposed, on good grounds, to be the picture which Raphael left with the blue drapery

unfinished, and which, in that portion, was completed by Ridolfo Ghirlandajo. The picture at Panshanger can be conveniently compared with the earlier work, before described (p. 160), in the same collection. In the later work the flesh has more body, so that the surface has here and there fine hair-like cracks, like those already noticed in Leonardo da Vinci. The green and blue portions of the drapery are much raised, the darks are universally so, and the blue sky is more prominent than the heads.

In the " Belle Jardinière," although the sky is thicker than the flesh, the latter has considerable body in the lights, while in the thinner faint shadows hatching is here and there apparent. The more solid parts of the flesh have the same hair-like cracks as the specimen last described. The darks throughout are prominent, the blue drapery is especially so, and appears to have been painted with much vehicle. The work of the brush is visible in the semi-solid colour.

These examples have been selected from among many others, partly because their dates are more accurately determinable. In comparing the technical qualities, to which our attention is, for the present, confined, with those before noticed in the first Florentine oil painters and in Leonardo da Vinci, it will now be apparent that Raphael, especially in his more elaborate and studied works, gradually adopted the system of painting the flesh

with substance. In the absence of unfinished pic-
tures of his later time, it may be inferred that this
more solid execution was the result, as in Leo-
nardo's case, of repeated operations. This method
afforded the means of revising the forms; but it is
remarkable that this advantage was never abused
by Raphael. To the last his preparatory outline
was definite, and his corrections rarely differed
much from the design which, after numerous
sketches and studies, was fixed as the ground-
work of the picture. Examples of a very opposite
practice by some of the colourists will hereafter be
noticed. There can be no doubt that habits of
decision and of mental activity are best cultivated
by determining the design at first, while the oppo-
site practice of relying on the facility with which
alterations may be made in oil painting tends at
least to procrastinate the needful exertion. It is
curious to compare, in this respect, the *pentimenti*
(after-thoughts or corrections) of Raphael with
those of Leonardo da Vinci. The Adoration of the
Magi, before described, by Leonardo, shows how
soon the artist's experience of the possibility of
correcting an oil painting by repeated operations
led him, in the instance quoted at least, to capri-
cious changes and apparent indecision. At a later
period, painters accustomed to a very different
practice would have easily remedied the mere out-
ward defects thus occasioned; but Leonardo, fasti-
dious in regard to the process as well as the design,

appears to have thrown aside the sketch, which perhaps he felt he had marred, in disgust.

As before explained, Leonardo appears to have gradually adopted (perhaps invented) the system of repainting, in order to reserve the power of improving his forms and expressions. It will now appear that Raphael, in following that method, may have been influenced by a conviction that the work was likely to be more durable by being solidly executed. It is true he found another advantage in departing from the "alla prima" method of the early oil painters. As occupation crowded upon him, he must have soon looked forward to the employment of assistants, and it seems that, even in Florence, he sometimes availed himself of such means of gaining time. In such a system repeated operations are indispensable. The *abbozzo*, or under-painting, however thinly executed by an assistant on the outline (perhaps traced by the scholar, and afterwards corrected by the master), would, in most cases, be entirely covered again by the master's work, and thus a certain thickness of the colour would be unavoidable. The question is so far interesting, inasmuch as all pictures executed so thinly as to indicate one operation only, must, if exhibiting other sufficient evidence of their authenticity, have been painted by the master alone. But the proof that Raphael aimed at solidity in his later works, from a belief that such a mode of execution insured their durability, is to be found

in his later portraits—works in which the heads at least must have been executed by his own hand. The portrait of Julius II. in the Pitti Palace, of which there are numerous repetitions, is thus solidly painted; that of Leo X. in the same gallery, that of Count Castiglione in the Louvre, that of the Violin Player in the Sicarra Palace at Rome, with many others, have the same quality, as distinguished from the more thinly painted portraits of the Florentine period, such as those of Agnolo and Maddelena Doni, and others.

On Raphael's arrival in Rome in 1508, he was soon engaged in preparing designs for the Vatican frescoes, and during the pontificate of Julius, who died in 1513, his oil pictures are not numerous. Among them may be mentioned the " Vierge au Diadème " (called also " Le Sommeil de Jésus "), now in the Louvre; the Madonna and Child in the Stafford Gallery; and the Madonna di Foligno. In these and other oil pictures of the same period by the great artist, although the co-operation of assistants is in some cases to be supposed, the work may have been entirely covered by the master's hand. The three pictures referred to all exhibit, together with the prominent darks of the old practice, a thicker *impasto* in the flesh. In the first named—the " Vierge au Diadème "—the flesh in the sleeping infant exhibits the fine cracks so perceptible in the works of Leonardo. In other technical respects the habits of the early oil painters

are apparent; the darks are raised, and the blue drapery on which the infant sleeps is extremely thick. In the graceful Madonna and Child in the Bridgewater Gallery the flesh has the usual cracks, and the blue drapery is extremely prominent, so as to make the flesh near it appear embedded. The Madonna di Foligno, in the Vatican Gallery, was transferred from wood to cloth in Paris, and, for the reasons before given (p. 139), perhaps the original varieties in the surface may have been somewhat obliterated in the process. Still, the greater prominence of the darks is here and there to be observed, as, for instance, in the green background next the boy standing below. The flesh is, however, much more solid throughout than in the early works of the master: the most prominent darks are the shadows in the grey dress of St. Francis.

During the remainder of his laborious life, from 1513 to 1520, the number of Raphael's undertakings rendered it necessary for him to depend more than ever on the assistance of his now numerous scholars. All the oil pictures of this period are remarkable for the thicker painting of the flesh; in some which have been transferred from wood to cloth, the difference between the surface of the flesh and that of the darks is scarcely perceptible. This is the case in the large Holy Family, now in the Louvre, painted for Francis I. (1518), in which the hand and colouring of Giulio Romano are apparent, agreeing with Vasari's statement respecting

that painter's assistance in the work. The large
St. Michael, in the Louvre, also transferred from
wood to cloth, is in the same state; but the thicker
impasto of the flesh is here not to be mistaken. In
the Madonna della Sedia in the Pitti Palace, the flesh
has again much substance; but in this instance all
the darks are raised, and the green drapery is espe-
cially thick. Lastly, in the Transfiguration, which
is still on its original wood, although the flesh has
considerable body, the darks are all raised round
it, and the blues and greens remarkably so. The
shadows of the blue drapery of the woman kneeling
in the foreground are loaded with vehicle, which
has cracked widely. The sky is, as usual, more
raised than the flesh, which is evident where they
come in contact—as in the undraped portions of
the figure of Christ. The heads and extremities of
the figures kneeling on the left, though thickly
painted, are embedded in the surrounding darker
colours.

These examples are sufficient to prove that the
process of transferring large pictures from wood to
cloth tends to efface the varieties of surface, thus
obliterating indications which throw great light on
the early history of oil painting. It is not to be
supposed that the difference which has been pointed
out in the larger pictures so transferred, as com-
pared with better preserved specimens, is to be ex-
plained by the different habits and practice of
Raphael's scholars. One of the altar-pieces which

he had early engaged to paint was, in consequence
of his increasing occupations, so long deferred that
the design only appears to have been ready at his
death. The subject of this work, originally in the
convent of Monte Luce, near Perugia, and now in
the Vatican, is the Coronation of the Virgin. Four
years after Raphael's decease his two principal
scholars and executors—Giulio Romano and Fran-
cesco Penni—undertook to complete the work;
Giulio painting the upper portion, and Francesco
the lower (the picture, executed on wood, being
composed of two separate parts). In this work the
treatment of the flesh, as compared with that of
the darks in regard to surface, corresponds with
Raphael's later manner. We find the same system
in a Nativity by Giulio Romano in the Louvre.
In this instance, while the flesh is comparatively
solid, the blue drapery of the Madonna and the
green dress of St. John the Evangelist are, as usual,
prominent, from the quantity of varnish used with
them.

The foregoing observations show that the method
of Raphael and his scholars ultimately approached
that of Leonardo. The main characteristic, as dis-
tinguished from the earlier practice, and from that
of Perugino, being that the flesh and light portions
of the work acquired a certain solidity—the result
of repeated operations after the outline was com-
pleted—so that the intermediate process, prepara-
tory painting, or *abbozzo*, could be entrusted to a

scholar. The authority of two such masters was more than sufficient to establish this method in the Florentine and Roman schools, and we shall now see that the words of Vasari, in his *Introduction*, where he treats of the first Italian practice of oil painting, have a peculiar and just meaning. After speaking of the Flemish inventors of the method, and of Antonello da Messina's residence in Venice, he adds:—" it continued to be improved till the time of Pietro Perugino, Leonardo da Vinci, and Raphael; so that, through their means, it has been brought to the perfection which our artists have since imparted to it." It is quite excusable in Vasari to suppose that the new art had attained perfection in Tuscany. Perhaps the example he had in his view at the time he wrote was Andrea del Sarto—a consummate painter as well as designer, and who inherited the technical ability, though not all the higher qualifications, of the two great masters above named. In the " Proemio," or preface, to the third part of his work, Vasari still gives the first place to Raphael, and, after describing his various excellences, adds:—" Andrea del Sarto followed in the same style; that is, only was more delicate and less robust (*gagliardo*) in colouring."* The last epithet, applied to Raphael's colouring, is borne out chiefly by his frescoes of the

* " Seguì in questa maniera, ma più dolce di colorito, e non tanta gagliarda."—Vasari, *Proemio alla terza Parte,* p. 442.

Mass of Bolsena and the Heliodorus. It is also applicable to some of his oil pictures, in which, probably emulating Sebastian del Piombo, he aims for a time at greater warmth in the flesh. His pictures of this class are, however, rather fiery than golden, and the manner cannot be considered characteristic. It was adopted, and sometimes carried to excess, by one of his scholars, Perino del Vaga, who, again, in assisting Raphael, may have imparted it somewhat too largely to the works' in which he co-operated.

Among the early Florentine oil painters none comprehended the resources of the new art better than Baccio della Porta, afterwards, when he became a Dominican monk, called Fra Bartolommeo. He was born in 1475, and having, in the last years of the century, become a zealous follower of Savonarola, he was so deeply affected by that reformer's fate that he quitted the world for the cloister in 1500. Among those united with him by a religious aim in art, and by attachment to the preacher, was Lorenzo di Credi, whose predilection for oil painting has been already noticed, and who, from his ripe age and experience, was well qualified to instruct Bartolommeo in the mysteries of the new art. Another circumstance may also have had its influence: the younger artist was commissioned to paint a fresco of the Last Judg-

ment in the chapel of the cemetery in S. Maria
Nuova. While employed on that work Barto-
lommeo must have had daily opportunities of
making his observations on the chapel of the hos-
pital, which, as we have seen, exhibited specimens
of Flemish oil paintings. On these examples his
practice in the new art, considered without re-
ference to his general taste, appears to have been
formed. On his change of life, Fra Bartolommeo,
stricken in spirit, for a time abandoned the pencil:
the fresco above mentioned was left half finished,
and was completed by his fellow-student and fol-
lower, Mariotto Albertinelli. The remains of this
fresco have been removed from the chapel of the
cemetery to a neighbouring *cortile.*

Fra Bartolommeo, or, as he is commonly called
by way of distinction, the Frate, may, on the
whole, be considered the best colourist of the Flo-
rentine school. His adherence to the Flemish
method of oil painting is apparent in the thinness
of his flesh tints, as compared with the works of
Lorenzo di Credi, Leonardo da Vinci, and the
later pictures of Raphael. In this peculiarity, in-
deed, he sometimes, like Perugino, went beyond
the inventors of the art, and perhaps there are no
Flemish masters so thin in the lights (especially
when we consider the dimensions of his works) as
Fra Bartolommeo. The softness of his gradations
is to be traced to Leonardo, but in emulating the
force and roundness of that painter, he at one time

fell into the defect of blackness; and as, according
to Vasari, he used lampblack, the evil has, in the
cases alluded to, since increased. His best pictures
are quite free from this opacity in the darks, and,
with equal force, have a luminous transparency
and depth in the lower tones; exhibiting, in large
dimensions, the vivid clearness of the Flemish
manner combined with greater softness and far
nobler forms.

Of the Madonnas painted by Fra Bartolommeo
in his youth, and which are alluded to by Vasari,
none can with certainty be pointed out. A smaller
work, belonging to the same period, is a shrine
which served to enclose a small statue of the Virgin,
by Donatello. On the inner sides of the doors
are represented the Nativity and the Presentation
in the Temple; on the outer, in chiaroscuro, the
Annunciation. These delicately executed oil paint-
ings, but a few inches high, are now in the gallery
of the Uffizj. In a miniature size even a painter
accustomed to a thin execution unavoidably treats
the flesh tints and lights with more body than in
his larger works—as is observable in Raphael's
" Vision of a Knight," as compared with larger
specimens of the master corresponding with it in
date. It is not, however, unlikely that, during
Bartolommeo's intercourse with Lorenzo di Credi,
his works may have partaken more of the solidity
of that painter's manner. Still, in these minute
works, the darks are more prominent than the flesh;

but not the blue, which, in this case, may well be supposed to be ultramarine.

The four years which, according to Vasari, Bartolommeo passed without exercising his art are to be reckoned, not from his taking the vows, but from the troublous period which ended in the execution of Savonarola in 1498. The first work executed by him afterwards (in the beginning of the following century) was the altar-piece representing the Vision of St. Bernard, formerly in the Badia di Firenze, and now in the Florentine Academy. This picture has been much injured and repainted, and perhaps in consequence of its various cleanings and restorations, now presents little variety of surface. The flesh is thinly painted, but has sufficient substance to conceal in most places the dark outline: an original correction is apparent in the St. John's foot, where a second outline appears above the first painting. In this, as in various pictures of the time, the ruled lines of architecture are indented in the gesso ground. The Holy Family, with the Infant St. John, painted for the favourite chapel of Agnolo Doni, is now in the Corsini Palace in Rome. This picture exhibits, in an extreme degree, the peculiar transparent system of the Frate. Whatever care may have been taken with the design, it is difficult to suppose any underpainting, properly so called, in a work which has so little body. The white or yellowish ground is everywhere visible underneath the lights, and as

these, in the fairer carnations, are not very broken in tone, the flesh has a bright, but almost too clean an appearance at a distance, as in the fine specimen of the master at Panshanger. This approach to crudeness is sometimes, doubtless, the result of injudicious cleaning, but it is partly to be explained, as we shall hereafter see, from other causes. Even the hair of St. John shows the ground through the lights, and the only parts of the flesh which have any approach to body are the lighter portions of the Infant Christ. The brown outline on the ground is frequently apparent, especially round the limbs of the children; the flesh, which is not at all cracked, is blended or fused, and free from hatching. Some of the draperies are intensely deep and rich, the darker colours, and especially their shadows, being applied with a thick vehicle. The shadowed portion of the red drapery of St. Joseph projects in a ridge next the face of the Madonna; the whole surface of this drapery is covered with the minute cracks of the red " vernice liquida." The only colour which has much substance in the light is the blue drapery of the Madonna—a substance in this case not produced by the vehicle, but by solid painting, afterwards slightly glazed; the brown transparent shadows, on the contrary, are extremely thick with the oleo-resinous varnish, and form a projecting surface round the Infant's legs.

Vasari, in the commencement of his Life of Fra

Bartolommeo, after speaking of his first studies
with Cosimo Rosselli (from whom he could learn
nothing of oil painting), immediately proceeds to
tell us that he studied with great interest the works
of Leonardo da Vinci. Leonardo had quitted Flo-
rence after his first residence there when Barto-
lommeo was about twelve years old. The works
which he left in Tuscany may, undoubtedly, have
had their influence, but it was after his return in
1500 that an imitation of his works by the Frate
is to be observed. The St. Bernard, above men-
tioned, though painted after that date, has, however,
no approach to the intense force and soft gradation
which the younger artist admired in the works of
Leonardo. In these qualities alone is the imita-
tion in question to be at any time traced in the
Frate; for the general thinness of the opaque
colours, even in his mature works, differed widely
from the practice of Leonardo, and from that of
his own early companion, Lorenzo di Credi.

A picture representing the marriage of St. Cathe-
rine, painted for St. Mark's (the convent of the
Frate), and presented it appears in Vasari's time
to the King of France, is now in the Louvre. The
flesh, which is thin and free from cracks, is em-
bedded in the surrounding colours, the darks,
blues, and greens being treated in the usual way.
The red (lake) draperies of Fra Bartolommeo are
sometimes executed at once with the transparent
colour on the light ground; in this instance the

outlines on the ground are seen through it: the sandarac vehicle used in the shadows has here and there become corroded; in the green lining of the Madonna's blue drapery the cracks indicate the use of the white varnish. Another picture of this kind, dated 1515, which the Frate painted to replace the first, is now in the Pitti Gallery, where it is called the "Madonna del Baldacchino." This is one of those works in which the artist, in aiming at force, is betrayed into blackness: although the flesh is thin, the whole has an opaque, cold effect. Vasari speaks of the great relief for which this picture was remarkable, adding, that the artist in this instance imitated Leonardo's system, "especially in the darks, in which he employed lamp-black and ivory-black; in consequence of the use of these materials," the picture, he continues, " is now much darker than it was when it was painted, the shadows having constantly increased in obscurity." Here, as in other instances, the outline is sometimes visible through the flesh in the light portions; the intense and opaque shadows—not improved by the effect of time, in the centuries that have intervened since Vasari's observation—allow of no such inspection: the outlines of the architecture are, as usual, indented.* A third picture of this class, executed soon afterwards, is still in the convent church; it represents the Madonna

* A copy of this picture, by Gabbiani, is in the convent of S. Marco.—Vasari, *Life of Fra Bartolommeo*, note 15.

and Child, six saints, and two angels. This is also
in a very blackened state, and the face of the
Madonna is badly repainted; the Infant Christ is,
however, well preserved, and is so fine as to justify
the mistake of Pietro da Cortona, who, according to
Bottari, believed the work to be Raphael's. The
flesh appears to have been originally thin, for in
some places—for example, in the Infant's right arm
—the outline is visible through the colour: the
indented outlines of the architecture are apparent
in the steps, but are almost filled up with re-
painting.

The Pietà formerly in S. Jacopo fra Fossi, now
in the Pitti Gallery, was left unfinished*, and was
completed, Vasari says, by Bugiardini. It is now
in a very ruined state; the boards of the panel on
which it is painted are much warped, and the whole
surface (the ground being partially detached) is
more or less blistered. The background is entirely
repainted, and the two figures of St. John and
St. Paul, which, it seems, were added by Bugiar-
dini, were thus obliterated. The only conclu-
sions to be drawn from the present state of this
once grand picture are that the flesh was thinly
painted, and that the darks generally had the usual

* In Life of Bugiardini (vol. ii. p. 801), Vasari says it was
merely outlined. The Rape of Dinah, copied by Bugiardini,
was also left unfinished. See note to Vasari's Life of Fra
Bartolommeo, note 24.

apparent substance in consequence of the profuse
employment with them of a thick vehicle.

The picture of the " Salvator Mundi," once in the
Annunziata, and now in the Pitti Gallery, with
rather more body than some of the works described,
has the same general characteristics. The two
figures of prophets, Job and Isaiah *, now in the
tribune of the Uffizj, appear to have originally be-
longed to this picture, and are fine specimens of
the master. These also have somewhat more sub-
stance in the lights, and are very powerful from the
intense and rich darks which, in this instance, have
not the effect of blackness. With these may be
classed a half-figure of S. Vincenzo, once in St.
Mark's and now in the Florentine Academy. This
is the picture which Vasari observes was much
cracked (in the shadows), in consequence, as he
thought, of being painted without allowing time for
the size and gesso ground and for the first co-
lours to dry—as in the case, according to him, of
Perugino's altar-pieces at S. Giusto alle Mura. The
picture is placed too high to allow of any minute
inspection. The cracks appear to have been filled
up, and although by no means in a good state, the
work is striking from the richness of its effect. In
this case again the flesh is somewhat less thin than
in the generality of the Frate's works.

The celebrated St. Mark, painted for the con-

* See note to Vasari's Life of Fra Bartolommeo.

vent, and now in the Pitti Gallery, has also suffered from cleanings and restorations. It is a specimen of the transparent, forcible, and rich manner of the painter; the lake drapery consists of little more than a glazing on what appears to have been a yellowish ground, which is seen through the lights. The extremely warm, lighter shades in the flesh are well calculated for the almost colossal size of the figure, and produce their just effect at a due distance. The darks in the eyes have unfortunately become, or have been made, too intense, so as to give them the effect of spots; the green tunic has lost its tone, and is now become almost blue.

A small Holy Family in the same gallery has the same brilliant and transparent character; the colours of the draperies—especially of a green—are here, as usual, more prominent than the flesh, which, however, is not deficient in body. With these specimens, considered with reference to their technical characteristics, may be classed a Holy Family in the possession of Earl Cowper at Panshanger. The flesh is thin, and is exceeded in apparent substance by the other colours; the outlines on the light ground are seen through the wrist of the Child, in the extremities of both children, and round the eyes of the Madonna. A slight appearance of hatching in the fainter shades is probably the first drawing seen through the colour—as in the leg of the St. John. The darks throughout

are prominent; the thick vehicle, which was profusely used in the shadows of the blue drapery, is now cracked and corroded, presenting a dull appearance where the utmost lucid force was intended. Notwithstanding this and other imperfections, the picture has a powerful glowing effect —intensely forcible without blackness—and is only somewhat too fresh and clean in the lighter carnations.

In the former part of this work it was stated that a thinner and less durable vehicle was used by the early oil painters with the opaque than with the transparent colours. The proof of this may be found in the fact, that the cleanings to which pictures like those of the Frate have been subjected have sometimes stirred the lights, but have not affected the darks. The latter have been more or less injured by time, but, at all events, their relative prominence is a proof that they have not been rubbed away : on the other hand, the occasional crudeness of the flesh tints, and perhaps the undue display of the outlines underneath them, may be partly attributed to the effect of cleanings.

Three of the Frate's works are in churches in Lucca. Of two that are in S. Romano, the smaller, on cloth, has the date 1509; the larger, also on cloth, is dated 1515. The third, in S. Martino, of moderate size, on wood, is also dated 1509. The large picture—the " Madonna della Misericordia " —has been much restored, and now appears

scarcely worthy of its great reputation. Both the others are superior to it; but that in S. Martino (the cathedral)—representing the Madonna with St. Stephen and St. John and an exquisite angel seated on the steps of the throne playing a lute— is to be classed among the finest examples of the master. The smaller picture in S. Romano, representing the Magdalen and St. Catherine of Siena (or, according to some, the two St. Catherines), with a glory of angels above, has also great beauty and harmony. In all these pictures, with an exception presently to be noticed, the flesh is thin relatively to the other colours; the outline is distinguishable through the lighter shades and half-tints, and through the middle tints of the lake drapery. All the darks are more prominent than the flesh. With regard to the colours, the greatest apparent thickness is observable in the greens, somewhat less in the blues, and least in the reds. Wherever the vehicle has been thickly used, cracks or a corroded surface are more or less observable.

It would appear that Raphael furnished the design for the upper part of this picture, as a drawing for it by him exists in the gallery of the Uffizj at Florence. Rumohr even supposes that the angels in the picture are also partly by the great artist's hand: his reasons are that the shadows of the flesh tints are painted with considerable body—a system, as he justly remarks, corresponding with Raphael's method, but quite

opposed to that of the Frate.* The date, 1509, does not render this co-operation improbable, as the upper part may have been finished before Raphael's departure from Rome in the preceding year.

A desire to see the works of Michael Angelo and Raphael—the motive assigned by Vasari for Fra Bartolommeo's journey to Rome—would be but an imperfect guide to the date of his visit, had not the biographer also informed us that he was entertained there by Mariano Fetti, called the Frate " del Piombo," from his holding that office, to which, in the time of Clement VII., Sebastiano Luciano succeeded. Mariano's predecessor in the office was Bramante the architect, who died in 1514 ; it was therefore, in all probability, after that date that Fra Bartolommeo visited Rome.† There he began two figures of St. Peter and St. Paul for Fra Mariano. His stay, Vasari tells

* Rumohr, Italiänische Forschungen, vol. iii. pp. 71, 72, and 134.

† The works of Sebastiano Luciano which are most known, including the Raising of Lazarus, in the National Gallery, were painted some years before he obtained the office " del Piombo,"and before he assumed with it the habit and designation of " Frate." The same title may therefore, not impossibly, have been applied to Mariano Fetti, without reference to the precise year when he was appointed to the office. Still, the date 1514 may, on many accounts, be considered as that of Bartolommeo's visit. The then recent promotion of Mariano may have been the immediate cause, and his employing Bartolommeo indicates that he was possessed of some authority.

us, was short; he appears to have been oppressed with the excellence of the works he saw, and probably finding the place unsuited to his habits and his health, he departed without even finishing the work on which he was employed, and praying Raphael to complete it. This the great painter found time to do, and the figure of St. Peter is chiefly by his hand. These works, which are on wood and well preserved, exhibit therefore the best possible means of comparing the methods of the two painters. In renewing his communication with Raphael, and in observing the changes which that master's style as an oil painter had undergone since they had studied together in Florence, Fra Bartolommeo could not fail to remark a greater solidity of execution as compared with works painted by the younger artist at a former period, and partly perhaps under his own guidance. But if he acknowledged the advantages of the subsequent method, recommended, as it now was, by so celebrated a painter, there is but slender evidence to show that his own practice was influenced by the example. Of the two Apostles above mentioned, the head and hands of the St. Peter are evidently by Raphael; and those portions are much more solid than the flesh tints in the St. Paul. The surface in the latter exhibits no marked change from the well-known manner of the Frate; the left hand, for example, is embedded in the surrounding drapery: it is also to be observed that the colour is more glowing

and transparent than in the companion picture. Raphael, who must have found it difficult, in the midst of his associations, to fulfil his promise to his friend, evidently executed his task in haste; but, far from being disadvantageous, this has afforded a striking proof of the mastery of the great painter in the management of oil colours. The picture is remarkably well preserved, and, though the flesh is painted with considerable body, free from cracks. The traces of the full brush are everywhere observable; the colour is sometimes left in solid touches, and the execution is as bold as that of the later Venetians. Had Raphael oftener executed oil paintings entirely with his own hand in his later time we should, no doubt, have seen a more evident result of that dexterity which his practice in fresco, and knowledge of form, must have given him. In adhering to his own method, the great artist has emulated in this case the warmth of his friend's colour, but as his work is solid, with scarcely any glazing, the head of St. Peter, noble as it is, is rather red than glowing.* The St. Paul by the Frate is perhaps the finer of the two in expression, as well as in transparent warmth; it is only inferior in substance and execution. The union of solidity with that richness which glazing can best give was reserved for the Venetians.

An unfinished Madonna and Child by Fra Bar-

* See anecdote in Cortegiano, book ii. p. 213.

tolommeo, more solidly painted in the flesh than
the generality of his works, was exhibited at the
British Institution in 1841 under the name of
Raphael : if that picture was begun in Rome—
which the circumstance of its being half finished
renders not improbable—it might be supposed that
its greater substance was a consequence of the
painter's then new impressions. But, whatever
may have been the Frate's experiments in Rome,
it is certain that his latest finished oil picture,
painted after his return to Florence, and in the
year before his death (died October 1517), exhibits
all the extreme peculiarities of his technical style.
The picture here alluded to is the Presentation, in
the Belvedere Gallery at Vienna, formerly the altar-
piece of a chapel in St. Mark's at Florence.* The
colouring is, as usual, vivid and clear, the conse-
quence of the transparent system of the painting—
a system carried so far in this instance that the
outlines are visible through the flesh tints. The
picture bears the inscription, " Orate pro pictore
olim sacelli hujus novitio 1516."† A small picture
of the Annunciation, now in the Louvre, in which
the Madonna is accompanied by various saints, has
the date 1515. In this instance again the flesh is

* The tradition repeated at Vienna that Rubens formed his
style from this particular work, can have little weight when
it is recollected that the picture migrated from Florence to
Vienna so late as 1782. See Wilkie's remarks on its ruined state.

† The repetition in the Uffizj is inferior.

thin, and without cracks, while the darks and the
usual colours are prominent; the inscription is,
" F. Bart°. FLOREN. oris *pre* ("ordinis predicato-
rum") 1515."

A large picture by the Frate representing the
patron saints of Florence was left unfinished at
his death, and is now in the gallery of the Uffizj.
This work, Vasari tells us, was a commission from
the Gonfaloniere Soderini, and was intended for
the same council-chamber where Michael Angélo
and Leonardo da Vinci had been employed; but
by a singular fatality neither of the three masters
completed the work allotted to him. An engraving
of Fra Bartolommeo's composition may be seen in
the small edition of the Florence Gallery. The
white ground of the picture appears to have been
covered with a semi-opaque yellowish tint: this
tells for the lights; the shadows are laid in with
brown, which, in the darkest touches, appears
almost black. The effect of the whole is like an
immense bistre drawing on wood. The forms are
drawn with a clean, very dark outline, which
appears thin and wiry for so large a scale: the
outlines of the architecture and steps, and even of
some books, are ruled and indented. Vasari inti-
mates that Fra Bartolommeo was employed on this
composition immediately before his decease, but
the banishment of Soderini in 1512 was no doubt
the cause of the suspension of the undertaking. The
Gonfaloniere quitted Florence in that year, never

to return, and unless we suppose that Ottaviano de' Medici, ultimately the possessor of the work, commissioned the Frate to proceed with it (which does not appear), it must have been left incomplete some years before the painter's death.*

This picture, together with Vasari's description of the Frate's method, and the evidence of his more finished works already described, gives the fullest insight into his general process. The yellowish ground seems to have been adopted by Fra Bartolommeo in other instances—for example, in the gigantic St. Mark now in the Pitti Gallery. Occasionally, as is evident from an uncovered portion of the small Holy Family before described, which is now in England, the ground was white. The large work above referred to, however, shows that at the best period of his practice the Frate preferred the yellowish tinted ground, due allowance being made for the yellowing and darkening of the varnish with which the surface of the unfinished picture in question is now covered. The habit was probably derived from Leonardo : that master, as we have seen, apparently with a view to correct the yellowing of the oil, painted his flesh of a purple hue, sometimes even exaggerating this tint. Such being his practice, he would consistently select a ground tint (yellowish) which was again the opposite of the purple preparation, in order to give it value. On

* Vasari, Life of Fra Bartolommeo, notes 43 and 44.

the same principle the tempera painters prepared their carnations with a green tint; with the same view Titian prepared his blue skies with a light brown inclining to orange; while Rubens and Vandyck often painted their flesh tints on a grey ground. The Adoration of the Magi, by Leonardo, exhibits the yellowish ground, and is only not carried far enough to exemplify the purple preparation.

It is not easy to determine to what extent the extreme thinness in the flesh tints which some of the pictures of the Frate now exhibit may be the effect of time and cleanings; but as the thinness, in greater or less degree, was undoubtedly one of the original characteristics of his works, it is not to be supposed that he would ever make the ground so dark as to mar the brilliancy and warmth of the superadded carnations. The internal light which they actually display, and the brightness which they acquire from their transparency, are conclusive on this point. The cold effect of a thin light over relative darkness is apparent wherever the outlines are seen underneath the semi-opaque light colour, a bluish tint being necessarily the result. The general principle, independent of any authority, is not to be mistaken. As Descamps (quoting Rubens) observes, the ground tint is of no importance if it be entirely and thickly covered: when thinly covered, it will, if darker than the superadded colour, impart a coldness to it; if

lighter, it will enhance the warmth. The bright and glowing carnations of Fra Bartolommeo, thinly painted as they are, or have been, suppose, therefore, a ground which, when yellowish, was still of a very light tint. A partial coldness may be sometimes intentionally produced, on the principle just adverted to, for the sake of the pearliness of the tone, as colours of all kinds are never so clear, never so unlike pigment, as when they are seen through each other without an atomic mixture: only it is necessary to bear in mind that white lead has a tendency to become transparent by age, especially when not fortified by a firm vehicle, and that therefore cool tints which are produced by thin lights over a darker preparation will become colder in time, even though that tendency be somewhat counteracted by the gradual mellowing both of colours and varnishes.

With the exception of the occasional use of this light yellow tint for the ground, the method of Fra Bartolommeo was nearly in accordance with that of the Flemish masters. The defined outline, the insertion of the shadows upon it—the ground being left for the lights—the comparatively thin flesh tints (thinner than the Flemish*), the darks lucid and prominent with a thick vehicle, all correspond with the principles and practice of the first oil painters. Vasari observes that the Frate was in

* This system was imitated by the later Flemish painters.

the habit of preparing his pictures as if they were
cartoons—that is, merely with reference to the
composition, forms, and light and dark—using
(printer's) ink or asphaltum for the outlines and
shadows. This general system, he remarks, is
evident from many unfinished works left by the
artist. The use of lampblack is to be recognised,
not only in the outlines of some of his pictures
(as, for example, in the St. Bernard), but in the
shadows of some of his finished works, where it
has not unfrequently done mischief: the use of as-
phaltum was, it seems, no less common. The chief
objection of the moderns to this pigment—its ten-
dency to crack—was counteracted, at least for a con-
siderable time, by using it with the oil varnishes. It
is also consistent with the habits of the early painters
to suppose that it was first thoroughly washed,
after being well ground, so as to free it from greasy
particles, and thus to render it more drying. Still,
as its tendency to crack and blacken was not quite
overcome, the corroded appearance of the darks in
many pictures of the sixteenth century of various
schools, is no doubt partly to be attributed to its
use. The S. Vincenzo of Fra Bartolommeo was,
according to Vasari, cracked in all directions in his
time, and, unless the picture had been exposed to
the sun's rays in its original situation, this effect
may have been accelerated by the use of the colour
in question.

The Frate's habit of studying the chiaroscuro of

his compositions, independently of the effect of colours, led him occasionally to complete works in this style. A picture of St. George and the Dragon, and a head of Christ, are enumerated among his productions in chiaroscuro, and to this practice the force and delicacy of his gradations are partly to be attributed. Fra Bartolommeo, observes Vasari, was in the habit of working from nature, and in order to copy draperies, armour, and articles of dress, he made use of a wooden lay figure the size of life, contrived, like those now in use, to bend at the joints. From the manner in which the biographer speaks of this circumstance, and from his having, as he informs us, possessed himself of the identical wormeaten mannequin as a memorial of the painter, it would appear that the Frate was the inventor of this useful auxiliary. Later writers, and among them Baldinucci, have accordingly assumed this to be the case. It seems that the artist was also accustomed to use clay models, probably in order to study the effects of light and shade in groups.

We now proceed to consider Mariotto Albertinelli, the early friend and companion of Fra Bartolommeo, whose studies were directed to the same outward qualities in painting, though they were not always informed by so pure a feeling. The circumstances which induced the Frate to become

a monk had the effect of driving Mariotto into the
world and into opposite habits, while his attach-
ment to his art chiefly showed itself in the pursuit
of technical methods to attain perfection in relief—
a taste which had been introduced, together with
better things, by Leonardo da Vinci.

It will not be necessary to follow the practice of
this painter so closely as that of Fra Bartolommeo,
since the technical qualities are nearly the same.
The masterwork of Mariotto—the Visitation, in the
gallery of the Uffizj—has the outward peculiarities
that have been noticed in the works of the Frate.
The flesh is thinly painted in comparison with the
darks, as is evident from the appearance of the
head of Elizabeth, surrounded by the thicker blue
drapery of the Virgin. All the darks are raised and
have suffered much, but the cracks and inequalities
have been here and there filled up by the restorer.
The altar-piece formerly at S. Trinità at Florence,
and now in the Louvre, representing the Madonna
and Child with St. Jerome and St. Zenobius, has
the same peculiarities: the flesh is embedded and
the darks are substantial with vehicle; it has the
date 1506. In this picture, as in the works of the
Frate and others of the time, the red (lake) drapery
has less body than the blue and green, except in
the shadows—an indication, perhaps, that a durable
colour was used, which did not require to be so
effectually "locked up" as the " azurro della Magna,"
" giallo santo," and other tints. The Assumption,
formerly in the Casa Acciauoli at Florence, is now

in the Berlin Gallery. Lanzi* attributes the lower
part of this work (consisting of various saints) to
Mariotto, and the upper part to the Frate; Dr.
Waagen reverses the masters, and his judgment is
probably correct.† If the upper part is by Mariotto,
the thinness of the flesh exceeds even his ordinary
want of substance; the darks, on the contrary, are
thick with vehicle. The same general characteristics
are observable in the lower portion, and it is only
by a comparison of the two works in other qualities
that the respective masters are to be recognised.

Vasari is sufficiently clear in his explanation of
Mariotto's efforts to secure relief, although the
present appearance of the painter's works, from the
effects of time, does not always correspond with the
biographer's description of their merits. This is
the case with the picture of the Annunciation,
painted for the Compagnia di S. Zanobi, and now
in the Florentine Academy. It is a forcible and
expressive work, and has the usual characteristics
of the master, but it can hardly be regarded as an
illustration of the principles and objects which, if
Vasari be correct, the artist had in view. Mariotto,
he informs us, worked on this picture in the place
which it was to occupy, and had even contrived
additional windows so as to regulate the light for
the upper portions. " He was of opinion," con-

* Storia pittorica d' Italia. Epoca seconda, p. 129.
† See Catalogue of Berlin Gallery.

tinues the biographer, " that such pictures were
only to be valued which combine force and relief
with tenderness (in the shadows). He was aware
that relief could only be attained by shadow, while
at the same time, if the obscurity be too great, in-
distinctness is the necessary consequence. On the
other hand, if the tenderness be indiscriminate,
relief is sacrificed. His object, therefore, was to
unite with delicacy of shade a certain system of
effect, which, he considered, had not before been
attempted. An opportunity seemed to present
itself in this work, on which he bestowed infinite
study. This is apparent in the figure of the
Almighty and in some infant angels, which are
strongly relieved against a dark background, con-
sisting of the perspective of a waggon roof, the
arches of which, duly diminishing, recede so as to
produce illusion. There are also some angels in
the air, scattering flowers. This work was painted
and repainted by Mariotto before he could satisfy
himself; he changed the effect repeatedly, now
making it lighter, now daiker, sometimes increas-
ing, and again reducing the vivacity of the tints.
He was fastidious to the last, feeling that his
hand could not realise his intention. He would
willingly have found a white more brilliant than
white lead, and therefore tried to purify the colour,
in order to add still brighter lights to the illumined
portions." Compelled to content himself in the
end, his work was highly extolled by the artists of

the day, and when a difference arose between him and his employers respecting the remuneration, the case was referred to Pietro Perugino, then aged, Ridolfo Ghirlandajo, and Francesco Granacci, who pronounced a satisfactory decision.

The opinion of Mariotto that the desired union of force and delicacy had not been sufficiently attained by preceding painters, may have been directed, and not unjustly, against the darker works of Leonardo da Vinci. The judicious system which he proposed, whether really his, or supposed to be so by Vasari, cannot, however, be said to have been fully exemplified till the best Venetian painters solved the difficulty. The principle is admirably explained by Zanetti, not only in describing Titian's colouring, but in other parts of his work. The example which best illustrates the (assumed) aim of Mariotto is perhaps Pordenone. Zanetti observes that one of that great painter's peculiarities was his love of foreshortening, the results of which, like those of perspective generally, tend to get rid of the flat surface; another peculiarity was to employ half-shadows chiefly in the flesh, with a very sparing proportion of extreme darks, reserving greater force in large masses for the background of the figures; or, when the (draped) figures admitted of dark masses, relieving them by an expanse of light in the background. The system of breadth of light relieved on breadth of shade was aimed at by Mariotto in the upper part of the Annunciation;

the opposite principle is more successfully carried
out in the Visitation. The addition of the effects
of perspective in the background of the Annuncia-
tion is analogous to that love of foreshortening
which all these painters have exhibited whose at-
tention has been especially directed to the study of
gradation.

To some it may appear that the above compari-
son between the efforts of a Florentine and the best
Venetian practice is inadmissible; and assuredly it
would have occurred to none to hint at such a com-
parison, but for Vasari's remarks. But the his-
tory of art, at all times, is full of examples of a
clearly understood principle failing in its effect
from not being carried far enough, and from not
being assisted by such other executive means as
can convey the intended impression distinctly and
powerfully to the eye. It is for this reason that
the best theories of art, and the best descriptions of
methods, can never convey their full meaning so
as to be available with certainty in practice. The
same words may be applicable to very different
degrees of the effect proposed—to degrees so im-
perfect and so little expressive of the intention, ex-
cept to the imagination of the artist, that the result
may, to his astonishment, be criticised for a want
of the very qualities to which his attention may
seem to himself to have been especially directed.
This shows the great use (amidst some unavoidable
evils) of modern exhibitions: they may be said

to supply the place of that competition in churches and public buildings from which the painters of Italy reaped so much advantage. They had the additional advantage of first displaying their works to the public in the situations they were ultimately to occupy, and of studying their effect under such circumstances accordingly. While a work of art is seen alone, aided perhaps by the descriptions of the artist and his eulogists, every merit, in some unassignable degree, may be ascribed to it. It is the same with schools and periods while they are studied apart. It is quite conceivable that the Annunciation of Mariotto and a masterwork by Titian, considered solely with regard to the relief attained on the above principles, and avoiding allusions to the peculiarities of the masters, might be described in the same terms; so powerless is language to represent the relations of light and colour —to represent proportion.

Of the other early Florentine oil painters— Ridolfo Ghirlandajo, Granacci, Bugiardini, and their contemporaries or immediate followers—none were so uniformly thin in the flesh tints as the Frate and Mariotto, although in their works generally the darks are more prominent than the lights. In Ridolfo's funeral of St. Zenobius, in the Uffizj, the flesh has a moderate substance, while the darks, and especially the blues, are thick with vehicle. In the other picture, in which the saint raises a

dead boy to life, the same peculiarities are observable: the thickness of the greens is especially visible. Granacci's technical manner may be traced in the two pictures of angels in the Florentine Academy, though these are now in a ruined condition, and badly restored: the darks are cracked and corroded throughout, but it is evident that they had the usual prominence as compared with the flesh. His picture in the Uffizj of the Madonna dropping her girdle to St. Thomas is also in a very injured state, and is placed too high to admit of accurate inspection; the details that are visible confirm, however, the above general statement. A Madonna attributed to him in the Pitti Gallery agrees in the same qualities; the flesh has a good body, but is, still, less raised than the darks. A Madonna by Bugiardini resembles it in the comparative solidity of the flesh. Several of these painters and their companions studied for a time either with the Frate or with Mariotto Albertinelli, yet the extreme thinness in the flesh tints which those painters' works exhibit does not often occur in the same degree.

———

Andrea del Sarto (1478–1530) first appears as an oil painter in company with Franciabigio, a scholar of Mariotto. The two artists worked for a time together, both gradually adopting a somewhat more solid texture in the flesh than the works of Albertinelli exhibited. In less finished paintings

by Andrea the transparent system prevails; for example, in some small but well-designed pictures from the history of Joseph, originally painted on some furniture for Pier Francesco Borgherini, two of which are in the Pitti Gallery, and three, apparently from the same series, at Panshanger.* In all these the system of the early Florentine oil painters of the Peruginesque school (as distinguished from that of Leonardo, Lorenzo di Credi, and Raphael in his later works) is clearly exemplified: the flesh is thin, the darks all prominent, the blues and greens most protected with vehicle, the lakes less so, except in shadows. Part of the

* The history of these pictures is as follows:—Four painters, Andrea del Sarto, Ubertini, called Il Bachiacca, Francesco Granacci, and Pontormo, were employed to ornament the wedding-chamber of a young couple (Pier Francesco Borgherini and Margherita Acciauoli) with pictures adapted to the *cassoni* and other furniture. The history of Joseph was chosen as the subject. At the siege of Florence (1529), when the citizens hastened to propitiate Francis I., Pier Francesco retired to Lucca, leaving his wife in the house. During his absence the Gonfaloniere and Council decided that the pictures of the Borgherini wedding-chamber would be an acceptable present to the King of France. A certain Giovan Battista della Palla, who had already prepared other peace-offerings for the enemy, was foremost in desiring to add these pictures to the number, and undertook to obtain them from the lady. His reception by Margherita, who responded to his errand by the "maggior villania che mai fusse detta ad altro uomo," will be found in Vasari's *Life of Pontormo*, vol. ii. p. 821. The fate of the pictures by Il Bachiacca and Granacci is not known. For other allusions to these works see Vasari, vol. i. pp. 572, 670-672.

series was painted by Granacci and others; two by
Pontormo are in the gallery of the Uffizj. Such
works were probably executed " alla prima," but
Andrea soon adopted the system of preparing his
pictures with a dead colour : an unfinished painting
by him in the Guadagni Palace at Florence exhibits
his process ; the subject is the Adoration of the
Magi ; the black outline, drawn apparently with a
reed pen on a light (perhaps originally white)
ground, is seen everywhere, but the features and
minuter forms are not defined, and sometimes are
very roughly indicated. The sky and background
only are finished ; the flesh, draperies, and adjuncts
are all true in tone, although laid in with so little
colour. This exemplifies the process, consisting of
several operations, which Vasari (in speaking of
some damaged pictures by Perugino) assumes to
have been common to all oil painters, but which
perhaps was first reduced to a system by Andrea,
with whom Vasari himself for a time studied. The
method of covering a work repeatedly with more or
less of opaque colour would soon suggest the possi-
bility of corrections in the forms and composition.
In a Holy Family by Andrea, now in the Louvre,
a hand of St. Elizabeth has been introduced across
the arm of the youthful St. John after that figure
was completed, and, not having been painted with
sufficient body, now shows the shadow underneath
it, thus reducing the superadded flesh tint in that
part to a grey. Andrea's method, though more

solid than that of the Peruginesque school gene-
rally, was not sufficiently so to permit his painting
light over dark without ultimate injury to the
brilliancy of his colour. That he could, however,
paint solidly when he pleased, the copy of Raphael's
Leo X. (which deceived Giulio Romano) may be
considered a sufficient proof.

This semi-solid system—a middle process be-
tween that exhibited in the substantial works of
Leonardo (such as the Mona Lisa) and of the
followers of Raphael, on the one hand, and the
transparent method of the Frate and those who
resembled him on the other—continued to charac-
terise the succeeding Florentine painters, till the
period of what is called the reformation of art in
Tuscany, by Cigoli, Jacopo da Empoli, Cristofano
Allori, and their contemporaries, who appear to have
aimed, to a certain extent, at the solidity of Cor-
reggio.* Less change is, however, apparent in the
treatment of the darks, which, in the works of the
later painters, are often remarkable for a profusion
of vehicle; but rather, it would appear, with a view
to preserve certain colours than, as at first, to give
depth to the intenser shadows.

On the whole, it appears that Perugino, Fra
Bartolommeo, and Mariotto Albertinelli carried the
transparent system in the lights farther than the
early Flemish oil painters, while they retained, and

* See Lanzi, Storia pittorica d' Italia, pp. 189-90.

sometimes exaggerated the use of rich and lucid
vehicles in the darks. If this latter practice on the
part of the Italians may be accounted for by the
increased dimensions of their works, as compared
with those of the Northern districts, it must still
be obvious that the light portions in their pictures
might, on the same principle, have been more sub-
stantial. It may be a question, as before remarked,
whether the greater apparent solidity of the flesh
tints and illumined parts in the works of the Van
Eycks, and some of their scholars, may not have
been the consequence of using a firmer vehicle,
which has prevented the white lead from becoming
transparent : from whatever cause, those painters
are certainly more solid than the Italians above
named. It is also worthy of notice that the produc-
tions of some later Flemish painters (for example,
Lucas Van Leyden and his contemporaries) have
less body than those of their predecessors, and this
is not improbably to be attributed, directly or indi-
rectly, to a Florentine influence. At a still later
period the rich and transparent shadows of Rubens
were, as some have conjectured, derived from the
manner of Fra Bartolommeo.* The followers of
Raphael carried with them throughout Italy, some-
times to the Netherlands, the more solid system,
and the example of Leonardo was the means of

* It has been seen that the author repudiates the tradition
regarding a particular work by Fra Bartolommeo, which Rubens
was supposed to have seen at Vienna. See p. 187, note.—*Ed.*

establishing it in Lombardy. The early Sienese oil painters fluctuated for a time between the Peruginesque and the opposite method, but, on the whole, inclined to the latter.

Having noticed the points on which the practice of Fra Bartolommeo and his followers differed from that of Leonardo da Vinci, it remains to speak of those qualities which were common to the two masters. Among the technical methods and peculiarities which the Frate adopted from Leonardo, as distinguished from the Flemish method, we first find that he laid in the shadows with the brush on the ground instead of hatching them: the use of a yellowish ground, perhaps suggested by the occasional practice of Leonardo, has been already noticed. In more important particulars the improvement attempted, rather than attained, by the Frate was a transparent system opposed to the solid purplish lights, and often inky shadows, of Leonardo in his carnations. The depth and brilliancy which Fra Bartolommeo sometimes attained in this way (exemplified by the picture at Panshanger) approach, however, a glassy unsubstantial appearance, when such specimens are contrasted with more solidly painted works. The Annunciation of Mariotto Albertinelli, before mentioned, is, with all its force, a remarkable example of the defect here alluded to. The succeeding painters of Tuscany corrected this thinness in the lights imperfectly, without retaining the extreme force and

richness in the shades which characterise the Frate. Another quality which was adopted from Leonardo, and of which the Florentines were especially enamoured, was the 'sfumato' system — the imperceptible softening of the transitions in half-tints and shadows. The want of substance which long characterised the school is ill adapted for this softness in the passages from light to shade. The 'sfumato' applied to a thin preparation seems to add to the glassiness and poverty of the surface, and gives a look both of labour and incompleteness. It is more agreeable in small works, where a moderate thinness may assist the delicacy of the execution. A picture by Ubertini, called il Bachiacca, once in the gallery at Dresden, and now in that of Berlin, is a good example of the Florentine 'sfumato' on a small scale.*

On the whole, it must appear that the method of the Frate, though recommended by extreme force and transparency, as well as by a noble style, had an unfortunate influence on the Florentine school as regards one important quality—solidity. It was in fact a retrograde step as compared with the Van Eycks, and was the means of introducing an

* This is one of two pictures painted originally for Giovanni Maria Benintendi of Florence, and afterwards sold to the Elector of Saxony. See last Florentine edition of Vasari, (1832–38), Vita di Franciabigio, vol. i. p. 627, notes 15 and 16 ; Vita di Bastiano di S. Gallo, vol. ii. pp. 868–9 ; see also vol. i. p. 427, note 62.

executive imperfection, which was never quite retrieved by the Tuscan painters. It suited a school of designers. The mode in which such a school would endeavour to compass the excellences of oil painting without sacrificing form would naturally be by a transparent tinting, in the application of which the outline was covered with reluctance, and in such a mode as always to be recovered. The terms employed to describe the operations of such a school have thus sometimes only a relative application as compared with their ordinary meaning. When, for example, Vasari says that Mariotto Albertinelli frequently altered the colouring and effect of his picture of the Annunciation before described, repainting it more than once, we are not to suppose that the result was a thickly painted picture—a reasonable conclusion in any other case —for the work (which exists to attest that it is not so) proves that these changes were made without destroying the characteristic thinness of the artist's execution. Such changes suppose that both lights and shadows were washed out with an essential oil, and again inserted on the ground, not that the work was loaded again and again, as in modern cases of *pentimenti*.*

* Sir Joshua Reynolds is reported to have said of his picture of the Infant Hercules, now at St. Petersburg, " There are several pictures under it, some better, some worse." The pictures of the colourists frequently tell the same tale, as their *pentimenti* come to light.

Hence the lesson which the more established Florentine practice teaches is, that while there may be no necessity for deviating from the original design—supposed to be decided in sketches and in the preparation—the powers of oil painting are but half displayed unless the preparation be either immediately or gradually wrought up to solidity. The gradual mode of attaining substance, on Leonardo's most finished system, considered irrespectively of his colouring, is undoubtedly the safest, as it admits of correcting the forms; but it is by no means assumed that even this practice can ever supersede the necessity of enriching operations at last. There have been no colourists, painting the size of nature, without solidity in the lights.

CHAP. V.

CORREGGIO.

HITHERTO the progress and vicissitudes of oil painting in the hands of individual masters have been partly traceable to distinct influences, and have not failed of due illustration by a reference to existing works in their chronological order; but we have now to examine the technical style of a painter of the highest rank—Antonio Allegri da Correggio—whose early history and education are wrapt in obscurity, and whose authentic productions cannot, in the majority of cases, be referred with certainty to dates. An easy explanation of the originality and excellence of this painter might be found in his transcendent genius; yet, could we follow his steps from the commencement of his career, we should probably find in his case, as in Raphael's, that he at first adopted much from others, and that his style received a bias from circumstances of time and place as yet imperfectly known to us.

The best life of Correggio is that by Pungileoni :*
though needlessly diffuse, and written in a con-
fused and desultory style, the more important state-
ments it contains are supported by documentary
evidence, and the author shows no disposition to
adopt without examination the vague stories of
former biographers. Many of these stories, though
not supported by sufficient authority, need not be
rejected merely on account of their improbability;
but it may be observed, once for all, that Vasari's
remarks on the artist's poverty, and the absurd
account of his death in consequence of carrying a
load of copper money from Parma to Correggio,
have not the remotest foundation beyond the mere
assertion of that writer, while they are contradicted
by the clearest facts. The great painter, though
not wealthy, was in easy circumstances, and was
sufficiently well paid, as appears by existing con-
tracts and receipts, for the works he undertook. The
works themselves—among others, the cupolas of
two churches—would not have been confided to an
indigent professor; and, as Lanzi † and others justly
remark, the artist himself spared no time, study, or
expense in the execution of the important com-
missions he received, and grudged no outlay in
the materials of his pictures. Documents further
prove that purchases of land were the result of his

* Memorie istoriche di Antonio Allegri. 1818.
† Storia pittorica d' Italia, vol. iv. pp. 55–57.

increasing fortune, and that his family inherited from him a considerable property.

Enough has been therefore ascertained to prove the worldly prosperity, the public estimation, and the liberal spirit of Correggio: what is wanted is a more accurate knowledge of his professional career, especially at its commencement. The zeal with which the history of art at any given period is investigated necessarily depends on the interest with which the productions of that period are regarded : none will regret that the activity of modern research has hitherto been directed to the early Italian and Flemish schools, since the facts arrived at form, in every view, a proper foundation for further enquiry. But it is to be feared, from the almost exclusive predilection for those schools on the part of writers the most competent to treat such subjects, that the history of the great painters of Venice and Parma is not likely to be undertaken with equal love. The aim of Correggio, especially, is so opposite, in many respects, to the spirit of the fifteenth century; his peculiarities find so little favour at present with the admirers of that tendency and of its consummation in the best works of Raphael, that we cannot as yet look for an investigation of his life and progress in art at their hands.

A critic of the last century—Raphael Mengs— to whom we are indebted for a careful analysis, at least, of the great artist's external qualities, is not

unjustly looked upon by his own countrymen as the latest important representative of that effete imitation of the old masters and of the antique statues which the modern German school, at its commencement, especially sought to avoid. While Mengs devoted his life to the study and illustration of his favourite painter's works, a representative of the new German tendency dates the moral decline of art from " the effeminate Correggio :" the epithet must, however, be understood to relate to the taste rather than the practice of a great painter whose colossal foreshortenings on a curved surface in fresco, might have excited the wonder of Michael Angelo himself. The judgment, of which the above is a specimen, is partly the consequence of the exclusive admiration with which even the peculiarities of the great artist were regarded in the last century; for it is to be remarked that while the writers of that period enlarge on the technical merits of Correggio, they scarcely allude to the total change which his altar-pieces exhibit, as compared, in their impression on the mind, with the similar works of earlier masters. Mengs, Reynolds, and others, in the midst of enlightened criticism on the qualities of the mere painter, and while extolling his playful grace, have little to say on the absence of all solemnity, all devotional feeling, from his church pictures, in which, except where the subject is essentially pathetic, a joyous and even humorous feeling may be said to prevail.

The most extraordinary instance of the trivial and childish treatment of a sacred subject, as regards invention and composition, is perhaps the St. Sebastian at Dresden, in which the actions of some of the infant angels and of other figures border, and intentionally so, on the ridiculous. This playful feeling, though still utterly unfit for an altar-piece, is kept within more discreet limits in the St. Jerome at Parma and the St. George at Dresden; but even in these the misapplied conceits, graceful as they sometimes are, and safe from caricature by the accompaniment of beauty, would be felt to be irreverent on a comparison of such works with corresponding subjects by Raphael, Lorenzo di Credi, and many an earlier painter.

Correggio's power of seeing and rendering certain qualities in nature which constitute the essence of painting as an art, also interfered, to a certain extent, with the customary forms of representation. Painting, in its infancy, aimed only at intelligible appearances on a flat surface; and, in afterwards recognising the importance of grand lines and masses, still kept those lines and masses in a great measure parallel with the plane of the picture. For colossal works, intended to be seen at a distance, and under circumstances which do not admit of the discrimination of the delicate varieties of light and shade, this flatter treatment is probably the best, since it must, under such circumstances, be the most easily intelligible; but when the distance at which

the work is to be viewed admits of a full perception of the finer gradations of light, then the qualities in which Correggio excelled come legitimately into operation—legitimately at least in reference to such physical conditions; and it would be difficult to suppose that a painter possessed of the requisite skill would, from a regard to certain questionable principles, exercise such self-denial as to suppress the resources of art which he felt to be at his command. The qualities here alluded to are, however, many of them, opposed to the real and permanent attributes which the earlier painters aimed at: they consist in foreshortening, a term commonly restricted to figures; in the alteration of forms generally by perspective; in depth, or the representation of space; and in gradations of light as well as of magnitude. All these directly tend to get rid of the flat surface, and are, consequently, characteristic excellences of the art of painting. Accordingly, in Correggio's system, figures are generally placed at some angle with the plane of the picture, and are seldom quite parallel with it; the consequence is that his masses of light are often composed of many objects. This has been called a broken assemblage of shapes, and, if reduced to outline, it would sometimes undoubtedly appear so, the objects being (to use an exaggerated expression for the sake of clearness) placed *endwise* towards the spectator; but when connected by a magic harmony of light and shade, the result, far from being

scattered, is "a plenitude of effect" seldom to be found in other painters, and more satisfactory than when that mass is cheaply attained by broad flat surfaces. But this picturesque style of composition is ill adapted to the solemn repose which devotional subjects require, especially as Correggio is seldom happy in the arrangement and forms of his drapery; while, as regards the application of chiaroscuro (as he used it) to such subjects, it must again be evident that the charm thus imparted, and without which his composition would have appeared incomplete and unsatisfactory, was sometimes calculated to supersede the consideration of the subject as such, and to become itself the chief source of interest.

The censure of the modern critics before referred to is more especially and justly directed against Correggio's selection and treatment of certain mythological subjects, such as the fables of Leda, Danae, and Io. The effect of soft and harmonious transitions of light and shade—a characteristic excellence of the master—is of itself allied to the voluptuous: the principle was oftener applied by Correggio to subjects of pathos and solemnity; these, assisted by the soothing spell of his chiaroscuro and by forms of beauty, excite a calm and pleasing impression, by no means foreign to the end proposed; but the application was, unfortunately, not less successful when he united beauty and mystery in subjects addressed to very different feelings. Yet, although it may be admitted that the tendency of

Correggio's feeling and fancy, as well as the fascina-
tion of his light and shade, found, as it were, a
natural application in subjects of the above descrip-
tion, it ought not to be supposed that he alone,
among his contemporaries, ventured on such themes.
The taste was encouraged by the age; nor were the
painters of severer schools free from the infection,
though their designs wanted the dangerous attrac-
tion which Correggio's style could impart.

In the application of (fresco) painting to archi-
tecture, the practice of Correggio differed again
widely from that of preceding masters: his inno-
vations in this department may be exemplified by
comparing his cupolas with the ceiling of the
Sistine Chapel by Michael Angelo. That great
painter, though a master of foreshortening, has not,
in the instance referred to, supposed his figures to
be *above* the eye, but *opposite* to it, so that they
are still intelligible when seen in any other situa-
tion, as, for example, in an engraving; Correggio,
on the other hand, in his cupolas, always aimed at
producing the perspective appearance of figures
above the eye; and the violent foreshortening
which is the consequence renders his figures un-
satisfactory except in their original situation and
when seen from below, where their effect must at
first have been marvellous. Mengs himself was
astonished at their apparent distortion when he in-
spected them near. Yet we have reason to believe
that, when aided by light and shade, and in their

uninjured state, their effect was precisely what the painter intended. But, after all, if the object of art be to meet the impressions of nature by corresponding representation, it is evident that foreshortening on ceilings or cupolas, as it necessarily presents the human figure and all objects in a mode absolutely foreign to our experience, must more or less depart from the plain end of imitation, and can only excite wonder at the artist's skill. It remains to observe that the foreshortenings which Correggio has introduced in his cupolas are, in most cases, incompatible with all but a general expression in the features, as the heads are almost always represented as if seen from below. All nobler objects were thus overlooked in the pursuit of a favourite excellence, and Correggio ever sought the attributes of perspective as opposed to qualities of the mere surface: his management of all the elements of gradation, by which he secured space and depth, is (thus) less allied to that perspicuity of representation which distinguishes the formative arts from poetry, than to the specific excellences which distinguish painting from sculpture. To pierce in appearance the surface of a cupola with ascending figures, notwithstanding the amazing difficulty of the undertaking, was an enterprise quite to his taste.

In such attempts to express space no attention was paid to the form of the architecture; the dome was apparently annihilated, and the real and unreal were confounded. In the subsequent abuse of this

system the architectural forms were sometimes literally altered, as in the ceiling of the Jesuits' Church in Rome, where clouds and figures descend here and there below the real cornice, and appear to cast their shadows across it: a surface adapted for painting being inserted in place of the actual entablature where it is supposed to be covered with clouds. The absurdity of such caprices requires no comment; but where the actual mouldings are not interfered with it seems at first a more doubtful question whether the painter has not a right to give the same idea of extent upwards as he aims at in all pictures in the horizontal sense. It appears, however, from the example of Michael Angelo and Raphael, that those masters considered painting on walls and ceilings wholly subservient to the architecture; they seem, at all events, to have considered that no attempt should be made to deceive the spectator respecting surfaces which it may be the architect's purpose to preserve, either for the unity of his design or as essential to construction.

It has been seen that Correggio, in his frescoes, far from sacrificing his favourite qualities in order to make forms more intelligible at that distance from which they were chiefly to be viewed, seized the opportunity of attempting the most daring foreshortenings—such as, indeed, never occur in his oil pictures, where, with every aid from completeness of execution and the power on the part of the spec-

tator of selecting the best point of view and the fittest light, perspective appearances in general might be more clearly expressed. The obvious precaution of greatly enlarging the dimensions of his figures in the cupolas was, however, duly observed, and it must be admitted that, in this respect, he calculated the proportions for the distance better than Michael Angelo, who, in the ceiling of the Sistine Chapel, began his compositions on too small a scale. As regards colour, Correggio seems to have fully comprehended the style fit for pictures requiring to be viewed chiefly from a distance. The peculiarity of his frescoes in this particular, as distinguished from his oil pictures, is the extreme warmth of the shadows in the flesh: the effect of this, as seen from below, is quite satisfactory, although the exaggeration is found to be violent on near inspection. The cooling effect of interposed atmosphere reduces the excessive warmth to the truth of nature, and prevents the opaque and leaden effect which would otherwise be the result. On the colour of Correggio's frescoes Wilkie thus expresses himself:—" Here, I observe, hot shadows prevail: this he has to a fault, making parts of his figures look like red chalk drawings, but the sunny and dazzling effect of the whole may be attributed to this artifice." Again:—" This great work of Correggio (the cupola of the cathedral) has all the harmonious colour of his oil pictures, but is notwithstanding conducted upon a plan quite different

—lightness and freshness being the leading principles. . . . The flesh tint, though never warmer than nature in the lights, is in the shadows hot to foxiness, giving much of it the appearance of a red chalk drawing. The effect of the whole is, however, extremely varied by different coloured lights and shadows, producing the utmost zest and harmony, and, in point of colour, the most rich and beautiful fresco I have seen."

In this treatment of fresco, considered with reference to the important department of colour, Correggio, probably without having seen any similar examples, adopted the same principle which other great painters found, under such conditions, to be indispensable. The remains of Giorgione's works of the kind, the frescoes of Titian and Pordenone, more especially when in the open air, Raphael's Mass of Bolsena, as well as oil pictures by the Venetians and by Rubens, originally intended to be viewed from some distance, are remarkable for this warmth in the shadows. Indeed, in comparing Correggio with these masters, it will be found that while he ventured to the utmost limits in the warmth of shadows in fresco, he is in oil pictures much more neutral and negative in his shadows than the great Flemish and Venetian masters.

It will be unnecessary to dwell on other qualities which can be better exemplified in describing the great painter's practice in oil painting, and which evince the most comprehensive view both of the

appearances of nature and of the modes of attaining their equivalents in art.

Antonio Allegri was born at Correggio, a town afterwards comprehended in the Duchy of Modena, in 1494; he died at the age of forty, thus resembling Raphael and Giorgione in the shortness of his career no less than in the extent of his fame. Little is known of the state of painting in Parma and its neighbourhood at the beginning of the sixteenth century. The influence of Francia, by means of his scholar Lodovico da Parma, and of Bellini by means of Cristoforo Caselli, are slender evidences of the style that may have prevailed there. Correggio is supposed to have learned the rudiments of his art from his uncle Lorenzo Allegri, and from Antonio Bartoletti. If Vedriani is correct in saying that he studied under Francesco Bianchi, called Il Frari, at Modena, this could only have been for a short period, as that painter died in 1510 after a lingering illness, when the scholar was but sixteen years old. A picture by Francesco Bianchi, representing the Virgin and Child enthroned, St. Benedict, St. Quentin, and two angels, is in the gallery of the Louvre; in the general arrangement and in some particulars, even to the coloured bas-relief on the throne, this example has certainly a striking resemblance to an early work by Correggio—the St. Francis in the gallery at Dresden; in execution, however, it has little in common with the style of the great painter except

in the softness of the gradations. In other respects
it has the characteristics of most oil pictures of the
period; the flesh is thinly painted, while the surface
of the darks—of those in the blue drapery particu-
larly—is comparatively raised.

In 1511, in consequence of a plague, Manfredo,
then Lord of Correggio, removed for a time to
Mantua; and there is good reason to suppose that
the young painter, then seventeen years of age,
took refuge in that city from the same cause, pro-
bably accompanying the court. Of the supposed
journeys of Correggio to various parts of Italy,
none can be more safely assumed than his visit to
Mantua. The communication between the cities
of Lombardy, on each side the level course of the
Po, presented indeed no difficulty; but the inter-
vening Apennines are perhaps to be regarded
among the obstructions which, added to political
jealousies, may then have rendered a journey to
Florence somewhat formidable. At all events,
there is no evidence to show that Correggio was
ever in Tuscany, still less that he made a pilgrimage
to Rome. Had he even proceeded so far as Lucca,
he might there have seen works by Fra Barto-
lommeo—two of which were painted in 1509—and
in that case the sight of these pictures, remarkable
as they are, both for force and for delicacy of light
and shade, might not unreasonably have been sup-
posed to have influenced in some respect the style
of Correggio. The great painter's presence in
Bologna rests on an apocryphal story first promul

gated, it seems, by Padre Resta. Correggio is here represented as standing before Raphael's St. Cecilia, the fame of which rendered it an acknowledged type of excellence; but the conclusion which it forced on the mind of the painter of the " Notte " is said to have found utterance in the words, " Son pittore anch' io."

The supposition that Milan was among the places Correggio visited receives some support from the connection which is to be traced between the works of Leonardo and his own. That connection, more or less distinct, but never very positive, consists in a sweetness of expression, in the love of roundness, in softness of transitions, in solidity of surface, and in the use of certain materials. But, as before observed, it is in Mantua that we must look for the most unquestionable sources of those influences which may have contributed to form the style of Correggio.

The works of Andrea Mantegna, from the originality of power which they displayed, and from the great reputation of the master, must there have made a strong impression on the mind of a young artist seeing them for the first time. The historians of art have traced a resemblance between the earliest altar-piece of Correggio — the St. Francis now at Dresden, and the Madonna della Vittoria by Mantegna,—particularly in the action and drapery of the Madonna, to which we shall presently allude; but the quality which was likely to attract the young painter most, and which

he could see nowhere carried so far, was that of foreshortening on ceilings. Andrea Mantegna died in 1506 ;* consequently, it must have been from his works, and not from his personal instruction, as some have supposed, that Correggio could have derived any improvement. A room in the " Castello " at Mantua, called the " Camera dei Sposi," and which still exists, was completed by Mantegna as early as 1474;† the ceiling of this room is a remarkable example of that species of foreshortening, before described, in which the objects and figures are represented as if seen from below, or " di sotto in sù." Round a supposed open space in the centre of the ceiling, through which the blue sky appears, a balustrade is painted, over which Genii look down into the room; the whole being foreshortened as objects would be if really so placed.

The only other work of this kind which, as far as we know, had then appeared in Italy, was a fresco of the Ascension of Christ in the semi-dome of the tribune in the church of the SS. Apostoli in Rome (now in the Quirinal), by Melozzo da Forlì,

* This appears from a letter to the Marchese Francesco Gonzaga, written September 5, 1506, by a son of Mantegna, announcing the death of the great painter as having taken place on the previous Sunday. See *Memorie biografiche dei Pittori, Scultori, Architetti e Incisori Mantovani, del fu Dottore Pasquale-Coddi*, p. 102. The letter is given in appendix.

† See Ib., inscription in the Camera dei Sposi, by Mantegna, p. 101.

originally a fellow-scholar of Mantegna with Squarcione at Padua. Melozzo's work is supposed, on good grounds, to have been executed about 1472; it could therefore hardly have been earlier than the ceiling of Mantegna, which, as it required to be finished before the walls were painted, may well be supposed to have been executed a year or two before 1474—the date of the completion of the whole room. The "sposi" from whom this room received its name were Lodovico Gonzaga and Barbara of Brandenburgh, daughter of the Elector John I. A lady of the same family, Frances of Brandenburgh, the wife of Borso, Count of Correggio, built a palace in 1506 at Correggio.* The rooms were decorated by a painter whose name has not been preserved, and on the ceiling of one of them was repeated, though in a far less skilful manner, the foreshortened design of Andrea Mantegna at Mantua. The sight of this ceiling, and still more that of the original, may have first awakened in Correggio the desire to attempt a similar work, and to this early impression the cupolas of Parma probably owed their existence.

Yet it does not appear that Correggio ever aimed at producing elaborate architectural effects of perspective. It was chiefly the foreshortening of the human figure which he sought to represent with

* See Pungileoni, Memorie istoriche di Antonio Allegri, 1818, vol. ii. pp. 30–31.

truth. To do this he must either have modelled
figures himself, in order to copy from them when
suspended above the eye, or he must have been as-
sisted by some sculptor. As an excellent modeller,
Antonio Begarelli of Modena, was at hand, and as
the tradition existed in the seventeenth century that
Correggio availed himself of that artist's skill for
the purpose in question, it may fairly be supposed
that such was the fact; nor is it any derogation,
as some writers have insisted, from the great
painter's genius, to assume that after having com-
pleted his design he would call in the assistance of
a sculptor to enable him to prepare clay models of
such figures as he could not possibly see, suspended
as was required, in nature. At all events, it is cer-
tain that Correggio could not have drawn some of
the figures in his cupolas except by the aid of
models prepared either by himself or by others.

Among the earliest works attributed to Correggio,
but of uncertain date, may be mentioned a picture
the Betrayal of Christ, in which the incident of the
young man escaping naked (Mark xiv. 52) is intro-
duced. Copies are sometimes met with, and two
exist with the obviously false dates of 1505 and
1506; the original appears to be lost.* A small
picture representing the Virgin and Child with St.
John, the authenticity of which had been attested,

* Opere di Mengs, p. 188, and note; and Lanzi, vol. iv.
p. 65

in the beginning of the present century by various professors of Parma, was sold in London, at Christie's, with the collection of the late General Sir John Murray, in 1851. The well-known and better authenticated sketch of the Muleteers, in the possession of the Duke of Sutherland, is also placed by most writers among the master's early productions; but, however slight, it betrays no want of experience or of freedom. The three pictures above noticed are supposed, perhaps erroneously, to have been executed before Correggio's visit to Mantua in 1511. His return to his native place is fixed in 1513, and the following year is the date of the St. Francis now at Dresden, as appears by the documents and accounts of expenses relating to it, published by Pungileoni. The undoubted authenticity of this work and its certain date render it a safe criterion for the earlier practice of the painter. It has a certain hardness in the outlines from which the two last pictures above named are exempt, proving that at the age of twenty Correggio had not attained that richness and plenitude of manner which, soon after, characterised his works.

With regard to the influence of particular painters or particular works to be traced in the St. Francis, it would be difficult to believe that Correggio had not somewhere seen examples of the expression of Leonardo da Vinci; the imitation of another master is still less questionable. It is evident

that the Madonna, though not the infant Christ, in this picture, dedicated to St. Francis, is taken directly from Andrea Mantegna's Madonna della Vittoria, an altar-piece which Correggio must have seen at Mantua. The coincidence is so complete, that it would alone suffice to prove the previous acquaintance of Correggio with the works of Andrea. In justice to the earlier master, it should be noted that the extended hand of the Madonna is more successful in his work than in that of Correggio. Setting aside this defect, the graceful, free, and picturesque treatment of hands for which Correggio was distinguished (occasionally carrying it to mannerism) is already apparent in its best form in the picture now under consideration; as, for example, in the hands of the St. Catherine, the hand of the St. John holding the cross, and the lower hand of the St. Francis. That tendency in Correggio to make the composition subservient to the expression of space is apparent even in this production, the arrangement of which might be called severe in comparison with his later works. The tendency referred to appears to have dictated a certain sway of the figures by which their parallelism with the plane of the picture is avoided, while the movements are agreeably contrasted with each other. The circumstance of the two infant angels above (two only are seen as entire figures) being nearly similar in action though in opposite views, may evidence the practice, common no doubt in the

school of Mantegna and his followers, of using clay models for similar foreshortenings.

If the St. Francis may be said to foreshadow the characteristics of the painter in the qualities hitherto considered, the resemblance is still more complete as regards the method of oil painting which it exhibits. It was probably in Mantua, during a residence of two years, that Correggio adopted that solid, full manner of painting which is more or less apparent in his earliest known works; the system of using a thick, rich vehicle for shadows was common, as we have seen, to most painters of the time, but the smooth solidity of his lights was new, and may be said still to remain peculiar to him. The technical conditions of this surface will be considered hereafter; its early adoption by Correggio may perhaps be traced to the method of some painters of the Mantuan school but little known, and with whom it may have been an accidental attribute. The remaining works of Leonbruno*, for example, sometimes exhibit a fulness of "impasto" which, if adopted sufficiently early (and he was five years older than Correggio), may have influenced the style of the master.

The flesh throughout the picture of St. Francis is smooth yet solid, nowhere so thin as to show an outline underneath, and nowhere hatched. The

* Notizie storiche spettanti la Vita e le Opere di Leonbruno, da Gir. Prandi. Mantova, 1825.

flow and fusion of the substance in the flesh tints, without apparent handling, indicates the use either of a half-resinified oil or of an oil varnish—probably the finest amber varnish of the Flemish masters. Where the vehicle abounds, for example, in lucid darks, as is generally the case in Correggio's works, the surface has frequently that blistered, roughened appearance so often before described as the effect of time on the "vernice liquida." To account for this, we must either suppose that the commoner vehicle (sandarac oil varnish) was used with the darks, or that a lavish use even of the amber varnish is subject to the same effects after a long lapse of time—effects consisting, apparently, in the gradual separation and desiccation of the oleaginous portion, and the concretion and agglomeration of the resinous particles. In the works of the Van Eycks and their immediate followers, the more moderate use of the oil varnish has had no worse consequences than to produce small, reticulated, uniform cracks, the substance of the vehicle having been too inconsiderable to cause the change above mentioned; but the large scale on which the Italian masters painted soon led to a copious employment of the oil varnish, and when we occasionally find the same change in the darks of Titian and of Rubens, we must either conclude that they all made use of the sandarac oil varnish in such portions, or that the firmer amber varnish, when so abundantly used, is liable to the same consequences.

To return to the St. Francis. In the masses of shade and in the darks generally in which the vehicle was abundantly used, the surface has now that rugged, more or less agglomerated appearance before alluded to, producing the very opposite effect to that intended by the painter: the effect is especially remarkable in the shadows of the grey dress of the St. Francis, and in those of the red drapery of the St. John; in the latter, especially in the shadow between the legs. The other peculiarities are such as we should expect from the use of the materials often before described; the blue drapery of the Madonna has the usual prominence, while the red is not more raised than the general surface; the flesh, as before remarked, is comparatively solid and smooth, and rarely exhibits cracks: the left foot of the St. Francis has, however, the fine and numerous cracks so often occurring in the works of Leonardo da Vinci. The picture is on wood.

It will now be desirable to take a rapid glance at the works of Correggio, as far as possible in their chronological order, indicating peculiarities of execution where they occur, but reserving any further remarks on his technical methods and materials till his principal works shall have been noticed.

A picture painted for a church at Carpi, and which has been confounded by Lanzi and others with the St. Francis, probably represented a Pietà,

being described as " Maria Vergine con Gesù Cristo nel grembo."

The portrait of a Physician in the Dresden Gallery belongs to the same period: reasons for supposing it to represent Giambattista Lombardi rather than any other person, are given by Pungileoni. Hirt remarks that it might pass for the work of a Venetian master, but for the peculiar solidity of the colour which distinguishes Correggio. Mengs also remarks that it has even more "impasto" than Giorgione. It is on wood, and is generally free from cracks. Lombardi was at once the physician, the friend, and the instructor of the artist; he was godfather to Correggio's first-born child in 1521. In the close intimacy which subsisted between them, he assisted the painter not only in his anatomical studies, but in such chemical researches as were calculated to aid him in the practice of oil painting.

A " Riposo," formerly in the church of the Franciscans at Correggio, representing the Virgin and Child, St. Francis and St. Joseph, has disappeared. The pretended original is in the tribune of the Uffizj at Florence ; but, notwithstanding some historical circumstances in its favour, it has not sufficient internal evidence to warrant its being classed among the genuine works of the master. Among other lost works may be named three pictures, originally forming an altar-piece in three

parts, representing a figure of the Almighty in the centre, on one side St. John the Baptist, on the other St. Bartholomew. The picture of Christ, seated on a rainbow, with some angels above, formerly in the Marescalchi Gallery at Bologna, is now in the Vatican; it is by many not considered genuine. A picture of the daughter of Herodias with the head of St. John, and another, a shepherd playing on a flute, are among the works of the master at present known only by copies.

The picture called S. Marta (more properly Margarita), containing figures of St. Peter, the Magdalen, and S. Leonardo, is now in the possession of Lord Ashburton. This work, attributed by high authorities to the master, has, with some evidences of inexperience, the solidity of the flesh peculiar to Correggio, but the dark shadows have no longer the transparency nor the superficial indications of a rich vehicle. This may be partly the result of its having been lined (if not transferred from wood to cloth)—a process which has always the effect of flattening and equalising the surface of the colour. The blue drapery of St. Peter has, however, the usual relative prominence, as may be seen in the portion above the yellow drapery. It seems that this picture was at one time, while at Correggio, purposely covered with a dark varnish to prevent its being taken away, and probably the removal of this, whenever the

operation took place, may have removed also some of the original surface, and may have rendered considerable retouchings necessary.

An altar-piece of the same quality and period was painted for a church in the village of Albinea, near Scandiano. The composition, to judge from an ordinary engraving, was but indifferent. The original cannot at present be traced; a copy by Boulanger was substituted for it in the seventeenth century.

Of Correggio's frescoes in the convent of S. Paolo at Parma, painted about 1518, it is unnecessary here to speak. A fresco of the Assumption of St. Benedict, painted about the same time on the ceiling of the dormitory of S. Giovanni, at Parma, is now known only from descriptions.

While on the subject of Correggio's frescoes, his more important works of that kind, though some were executed later, may be here enumerated. The cupola of the church of S. Giovanni at Parma represented the Ascension witnessed by the Apostles: the figures of the latter are colossal. In the tribune of the same church Correggio painted the Coronation of the Virgin amid an assembly of saints and angels. This latter work was destroyed in 1588, in order to enlarge the choir. The largest fragment which was saved—part of the main subject— is now preserved in the Library at Parma; other portions are sometimes to be met with in private collections. Before the demolition, portions were copied by the Carracci, and the two pictures of

groups of heads and portions of angels in the
National Gallery are probably by Annibale Car-
racci; other portions so copied are in the gallery
at Naples. The design of the whole fresco was
repainted in the tribune of the enlarged choir by
Cesare Aretusi, from a copy made by him in oil.
These frescoes in S. Giovanni were completed by
Correggio in or before 1524.* Vestiges of another
(fresco) representing some infants, in a garden
niche in the precincts of the Benedictine convent
in the same city (Parma), may still remain. Other
less important works in fresco attributed to this
period may be passed over. Some remains, re-
moved from their original places, are preserved in
the church of the Circumcision, and in the Academy
at Parma.†

In 1519, the marriage of his sister Catherine to
Vicenzo Mariani is supposed to have suggested the
picture of the Marriage of St. Catherine, now in
the Louvre, as a present to the bride. The small
picture of the same subject in the Naples Gallery

* The first payment on account of the cupola of the Duomo
at Parma is dated 1526. The work was suspended occasion-
ally, but was completed in 1531. The subject is the Assump-
tion of the Virgin. Both cupolas—that of the Duomo and
that of S. Giovanni, with other works of the master—are
engraved in an admirable manner by and under the direction
of the Cav. Toschi.

† For an account of some minor works in the church of
St. John Evangelist, over the door of the chapter-house, see
Pungileoni, pp. 145-146.

is different in composition, and was probably painted later; there is also in the same gallery a copy of the Louvre picture. That picture exhibits the perfectly formed technical manner of Correggio, while the peculiar golden tone of the flesh may indicate the use of a mellowing vehicle: the solidity of the surface is of the fullest kind, and the lights are almost free from cracks; the darks are comparatively raised, and in some few parts are slightly corroded in the manner so often described; the blue, both in the drapery and in the distance, is very prominent. The Naples picture has that shrivelled surface which indicates a profuse liquid medium, probably an oil varnish; the surface is also minutely cracked; the sky is more thickly painted than the flesh, and the blue drapery, now darkened, has the cracks which indicate the use of the " white varnish."

Some writers place the small picture of Christ in the Garden, now in the possession of the Duke of Wellington, about this period of the master's practice; if they are correct it is plain that, soon after the age of twenty-five—when the Marriage of St. Catherine may have been painted—he had attained the perfection of that taste in chiaroscuro which distinguishes his finest works. The use of an oil varnish, or of a copious vehicle of some kind, with the colour, is apparent in the shrivelled surface of the blue drapery.

In 1520, at the age of twenty-six, Correggio

married Girolama Merlini, and there appears no reason to doubt the common opinion, that, after the birth of his son Pomponio, in the following year, the picture of the mother with the sleeping child, called La Zingarella, in the Naples Gallery, that of the Virgin adoring the Child, in the Tribune at Florence, and, at a somewhat later period, that of the Virgin dressing the Child, in the National Gallery, may have been suggested by domestic scenes. The Zingarella appears, from some slightly injured portions of the picture, to have been painted on a light warm ground; the background is more thickly painted than the flesh; the light portions of the flesh are shrivelled, but the cracks are probably in the ground or priming. The intense blues and greens have the usual prominence of surface.*

The Madonna, with the infant lying before her, in the Tribune at Florence, with all its grace, borders so nearly on affectation and quaintness that it is doubted by some; in all technical respects it is worthy of the master. The substance is, as usual, considerable throughout; still the darks are thickest, and are more cracked than the lights. Mengs remarks that a " Noli me tangere,"

* Of this picture Wilkie says :—" The Virgin and Child with the Rabbit is a first-rate specimen. The white is of a rich cream colour, the flesh like Rembrandt's, the blue drapery toned into complete harmony, the green (some fresh colours) glazed into great depth, and the leaves of the trees behind the Virgin's head like the deepest emerald."

by Correggio (formerly in the Escurial, now in the
Madrid Gallery) is similar in style to this picture.
The Madonna dressing the Child, in the National
Gallery, is, as regards the painting, a perfect speci-
men of the master; in this instance again, although
the flesh is remarkably solid, the darks are still
more prominent. Mengs noticed several "penti-
menti" in this picture; they are apparent in the
changes of the action of the Madonna, and also of
the Infant.*

The graceful Cupid making his bow, while two
Amorini, in the lower part of the picture, laugh
and weep, is well known by repetitions; on the
authority of Vasari, it is commonly ascribed to Par-
migianino; the invention is, however, probably due
to Correggio alone, as it is essentially his in con-
ception and feeling. The example in the Belvedere
Gallery at Vienna is perhaps the original, but even
its warmest admirers acknowledge that it has
suffered considerably; the picture is on wood; there
is, or was, a good copy in the same gallery by
Heinz. The repetition in the Stafford Gallery,
formerly in the Orleans collection, and long ascribed
to Correggio, is now more justly attributed to
Parmigianino.

The "Ecce Homo" in the National Gallery, a
picture of Correggio's best time, is also one of the
best examples of his treatment of sacred and grave

* Mengs, Opere, p. 312.

subjects.* It has been justly observed that the painter, distinguished as he was for a graceful sentimentality and an exuberance of feeling, sought, in undertaking such subjects, rather to express the passion of grief than the profound sense of sorrow or resignation. This work is an instance: the expression, even of the Christ, may be said rather to excite sympathy than to inspire awe, while those of the Madonna and the Magdalen embody the intenseness of grief. As this picture is on wood, the relative prominence of the colours is sufficiently apparent; the blue of the Madonna is much raised; the richly varnished deeper shadows also indicate the use of a copious vehicle; the cracks in general appear to be those of the panel, or of the ground only; but behind the figure of Pilate the peculiar cracks of the " vernice liquida" are apparent. The head of the Magdalen appears to have been an afterthought, or "pentimento," as the blue drapery was originally completed underneath it.

The Mercury teaching Cupid to read, in the National Gallery, is not in so good a state as the other two pictures by the master in the collection; to say nothing of its retouchings, the operation of lining has had the usual effect of flattening the colour, so that there are now few indications of the appearance which the surface of the shadows may once have exhibited.

* Reynolds' Life, by Northcote, vol. i. p. 36.

The Jupiter and Antiope, now in the Louvre, though in better preservation, has the same equality of surface from the same cause: the cracks in the substance of the solid colour are such as are found in canvas that has been rolled; a darkened varnish which has penetrated some of the cracks conveys the impression of the picture having been painted on a dark ground, but a careful examination shows that such was not the case. With the exception of these slight defects, the picture is an excellent example of the best style and period of the master. The preparation, or under-painting, of the now warm and golden flesh must have been cool; a rich brown is glazed round the outlines, in shadows, and round the herbage and other objects.

The Deposition from the Cross and the Martyrdom of S. Placido and S. Flavia, two pictures originally painted for a chapel in the church of S. Giovanni at Parma, are now in the gallery of that city. Both are on cloth, and, from the cause before mentioned, exhibit but little indication of the original delicacies of execution. In the Deposition both the blue and lake draperies of the Virgin are covered with the minute cracks of the " vernice liquida" moderately used. In the subject of the Martyrs*, the shrivelled surface of the darks indicates the more copious employment of an oil varnish; the same appearance is observable in

* This picture was among the Correggios taken to Paris.

the blue and orange draperies of the S. Flavia. Both pictures are tolerably free from cracks in the solid lights. Repetitions are in the Madrid Gallery.

The St. Sebastian, now at Dresden, was painted about 1525, for the confraternity of St. Sebastian at Modena. It was one of the six Correggios which migrated from the gallery of Modena to the Saxon capital.* It was repaired in the seventeenth century by Flaminio Torre, a Bolognese painter; in the hands of another renovator it is said to have been placed in the sun, and to have suffered in consequence. Its last restorer was the celebrated Palmeroli. It is, however, not in so ruined a state as was supposed. The flesh is as usual smooth and solidly painted; the shadows only exhibit a corroded appearance, the use of a rich vehicle desiccated and contracted in the mode before described. This is observable in some shadowed portions of the flesh—for example, in the left leg and arm of the St. Sebastian, and in parts of the body, and still more in the shadows of draperies, as in those of the yellow ecclesiastical garment of the S. Geminiano. The surface of the blue draperies of the St. Rock and of the Madonna is more raised in comparison with the other parts. The picture is on wood.

* Ninety-nine pictures, selected from the gallery of Francis II., Duke of Modena, were purchased in 1745 by Frederick Augustus III., Elector of Saxony and King of Poland, for the sum of 30,000 gold sequins, which, as is supposed were coined in Venice for the occasion.

The "Madonna della Scodella," now in the gallery at Parma, may have been painted in 1528; the date on its frame when in its original place—the church of S. Sepolcro at Parma—was "1530, 19 Giugno." Some accounts of its having been early maltreated are contradicted by Mengs; but its present state, probably from the partial removal of glazings, does not exhibit that general harmony so remarkable in most of the master's works. The shadows have the short cracks and an approach to the corroded appearance of the usual oil varnish. The surface is partially cracked and blistered in the lights, as in the lower angel. The blue drapery of the Madonna and the subdued green drapery of St. Joseph have the raised appearance so often noticed on wood. Wilkie writes thus from Parma in 1826 :*—"The Holy Family, Madonna della Scodella, is here, but has suffered much—blues rubbed to the bone. The trees behind the Virgin are most rich and lucid, scarcely anything but asphaltum; the whole picture more thin and transparent than is his wont. The drapery about Joseph is of the brightest chrome and orange; and though parts of the picture are out of harmony, it is still most captivating in its effect."

The celebrated St. Jerome, also in the gallery at Parma, must have been completed in 1527–1528,

* Life of Sir David Wilkie, by Allan Cunningham, vol. ii. p. 279.

for a chapel in S. Antonio at Parma. The com-
mission, given some years earlier, was from Donna
Briscide Colla; the price was four hundred gold
" lire imperiali," and the lady, to show her satisfac-
tion, when the work was finished, sent to the artist
among other acceptable presents from her farm a
well-fattened pig.* According to another record,
the monks of S. Antonio were the givers: in
either case an allusion was probably intended to St.
Anthony, for although that saint is not introduced
in the picture, his church was benefited by the
addition of such a work to its internal decorations.
The inequality of the surface in this picture is at
once a proof of its good preservation and an illus-
tration of the practice of the master. The substance
or " impasto " of the flesh and of the lighter objects
generally, however solid, appear embedded next the
darks, and next the blue draperies. This is very
apparent in the shoulder of the infant next the
blue on the Madonna's left shoulder, in the right
arm of the St. Jerome, and in the roll of paper he
holds, as compared with the raised surface of his
greenish blue drapery. The leg of St. Jerome
clearly shows, with the surrounding colours, the
practice so often illustrated; the upper portion
next his blue drapery is much embedded as com-
pared with that drapery; next the lake drapery it

* The story is also told of other pictures, with circum-
stances intended to prove the poverty of Correggio. See Pun-
gileoni, vol. i. p. 196.

is less so; while the knee, and the red drapery of the Virgin, on which the knee is relieved, are level. The red lining of the drapery of St. Jerome is in like manner embedded in the blue next it. The same appearance is observable in the relative surfaces of the shoulder of the Magdalen and the dark background, the latter being much more prominent. The portions most cracked are the blue drapery of the Virgin (which, in its nearer portions, exhibits a cream-coloured ground through the cracks) and the darker parts of the blue drapery of St. Jerome, especially behind the arm. The continuous cracks in the blue of the Madonna and elsewhere indicate the white varnish; the lake draperies and some of the more thinly glazed darks exhibit the short reticulated cracks of the firmer varnish. The solid smooth lights are as usual less affected in this way; the portion which is most cracked is the white drapery under the left hand of the Madonna, and the appearance indicates a more copious use of the varnish.

Wilkie observes of this picture:—* " The famous St. Jerome (or the Day) takes the lead; this, for force, richness, beauty, and expression, makes everything give way. Hundreds of copies have been made, but all poor compared with the fearless glazings, the impasted bituminous shadows of this picture." Again: " The famous picture of the Holy

* Life of Sir David Wilkie, by Allan Cunningham, vol. ii. p. 279.

Family and St. Jerome, of which there are so many poor and black copies, though it is rich and brilliant beyond description. This, compared with all about it, has a power quite extraordinary; the lights, particularly of the flesh, are mellow and rich, the shadows transparent and clear, and some of them deep as midnight. The Magdalen, for character, colour, and expression, is the perfection not only of Correggio but of painting, and the head and body of Christ have that luminous richness that forms one of the greatest delights and one of the greatest difficulties of the art. In looking closely into this picture, I find the lights generally the least loaded; the blues extremely loaded both in light and shade, and the thickest paint of all is that in the deepest shadows in the centre of the picture, where the colour appears both to float and to crack from the impasted colour and vehicle necessary to the strength of his effect.* . . . His red on St. Jerome's drapery is of the most intense kind that vermilion, glazed, will produce; but if I do take an exception, it is to the quality of his brightest blues, being, in comparison with what I have seen in his other works, too intense and too cold for the harmony of the rest of the picture. The usual excuse in pictures of this kind is the ravages of the picture-cleaner; but in a work so carefully preserved this will not serve. The ap-

* Life of Sir David Wilkie, by Allan Cunningham, vol. ii. pp. 289–90.

pearance in the blues of rubbing is not obvious; indeed their being painted in a thicker body than the rest of the picture would seem to show an intention that they should tell strong. Their effect almost amounts to harshness; but to question Correggio's harmony is like cavilling at Sacred Writ. In his Madonna (the Zingarella) at Naples the blue is softened down to a greenish hue like Rembrandt." On wood.

The celebrated picture of the Nativity, called " La Notte," as the St. Jerome, by way of contrast, is distinguished as " Il Giorno," was painted for the Pratoneri family in Reggio, and was placed in the church of S. Prospero in that city in 1530. Correggio received the commission in 1522, but the picture does not appear to have been painted till 1529. It was removed to Modena in 1640, and passed from the Ducal Gallery of that city to Dresden in 1745. It is unnecessary for our present purpose to dwell on the higher qualities for which this work is renowned. Its technical excellence was originally as remarkable as its invention, but it is one of those works which have suffered from time and cleaning. The present relative smoothness both of lights and darks is to be attributed to the operations of restorers; the blue drapery of the Virgin—the usual test of the preservation of a picture of the time—is still, in a slight degree, more raised than the surrounding colours, but the shadows generally have no longer the rich sub-

stance derived from a substantial vehicle, which, in all probability, they once possessed.

"The Notte of Correggio," says Wilkie, writing in 1826, "is no longer what it was—*it is a rubbed-out picture.* The glazings upon the lights having been taken off, they are left white and raw, and can no longer be judged of as the art of that great master."* Elsewhere: "Correggio did not, like Rembrandt, in these effects attempt to give the colour of lamplight; the phosphorescent quality of light was more his aim, as in his Christ in the Garden. But here the light on the Virgin and Child is white, chalky, and thin; Still, however, the beauty of the Mother and Child, the matchless group of angels overhead, the daybreak in the sky, and the whole arrangement of light and shadow, give it the right to be considered, in conception at least, the greatest of his works."† The picture is on wood.

The picture called S. Giorgio was painted for the church of S. Pietro Martire in Modena, about 1531–2; from the Ducal Gallery, to which it was afterwards removed, it migrated with the flower of that collection to Dresden in the last century. The solidity of the lights in this picture is unimpaired and is very remarkable, but the rich glazings have

* Life of Sir David Wilkie, by Allan Cunningham, vol. ii. p. 327.

† Ib. vol. ii. p. 337.

been disturbed, so as to obliterate in a great measure the inequalities of the surface. On wood.

The well-known recumbent Magdalen reading was one of the six works of the master which, with other fine works in the gallery of Modena, enriched, or rather formed, the Dresden Gallery. The precise date of this picture is uncertain, but it may be safely concluded that it was the result of the consummate experience of the artist. The description which Sir D. Wilkie has given of this picture is sufficiently applicable to the purpose of these notes. " To those," he says, " who like pictures in their pristine condition, the Magdalen will be highly satisfactory. This is perfect, almost as left by the master, without even varnish. The neck, head, and arms, are beautiful; the face and right arm one of the finest pieces of painting I have ever witnessed. The shadows of this picture are extremely loaded—the lights, though painted flat and floating, are, compared with them, thin and smooth. The book and left hand are finished with a softness and detail resembling Gerard Dow, or Van der Werf. The background and darks of this picture, even the blue drapery, want richness and transparency."*

Elsewhere: " The small Magdalen, though it is very small, is in the most perfect condition; the head and arms most highly finished, and in a most

* Life of Sir David Wilkie, by Allan Cunningham, vol. ii. p. 327.

creamy, floating manner of painting, but the background and blue drapery want richness."* This picture is on copper.

The Io, the Leda, and the Ganymede have been so much injured and repaired that a description of them would be of little use. The best example of the first-named is in the gallery at Berlin, where the Leda is also preserved. The Ganymede and a repetition of the Io are in the Belvedere Gallery at Vienna. All are on cloth. The Danae, formerly in England, in the collection of Walsh Potter, is now in the Borghese Gallery in Rome; this is also on cloth, and, like the pictures last noticed, is covered with cracks: although better preserved than those specimens it exhibits little inequality of surface: a dark blue, part of the couch, has the usual appearance in consequence of the thick vehicle used with it.

The two allegorical pictures of the Triumph of Virtue, and the Bondage of Vice, described by Mengs as forming part of the Royal Gallery of France, are now in that part of the gallery of the Louvre which is devoted to drawings. Both are in tempera, and on cloth. A repetition of the Triumph of Virtue in the Doria Gallery in Rome is interesting from being unfinished, clearly showing the process—or, at least, one of the processes—of Correggio, not only in tempera but in oil. The

* Life of Sir David Wilkie, by Allan Cunningham, vol. ii. p. 338.

cloth, which, as usual in tempera painting, is not
primed, has a warm brown tint by way of ground. In
the upper part of the picture there is a portion,
consisting of infant genii amid some clouds, which is
outlined only, with a red (painted) outline. The
figure of Virtue is prepared with white and a
brownish black only; the high lights in this figure
are cracked in very small cracks. The winged figure
of Glory is partly coloured, apparently on a similar
preparation, the flesh colour having warm shadows.
One of the infant genii above is begun in a cold black
and white, slightly tinted in the face and in the pale
golden hair. The head of a figure seated near the
figure of Virtue is finished very carefully, and in
full colour. There is some doubt whether this
final work is tempera or oil; it is more probably
the former. In consequence, perhaps, of the rolling
of the cloth, or other careless treatment, the colour
has scaled off in a few parts, and sometimes in lines,
as if the cloth had been folded. The sky and green
ground appear to have been painted at once in their
present colour. Mengs, who also describes the
Doria picture, does not hint at any part of it being
in oil. He says: " In this work we see one portion
prepared only in black and white, very thinly, but
at the same time with the grace and intelligence of
his finished works. Other portions are executed
in colour, scarcely tinted, yet giving the perfect
effect of nature. Above all, it is wonderful to
observe the great intelligence of foreshortening,

especially in those parts where the prominence of muscles or the fulness of forms partly conceals the forms beyond, producing that intricacy of modelling which is so difficult to express satisfactorily. On the whole, I should say," continues Mengs, "that there are many pictures of the master more beautiful than this, but in none of the finished examples is the greatness of Correggio more apparent." *

Other pictures by Correggio in tempera were once in the Farnese collection at Parma, as appears from Barri's notices, and from portions of a MS. catalogue of that collection published by Pungileoni.

Having now enumerated the greater part of Correggio's existing works, and having described their appearance so far as is requisite for the present enquiry, it remains to compare the evidence so furnished with other circumstances tending to throw light on the technical method of this consummate master.

Every method was familiar to Correggio; the drawings and studies for his frescoes, which are preserved in various collections, are generally executed, or at least completed, in red chalk †, and exhibit the most profound knowledge of foreshortening, the most delicate feeling for roundness, and a thoroughly practised hand. His love of gradation and of the imperceptible union of half-tints led

* Opere di Mengs, p. 187.

† Drawings of this class were in the collection of Vasari. See Pungileoni, vol. i. p. 144.

him to use the "stump" or some similar mechanical means.* Among other materials he appears sometimes to have employed coloured crayons, or, at all events, to have produced drawings similar to crayon drawings. Bellori and Baldinucci mention the circumstance of Baroccio having been first induced to emulate Correggio by seeing some studies by that master in crayons. As regards Correggio's practice in modelling, it must be evident to every painter that he used clay models for the drawing of some of his foreshortened figures, and for light and shade generally. Mengs remarks that the infant angels standing behind the figure of St. George (playing with the helmet of that saint), in the picture called the "S. Giorgio," show, by the peculiar effects of cast shadows upon them, that those effects must have been copied from clay models.† The practice of modelling, as an auxiliary to foreshortening, may have been first learnt by Correggio at Mantua among the followers of Mantegna. In Mantua also he may have studied from specimens of the antique (which some writers send him to Rome to see), and in the same city he probably acquired that solidity in oil painting which neither his Modenese instructors nor the older artists of Parma had approached. The practice of tempera might have been acquired anywhere, but

* Waagen, Kunstwerke und Künstler in England, vol. i. p. 126.

† Opere di Mengs, p. 179.

the examples of Mantegna's Triumphs, at Mantua,
painted as they are on cloth, were more allied to
Correggio's freedom of hand than the laboured
productions of the earlier masters who practised
that method on wood. The advantage of painting
in tempera on cloth, when delicate modelling is
required, is that the work (otherwise rapidly dry-
ing) can be kept moist by wetting the back of the
picture. This method is noticed by Vasari and by
Armenini.* The few existing tempera pictures
by Correggio are all on cloth; whether they were
intended as preparations for oil pictures, and whether
all his oil pictures on cloth were originally prepared
in tempera, it is impossible to say. The tendency
of size colours to crack renders it advisable to use
them very thinly; but, even if thickly used, a layer
of oil colour, applied with a firm vehicle, sufficiently
fixes the more fragile substratum. The chief use
of a light tempera preparation is to arrest the forms
and masses of light and shade before the application
of oil; but the same end may be answered by using
essential oils mixed in a large proportion with the
fixed oil, according to the method before described
of Leonardo da Vinci. Whatever may have been
Correggio's object in occasionally painting in tem-
pera, it is not probable that the fear of oil, which
we have seen operated so strongly with some of
the Florentines, was among his reasons. At the

* Dei veri Precetti della Pittura, vol. i.

same time it is evident, from the unfinished por-
tions of the Doria picture, and from many of his
pictures which have, to a certain extent, lost their
glazings, that he began his flesh colour on a com-
paratively colourless, and sometimes even cold
scale, as compared with the glow of his finished
works. It is not difficult to trace this fresh and
cool preparation even in some of his warmest pic-
tures, as, for example, in the Jupiter and Antiope
in the Louvre. Others, again, like the St. George at
Dresden, and the beautiful Madonna and Child in
the National Gallery, are probably in a cruder state
than when they were first completed, and tend to
throw light on the artist's process. Sir Joshua
Reynolds was of opinion that Correggio began his
pictures with cool colours. He says : " The Leda in
the Colonna Palace, by Correggio, is dead-coloured
white, and black or ultramarine in the shadows ;
and over that is scumbled, thinly and smooth, a
warmer tint—I believe caput mortuum [colcothar
of vitriol]. The lights are mellow, the shadows
bluish, but mellow. The picture is painted on
panel, in a broad and large manner, but finished
like an enamel ; the shadows harmonise and are
lost in the ground." * The following observation
also occurs : " Dead colour with white and black
only ; at the second sitting carnation ; to wit, the
Baroccio in the Palace Albani, and the Correggio in

* Northcote's Life of Reynolds, vol. i. p. 36.

the Pamphili (Doria)." He further observes: " The
Adonis of Titian, in the Colonna Palace, is dead-
coloured white, with the muscles marked bold: the
second painting, he scumbled a light colour over
it: the lights, a mellow flesh colour; the shadows
in the light parts of a faint purple hue—at least so
they were at first. That purple hue seems to be
occasioned by blackish shadows under, and the
colour scumbled over them. I copied the Titian
in the Colonna collection with white, umber,
minium, cinnabar, black; the shadows thin of
colour. In respect to painting the flesh tint, after
it has been finished with very strong (crude)
colours, such as ultramarine and carmine, pass
white over it, very, very thin with oil. I believe
it will have a wonderful effect. Or paint carnation
too red, and then scumble it over with white and
black."*

The above remarks were made by Reynolds at
the age of twenty-seven, but his unfinished or
damaged pictures at a very late period of his prac-
tice exhibit a similar principle. Not long before
his death, some pictures, which he was in the habit
of lending for students to copy, were prepared with
indian red, black, white, and umber, and purposely
left in that unfinished state. His biographer
(Northcote) remarks: "It was always Reynolds'
advice to his scholars to use as few colours as

* Northcote's Life of Reynolds, vol. i. p. 37.

possible, as the only means of being secure from becoming dirty or heavy in colouring."* With regard to the use of black, it is to be remembered that a preparation of shadows with white and black requires to be very light, for, if painted with much force, no glazings, however warm, can overcome the greyness, and the result will be heavy and opaque. The practice of Reynolds and of Correggio (in part of the Doria picture most clearly) shows that the use of black and white in the preparation is compatible with extreme warmth at last; but many colourists—and the late Mr. Etty may be quoted as an example—either avoid black altogether in flesh, or use it very sparingly, preferring raw umber. Mr. Etty used black (with white) in his light tempera preparations only. When questioned about this by the author, to whom he once showed a beginning in tempera, he replied: "I use black in this stage of the work, but never afterwards."

The use of a warmer and colder chiaroscuro preparation in the same work, is observable in the works of many colourists—in the Doria Correggio, in Vandyck's chiaroscuro pictures and sketches, and in those of Rembrandt. The later system of Reynolds—the use of white, black, indian red, and raw umber—may be safely recommended, inasmuch as these materials comprehend representatives (however negative) of the three primary colours; black

* Northcote's Life of Reynolds, vol. i. p. 40, note.

representing blue, colcothar red, and umber yellow. In his copy of the Colonna Titian, it appears Sir Joshua used vermilion instead of indian red. Such colours, while they are too few and simple to become heavy by immixture, and while they thus invite freedom and solidity, may also be used at last as scumbling colours, (the black excepted) by which the qualities of warmth and transparency, if not that of force, may to a great extent be rendered.

When the simple materials above named, or others equivalent to them, have done their utmost in arresting form, roundness, expression, solidity, and, as far as possible, warmth and depth, the work is duly prepared for rich shadows—applied with a lucid but very substantial vehicle—and, for corresponding half-tints and lights, toned by semi-transparent and transparent colours, and always applied with a rich vehicle.

It is here that the great difference—after all more apparent than real—between the Italian and Flemish system is to be remarked. The advice of the earliest oil painters, and of Rubens, was to begin with the shadows. In the methods above noticed, the darkest shadows are first inserted after the work is far advanced. This seeming contradiction is easily reconciled: in the preparation, the rule of Rubens may, and had better be strictly followed; and when the preparation is complete and the work thoroughly dry, the new operation is

only a repetition of the same order of processes on a more transparent scale: the painter again begins with the shadows—this time carefully avoiding any admixture of opaque tints with the dark transparent colours, and keeping the thinly applied (in their nature opaque) scumbling colours from mixing with the shadows. In short, the *last* operation of the Italian practice is, strictly speaking, the *only* operation of the Flemish practice.

The first stage of the Italian process—the solid and well-modelled preparation—as has been already stated, was first reduced to a system by Leonardo da Vinci; but it was perfected, and sometimes perhaps abused, by Correggio and the Venetians. The confidence which a painter acquires when he is confined to a few colours, and the feeling with which he works when solidity is made an object, render him indifferent to alterations, and the works of the Lombard and Venetian colourists consequently often abound with *pentimenti*. The history of *pentimenti*—literally repentances, or afterthoughts—throws some light on the progressive practice of art. Doubtless the early painters abstained from such changes partly from timidity; but their method also had its influence. The fresco painters were compelled, from the nature of the process, to complete their design before beginning to paint; the tempera painters, partly from the habit of fresco and partly from the peculiar conditions of tempera, as it was then practised for

altar-pieces, considered a finished design as a preparation for the picture indispensable. The same may be said of the early Flemish and of some Italian oil painters. In all these cases it is plain that any experiments or changes in the composition must have been made in separate drawings and sketches. Some of the Italian masters who adopted the Flemish practice deviated so far from this system that they occasionally made considerable alterations in the design on which the picture itself was to be painted, but, in general, none in the picture properly so called. Fra Bartolommeo, for example, sometimes painted on outlines on which the original sketch and the subsequent (and final) composition existed together, the picture itself being altered no more. Lastly, *pentimenti* in the picture itself suppose solidity, and hence they occur chiefly in the works of the habitually solid painters, such as the Lombards, the Venetians, and their followers.

The brightness of the ground is of less importance when that ground is everywhere thickly covered; still, as a measure of precaution, it is always desirable to use a light ground, as it is always convenient to paint on one slightly tinted. Correggio's tempera work in the Doria is on a warm brown ground; his oil pictures appear to have been painted on a lighter warm tint. *Pentimenti* sometimes, as the case may happen, are painted on the worst possible ground; thus the

alteration in the face and neck of the Madonna, and the introduction of the hand of the Magdalen in the "Ecce Homo" of Correggio in the National Gallery, involved the necessity in both cases of painting flesh on a very dark blue. It has before been explained that the tendency of the white to become transparent sooner or later renders the dark colour underneath visible, even when the super-added pigment is unusually thick. On this account it is advisable to remove very dark colours, and to lay bare the light ground before repainting.

Black, white, and red were, in the opinion of Reynolds, sufficient to prepare a picture for the colouring of Correggio. In speaking of the Venetian painters we shall hereafter have occasion to quote a still higher authority recommending the same materials. Black, white, and red are sufficient not only to prepare a picture, but to imitate nature in many important qualities closely; and when no approach to completeness is attainable with such means, the addition of a multiplicity of colours would not really finish the work more, but, on the contrary, would rather multiply its defects. The extreme of force is obviously not within the compass of such colours, especially as blackness is to be avoided; for while black itself has not the depth of some intense and transparent browns, the necessity of always largely qualifying it with red, and in most cases even with white, leaves the extreme depths unexpressed. The last glow of

warmth is also clearly unattainable with such means. But, with these exceptions, most of the attributes of the skilful painter can be expressed with the simple materials in question.

Solidity of execution, with the vivacity and graces of handling; the elasticity of surface, which depends on the due balance of sharpness and softness; the vigorous touch and the delicate marking —all subservient to truth of modelling—are qualities admired in good pictures as if colours in all their variety were essential to produce them; but the material conditions on which such qualities depend are literally confined to solid white paint and any representative of darkness which can serve to measure the gradations of light.

The skilful application of a relatively dark colour on a light ground—often so admirable to painters' eyes in the backgrounds and obscurer portions of Rembrandt, Rubens, and Teniers—the depth that is expressed by an irregular veil of comparative darkness swept over the light ground, while that light is seen more or less in unequal intensities and shapes, as glimpses of it appear through the mazy network of the large brush-marks, or disappear in more cloudy patches—this expression of depth, measured still further by more or less solid work above it, and by thinner darks above all—this mastery, by which the flat surface is transformed into space, so fascinating in the judicious unfinish of a consummate workman—depends not on

colours, but solely on the dexterous use of dark and light materials.

Again, the plain definition of transparency is the appearance of one thing through another; the irregular, dragged application of a solid and opaque material, by allowing the under-tint to appear at intervals, at once conveys the impression and constitutes the fact of transparency, and, as in the former case, the result depends on the hand and eye, and on paint of any kind, not on colours as such.

Lastly, all colours—even the opaque, even the cold—acquire warmth by being so thinly applied as to allow a brighter tint within to reflect light through them. Colours so applied may be either unsubstantial or transparent in their nature, or, though naturally solid, they may be applied in so thin a film that the under-tint shall be visible through them. The application of colours that are in their nature transparent is called *glazing*. The thin and transparent application of solid and opaque colours is called *scumbling*. When the superadded thin tint is darker than the ground on which it is spread, the result is warmth; when the thin film or tint is lighter than the ground, the result is coldness. The Italians have but one term for glazing and scumbling; for both operations they have always used the word " velare," to veil. As final " veilings " were always applied by the old masters with a thick and glossy vehicle,

the term glazing, as it seems to imply a shining glassy surface, may perhaps owe its origin to the old practice and vehicles.

The warmth which is attainable even with black, white, and red, is therefore not to be estimated by the mere atomic and clayey mixture of the materials. The same may be observed of the degree and kind of coldness that may be expressed. The blueness that is produced by " veiling " black with white, or red with white (both being cases in which the under colour is the darker), is incalculably more pearly and ethereal than any mere admixture of black and white. Leonardo da Vinci did not omit to remark that the blueness of distant objects is in proportion to their darkness and to the purity of the intervening (white) atmosphere.* The opposite effects of warmth when the superadded tint is the darker may be observed by holding the commonest object that is thin enough to transmit light between the eye and the light. The ordinary, nameless colour of the material becomes kindled to gold and flame, ranging in brilliancy and glow according to the varying thinness of the texture or substance. Every curtain and window-blind and every stained glass window exemplifies this effect of a diaphanous colour—no matter whether the medium be actually transparent, like glass, or relatively so, like any light-transmitting material—interposed between

* Trattato della Pittura di Leo. da Vinci, pp. 22, 36.

the eye and a light ground. Every such ap-
pearance exemplifies the effect of glazing, while a
white gauze suspended before a dark opening re-
presents the operation and result of scumbling—
viz., light over a dark ground.

It is therefore plain that the qualities most
admired in finely coloured pictures are not the
consequence of the variety of materials, but of the
skilful use of very few simple colours. But, while
laying a stress on the power of such materials, it is
to be remembered that the picture conducted to the
utmost possible completion by such means is still
deficient in (absolute) warmth and force, and still
more obviously in variety of colour. With regard
to the variety of colours in accessories, it is indeed
evident, from the example of the Doria picture,
that Correggio's chiaroscuro preparation was con-
fined to the flesh, and that other objects were
painted in at first—not indeed with their full force,
nor, of necessity, in their full warmth and tone,
but in their local colours. Other painters, both
Italian and Flemish, were sometimes in the habit
of preparing the entire picture in chiaroscuro, but
even when that system is adopted, it appears ad-
visable to tint the accessories to some approach to
the actual colour before so treating the flesh. By
Correggio's method, as exemplified in the instance
of the picture referred to, and perhaps in others
which may come to light, the want of warmth and
vigour in the flesh would be more apparent, and

the first toning operations would be at once nearer
to nature. Without, however, comparing the rela-
tive merit and utility of the two methods, it is
sufficient to advert to the fact that the system of
tinting the accessories at first, while the flesh was
comparatively colourless, was in all probability the
ordinary practice of Correggio.

The peculiar finish of the flesh, and the softness
of its gradations in light and shade, which are
remarkable in Correggio's works, may have been
partly the result of the completeness of the pre-
paratory state, or under-painting. A picture pre-
pared for scumbling and glazing was generally
painted sharper and harder in the forms and
markings than it was ultimately intended to be,
because the general operations of thin coatings,
scumblings, and glazings, tend to soften such
markings. The under-painting of Correggio's flesh
has, however, already in a great degree the requi-
site softness, and hence, when it received the final
operations, the gradations were still more delicate;
a certain amount of sharpness in forcible markings
being attainable with dark transparent colours in
finishing. The softness of the preparation does
not, however, extend to draperies and objects that
are rugged, crisp, and sharp in their nature: it is
apparent even in the finished works of Correggio
that such substances were prepared very differently
from the flesh.

A work arrived at the stage we have supposed

may be thus described. The flesh is solidly painted on a light scale, either in a neutral colour or in a purplish colour, which in the shadows and half-lights does not approach to the black or the inky. The deepest shadows and the darks of the hair still do not give the impression of blackness, but by the sufficient admixture of red have a purplish brown appearance. The lights are very nearly pure white, and if small in quantity are literally white; the half-tints are still purplish, being rarely composed of white and black only. The effects of light and shade, the finer gradations in the half-tints, and the place of the red tints, though not in their full force, are all closely rendered; and the work, wanting only the last degree of force and warmth, has already a finished appearance. The last operations in this preparatory work have been scumblings of light over dark or over red to produce pearliness and roundness; or, if red tints scarcely darker than the under-painting have been so used, it has been to increase warmth by transparency, and at the same time add to relief. The draperies and other objects, whether begun with the same neutral materials or not, are carried to the same degree of relief with their local colours, the lights being much lighter, and the shadows less forcible than they are ultimately to appear.

The whole work has been hitherto painted either with linseed oil alone, or with linseed oil diluted with an essential oil. The essential oil used by

Correggio was probably petroleum, (also known as naphtha, or olio di sasso), which was common in the schools of Parma and Bologna. Petroleum is found in abundance in the territory of Parma and Modena, and according to a modern authority*, the city of Parma is lighted with it. But whether petroleum, or spirit of turpentine, or spike oil (the diluent of Leonardo) be used, it should be perfectly well rectified first; the linseed oil should also be of the purest kind.

The picture so painted, and in the state that has been described, will probably be free from a glossy surface, and will appear, from that circumstance, to be much less finished than it really is. The dull unglossy surface, it is to be remembered, is as desirable in a picture prepared for toning as it is prejudicial to the effect of the completed work, and the vehicle used for toning was for this reason of a lustrous and substantial kind. The prepared or dead-coloured work should be left in this state till the surface is perfectly dry, and if alterations are required they had better be made before the next operations are begun. It is difficult to say whether the *pentimenti* of Correggio were made while the work was in this state, or after it had been partially toned, or even quite finished; there can be no doubt, however, that they had better be made before the toning takes place.

* Ure's Dictionary of Arts and Manufactures, p. 879.

The mechanical treatment of pictures, before toning, can be better illustrated by the more known practice of the Venetian and other schools. A picture painted with a due proportion of essential oil mixed with linseed oil may be turned to the wall without fear of discoloration, but it is safer to place the work so that it should receive sufficient light and air. It should at least be well washed and cleaned before it is again painted upon.

It has been before observed that the final operation of the Italians was the only operation, as regards painting and tinting, of the Flemish masters and of their first Italian followers. While the Flemish masters generally endeavoured to show the light ground (on which the design was carefully drawn and shaded) through the colour, so as to give brilliancy and warmth to the superadded thin lights and rich shadows which alone constituted the picture, using a thick but lucid vehicle with the transparent or transparently used colours, the Italians in their final operation worked in precisely the same way and with the same or a similar vehicle, allowing the bright under-painting to tell through the thin substance of the toning colours.

The picture being quite clean and free from all superficial greasiness, the portion to be coloured and enriched should first be oiled out, and this had better be done with the same thick vehicle with which the tints are to be applied. The advice of Rubens is then quite applicable: begin by inserting

your shadows, and take care that no opaque colour, especially white, insinuate itself into their lucid depths. The half-tints will then by degrees be floated in with tints composed more or less with white; the lights, though already warmed by the oil varnish, should be tinted in like manner. The whole surface having been thus, to a certain extent, toned and coloured, the shadows should be gone over again, and should by degrees receive the last degree of warmth; the lights should be revised and tinted in like manner; the same operation with transparent and semi-transparent colours, always applied with the same vehicle, may be repeated till the depth and warmth of nature is approached. It is quite possible now to insert (partially) more solid lights, cool touches, and points of warmth in the flowing mass of vehicle and transparent colour. Such operations, and indeed the application on the lights of opaque pigments in a semi-transparent state, entirely conceal the process, and give the work the appearance of having been painted at once. The draperies and accessories should be treated in the same way; the shadows being inserted with transparent colours and applied with an abundance of vehicle; the lights toned either with transparent or semi-transparent colour; but as the tint is supposed to be nearly attained in the preparation, transparent colours alone may suffice in this case.

When fugitive or changeable colours are em-

ployed in the accessories, they require to be locked
up with a more than usually copious vehicle; and
in such cases the preserving medium appears to
have been used with the more or less solid colour
before the final toning. Thus the oil varnish
abounds most in the deepest shades, whatever may
be the colour; and in colours it abounds most in
blues and greens—the first, as before explained,
having been often painted with the carbonate of
copper, and the latter with verdigris, and subse-
quently with yellow lake.

With respect to the vehicle, there is no room to
suppose that the adoption of the Flemish method
was not as common to the painters of Parma as to
all other early Italian schools of oil painting. The
careful execution of Correggio would probably lead
him to prefer the finest and firmest of the ancient
oil varnishes—the amber varnish. It is remarkable
that Pliny should explain the fable that " trees
weep amber on the banks of Po" by the fact
that amber ornaments were very commonly worn
in the plains of Lombardy, while he distinctly states
that it found its way to Italy from the North over
the Rhætian Alps. A modern might have remarked
the great use of amber as a varnish by the Cre-
monese manufacturers of musical instruments; and
the painter Gentileschi tells us that in his time all
the colour-vendors in Italy sold the amber varnish
used by the varnishers of lutes. The Flemish
method once known, there would hardly be a more

convenient place than Mantua, " vicino Cremona," for obtaining amber varnish of good quality; and Correggio might have been indebted to his friend Lombardi for preparing it in the most transparent state. With regard to the supply of amber, it was not even necessary to depend on the North, for it was, and is actually, found in the neighbourhood of Parma. It being thus probable that Correggio used the amber varnish in his final operations, it only remained to prove this by means of his existing works. The late Professor Moreni of Parma is said to have analysed a portion of a damaged picture by Correggio, and to have detected amber where the traces of the vehicle were most abundant. Signor Moreni was hopelessly ill when the author sought to obtain some information from him on this point; but his researches were known to many, and Cav. Toschi, the celebrated engraver of the works of Correggio, has distinctly certified* that his deceased colleague had found amber in the analysis of a fragment of the " Procession to Calvary" in the gallery at Parma—a picture supposed to be an early work of Correggio, though, according to others, the production of his friend Anselmi.

* In a letter to the author, dated July 6, 1847.—*Ed.*

CHAP. VI.

VENETIAN METHODS.

In approaching the consideration of the methods of oil painting practised by the great masters of Venice, the first step to a right understanding and appreciation of those methods is to forget for a time many associations and reminiscences of the Flemish practice, even in its highest examples. The leading diversities of the two methods may be briefly stated thus. In the Flemish mode the composition, previously determined, being outlined on a white or on a light ground and the chiaroscuro slightly indicated, the picture was painted *alla prima*—that is, though the work might be long in hand, each part was finished as much as possible, and often literally, at once. The transparent darks in these portions were inserted frequently in their full force at first; the greatest care was taken not to dull their brilliancy and depth by any admixture of white, or by any light opaque colour ; the half-tints were only moderately solid, the lights alone were sometimes loaded. The ground was thus seen through the darks and deeper half-tints, and often through other portions. In every part more

or less oil varnish was used with the colours, but especially in the darks. The picture thus painted required no varnish at last. Such, making due allowance for occasional variations in practice, were the prevailing characteristics of the Flemish system.

In the Venetian method, though the composition was in a great measure and sometimes quite determined at first, alterations were admissible, and the first outline was not always adhered to. The darks were in most cases painted much lighter than they were ultimately to be, and white might be used in any part : although roughness in the shadows was avoided, solidity was not restricted to the lights. The ground was not often seen through any portion of the work. No part was finished at once, and, far from desiring to give a glossy surface while the picture was in progress, the contrary appearance was aimed at till the whole was completed. The vehicles, therefore, were thinner at first.

Thus, supposing the system to be always regular, the Venetian *abbozzo* or preparation, when quite completed, resembled the Flemish chiaroscuro design—the final processes of the Venetian and the only processes of the Flemish artist were, in a great measure, the same. But as the Venetian process was rarely so methodical as here supposed, it is only in the early works of the school that even this resemblance is to be recognised.

The great object proposed by the Venetian masters was the perfection of colouring, and, in

aiming at this, they subdivided the processes of painting so as to make the result more certain, but certainly demanding less immediate and constant exercise of all the powers than was required in the Flemish process, which, in a certain degree, was more allied to fresco. Of all the merits and advantages of the Venetian and Italian method, the moderns have clung most to the indolent, or what may be made the indolent, habit of postponing the exercise of necessary decision, because of the continued possibility of alteration. Where this method of the *abbozzo* is not made use of in order to aim at a peculiar perfection in colouring, the *alla prima*, neck or nothing, irrevocable Flemish method is a far more manly and more difficult practice. But whoever wishes to enjoy the luxury and delight of painting, should settle his design and composition as unalterably as Rubens did in his coloured sketches for great works, and then proceed with the picture according to the Venetian system.

The most important difference, however, between the two methods remains to be noticed. In the Flemish mode, the ground being supposed to be, as it often was, white, it follows that every superadded tint will be darker than the ground. Darkness over light, provided the light be apparent through, produces warmth, and this was one of the sources of that glow which the thin shadows of the Flemish colourists exhibit. For the same reason that every tint (as distinguished from mere white) was darker

than the ground, the cool tints of these colour-
ists could never be produced by passing light
over darkness ; they therefore sometimes admitted
the most delicate azure in their flesh, and rarely
suffered black to come near it. The Venetians, on
the contrary, banished blue from their flesh, be-
cause they could produce tints of equivalent and
even greater tenderness by passing light pigments
very thinly over relative darks.

The aim of the colourist is first to produce a
pleasing balance and a constant and even minute
interchange between cold and warm hues. His
next object is that the nature of these warm and
cold colours shall be of the last degree of refine-
ment and delicacy. The system of glazing—pass-
ing a relatively dark colour in a diaphanous state
over a lighter colour—is a mode of insuring deli-
cacy in the warm tones. And to attain an equiva-
lent delicacy in the cool tints the expedient presents
itself of passing a relatively light colour, or even
white, in a diaphanous state over a darker hue.
This method of producing the cool tones constitutes
the essential difference between the Venetian and the
Flemish practice. Both agree in attaining the acme
of warmth by passing relative darkness over light,
but the practice of the reverse as a means of obtain-
ing coolness was not even compatible with the Fle-
mish system, and cannot consistently form a part of it.

In glazing to produce warmth, all colours, even
the coldest, when light is seen through them, be-

come relatively warmer and more vivid ; but the increased warmth is a difference of degree only, and as such does not materially affect the nature of the hue ; but, in thinly passing white over any colour, or over darkness, to produce coolness, an actual change of tint takes place. Leonardo da Vinci remarked the production of blue by this means in nature, when thin colourless vapour is interposed between the eye and darkness or depth beyond, as (he instances) in the blue of the sky, and in the blueness of distant dark objects (see p. 263). So it may be observed that smoke when seen against a dark object appears blue, but seen against a light object or a light sky looks brown.

The effect also of a film of white spread over differing and sufficiently warm dark colours is far more powerful and varied in its result than that of the opposite process with a film of darkness. Not that the changes produced by a thin pigment can equal the effects of vapour in nature, but the approach to these effects thus attainable is of the utmost value to the colourist—for the blueness which may be produced in a picture, as in nature, by the interposition of a light medium before darkness, especially if the darkness be warm, will be of the finest kind. Thus, in the Venetian practice, degrees both of warm and cool tints could be obtained *dynamically* * as opposed to a clayey or *atomic*

* "*Dynamics*: The science of the motion of bodies that mutually act on one another." Crabb's Technological Dict.—*Ed.*

mixture of the colours. In the Flemish practice the cool tints could only be produced by actual colour; accordingly the finest azures, as we have said, were admitted by the Flemish masters into delicate flesh from which black was invariably excluded. The Venetians, on the other hand, not only banished all blue colour from flesh, but admitted black in the fairest carnations ; not as a colour, for as such it never appeared, but as sufficing, when mixed with red, to give that amount of darkness which in its turn produced the pearl when seen through the lighter tints passed over it. To imitate this delicate effect, Rubens, when copying or freely reproducing the works of Titian, introduced azure tints where the Venetians had obtained as fine a coolness without them.

An objection may be raised to this system on the ground of its possible want of durability. It may be urged that, as pictures painted even with solid colours on a dark ground are always liable to grow colder by the tendency of the white pigment to become transparent, so this evil effect may be the more speedily and decidedly apprehended where only a slight film has been laid on. It may be replied, that the ground in the cases referred to was always decidedly dark, whereas the cool tints we have described are only passed over what we have defined as *relative* darkness—viz., over hues often but slightly darker than themselves. But, even supposing a really dark ground, it is to be

remembered that the cool tints so brought forth are always preparations for glazing, and that such glazings effectually lock them up. On the other hand, such is the ultimate warmth and glow of Venetian pictures, that if it were possible for the locked-up "dynamic" greys to become cooler by growing more transparent, the result would be rather advantageous than not. Indeed, the thinner the superadded light becomes, the finer will be the tint. But, we repeat, such tints are always comparatively internal, and glazings must disappear before their existence can be endangered.

Another and more general objection may be made against the refinements of scumbling and glazing. They may be accused of being too exclusively subservient to colour, and of involving a certain effeminacy of execution. But without contending for the highest place in the scale of art, either for the Venetian school or for that perfection of colouring which it attained, it is not possible, in the presence of the master-works of Titian, Tintoret, or Paul Veronese, to feel that any charge of effeminacy can be brought against it; and this leads us to consider the counteracting principle which at once ennobled and concealed the consummate refinement of practice which these masters have bequeathed.

The system of producing warmth and richness by means of comparative darkness over light, whether by transparent or opaque colours thinly applied, had been practised and carried to great

perfection by Giovanni Bellini and by others; but there is no evidence of their having known the opposite process—namely, the effects of light colours over dark. That great master and his cotemporaries had all been instructed in the Flemish method, and it must have been long before an expedient so opposed to its conditions could have been entertained.

Giorgione appears to have been the first painter who, aiming at all that could combine freshness with that fiery glow which his finished works display, adopted a mode of preserving coolness which could be regulated to any extent, and introduced with safety and purity in any stage of the work. Assuming this to be the case, he would at the same time see the danger of the extreme softness and obliteration of form to be apprehended from this treatment, and therefore the necessity of a proportionate boldness and solidity as its basis. Without the substance and ruggedness of the rock, the superadded cloud, still more softened by glazing, would have wanted contrast of texture and truth of imitation. While therefore adopting contrivances which insured the softest transitions, the most perfect roundness, and the largest breadth, it was impossible for a painter of energetic character like Giorgione not to feel that the utmost vigour and apparent contempt of labour were requisite in the earlier stages of a work in order to conceal the delicate operations reserved for its completion. His

follower, Sebastian del Piombo, however resolute of hand in preparing the *abbozzo*, could not conceal from M. Angelo the extreme delicacy of the subsequent operations; and it was of Sebastian's system he spoke when in an angry moment he told that master that oil painting was an employment fit for women and children.

The energetic Tintoret was intent on avoiding another danger of his school—the neglect of drawing. His studies to this end, with M. Angelo's works as his guide, are well known; and although he could at times compass all the delicacies of his cotemporaries, his practice was so forcible and powerful, and his rapidity so great, that M. Angelo might possibly have retracted his hasty sentence, had he witnessed the prowess of such a workman.

But to return to Giorgione. Without this clue to his style, Venetian writers who had seen his best works in their best state must appear to contradict themselves in speaking of his characteristics. According to some, one of his chief merits consisted in inventing that daring and contemptuous execution which forms so decided a line of separation between him and Bellini; at the same time it is stated that his outlines and forms are soft, and one writer (Ludovico Dolce) observes, that the delicacy of his transitions in masses of light and shade is such, that it seemed as if there was no shadow at all. Others refer in like manner to the consummate refinement with which such passages

are blended—to his "sfumato" and extreme ten-
derness—and then again extol his rapidity, his bold-
ness, and his solid touch. In short, softness and
freedom ("*morbidezza e franchezza*") are the attri-
butes most frequently cited as characteristics of this
master. All this, however seemingly incompatible,
is perfectly true, and supplies the best eulogy on
Giorgione.

Whoever, therefore, aims at Venetian delicacy of
colour cannot do justice either to the system or to
himself unless a foundation of the firmest execu-
tion be prepared for it. It is also of the nature of
solidity and freedom of hand to attract more atten-
tion than those more indefinite processes we have
been describing; and it is pleasing to find spectators
extolling the boldness and apparent carelessness of
works which in their more subtle treatment are
examples of the highest refinement and most ex-
quisite delicacy.

In this respect our country has reason to be
proud that the finer works of Turner are a very
intelligible introduction to one, and that not the
least, of the excellencies of Venetian colouring.
He depended quite as much on his scumblings with
white as on his glazings, but the softness induced
by both was counteracted by a substructure of the
most abrupt and rugged kind. The subsequent
scumbling, toned again in its turn, was the source
of one of the many fascinations of this extraordi-
nary painter, who gives us solid and crisp lights

surrounded and beautifully contrasting with etherial nothingness, or with the semitransparent depth of alabaster.

With respect to the ultimate richness of the Venetians and the influence of what has been termed the dynamic grey underneath, it is undoubtedly true that there is more power in the freshness produced by light over dark than in that of a solid cool tint; just as there is more real warmth in a glazed colour than in what professes to be its equivalent in an atomic mixture. But all such refinements and remedies are not calculated for description. The cases are endless in which partial deviations even from the fittest recognised means may serve a special purpose. All that can be attempted in a mere outline of this kind is to describe the leading principle, leaving its infinite modifications to the varieties of ability and feeling.

To turn now to matters of practice. Before applying this system to flesh painting it is better to test its capabilities on subordinate subjects. A picture or sketch will probably be at hand, with rocks, broken ground or similar objects of negative colour, on which the painter may make the experiment, and it will interest him to find how the preciousness of colour may be thus imparted even to mere stone or clay. It is necessary that there should be some indications of light and shade, but no shadow of any extent should be intensely dark; while it matters little, for the purposes proposed,

what the forms may be, nor even, provided it be not absolutely false and violent, what the colour may be. A picture, therefore, having been selected for the experiment, the whole surface should be covered so thinly with white that the forms and the light and shade may be seen through it. The film of white should then be equalized and flattened; in glazing, when the dark colour sinks into the inequalities of the surface the effect may be agreeable, but in spreading an opaque colour over a more or less rough surface no particles of the white should be allowed to collect round the prominent points. The readiest mode of flattening the colour is by beating or stabbing (*botteggiando*) with a large brush adapted for the purpose. The white should at last be so delicately spread that it shall look like a grey preparation, retaining all the forms slightly blunted, and being equally diffused over lights and shades. Where the points of shadows were very dark the tint will be bluest; where there was any tendency to warmth of colour the grey will incline to violet or lilac. Should it be desired to increase this violet tendency—the tint being exquisite of its kind—it will be remembered for another experiment that a previous glaze of some warm colour, first allowed to dry, will insure it.

For the next process of glazing, the surface may be oiled out. A warm brown is the only colour required, but its warmth may be sometimes in-

creased with effect. The object is to kill the cold colour, and the whole surface may or may not be first slightly tinted with this general glaze. Then the bluish shadows should be neutralized —afterwards the lower purple half-tints—till gradually the whole surface is warmed. The predominant colour will long be grey, but at last, though this colour is not and perhaps cannot be quite suppressed, it assumes a general warmth tempered by freshness and presenting points of contrast between cool and glowing hues of infinite variety.

This experiment is purposely proposed in the simplest form, but it contains the principles of the whole system. The elements of harmony here are two-fold, the cause of the coolness being universal, while the coolness itself is infinitely varied in degree. For it will be seen that the scale of colour thus produced is not in inverse ratio with that of the original picture. The varieties of coolness in the film are far greater than those of warmth in the substructure. The film of white thus added will, as we have said, produce blue, and in proportion to the warmth underneath, that tendency to red which includes various tender shades of the violet and purple, but it cannot generate yellow, orange, or green. These hues will be the result of the brown glazing (suppose asphaltum) which, passed over the bluest parts, gives rise to olive tints, or an approach to green—over the redder, tends to orange, and in the high lights borders on yellow. Thus, while

there are abundant elements of harmony and gradation, there are infinite materials of contrast —and this constitutes fine colouring.

This system of scumbling may be said to double the fascinations of ordinary glazing—indeed neither can be completed without the other—for as the one supplies warmth dynamically, so the opposite provides coolness in the same way. With such harmonies as these unmixing surfaces produce, the mere palette has nothing to do, although the palette is especially required to do its work efficiently at first.

Let the same method be adopted for architecture. Suppose a portion of a building carefully executed as to light and shade, with all its members defined, and its surface solid, and here and there crisp. It may be painted in black and white with a slight admixture of indian red—or in any neutral colour. Cover the surface with white, and equalize it perfectly as before, till the whole looks like a very delicate grey preparation, the light and shade and every form being sufficiently apparent. When dry, glaze as before, opposing warm lines to the pearly middle tints, and defining the minute mouldings with the same brown. Patches of extreme cold should be neutralized, and the general warmth regulated as desired. By way of focusing the browns, a stain or two, or perhaps a brown weed, will have a pleasing effect. So simple a process as this will banish all ideas of the palette, and,

evident as the brush-work may be, and ought to be, will transform the mere paint into silver and gold.

In this, as in the former experiment, purely dynamic conditions are purposely preserved, but the modelling or rounding of objects may be assisted or completed, even in this stage, by middle tints used transparently over lighter portions:—they can hardly require to be used over darker portions, for the white alone suffices in such cases. A middle tint of grey, composed of black, white, and Indian red, if used transparently and as a preparation for fresh glazing, will sufficiently match the dynamic grey. But if required to be used solidly (which is not here supposed) a much more elaborate compound of tints would be necessary. To imitate, and that imperfectly, this nameless dynamic coolness in solid colour we recommend the following method. Place a touch of white on a somewhat dark-coloured palette— such as rosewood—spread a portion of it in various degrees of thinness, and various tints of grey, bluish, and violet will be the result. Beside these etherial tones make up an atomic mixture matching one or more of them. Such tints will represent as nearly as solid painting can the depth of white, and will serve to prepare its shadows.

The above mode of finding the neutral depth of a tint may be applied to all colours that are lighter than the rosewood palette, for when very thinly spread they present their dynamic combination in the cool sense with darkness.

In the cases hitherto supposed, the groundwork being nearly neutral, the grey has partaken of that character. But when the light film of white is passed over a positive colour a more or less considerable modification of that colour is the result. Thus a vermilion drapery is changed to a pronounced lilac; on that preparation when dry the shadows may be inserted with lake, the original colour being more excluded from the lights, and the half-tints assisted with a tint (applied as usual in a transparent state) of black, white, and much lake. To correct the lilac further and to mitigate the lake a final glazing of asphaltum, or even of semi-transparent yellow would be adopted.

Again, the dynamic coolness may be sufficiently given to rich yellows by means of a film of Naples yellow instead of white, the darks being afterwards restored, and the cool tints neutralized with a deeper yellow. There are still more complicated modes of producing refined colours in draperies on the dynamic principle, but the examples given may suffice.

Blue, being itself the result of a light film over darkness, can gain nothing by being treated like the warm colours, as the grey produced would only be a degree of its own hue and would involve no contrast to it. A better mode of giving it value, for example in a sky, is to prepare the space it is to occupy with a very light warm transparent brown, gradually varied in depth according to the

natural appearances. On this a tint of blue and white graduated in the same proportion should be so thinly passed as to show the warm colour through, till, at the horizon, the scarcely perceptible blue is lost in the warm light of the ground. The clouds, if any, are in this process "left." The same system may be adopted in blue draperies —the folds and light and shade being entirely defined with a transparent brown. The blue is then painted upon it so thinly that the warm lights of the ground shine through it, while the deepest warm shades may be left almost untouched.

It remains to speak of the application of the system to flesh. The black, white, and red recommended by the actual precepts or by the obvious practice of all colourists from Titian to Reynolds, as the fittest materials for light and shade, modelling and solidity, in the preparation of flesh (see p. 260), can be varied in two only of the ingredients,—in the black and the red. For the first the Venetians commonly used " nero di Verona "—a black earth still to be found at Venice, and, no doubt, at Verona and in its neighbourhood. It is warmer than ivory or bone-black, or lamp-black, and perhaps warmer than common coal. But the coal, when mixed with white, is sufficiently identical with it. The red was generally light red, and warm reds of the same kind, but, no doubt, the colour called " Indian red " was also used. This warm red and warm black were quite sufficient on the one hand, when

used transparently, to produce a rich brown, and, on the other, when mixed with white (with less of the red), and used in the same way, represented cool half-tints. The first operations consisted, however, in solid modelling and bold execution with these colours, which being thus few and simple may be fearlessly intermixed without fear of muddiness. Those who object to black may substitute the "terra verde." A swarthy complexion may be first supposed. The whole tone is low, and the first object as usual is to preserve the masses of light and shade. The forms are then blended in the shadows, and the masses simplified and partly lost by the scumbling process; in which case pure white is not the medium to employ, but a middle tint consisting always of the same black, white and red. (In this manner were probably produced those low-toned preparations, without blackness, which we sometimes see in over-cleaned Venetian pictures, when their state enables us to judge of the first painting.) The masses of light may require to be treated in the same way, the tint used for the purpose being much lighter, though still far from white. The shadowed portion may now be considered sufficiently prepared, and may be left in the broad state just described. Not so the light: upon the broad scumbling which does not quite conceal the previous modelling, that modelling should now be renewed with tints (produced still with the same colours) applied in a

diaphanous state. By degrees, even with mere red and black (or the brownest and warmest shades of burnt " terra verde," still mixed with Indian red), the flesh acquires richness and roundness. The point to stop is where sufficient force cannot be attained without blackness. The next operation is glazing only with browns and reds.

The same colours are fitted to prepare the fairest carnation, of course in very different proportions. When sufficient solidity is attained the whole may be scumbled with white. The shadows should then be restored, the extreme coolness being duly corrected with a tint composed from the same common materials, while in the light portions the modelling and warmth should be most delicately renewed on the same principle. The intention of the scumbling is, in all cases, to produce extreme purity in the cool tints, and breadth in the whole: great care consequently should be taken not to destroy the tenderness of the one or the largeness of the other. The desired roundness and gradation being attained, more delicate tints (in the fair complexion) may be added, such as vermilion and lake in some places.

The hair, of whatever shade, may be prepared with the same tints that are used for the flesh, with less, or sometimes no white. The principle of avoiding blackness does not even apply here, for a thin black, to represent the colour black, may, judiciously used, answer, or partly answer, the end proposed.

An important observation should not be omitted in reference to the scumbling process applied to delicate carnations. The film of white passed over an already light surface will undoubtedly give it greater breadth, by rendering fainter the middle tints which are afterwards, at least partially, delicately warmed again. But a result quite as important or more so is the production of that exquisite cool tint we have so often described. Care therefore should be taken not to destroy or diminish that relative warmth or darkness on which the existence of the cool overlaid tint depends. If therefore the flesh, in consequence of repeated general lightenings, be found not to have sufficient elements of contrast left, the remedy is to glaze it entirely with a warm tint, in order to provide a fresh general foundation for the dynamic coolness. On this again the warm partial glazings may be applied in the manner before described.

We have alluded to the semi-opaque scumbling necessary for a dark complexion. The opposite practice in glazing may be said to meet it half way. For the " sfumato " of the Venetians was not produced by common glazing, as understood of a perfectly transparent medium over light, but by colours of a semi-transparent kind. All the half opaque reds—light red, Indian red, perhaps even vermilion, brown reds, and burnt sienna, &c.—may be used for warm lights, and for all but the deepest shades. Even these colours are too transparent,

and may receive both tone and body from a slight admixture of thick darks, or half darks—such as umber, burnt green earth, &c. In some cases white even may be necessary, or Naples yellow, but all yellows in glazing, or rather "nel sfumare" are powerful, and give even a *too* golden colour. The transparent yellows are only fit for the extreme darks—they jaundice the lights.

In describing a system which thus presents all the effect of blending without the appearance of handling we have perhaps given the impression— very difficult to avoid in treating such subjects— of an over regular and definable process. The youthful artist will soon discover that there are no mechanical recipes for an art which depends on the subtlest decisions of the eye and mind. The experience and observation of another may be given as far as possible in words; the actual meaning of those words can only be determined by years of practice. The efficacy of the process we have dwelt on will be perhaps soonest apparent when applied, with modifications, as a remedy where more positive aids are fruitless. When a piece of drapery—suppose vermilion and white—white for the lights, pure vermilion in reflexions, black and white in half-tints and shadows forced with lake, toned afterwards with brown (sienna)—when such a piece of drapery has been painted in strongly, and with too unbroken a colour, a white film, diluted with a thick oleo-resinous vehicle, will restore variety, cool-

ness, and what is called " sweetness " as opposed to rankness. The white film in spreading in the vehicle will settle into an apparently granulated (though really smooth surface) with points and vermicular forms, giving at once texture and sparkle. The colour so produced will be of the lilac kind. The white, before it settles and begins to dry, may be so wrought and adapted to the folds as to assist the relief. When dry, the too red shadows may be killed with umber and white, and others strengthened with lake and rich tones. The cool half lights and masses should be assisted with blue, black and white, all thin, and the lights further modelled by thin applications of white. When dry, all may be glazed with raw sienna. Thus will be produced a rose colour tint of that nameless, negative kind seen in Venetian draperies—abounding in delicate half-tints, yet ultimately warm. A head also, which has become too unbroken and rank in colour, may be treated in the same way.

Again, we cannot too often repeat, the best corrective for the only danger of such processes—viz., the excess of the " sfumato "—is to observe a rough and brisk handling in the first preparation. It is not impossible however to renew broken and rugged touches, which, by the addition of such helps as wax, ground resin, or ground glass, may be applied with substance and without colour. At all events, the crispness, whether given first or last, *must* be present in various degrees, preserved distinct from

the evanescent softness of the scumbling. This kind of contrast is of the most precious kind, and nothing contributes more to express the thinness of the skin and the seeming depth within it.

A further class of scumbling must here be alluded to. However frequently the operations of thin light over dark and transparent dark over light may be repeated, it will at all events generally be found desirable when the darker glazing is getting dry to drag thin light here and there upon it again. Such delicate, dragged retouches which may be either conspicuous as such, or of more than gossamer thinness, have many uses. They modify the light where requisite, they freshen the colour, and, by not stirring the surface of the glazing while they cling to it—by being suspended as opaque particles on a glassy medium—they instantly distinguish the surface from what it covers, and express the depth within. Representations of depth, depending on the fine distinction of the alternately superposed colours, are peculiar to oil painting and are worthy of attention as thus exhibiting the capabilities of the method. The most perfect expression of the relation between substance and space is that of an irregular, crisp and insulated light, suspended, as it were, on the depth and nothingness of formless transparency. When the crisp touch is underneath it becomes more or less blunted by repeated scumblings over it, and it is sometimes desirable, when all is done, to raise such islands again from the

depth. An effect precisely equivalent to this occurs in fresco painting, when the work is nearly dry. A touch of light no sooner meets the *intonaco* than all its moisture is greedily absorbed, and the impinged particles remain precisely as if a rock were suddenly left dry by the retiring of the sea. The contrast does not, however, remain thus complete; for, in fresco, when the whole is dry the last touches appear to unite more with the surface on which they are placed. The operation in oil painting resembles this in so far that the light is added when the surface is nearly dry. The surface not being stirred, the light remains distinct upon it. In oil, however, the appearance has the advantage of being lasting. It may be sometimes observed in the works of Paul Veronese.

The particulars described may be regarded by some as needless refinements, but this objection once admitted would strike at the root of all the finer effects of colour and transparency. There is another mode of looking at such studies, which is to regard them as a language to be learnt, the command of which will enable and induce the artist to attempt the imitation of certain exquisitely delicate appearances in nature which he would otherwise consider as beyond the reach of material pigments. The production of various degrees of transparency and of the whole range of warm and cool tints by judicious alternations of scumbling and glazing, is a world which may be said to be at the painter's

command. The art of producing such results may
be studied at first merely as an art, and without di-
rect reference to nature. The processes in fact are
in a degree precisely those of nature, and therefore
can never fail to open up a universe of colour un-
approachable by any other means. It need not
therefore be dissembled that the dynamic method,
considered with reference to the effect of colour
only, involves completeness in itself, and is so far
independent of nature as it is an application of
nature's own means. But the power and capabili-
ties of the system being felt, its possible refine-
ments, with all its accidents, and all its assistance
from vehicles and from substance—such as the re-
peated interposition of colourless media (for which
the Italian varnish is adapted) and the production
of internal sparkle by brilliant colours half ground,
or even by the veiled glitter of metallic particles—
all these capabilities being felt, with many more
aids from that " cunning " which he has acquired
at home, the painter goes to Nature and compares
her world with his own. He finds that infinite as
the Great Artist is, he too has in his possession a
miniature scale of processes which, in the conjuring
up of magical effects, is analogous to those which
Nature herself puts into requisition, and he at once
selects and delights in the most difficult of those
problems in light and colour which the external
world presents to him.

NOTE BY EDITOR.

WITH this last short chapter on Venetian methods, the manuscript of the second volume of "Materials for a History of Oil Painting" stops short. The work being thus incomplete, Lady Eastlake has felt it advisable to add a selection from a number of, what may be termed, professional essays and memoranda which Sir Charles had designed for ultimate publication, though deterred by ever increasing occupation from fulfilling that intention. Lady Eastlake has had the advantage of submitting this selection to competent judges, and is encouraged by them to present it to the public, with a view to its usefulness to the student of art.

PROFESSIONAL ESSAYS.

COLOUR, LIGHT, SHADE, CORREGGIO, &c.

THE agreeable impressions of Nature as address-
ing themselves principally to the senses are those
which are most apparent, and the colours of ob-
jects, which seem to have no other use than to
mark their differences, are thus intimately allied to
the principle of beauty. The variety of colours,
whether abruptly or imperceptibly expressed, is
therefore their leading characteristic, and their
office is to distinguish. The absence of colour,
whether in light or shade, is, on the contrary, a
common quality, its office is obviously to unite.
That degree of light which represents the reflexion
of its source is never admitted in the works of the
colourists, except in polished or liquid surfaces ;
the office of light being to display the colours of
objects, and not itself, such shining spots would
not only be so much deducted from the real colour
of the object, but, as they might occur in different
substances, they would prevent their necessary
distinction. The degree of light which is imitated
in art is therefore that which displays the local

hues of objects, that is, their differences, and thus the common and uniting quality is mainly reduced to shade alone.* The highest style of colour will thus be that which expresses most fully, consistent with possible nature, the general local hues of objects. The office of shade is directly opposed to that of colour; in aiding those representations of general Nature in which beauty resides, its end will be to display the forms of objects without unnecessarily concealing their hues. This may be considered its most abstract character, as freest from accident, but, as a vehicle of mystery in subjects which aim at sublimity or principally address the imagination, it is most independent and effective. The idea of the Sublime is, however, an exception to the general impression of Nature, and shade will be more accidental as it ceases to display form, or unduly conceals colour. The accidental effects of light and shade which do not convey ideas connected with the sublime, belong therefore to the

* Although the best colourists never suffer the high lights to reflect the source of the light so strongly as to differ decidedly from the hue of the object, yet it is not consistent with nature or the practice of those colourists to reduce " the common quality to shade alone." The highest light on objects, without being a mirror of the source of light, is *composed* of the *colour of the light* and the *colour of the object.* The consequence of this will generally be that cold colours will have their lights warmer than the general hue, and warm colours will have their lights cooler. This approaches a common quality in the lights.

lowest style. These accidental effects are infinite, and are all more or less opposed to the display of form and colour. Yet this very display is a relative term, and forms and hues are only apparent because others with which they are compared are less so. An unpleasant and untrue equality and want of gradation would be the consequence of neglecting this truth, and it follows that there is a point beyond which the display of local colour and the rejection of the accidents of light and shade would be untrue to the general impression of nature.

It was the opinion of Sir Joshua Reynolds that, had the fine pictures of the Greeks been preserved to us, we should find them as well drawn as the Laocoon, and probably coloured like Titian; but he soon after concluded on good grounds that the same works would perhaps be deficient in the skilful management of the masses of chiaroscuro. The general character of ancient art seems to have been to dwell on the permanent qualities of things in preference to their temporary and variable appearances, and hence the constant nature of the local hues of objects would be considered more worthy of imitation than the mutable effects of light and shade. The ancient paintings which have been preserved exhibit the excess of this system, and the want of gradation is among their prominent imperfections. The Venetians, the great modern examples of colour, may be considered to have

made the nearest approach to the theory of the ancients without falling into their defects, or violating the characteristic imitation of nature. Yet the Venetian school has not escaped the charge of deficiency in chiaroscuro, and although the example of Giorgione was followed by other men of eminence, the prevailing character of the school was local colour as opposed to light and shade. These rival qualities are admitted by the testimony of ages to have been united in Titian in such proportions as are most compatible with the perfection of art, and in him chiaroscuro is the subordinate quality. It would thus appear that the style in which colour predominates is the fittest for the display of beauty, and that the uncertainty of shade is adapted to ideas connected with the sublime. The quantity of shade employed by different schools seems at first sight to depend on the difference of climate, yet, in the works of Correggio, who formed his style under the same sun of Italy, both the colour and the forms are much less defined than in the works of the Venetians. His manner is in fact formed from the nature of shade; in his hands it is deprived of all its less pleasing attributes, and he has applied it almost uniformly to subjects of beauty. The extraordinary union of beauty with mystery, so contrary to the general idea of nature, is still true to some of her most important facts, to which indeed all ideas of beauty tend; and it is curious to observe that the same feeling which led

Correggio to make beauty indistinct, also led him sometimes to treat a class of subjects which he alone could treat adequately. In considering beauty and love, or a feeling which resembles the latter, as cause and effect,* it appears that the definite nature of the first diminishes as the feeling (or blindness) of love or admiration to which it tends, increases, till the abstract idea of love dwells solely in the imagination, and is no longer measured by its cause. To produce an adequate object for this internal sense of beauty is the great end of the fine arts, and its triumphs consist in meeting it by definite representation. The style of Correggio, which is one of the wonders of human invention, owes its charm to the union of the cause and effect above mentioned. The palpable representation of beauty by him is more or less united with the indistinctness of view which characterises the feeling it tends to create. The voluptuous impression produced by this union is doubly reprehensible in subjects of a certain description, but in scenes of a purer nature it produces a charm no other means can approach, and which no painter has embodied in an equal degree with Correggio.

The above remarks are necessary to show that although this great artist's style belongs, strictly speaking, neither to the definite idea of beauty, nor

* Burke says, " By beauty I understand a quality in things which creates the sentiment of love, or some feeling which resembles it."

to the feeling of awe and fear which more or less
accompanies the idea of the sublime, it is still true
to very general ideas of nature, and if it were not
so it would not be so fascinating as it is. The
great distinction between the offices of colour and
of shade admits in the nature of things of no other
exception; the other great masters who have at-
tempted to unite them, rather than to make shade
the rule, differ widely from Correggio, and their
styles are true to that view of nature which admits
a certain quantity of accident. Such is the cha-
racter of the Spanish, Flemish, and Dutch colour-
ists; their styles are all to be ranged under the
two great heads of agreeable or solemn impressions;
they are often beautiful and often sublime, but the
union of beauty and mystery occurs nowhere but
in the works of Correggio. In the works of
Rembrandt the very opposite *motive* appears; the
effects of that great painter, even in ordinary
subjects, approach the sublime, his shade is thus
legitimately employed to conceal unpleasant forms
or to excite ideas of solemnity and grandeur. His
colour, which is equal to Titian, is, from the abun-
dance of shade, less in quantity, but, in strict con-
sonance with the nature of both, the accidental
effects of shade are accompanied with proportionate
ideas of solemnity, and his colour fascinates the
eye with its richness and beauty. Thus, if the
value which the scarcity of his light acquires is
untrue to the general impression of nature in which

beauty consists, the degree in which he departs from this idea never fails to bring him nearer the nature of the sublime.

It must always be remembered that the sublime is more or less accidental or uncommon, and any degree of accident which tends to produce, or is even excused by grandeur of effect, must not be censured because it departs from beauty. The lowest styles of art are those which admit the greatest quantity of accident without approaching the sublime; they are to be considered as lesser, or rather as the least degrees of beauty. It may be added that the works of art which belong to this class are not very numerous. The Dutch schools, however individual in form and conception, are abstract and large in colour and light and shade. Even where a work is deficient in most other general ideas, composition, and arrangement either of forms or light are always observable, so that a purely accidental or literally imitative work of art is hardly to be quoted. It seems indeed a contradiction to the nature of the arts.

As usual, it will be necessary to attempt to define the highest style in colour and chiaroscuro in order to avoid the multiplicity of exceptions which would attend any other mode of inquiry; it must only be remembered that the principles thus arrived at are not the only principles because they are the most abstract; on the contrary, the use of a good rule in any part of the art is to have some-

thing to depart from; some point by which the admission of accident may be measured.

The colours in nature are so infinitely varied that even on comparing objects apparently similar in hue together, a slight difference will generally be perceptible. Hence, however slightly marked the tints of substances may be, whether in the light style of Guido, or in the sombre and almost colourless effects of Ludovico Carracci, their relative differences must still be in some measure expressed. The office of colour is to distinguish.

The differences of objects are invariably conveyed by their general effect, their component varieties may be, and frequently are, similar in some particulars, but it is obvious that the abstract nature of colour will be most attained by suppressing the accidental similarities in different objects, and dwelling only on the points of opposition. The skill of Titian was particularly shown in distinguishing objects that apparently differ but slightly in colour; by exaggerating the characteristic hues to which they respectively tend, and by suppressing their common qualities. Thus Mengs and Fuseli justly observe that he took the predominant quality in a colour for the only quality, by painting flesh which abounded in ruddy or warm tints entirely in such tints, and by depriving of all such tints a carnation which was inclined to paleness. This would be chiefly done if two such complexions were in immediate comparison, for it

is evident the qualities to be suppressed or dwelt
on must always depend on the surrounding rela-
tions. The same practice is observable, particularly
in the Venetian school, in all other qualities; soft-
ness and hardness, transparency and opacity are
always more or less opposed to each other. It
may be observed, once for all, as a general fact,
that every quality in Nature is *relative*, and that the
comparisons which exhibit the mutual differences
of things are as essential as shade is to the display
of light.

It has been already said that the degree of light
which represents the reflexion of its source is sup-
pressed or sparingly admitted by the colourists,
except where such effects are constant. In shining
surfaces light is a common quality, for the degree
of brightness which represents it may recur in
similar objects. In all other cases it is the colour
of the object, however mixed, as we have said, with
the light, which is reflected to our sight, and it
will hence be always slightly different. The shin-
ing lights on skin are particularly suppressed by
the masters of colour when the flesh happens to
be near a brilliant surface, and on the same prin-
ciples the softness of flesh or hair is more than
ever dwelt on when opposed to a hard substance;
the light in the eye even is not shown if near very
white linen; the qualities would be similar, and in
nature they are different. The *degrees* of these
differences are not always possible or advisable in

art, and Sir Joshua Reynolds objects to the prac-
tice of Rembrandt in painting flesh as much below
the shine of armour as it is in nature; a difference
to *some* extent is, however, indispensable in all
cases where it is observable in nature, for a very
small portion of absolute similarity, if it is visible
as such, is enough to destroy relief. The relative
effect of objects requires the expression of such
only of their component details as assist, or, at
least, do not weaken their general mutual differ-
ence; in other words the intrinsic qualities are
to be expressed in subordination to their relative
effect, and where the difference in the whole effect
of objects is strong, the expression of their re-
spective intrinsic qualities is least of all necessary.
In opposition to the practice of the great colourists,
the modern continental schools (German renaissance
at Rome and elsewhere), however, hold that the
relief and detail of black objects, such as hair,
drapery, &c., should be as equally apparent as in
lighter substances. If this could be done without
destroying the relative character of the object, art
would do too much, and dark hair, so executed,
would attract our attention before the face; but in
general the relative character (or value) is de-
stroyed in the attempt, and complete failure in the
real end of imitation (the impression of a whole)
is the consequence of endeavouring to surpass the
economy of nature. Whenever the characteristic
quality of an object is that of strong opposition to

everything near it, its whole effect appears to be more than ever necessary in imitation. Its chief impression is its relative effect; a property evidently in danger of being impaired by introducing too many of its own intrinsic qualities. It follows that in all such cases (where intrinsic qualities are introduced) the surface or colour so treated will be least like the object considered abstractedly. The effects of light on black substances are different from the colour of the mass, and thus materially weaken its relative effect. It will be found that in the works of the Venetian, Spanish, and Flemish colourists the gloss of black hair is in a great measure suppressed. In any other colour the practice is less necessary, because the effects of light are not necessarily so different from the local hue of the object. The intrinsic or proper qualities of objects in detail thus appear admissible in proportion as their relative effect is weak. An object absolutely isolated would require to be absolutely imitated in all its parts, but as long as a comparison of any kind exists, the points of difference are the essential requisites.*

For the above reasons it appears (and the standards of excellence in this part of art justify the conclusion) that it would be false to correct an

* On the same principle, Sir Joshua Reynolds observes that no single figure can properly make part of a group, nor any figure of a group stand alone ; also elsewhere that a single figure requires contrast and details in its parts.

exaggeration of the qualities of an object (if nature had been at all kept in view) by adding more of the same quality near it. The contrary practice of giving it character by opposition will be attended with better success. If flesh, for instance, is never more glowing than when opposed to blue, never more pearly than when compared with red, never ruddier than in the neighbourhood of green, never fairer than when contrasted with black, nor richer or deeper than when opposed to white ; these are obviously the contrasts such exaggerations respectively require, because they are the truest modes of accounting for them. To correct redness by red, or paleness by white is the opposite, and, as it would appear, the narrower and less effective method.*

It has been observed that shade is the common and uniting quality, for by whatever means the extreme degrees of it are represented, these appearances will occur, however varied in quantity, in every object seen at the same distance. With reflexion, the region of light and colours again begins, but the uniting principle of shade will of necessity soften the differences of hues in this case, and it is a well-known precept that the colours of

* It may be observed that any cold colour in the neighbourhood of flesh must be in its mass darker than the flesh. Red may be either darker or lighter—the latter if the flesh is dark and cold. Flesh is best treated as a dark in the neighbourhood of yellow, the yellow can only be treated as a dark when the flesh is very glowing indeed.

objects, however different in the lights, should be of the same or nearly the same colour in the shades.* It follows from the foregoing observations that it would be false to the general and largest view of nature to unite by colour and to distinguish by light and shade. Both these truths, however, have their modifications. In all cases where distinction by colour is no longer sufficient, distinction by accidents of light and shade may be necessary. This happens in such distances where the colours, even of large masses, cannot be much distinguished; in which case the accidents of light and shade are employed with success. It is very common to see these effects in the backgrounds of Venetian pictures, although they are jealously excluded from the nearer objects.† In the background they remind us of the *presence* of light, which thus exhibits *itself*, while in the foreground it is only used to display, as usual, *the objects of nature*. It may be remarked that we are only reminded of the source and operation of the light when its effects are accidental and somewhat extraordinary; for, although light reflects itself in shining or liquid surfaces, those appearances are permanent in nature, and thus may belong to the highest style

* Sir Joshua—notes on Du Fresnoy. The Venetians exhibit more of the differences of colour in shade than any other school.

† Such, at least, is the general character of the school. Tintoret is an exception, but the Bassans, however dark in their effects, are seldom accidental.

of imitation. Again, according to high authorities,
the difference between near and distant objects is
often expressed by accidental shades on one or the
other ; the distinction of near objects from each other
by accidents of light and shade is the most direct
infringement, and most needs circumspection. In
large compositions where variety must necessarily
accompany quantity and numbers, it can hardly be
avoided, or rather it would be false to avoid it, but
it is opposed to the most abstract interpretation of
nature.

The Venetians never seem to admit union by
colour till the differences of hues are lost (as we
have said) in distance, and accident necessarily
begins, but other schools, such as the Dutch and
Flemish, break and diffuse the local colours some-
times till they may be almost said to lose their
locality and become common qualities. Sir Joshua
Reynolds instances the Bolognese school and Ludo-
vico Carracci in particular as the strongest example
of this; in his works the colours are almost reduced
to chiaroscuro, and lose, as it were, their nature.
Such effects can be fit only for a particular class of
subjects, and must be considered exceptions to that
general idea of nature in which beauty resides, but
the more moderate degree in which the Dutch and
Flemish practised this system does not destroy joy-
ous impressions, but only serves to mitigate the too
pronounced integrity of the colours. In this ques-
tion, perhaps much of the difficulty is to be solved

by the influence of climate, yet even the northern critics acknowledge the pre-eminence of the Venetian school, and Rubens, one of the chief authorities for the *union* or breaking of colours, borrowed his style from the Venetians themselves, the great examples of the relative *difference* of hues.

The difference between the Venetian and Flemish schools is, after all, less than it appears, even in the point under consideration. It must be remembered that the brightest tints we see (in the brightest scarlet stuffs for instance) are never pure, and it is as impossible to separate one colour from a ray of light by a dye which shall absorb all colours but that one, as it is to mix the whole seven into white, by artificial or material means. Yet these imperfect tints, for such they are, of the brightest draperies are far too splendid for the purposes of art, and need to be sparingly introduced, so that a picture may be insufferably crude and gaudy, and yet be composed of impure colours. It is known that the brightest and apparently the purest colour reflects a portion of many, if not of all the others, nor is there a tint used in Painting, however bright, which is not in some degree broken by all the hues of the Prism. Nature is thus the remote as well as the immediate authority for this breaking and harmonising system. We are accustomed to attach ideas of splendour and brilliancy to the Venetian school, yet their pictures exhibit a low, solemn harmony compared to many a work that might be

instanced belonging to modern schools. It is need-
less to observe that this depth and harmony is
greatly attributable to a certain breaking and
toning of the colours; for the integrity and
purity of the tints which are remarked as charac-
teristic of the Venetian school are relative terms,
and mean anything but unbroken colours. The
difficulty of lowering, breaking, and warming the
colours so as still to *appear* pure is precisely in
what the difficulty of colouring consists, but it is
indispensable to a just imitation of nature. It is
perhaps impossible to determine, except by the
testimony of that accumulated experience which
settles the various claims of talent, to what degree the
union of colours should be carried. That decision
has been pronounced in favour of the Venetians as
the highest in style, and the bad imitations of that
school prove that it is very hazardous to attempt
the integrity of colours further than they have
done. The opposite system is undoubtedly safer,
for the Flemish painters by breaking and repeating
the colours still more than the Venetians, succeeded
in forming a pleasing and harmonious, though a less
elevated style. A still greater union such as we
find in the Bolognese school, in Murillo, and in
many of the Dutch painters has always been found
to be agreeable, and has, in many cases, entitled the
artist to the reputation of a colourist. It must not
however be forgotten, that, to whatever degree this
harmonising system is carried, and however mingled

the materials appear on a close inspection, a difference of some kind is absolutely necessary when the work is seen at its due distance. This is not difficult, for it is hardly possible (even if the artist intended it) to make two colours exactly alike on the breaking system. In like manner the repetition of colours which is so often recommended, does not mean an absolute repetition of the *same* tint; a slight variety of it is more pleasing, and is quite sufficient to appear a repetition. Thus in every school that pretends to colour it will be found that the great office of distinguishing and the great characteristic of variety always accompany the management of the colours; whatever may be the degree in which the principle is attended to.

NECESSITY FOR DEFINITIONS.

DEFINITIONS are arrived at by ascertaining what a thing is not. This is not so endless an enquiry as might at first be supposed: it would obviously be unnecessary to compare an object or quality with others totally and evidently dissimilar to it. In order to arrive at something like precision, the range of comparison must be narrower; it suffices to distinguish the object or quality from those with which it might by possibility be confounded, or which, at all events, are most nearly allied to it.

Definitions are arrived at by ascertaining what a thing is not. This, which is true of mental perception, is also true of outward vision. The immediate and indispensable cause of our perceiving an object, so as to be aware of its nature, is its difference from what is next it. Its essential character consists in those points in which it differs from *every* thing else.

Such being the cause of visible distinctness, the first step in painting, to produce a just imitation of nature, is to define and apply the principles of negation. The negative element sought may be either general or specific. For example, the expression of substance will be assisted by the opposition of space; but the representation of a specific substance or object will be assisted by a comparison with other objects calculated to define its particular character.

To proceed in due order : it is necessary to begin with general negations; general distinctness, which is their aim, being of primary importance. For it is not enough that the specific character of an object should be accurately expressed, it is first, and above all, necessary that the mere substance should be distinct. The positive elements are form, light, and colour : the negative elements are therefore obscurity, or space, and neutrality.

With regard to form, which always supposes variety, the comparative negation is the straight line; the absolute negation the absence of all lines.

With regard to light, the comparative negation is diminished brightness, the positive negation absolute darkness. With regard to colour, the comparative negation is reduced vivacity, the positive negation neutrality.

In each of these cases, the negation is the real cause of effect, and the attention should be chiefly directed to its due employment and not to the quality to be displayed, except only as it may be an exponent of the other. Diminished brightness, neutrality, and the absence of form are then the chief elements of effect, and they are to be considered as the foundation of all visible distinctness, vivacity, and character.

It is the same with other qualities; a spirited touch is desirable, but the touch itself is not to be thought of till a bed is prepared for it, which, by its more or less *sfumato* nothingness, shall give the touch value.

NEGATIVE LIGHTS AND SHADES.

The negative shade of every colour is best prepared by a hue exactly opposite to its light. The negative light of each colour may be obtained by a mechanical means. A colour placed on one side of a semi-diaphanous substance, thin ivory for instance, will give its negative light on the opposite side—that is, the medium of warm white through

which it is seen makes the real colour appear lighter and cooler in a just proportion. Intense orange yellow, (deep chrome) seen through this transparent medium, gives for its light a warm, light rose colour; vermilion gives a cold light rose colour; lake, a very cold light rose or purple colour; light red, a light purplish; burnt sienna, a light purplish grey; brown, a light grey; or, all these light colours being given, the other colours are their depths or multiples. Blue gives a comparatively warm light grey, light green a light greenish grey.

These colours are generally found together in nature. Thus when the sky is nearest to blue (for when the clouds are coloured it is no longer a pure blue), the clouds, with their warmish light grey, represent the same harmony which the above experiment gives, and which would be agreeable in a drapery. Green leaves give their negative light in their under colourless parts, and give as they change their tints also the colours that harmonise with green, such as brown, warm and cool, light yellowish brown, &c. A rose gives a cool light like the warm colours above mentioned, being most coloured in its reflexions, where the colour is multiplied into its real strength.

These things are easily arrived at with the more positive colours, but the colourist is shown most in balancing and adjusting with equal nicety those which are the most nameless. Any common colour,

such as the tone of the ground or rock, a tree, &c., has its true negative light and its true shade. A picture that is full of exquisite harmonies of this kind, even to the most undefined subdivisions of the colours, is highly finished; and this is one of the highest excellences of oil painting, because it is an excellence peculiar to this art.

NATURAL HARMONIES.

THE imitation of nature teaches the artist to apprehend, or at least to have some glimpse of the mystery of the *relations* of harmony; but the real power of the arts is not acknowledged or arrived at till the artist can supply the relations which cannot be got directly from nature. This creative power is necessary even in the lowest departments of art, for, unless an entire scene is copied from nature, something of arrangement, composition and harmony is supplied by the artist. Now the science derived from the imitation of nature teaches what follows from certain data, and although the rules which regulate it may be, strictly speaking, useless to one who has not found them for himself, still the grander principles which influence those rules are intelligible and applicable from the beginning, and comprehend in their just application all the minutest cases which demand solution. There can be no doubt that the Greeks had reduced the arts

to this certainty, and made them as sure in their results, although apparently imitative, as in the more creative arts of architecture, and the invention of the forms of vases, furniture, &c. The uniform and pervading excellence of all they did is not to be explained by any other means.

The dependence of every portion, every atom of nature on what it comes in contact with, is its *life*, its excellence, its beauty. A work of art is therefore not even imitative which does not represent this chain of mutual dependence. It is like the principle of the wedge, the smallest or the largest portion represents the same power; and so, in a fine work of art, the relation of the smallest portion, which is thought worth admitting, to its neighbour, is as true as that of the grander contrasts which first command attention. On the other hand a portion of an imitative work which is not allied to and does not present an epitome of the whole is dead and false.

Again, a work of art which is true to itself in these great principles of nature is more really imitative than a collection of facsimiles of the peculiarities and accidents of nature, which, it will generally be found, have no connection with each other. We admire a Greek temple or a Greek vase, and if any one should observe that there is nothing like them in nature, we might wonder (admitting the remark) that we could admire them; but a little reflexion would teach us that we only admire *because*

they are true to the principles of nature, although not imitative, or imitative only in the largest and truest sense. The Greeks were not at a loss in thus apparently creating, because their whole practice of the arts, even in those more apparently imitative, was equally intellectual,—equally removed from blind copying. However startling this assertion may be, it will cease to appear strange when it is remembered that the modern imitative arts are equally creative wherever they command permanent admiration. The *choice* of forms and attitudes, or, when these are less necessary, the choice of colours and their exquisite dependence on each other, and above all the indispensable requisite of that general effect in painting which is calculated to attract, partake of this creative power, being imitative of nature only in her spirit. The theory of the fine arts therefore which are addressed to the eye may be defined to be *the science of the relations of nature*, or the power of combining as nature combines without nature, for nature can only assist the artist in his actual operations by giving him the materials. We can thus understand it to be possible that Claude, who, his biographer relates, spent whole days in observing the appearances of the outer world and in forming a mind equal to all cases, yet never painted a study from nature, although he necessarily reverted to her for the details of forms.

NATURAL CONTRASTS.

As long as things are compared together their beauty will be identified with the points on which they differ, but the sum of these differences will be found to be their characteristic qualities. Hence the great principle of imitative art that contrast is as character, importance, and beauty, and hence the spell which rivets the attention on the points of interest, and regulates the gradations of interest in the spectator. The contrasts in nature by which the eye is principally informed, viz. those of forms and colours, are differences of *kind*; the contrasts of light and dark, hard and soft are differences of *degree*. These, we may suppose, comprehend the chief contrasts in imitative art, but it is scarcely necessary to observe that there is no quality which is perceptible to the senses which can be a quality at all but as differing from that which it is not. The qualities of transparency, solidity, smoothness, proximity, &c., can only strike us to be such by a comparison with some approach to opacity, lightness, roughness, distance, and so forth. The vast field of observation which is spread before the painter accounts at once both for the rarity and also for the variety of excellence in this art, and shows how natural it is for a nation, a school, or an individual to select such portions of this translation of nature as the authority of custom, accident, or inclination may direct. Thus we find

the Venetian school delighted in the vivacity which results from contrast of colours; while the Flemish and Dutch schools dwelt rather on gradations of light and shade, and hardness and softness; excellences but imperfectly practised by the Venetians. Each school had its exceptions. In Italy, Leonardo da Vinci, Giorgione, and Correggio tempered more or less the display of colour with the gradations of chiaroscuro, while Rubens, Rembrandt, and Reynolds added the colour of Italy to the fascinations of the Northern schools. The quantity of distinctness, and the greater or less rapidity of gradation in what relates to the conduct of a picture are the points in which schools fluctuate most. On the hazardous question "which is to be preferred?" we do not hesitate to assert that the representation which offers the greatest sum of such contrasts as agree with the general, remembered, or permanent impressions of nature is to be preferred to the truth with which a particular or extraordinary appearance is rendered. The works of art which a now immutable decision has placed in the first class exhibit in their several departments the largest facts or appearances of nature which were the object of study in that department. The excellence of such works in one or more qualities is often accompanied with very slender pretensions in others; hence the mistake often arising in the criticism of the arts, and the difference of opinion even among artists who see

nothing but their darling excellence. In a word, the excellence of imitative representation may be defined to be its conformity to the style of the arts —to the style of the particular art—and to its fitness to address human beings; in other words, its general means, its specific means, and its only end.

FINISH.

FINISH in an imitative work implies the accurate and true relation of each quality to its neighbour. In painting, the finish which is at once most in the style of the art and most difficult is the nice calculation of each hue on that next to it. This is called *fineness* of colouring, but it is in fact nothing more or less than that truth which the art proposes.

SPACE.

THE flat surface is got rid of by composition, aided by linear and aerial perspective; by roundness and gradation; by colour; by execution; and by the nature of the vehicle.

As respects composition, it is got rid of by varying the places of objects and their parts in depth, as opposed to superficial, basrelief composition. Every object should mark a different degree of distance. If there are but few objects, still, they should never occupy precisely the same plane; and one object should, as often as possible, be

placed obliquely with the plane of the picture,
by which means every point of its extent marks
a different distance from that plane. With regard
to different objects, the same rule in composition
which, in basrelief, dictates their not being placed
horizontally or perpendicularly in a line with each
other, requires that they should not be equidis-
tant from the plane of the picture. When their
position in depth is thus varied, their apparently
superficial parallelism, either horizontally or ver-
tically, is of less importance; but the same variety
should be observed in every direction; in the hori-
zontal and in the perpendicular direction, and in
the direction at right angles with the plane of the
picture—that is, in depth.

Architectural lines and surfaces are frequently
parallel with the plane of the picture: the common-
est case is a flat wall, or portion of one, directly
opposite the eye. This is a case where the other
modes of variety, above enumerated, are especially
required, and where the flatness of the wall, which
is unavoidable, should be shown to be quite distinct,
and more or less distant, from the flat plane of the
picture. To these modes of variety we shall return.

The representation of space is the abstract ex-
pression of that receding distance from the plane
of the picture which should be marked by objects,
when objects are introduced. In their absence
much depends on gradation, colour, execution, and
vehicle; and this is one of the instances where the

effect of nature may be approached by means entirely
belonging to the materials of art. The best example
of this peculiar skill is Rembrandt. Gradation is
applicable to a flat surface, and is therefore not in
itself sufficient to produce the desired effect of
space; gradation, in the case of the varied light and
tones on a wall, does not alter its flatness; it would
falsify the object if it did: all that it does is to
show that the flat surface, so represented, is, as a
whole, more or less *within* and distant from the sur-
face of the picture. It is quite allowable to give
a greater impression of transparency and depth to
the substance or texture of the wall than it really
possesses, but not to falsify its general character.
This character is easily maintained by a line of
architecture across it, a cast shadow across it, an
object suspended upon it, or any contrivance which
expresses and defines its actual flatness, even though
the execution should convey the impression, to a
certain extent, of depth.

But, in the expression of actual depth, the grada-
tion, which is more or less regular on a wall, is not
necessarily so in space. Here the appearance which,
on a solid surface, would give the effect of undula-
tion rather than flatness is admissible to any extent,
subject only to the effect of chiaroscuro required
in representing space. The *in-and-in* look which
Rembrandt expresses so well might doubtless be
regular, like a quiet evening sky, but he rarely, if
ever, represented such unbroken effects. His depth

is contrived on the same principle as its expression by accidentally placed objects would be conveyed —that is, its indications are irregular, undulating, and not in unbroken succession and order. The most distant point (if it be permitted so to distinguish such vague measures of distance), whether expressed by darkness, by inward light, by retiring colour, or by execution—by the mutual relation of semi-superposed pigment, or by lucid vehicle marking *real* depth—that most distant point or place represents what, in composition, would be the most distant object, and so of nearer points or places.

EFFECT.

WHAT is called *effect* in painting consists in sacrificing many things for a few. The Italian word "*despotare*" is a very strong one applied to the art of making the principal object tell. Effect is, however, incomplete till the objects or points in these objects (for the system may be for ever subdivided) surpass what is round them in all the requisites of effect. Perhaps the most essential course is to have no lines equally cutting in the immediate neighbourhood. Nothing gives relief more, for it corresponds with the effect produced in nature; when we fix our attention on a particular object all round it is mist and indistinctness.

CHIAROSCURO PREPARATIONS.

THEIR EFFECT, DULY MANAGED, OF PRODUCING
DEPTH AND RICHNESS.

In the system of thin painting, adopted by some
Flemish masters, and perhaps carried farthest (on
a large scale) by Fra Bartolommeo among the
Italians, much depends on the chiaroscuro prepara-
tion. The light ground is left for the lights, but,
by the time the half-lights (as well as the sha-
dows) are inserted, very little of the white ground
remains. The transparent preparation or chiaro-
scuro (formed by a brown only, with lights left)
being *quite dry*, the local colour is thinly painted
over it. Light over dark is cold; and, in order to
preserve the requisite warmth, the tint (suppose
light red and white) spread over the preparation,
still deepens in colour as the half-lights deepen:
if this were not attended to the half-lights would
still be too cold—and the darkest would be the
most leaden. But by still proportioning the depth
of the warm flesh tint to the depth of the half-
tint, a sufficient coolness (more or less as required)
may always be preserved; the deepest shades
should be retouched, if retouching is at all re-
quired, with transparent darks only, and will con-
sequently be very warm. In this system the cool
tints are produced in various degrees by passing
light over dark, and no positive cool colour need

be introduced anywhere, except, if required, in the highest lights,—for there, the ground being pure and bright, nothing lighter (consistent with truth of tint) can be passed over it; consequently cool tints cannot be produced *dynamically*, that is by seeing dark, or any degree of it, through light. In such cases actual cool tints may therefore be introduced if necessary, and the slightest tintings, whether of extreme warmth (as in vermilion touches) or coolness, which may be required to complete the work or to prevent monotony, will effectually conceal the artifice of the process. No other process so well secures depth and clearness, and combines richness of transparency with apparent solidity. To conceal the process still more, the high lights may be freely impinged with apparent substance (and some actual substance) by the aid of a thick, but not flowing vehicle, (drying cerate with " vernice liquida,") and the whole may be finally glazed to a still warmer, deeper tone. The whole circle of operations might then be repeated—scumbling and glazing to any extent; but probably without adding to the original qualities in colour and real depth, although other improvements (in expression, &c.) might be the result. If, in the chiaroscuro preparation, white is used to insure greater completeness in form and expression, the whole system becomes more complicated, and care is requisite, perhaps with repeated operations, to preserve transparency in the

shadows equivalent to that produced by leaving the ground. Heads, in unfinished pictures by Titian, are examples of this method. Solid chiaroscuro under-paintings, but by means of glazing brought into much the same state as a preparation with the ground left, should be first laid in; over such work, the thin, warm, flesh tints, leaving the deepest shadows for still richer tonings, would have the best effect.

In thus tinting a sky, prepared with a gradation of brown on a light ground (which should be quite dry), it is essential to clearness and depth that the blue and white superadded tint should be darker than the brown transparent preparation. When not so, the blue has a cold opaque look—on the contrary, it has always a toned warm effect when thinly painted over a ground lighter than itself. Care should therefore be taken not to make the brown preparation too dark, especially as the blue can always be toned by glazings and so rendered darker. In this system of sky painting, if there is any solid work it can only be in the preparation, ultimately toned and embrowned in the mode before described for flesh, before the thin blue is superadded. In order to get the blue flat (the preparation being quite dry) it should be laid in with a slow drying vehicle—mere oil—to which a little spike oil may be added to prevent needless yellowing. The same principle (that the superadded tint should always be darker) applies to all

cold colours—green, grey, &c., but warm colours
may be sometimes lighter than the brown ground,
even when they are transparent, in order to pro-
duce cool tints.

CHIAROSCURO PREPARATIONS.

TRANSPARENT BROWN.

RAW umber and white may be made a very pleasing
colour by the light over dark, and dark over light
system;—cool, silvery, tender tints are produced
by the former process, and (by contrast) a great
amount of richness by the latter. The softness
which is the result of the scumbling and "flat-
tening" system, with large brushes, can be agree-
ably contrasted with pressed, abrupt, crisp touches
in lights and in *sillons lumineux* with the same
brushes—as well as by occasional sharpness in
shades.

When umber alone has been used in darkest
broad shades, and proves to be too opaque a
preparation for ultimate deepest shades, it will be
found possible to lighten and warm them a little
by introducing vermilion and other very warm
tints in minute quantity, and without stirring
much, in the midst of a quantity of vehicle. This
can be finally glazed with a very rich brown, and
with more vehicle. In the Rubens system of lay-
ing in the deepest shades with a dark transparent
brown only, much vehicle should also be used with

the colour—if not at first, at last. This system is
difficult unless the whole be laid in with the same
brown, for otherwise chalky solid lights continue
long out of harmony with the rich, brown, diapha-
nous shades—the eye only tolerates the latter when
the lights are rich.

For an ordinary brown preparation, not too
glazy, raw umber, warmed with a tint composed
of Cap. brown, and burnt sienna, will do. This is
convenient because of its quick drying before the
dust adheres to it, but any brown, not too neutral
(sufficiently warm) and not too oily and glazy for
the lighter parts, will do.

The thick glossy vehicle used at last (and which
is useful for protecting and sealing the work) is
not desirable at first, and as a surface to paint
upon, for many reasons. Above all, because the
colour does not adhere to such a glossy surface,
and there is the danger of portions becoming after-
wards detached. To obviate this, when painting
on such a surface is unavoidable, it is advisable to
soften it as much as possible beforehand, with a
strong essential oil. The Venetian principle of
using nothing glossy in the preparation and first
paintings, is the safe principle. But they feared
not a thick glossy vehicle at last, and especially
for depth.

DEPTH OF LIGHT TINTS.

As the "depth of white" is found by spreading
white very thinly over a dark (warm) ground, and
imitating by a solid mixed tint the pearly depth so
produced, (see p. 286) so the (cool) depth of flesh,
or of any warm light colour may be found in the
same way. All such depths being more or less
negations of the colour, or opposites to it, must
consist of the three colours in some form or other,
and in varied proportions—the union of the three
being the characteristic and condition of negation.
The purplish greys which are the result may be
sometimes composed of blue and a warm red (the
warm red being strictly speaking of the nature of
orange). Thus ultramarine and light red will pro-
duce a purplish grey fit to represent the cool depth
of some warm lights; black, blue, lake and umber,
and a hundred other combinations come to the same
general result of neutrality, but more or less *fine-
ness* and delicacy of tone is arrived at by imitating
and matching, as nearly as possible, the ethereal tint
produced by thin warm light over dark, when a
flesh tint or other warm light tint is very thinly
spread over a warm dark ground. As the light of
this neutral coolness is warm, so the darkness
opposed to it requires to be of the same warmth in
an intense degree. A mellow, warm light, (which,
strictly speaking, is always some degree or kind of

orange) is, in its darkest state, the richest possible brown—the warmth and richness required may be heightened by transparency, by showing a light ground through the warm darkness, and by rendering the browns more lucid by a transparent but substantial vehicle.

WARM SHADOWS.

THE colourists of all schools treat the deepest shades as intense and, more or less, transparent browns. This brown could undoubtedly be produced by glazing over a not too dark grey (rather over a light grey—as was the practice, in consequence of his ground, of Rubens); but such a system could express no force of light and shade, and in Rubens' case, although the ground was often a light grey, the brown dark was inserted at first in its deepest power. There is, therefore, in this respect, no essential difference between the Italian and the Flemish practice; intense brown, no matter how produced, is common to all the colourists in dark shadows.

The system of expressing almost all degrees of chiaroscuro by grey, as the lower depth of white, led some great painters, and, to a certain extent, even Correggio, to adopt too blue a preparation for their darker shades. Neutrality, by dint of glazing, may doubtless be attained in such shade, but generally at the expense of clearness and warmth.

Zanetti, in eulogising Giorgione, says that his shadows were not "bigie" or "ferrigne" like those of some other painters. The Lombard painters generally, including many followers of Leonardo da Vinci, have this defect, this iron coldness in the shadows; but even they employ deepest brown, and brown only, in the intensest darks.

With this precaution, either avoiding very dark bluish greys in the lowest half-lights, or gradually warming them as they pass the ordinary force of light middle tints (where this coldness is desirable) the system of modelling with a grey that is really neutral cannot be too much recommended. The utility and the charm of this neutral tint are most felt when, after the preparation is dry, the middle tints are allowed to imbibe degrees of warmth— for the nature of the grey is such, from its absolute neutrality, that the slightest tinge of colour upon it is precious and harmonious.

TREATMENT OF GREEN AND BLUE.

1. A NEUTRAL grey preparation being duly lighted up and modelled, without bluish low tones, and with brown only, or a preparation for it, in the darker shades—vivid green tints, not, however, of the bluish kind, are passed thinly over the half-tints, the lights being left. The modelling may be assisted by darkening or lightening the green middle tint, but the higher lights are, more or less, untouched.

When dry, the whole is glazed with a rich brown
—the precise kind, (whether semi-opaque, or dark
orange-like, *ut scis*, or perfectly transparent of the
same or of a browner tint) depending on experi-
ment.

2. The only difference in the second mode is to
slightly glaze the whole grey preparation with a
warm brown at first, and, either at once, or better,
when this glazing is dry, to insert the green middle
tints in the mode above described. The vehicle
for such rich operations had better be the usual
Italian glazing vehicle.

The question now is whether blues, light or
intense, might not be prepared in the same way.
In the first place the method, No. 2, above no-
ticed, is the only one that would answer in such
a case. The grey, well modelled, and somewhat
sharp preparation, with brisk lights, very brilliant
or not, according to the colour required, with half-
tints not too bluish, and with brown in the in-
tensest darks—this grey preparation, when dry,
is first glazed with a rich orange-like brown.
When dry, (and here this is essential) the blue
middle tints are inserted in various degrees of
strength, so as to assist the modelling. The lights
are as yet left, and may be altogether left in
certain blues—in which case they present, by
contrast, a broken, mellow, dusky orange-tint to
the blue middle tints—a rich deep brown succeed-
ing in the intensest shades, and sometimes (as

there are examples in Titian) in reflexions. The crudeness of the blue, if striking, may be ultimately modified by glazing.

But, if the blue be required to be very deep, the preparation corresponding, the lights are entirely covered with the blue tints (though not the deepest shades, which are supposed to be, partially at least, as dark as possible). In this operation, therefore, much depends on showing enough of the glazed and warm preparation through the blue, especially in the lights and in the lower tones, for, in the middle tints, the blue may be most powerful. In this again a final toning may be required.

In repeated operations, such as those above described, it is not necessary to oil out when the dry surface is dull—as in glazing a brown over the solid preparation (which preparation, if properly executed, will present a perfectly dull surface), previous sponging being all that is required. But, after it has received the brown glazing, the surface will probably be more or less glossy, and, in inserting the blue on that surface after it is dry, it will be better to oil out—taking care to remove the oil afterwards with a linen rag till it scarcely leaves a trace on the cloth.

If this treatment of blue for draperies should prove satisfactory (as it certainly answers in greens), it would also be found that skies, and blue mountains, and distances might be treated in the same way, and thus the same system would be

used throughout. The forms of the sky being modelled, and the place of the blue, or portions of the blue, being indicated by a light grey (but not bluish) middle tint—the whole, when dry, may be lightly glazed with a warm brown, the portions which are to be blue being well warmed. When dry, oil out as above, and insert the blue, allowing the ground to be partially seen through in the places intended for it ; varying its depth of course as required, and as already indicated in the preparation, and toning finally, if necessary.

In landscape, generally, the forms may be defined and the lights impinged with the grey middle tint lightened with white ; still avoiding too bluish a grey in the lower tones. When dry, glaze first with brown, and then insert (the surface being dry) the local broken colours—masses of green, of brownish, yellowish, greyish, &c.—leaving the warm ground under and amidst the cold colours, and occasionally reviving and increasing the grey under-tint in the midst of warm colours. The whole are toned at last, more especially the greens and blues—the only tints which, in a landscape, are in danger of being crude.

With regard to reviving the grey preparation, this was evidently a frequent resource with the colourists ; the only difference being that the grey produced over a more or less finished and warmed surface may be a dynamic grey—that is, a cool tint produced by scumbling thinly a light tint over

a dark. Still, the same grey may be employed, only it should be spread more thinly. Occasionally, however, it may be solidly touched over the finished portion and toned again as required.

This system is also observable in the practice of the colourists in flesh painting. It is not a regularly calculated system, or rather, the system, however well calculated, rarely " runs smooth " through all the operations ; remedies are resorted to, and they consist in restoring comparative light and coolness where required, to be again toned and harmonised with the rest of the work.

The darkest shadows, or, at all events, very forcible shadows, may be improved in tint, when required, by the same means : the grey then used is not a violently light colour, nor does it really border on blueness; that it will appear light and cold, when so applied, is however certain, and it should be so contrived that the patched portion is not violently offensive even before it is glazed.

Untrue half-tints and depths may be rectified in the same way : they should be first scumbled (*botteggiando*) with a neutral grey, duly removed from blueness. If the passage to be rectified be sufficiently light, it may then be toned so as to harmonise with the rest of the work.

As the depth of light golden, or warm-coloured hair is prepared with this grey, so the same grey may also be used as the preparation for the depth of gold; for, when warmed by the right glazing

colour, (no matter whether semi-opaque or trans-
parent,—better semi-opaque at first) it expresses
the true depth of gold. In some pictures the
lights appear to have been at first indicated by
white, or a tint slightly removed from it, such
lights being covered with opaque (that is, semi-
opaque because thin) light yellow at last. Other
painters have taken a shorter course, but, in the
works of all colourists, a balance of warm and cold
has been by some means or other preserved in the
minutest, as well as in the largest portions.

In repeated operations the principle, therefore,
seems to be neutrality upon colour, and colour
upon neutrality. The only exceptions are blue and
green, which require to be inserted on a surface
apparently the opposite colour. Lastly, purple is
the representative and index of opacity; when
treated as a transparent colour it is most agree-
able when it has more lake than blue. A deep
transparent violet is found in works of the Ferra-
rese and Milanese painters, but never in those of the
Venetians. The purples or lilacs of the Venetians
are always opaque, and appear as half-lights, never
as transparent intense darks, and never as high
lights.

OILING OUT.

In painting the human figure, the refinements of
expression and the perfect anatomical modelling
of parts in subordination to general roundness, sup-

pose, at least in some stage of the work, great nicety of execution and great delicacy of manipulation. Whether this can be accompanied with evident freedom or not, there should, at least, be no appearance of labour. If the touch cannot be light and varied, it should not be apparent at all. There is no danger of extreme minuteness in the solid painting, nor in the transparent shades. In the first, the bright preparation may consist of few and simple colours, and as there can be no fear of sullying such colours, even in the lowest half-tints, there can be no temptation to a timid handling. In the shades also, if inserted once for all in a transparent state, on the Flemish system, any approach to minuteness of touch (except where mere lines are required) can be obviated by sweeping lightly over such touches with a broad soft brush; and if, on the other hand, the shades are painted more solidly, to be afterwards glazed, the method presents no more difficulty than that adopted in the lights, answering to that produced by the Italian " *sfumino.*" The degree of minuteness lies rather in the final retouchings and scumblings with a view to truth of modelling and tinting, and the evil is best obviated by glazing, or at least oiling out (and removing the superfluous oil) before beginning these more delicate operations. For if such operations are attempted on a dry surface, the scale of the work being small, a greater or less amount of stippling is the almost unavoidable consequence. No spreading and soften-

ing with the "*sfumino*" overcomes this quite, because many minute (hollow) portions of the surface remain dry, and present an untoned contrast with the rest. The previous glazing or oiling out may therefore be considered indispensable, before the more delicate work in question is commenced. The method is indeed recommended by Armenini, and was no doubt adopted by the Italian painters generally. The retouchings on a dry surface, which the Venetians perhaps almost exclusively employed, were always bold, and are not to be confounded with the final scumblings and glazings above referred to. The system of impinging sparkling lights, and even insulated darks, was rather a completion of the abrupt, crisp preparation before the finer union of the parts was attended to. That finer union, with the Venetians, as with all other painters, Italian or Flemish, was, and can only be duly accomplished, so as to avoid the appearance of labour on the one hand or spottiness on the other, by working on a moistened surface with finely ground tints. It rests with the artist to use, in this stage of the work, an ordinary thin vehicle or an oil varnish with his tints; for such literally alternate operations the Italians, and even the Venetians, frequently used the oil varnish. This, when employed profusely, as in Titian's St. Sebastian (Vatican), no doubt superseded the necessity of a final varnish, at least for many years. It appears probable that the oil varnish was then used abun-

dantly in the last general glazings and scumblings in large altar pictures, which were to be sometimes exposed to damp, and at all events to great varieties of temperature in churches; while, for works of less extent and intended for other situations, the surface, being less protected, (in consequence of a less robust vehicle having been used), immediately required the essential-oil varnish, which served to protect, as well as to bring out the colours.

VEHICLE FOR SHADOWS.

IN painting it is safe to assume that till the darkness reaches the intensest degree, transparency increases with darkness. Warmth, therefore, increases with darkness, at least as long as any inward light is visible; and, to avoid blackness in the deepest shades—to be " deep yet clear," it is still desirable that here and there points of warm reflected light, varying in extent of depth, should be visible. The transparency of deep shades is greatly assisted by the rich consistence of the vehicle; light being then reflected not from the lucid surface, but, however faintly, from within it. For rich darks it is always desirable to have a thick vehicle. This vehicle should be clear, but it need not be colourless. It should not be liable to crack. It should be also quick drying; because, if slow, the dust which unavoidably adheres to the surface may affect the transparency of the

shadows, and is, at all events, difficult to remove. Thickened, or half-resinified oil, is well adapted for this purpose, but an oil already inspissated with a resin is, perhaps, preferable, as the paleness of the oil is, for the purpose in question, not so essential. The oil and sandarac varnish, "vernice liquida," if made according to the old receipts (3 parts oil to 1 of resin) is sufficiently thick. In order that the richness and lustre in the vehicle should be permanent, it is safer to use such an oil varnish instead of resins dissolved in essential oils only. The latter, useful as they are for some purposes, and however brilliant at first, have not the lasting clearness which is desirable in deep shadows. The defect of the oil varnishes, even when much thickened with resins, is their tendency to flow, but this, if less compatible with extreme sharpness of execution, is of less consequence in shadows and may be corrected in a great measure by the dryer.

The internal light represented by a light ground, over which transparent colours are passed, may be renewed and reproduced (and can only be reproduced) by the hottest orange-red colours. The "rouge de Mars," sometimes lightened by the scarlet Mars, together with the vermilions, and similar colours, is well adapted for this purpose, but it is essential that the colour should be impinged in its brightness and not smeared or rubbed, for, when so passed over a darker tint it will only make a

heavy and even greyish colour. The best mode of
securing its sparkle and brilliancy and, at the same
time, of producing that partial broken effect only
of transparency which is so agreeable, is to apply
it carefully with an (ivory) palette knife, the shape
of which may be even adapted for minute as well
as for large operations. The more solid, cooler,
umber-like hues of the shadows will thus acquire
great effect, and still produce a balance of warm
and cold tones.

Some of Rembrandt's portrait backgrounds,
though treated with scarcely any attention to form,
and from the lowness of their tones presenting only
an harmonious mass, are found, on inspection, to be
full of a variety of hues; the warmth, as usual, in-
creasing with darkness and with light, the cool
colours pervading the half-tints. Besides this variety
of tones, there is a fascinating variety of another
kind, produced by the various apparent depths
which a thick diaphanous vehicle insures. Here
and there the lighter portions are loaded, but,
being again overlaid with the semi-liquid lucid
medium, broken with transparent tints, the surface
is sufficiently filled up. The absence of positive
form which generally accompanies this harmonious
obscurity in Rembrandt has the effect of increasing
the impression of depth. The result, for the par-
ticular end proposed, is perhaps more complete than
in the works of any other painter, not excepting
Correggio, although in his case the same principle

and method are, to a great extent, observable. The peculiar practice of Rembrandt here alluded to has also the great recommendation of being a distinctive attribute of oil painting, and of ranking among those qualities which successfully imitate nature by means proper to one art and one method alone.

Numerous examples might be selected from the works of Rembrandt where this most satisfactory union of truth and consummate art is attained. One of the most remarkable is in a portrait of an old lady exhibited at the British Institution in 1848, (the property of Mr. Jones Lloyd, now Lord Over-stone). The general tone of the low background harmonises perfectly with the head—at a moderate distance its depth appears to be nothingness—on a nearer inspection it is found to be full of vague forms, and a multitude of hues; golden reflexions and even crimson points are relieved by varied tints of umber and toned greys. The surface is equally diversified, sometimes rougher and more solid, some-times evanescent—the degrees of depth seem infi-nite. The mysterious forms look like the stalactites of a grotto, but whether intended for them, for the fringe of draperies, or for the indistinct forms of architecture, it is impossible to say.

The richer portions of this picture are probably painted with such a vehicle as the " vernice liquida " in all its original thickness, rendered sufficiently dry-ing. There is scarcely any sharpness in any part of the work, yet a gradation in this respect is preserved.

The quantity of vehicle used by such a painter as
Rembrandt in such effects is scarcely conceivable
by modern artists; but it is plain, from an inspec-
tion of many of Reynolds' works, that the founder
of the English school very commonly aimed at this
method. He sought to give the requisite body,
combined with more or less transparency, by means
of wax very copiously used, and with what unfor-
tunate results his pictures often tell.

It does not appear likely that Rembrandt used
wax. His scholar, Hoogstraten, who describes the
technical habits of the time so fully, would probably
have noticed this had it been common.

To return to the portrait referred to: it is plain,
from the sharp, arrested, unmixing touch in the
head, that the flowing vehicle was exchanged in
this case for an essential-oil varnish, mixed in due
quantity with the colours ground in oil.* No other
vehicle of the oleaginous kind produces this un-
mixing, abrupt, unflowing appearance more com-
pletely. But the flowing quality can be no objection
to a glazing vehicle, and it is therefore probable that,
except where a rapidly drying surface was wanted,
the transparent glazings were in all cases applied
with an oleo-resinous, and more or less thick me-
dium. For the lights, the purest bleached oil, with
mastic or even with fir-resin, would be preferable
to the dark " vernice liquida," and the dryer might

* See Mansaert; compare De Piles.

be sugar of lead, in moderate quantity, instead of gold size.

The preparation of the lights in Rembrandt's heads appears to have been often cool, and the quick-drying, broken, and arrested masses and touches that are applied on it, leave the cool tints of various degrees of darkness half visible at edges and uncovered dragged portions, as it were, through them.

It was important to cover the whole surface as much as possible at one painting, so as to insure sufficient union of the tints with all their occasional abruptness; when the surface was quite dry a slight application of thin and quick-drying varnish would answer the same end if covered at the right moment.

The flowing of the touch in consequence of using the oleo-resinous vehicle in the shadows may be corrected by implanting the last dark, sharper lines and touches when the thick transparent lucid shades are nearly dry; the touch then remains in its place.

As in the rich shadows the warm ground may be reproduced or represented at any stage, so the cool under-painting in the lights may be renewed at pleasure with a view to superadding warmer tints upon it. The transparent tintings last added, as in the more vivid hues of the flesh, had still better be introduced on a surface not quite dry: a thin application of varnish is one mode of contriving this, but such touches may also be added in the

final glaze or even before, on a dry surface, provided it is not too glossy to receive them.

It remains to observe that, as warmth increases with transparency and consequently with darkness, a picture may be richly coloured without any positive colours (since the richest hues on a low scale do not tell as such). Gilbert S. Newton, who had a fine eye for colour, was remarkable for selecting neutral colours for his dresses, while, like Gainsᵣ borough, he gave an impression of richness by avoiding coldness, blackness, and opacity in all his darks—even in dark blue skies. The shadows of trees may thus be warm; the shadows even of white or grey architecture are painted by Rubens and Vandyck with the richest transparent browns. The colourists took care of the darks, and left the lights to take care of themselves.

One consequence of this system, however, is, that the lights can never consist of " sickly white "—they must be toned, though comparatively colourless. Another consequence is that the picture can never be " poor." Depth of shadows supposes richness of vehicle, and the quality of the lights must sustain this. There is, however, a difference between the richness and depth of the two. The character of Rembrandt's lights is that transparency is attained not by thin paintings, but by half seeing what is beneath, between, or beside solid touches: sharpness and brokenness of touch is attained by a rapidly drying vehicle (mixing a portion of *essen-*

tial-oil varnish with the tints). The transparency of his shadows is quite different—the diaphanous effect is more simple; that is, tints are seen as if through a glass, and the operation of glazing is more general—the use of a thick *oil* varnish is also not compatible with much sharpness.

As Corelli and other musicians are said to have composed their bass first, so the Flemish and Dutch colourists painted their rich shadows first: a flesh-coloured ground being supposed, the outline defined (whether upon or underneath it matters little), and the glowing and brown shadows inserted, it is impossible for the lights to be crude, though they may be comparatively neutral—it is also probable that they will be boldly impasted and freely handled. When the lights are inserted first, (before the shadows), they are almost sure to be too light, and the consequence is that the *key* is always changing as the darks become increased. It is therefore on every account better to establish the maximum of darkness and richness at once *somewhere*, as a guide to the eye.

TRANSPARENT PAINTING.

WHEN many colours are mixed together, their effect can only be clear by being so thinly spread as to show the light ground through them; but, if a thick system of painting be adopted, it is a great object to avoid a clayey mixture of the colours. This has been attained by colourists in various

ways. One mode is to use few colours at a time, because then they may be mixed without restraint. This mode was often adopted by the early Italian masters, and by Reynolds—it consisted in painting at first chiefly for form and chiaroscuro, with a hint only at the ultimate colour. The work might be of any degree of solidity, but, even in this process, the shadows can, if desired, be left without body, so as to show the ground through them. The more ordinary process was, however, to paint lights and shadows with an almost equal body, the shadows being kept light, comparatively cool, and clear. This preparation, when dry, was then rendered fit for a new application of colour, by a very thin rapidly drying varnish—a spirit alone, or (as some preferred) a thin coat of oil, which was carefully wiped off again, leaving the surface scarcely moist. The warm colours, still few in number, were then freely used; transparent and rich tints being alone used in some shadows. Lastly, when again dry, the whole might be glazed, and not necessarily with one tint only. The harmony of the whole work would probably require a variety of tints—these, however, being transparent, would (with common precautions) no more affect the mere transparency of the work than the mixture of tints in water colour. The essential condition in glazing is that the superadded colour should always be darker, or, at least, quite as dark as the under-colour; if not, a leaden opacity will be the result.

Another method. Thick painting, with prepared tints, both warm and cold in great variety, but each mixed at first on the palette with a rapidly drying medium, so as to insure the comparative isolation of each touch, if desired. This is the method of Rembrandt in some of his finest works: in many, so painted, the shadows are still kept transparent, in others, their richness is insured by repeated but independent, and more or less *un-mixing* operations. One most agreeable consequence of this method is that tints, representing a cool depth on which the superadded warm colours are impinged and which may be partially reproduced at any time, dry soon enough and sufficiently to prevent the clayey immixture of the impinged tints; and not only is this effect produced, but the superadded touch does not melt into the tint underneath, but finishes abruptly with a more or less broken, ragged edge, which, by a contrast of mere texture, independent of the difference of hue, is thus sharply distinguished from the bed on which it is impinged, and, aided by the difference of hue (the under-colour being generally of a retiring nature) seems suspended in air, and conveys the idea of depth—the *in-and-in* look—which is the great charm of the master-works of oil painting, in the liveliest manner. Sir George Beaumont, whose precepts and taste were chiefly derived from Reynolds, used to say that "transparency does not necessarily mean effects produced by literally transparent

colours, but generally by seeing one thing within or partly within another."

In Rembrandt's works of the class referred to, the mere material application of the tints—(so distinct that the order of their application by the partial exhibition of what is underneath or behind them may be seen)—expresses the quality of depth, and closely resembles the peculiar semi-transparent effect of some stones—such as the agate—a comparison which Sir David Wilkie often made. There can be no doubt that these effects in pictures, when seen near, are more transparent than flesh, but, at a due distance, the imitation is perfect. In this finest of all exaggerations, the principle is the same as that of the extreme richness of colouring, and especially of the shadows, adopted (more especially in large pictures) by the great masters; the effect of air and the imperfection of vision soon reduce the darker glowing tints to the just truth of nature; whereas, when the truth is only literally rendered in a near view, the shadows appear opaque and black at a very moderate distance.

As regards the vehicles which may be used to insure this rapid drying, the first condition is that after extracting from the colours the excess of oil in which they were ground, the drying and more or less resinous vehicle should be mixed in due, and (as regards the darks) in varying proportions with *all* the tints.

DEPTH.

THE principle of depth, which is peculiar to oil painting, depends, in a great measure, on our being aware of a transparent medium. Colour may be seen through colour in the thinnest oil painting, or in water-colour painting, and great beauty of combined, yet unmixed, hues may be the result.

But the impression of depth here dwelt on, is that which we experience in looking at a gem set on a bright ground. Its colour is not only enhanced by the light shining through it from within, but the eye is conscious of the existence of the transparent medium—is conscious that its outer and inner surfaces are distinct. We have this impression even when the medium is colourless, as in looking at any object under crystal, or under clear water; however pure the medium there is always enough to mark its presence, and the objects seen through it have, more or less, the quality of depth.

Perhaps the word *tone* (so often confounded with *tint*) might be partly defined as the appearance of one hue within another, when the medium is also appreciable. The higher qualities of tone reside in the harmonious relation of hues in depth—an effect greatly attainable even where the medium is not distinctly visible—but the perfection of such qualities undoubtedly depends on that positive and

actual measure of the " within and without" which
a rich medium affords.

COOL LIGHTS ON RED.

THE shine (suppose of ordinary daylight) on red
morocco, appears to be the colour of the light only,
without any admixture of that of the object—the
cool, whitish, silver lights form an exquisite con-
trast to the toned, red lake depths, and would be
agreeable in separate objects placed next each other
(the same perhaps is true of all *shines* as contrasted
with the local colour on which they appear). The
whitish light which, on polished surfaces, is merely
the image of the light, had better be produced (not
merely by white, but) by the depth of white, (found,
ut scis) on a very light scale—that is, heightened
with white. It will thus always partake more or
less of a purplish hue on yellow, brown, and black
objects; of a purely neutral, silvery tint on bright
red objects, and of a relatively warm mellow colour
on blue, and green, and purple objects.

The tendency of the shine to a purplish hue is
very apparent on warm objects, (for instance, on
old polished or varnished oak) not in the highest
lights, but where the shine is scarcely perceptible—
at the edge or subsidence of such lights—as where
they die away on polished mouldings; in such cases
the more delicate the light, the purpler it becomes
—as if the object were very thinly scumbled with
semi-opaque light.

OIL PAINTING.

OIL PAINTING as a distinct method cannot be said to exist till the medium used produces that *in-and-in* look which is unattainable in any other mode or material. The quality of depth is to be sought even in solid, light, opaque objects, and can only be expressed in them (as in the darks) by exhibiting varieties of tone and light, suspended, as it were, in the substance or thickness of the vehicle. The difference between the treatment of the lights and darks, in this system of lucid, but substantial vehicles, is, that in the lights the surface may always be more or less marked, whereas in the darks the surface should never be visible. This has nothing to do with the *actual* surface or projection of vehicle, (which may be considerable without being visible, in a proper light,) but with the apparent surface—that which is intended to be seen when the picture is in a proper light.

MACCHIA.*

A MAN'S head of the ordinary complexion seen at a certain distance in the unpronounced light and shade of the open air, or of a room with more than one window, or with a diffused light, exhibits that appearance which Leonardo da Vinci somewhere describes, and which is common in Venetian pictures. The effect of the minuter shades or dark

* The blocking out of the masses of light and shade.—*Ed.*

colours (of eyes, brows, beard, &c.) is, as Leonardo
observes, to colour the whole mass—to make it
darker and warmer. The darker side of the face
(the light being assumed to predominate on one
side) has, seen at such a distance and under such
circumstances, a browner hue only, and is hardly
distinguishable from dark local colour on the light
side. Barry (the painter) somewhere describes
the shadow of Titian's flesh as "flesh colour dark-
ened and embrowned only." There is, however, a
fine gradation both in light and dark, (more per-
haps in light); the retiring parts of the face, as
for instance the side of the cheek and temple,
without losing their broad warmth of colour, are
less illumined than the cheekbone, and the fore-
head is often the same ; the nose again, even in fair
subjects, looks darker, partly because surrounded
with darks, and partly because its minute lights (at
the point and on the bridge) become invisible, as
Leonardo truly observes, at a little distance. There
is also no shine on dark hair at a certain distance.

This distant, broad, shadowy effect is most agree-
able when the surface in painting is not too trans-
parent and glossy, but rather mealy. This effect
is produced by using, where possible, semi-opaque
colours (always darker than the colour on which they
are scumbled) in tinting, toning, and darkening.
The same appearance is to be aimed at in golden
complexions; they should not look too glassy and
glossy, but have a due opacity. This may be ex-

tended even to half-shadows. In this is seen one great difference between the Venetian and Flemish masters ; the Flemish painters can never have too much transparency, and they certainly manage it well; but the Venetians with equal, or with scarcely less splendour, have more solidity, and yet their system, in its shadowy breadth, agrees more with ideal and somewhat distantly seen forms.

VENETIAN PROCESS.

THE Venetian process was divided into the blotting of the masses, solid painting, sharp touching, (*colpeggiare*), scumbling, and glazing. The chief requisite in this system—indeed in oil painting generally—is to restrict the *touch* to solid painting or to minute shadows, and never to show a small handling in scumbling, that is, when the paint is thin. Minute work with solid paint soon cures itself; the touch soon becomes bold and varied, but it is not so easily avoided with thin paint. Such thin scumbling should always be swept in masses, otherwise it will degenerate to stippling. (See pictures by Buonvicino (Moretto) as an example of the touch—small yet solid, sparkling and vivid.)

The bright minute touches of an unglazed Venetian picture must have appeared quite raw, and almost snow tipped—glazing was indispensable to lower and harmonise the work. Looking, however, to such a final process, the bright touches might

be most sparkling. It is a mistake to aim at this harmony too soon; the attempt leads to want of vigour in handling, want of light, and ultimate flatness and dullness. Boschini observes that Titian's pictures were *gemmed* all over during the work, and no doubt just before they were completed by glazing.

BELLINI THINNED HIS VEHICLE WITH LINSEED OIL.

If Bellini used the amber varnish, (or its substitute, "vernice liquida") with the colours, as this is apt to clog them, it is quite reasonable to suppose that he would, like painters now using the same material, dilute the pigments, so thickened, with oil. Hence the story of Ridolfi, though told with another and a mistaken view—viz., in the belief that oil was only then recently introduced in painting—may, after all, be a true tradition.

It is to be remembered that, with the early oil painters, essential oils had no place *together* with fixed-oil varnishes; the two might be used separately—the essential oils were perhaps used by Leonardo da Vinci in his solid preparations, but never to thin the oil varnishes. Their diluent was necessarily a *fixed* oil.

Ridolfi's account of Schiavone's preparing his tints some days before they were used, is interesting, and agrees with the fat, cloggy look of his

colour. His touch seems brisk by dint of force and firm brushes. It is, however, not impossible that he may have used amber varnish or its equivalent, in the manner of Correggio, only without blending the tints. He studied and used the designs of Parmigianino, and hence a possible connection with a Correggiesque practice.

It is very probable from the appearance of Baroccio's surface and handling, that he used the amber varnish.

The circumstance of Gentileschi, at a later period, inheriting this practice may be traced to a connection with the schools of Parma.

WARM OUTLINES AND SHADOWS.

ZANETTI marks the improvement of the early Venetian school in colour, by the observation 'fece più rosseggiare il contorno.' The outlines of the earliest painters were black. The effect of a warm outline to indicate flesh, even though the rest be white, is visible in some ancient mosaics in the vestibule of St. Mark's at Venice. The next step, or an extension of the principle, was the warming of the shadows, especially when small in quantity—the use of the blood tint. The reverse of these methods would be to make the centre of the flesh the warmest, and to allow it to grow colder towards the outlines and shades. The finer, broader principle consisted in kindling

the form at its boundaries and in its depths, and letting the centre take care of itself—for it would necessarily be cooler than the darker parts.

When the system of preparing a cool under-painting was introduced, (by the Bellini and their followers,) the warm glazings began in the darks, then toned the half-lights, and, lastly, tinted the lights. But, when all was tinted, the breadth of colour was sustained by keeping the focus in the darks. One consequence of this system was that the cheeks could not be much coloured—a general glow was rather attempted, for the colour being given in the shadow, contrast required that it should be less strong in the light. Ludovico Dolce, noticing this as the practice of Titian, gives a reason for it in his own way. It might be observed that the Venetians in adopting this system only copied the nature which they saw: if so, it must be concluded that Nature in Italy suggests a higher style of colour than elsewhere. The warm glazings (always semi-opaque in the *lights* and half-lights, though perfectly transparent in deepest shades) were even suppressed in a great measure by some Venetians in the lights; the effect was to give a certain effect of transparency, as if the skin were thin. (For, if we suppose a column of glass, we shall see the colour crowded towards the edges, and less strong in the centre; the colour is, as it were, accumulated in the foreshortened parts.) This effect had also, in heads, its use in expression.

Zanetti speaks of "certi lividi," introduced by
Basaiti. These "lividi" were merely parts less co-
vered with the warm tintings, such warmth being
suffered rather to accumulate in the darker, and less
prominent portions. The coloured (not reddened)
features, and paler cheeks of Basaiti's saints give
them a look of passion and emotion, not to be ren-
dered in an engraving.

The system easily degenerates into foxiness.
Paduanino is often an instance of the abuse. The
warm *brown* shadows (as opposed to Paduanino's
red) in Titian—for example, in hands and feet—
contrast agreeably with cool lights and middle
tints.

NEUTRAL TINTS IN WHITE AND OTHER DRAPERIES.

In the grey depth of white, the yellow ingredient
(represented, we suppose, by raw umber,) requires
to be very sparingly used, especially when the tint
is employed in scumbling over a light, since all
colours are warmer in effect when light is within
them.

For the blue element, black is sometimes not
sufficiently delicate ; a blue, however small in
quantity, is requisite, and the colour should even
be fine of its kind—the French ultramarine would
be preferable to common blues. It is quite possible
to do without black, in which case, of course, the

yellow and red ingredients must be increased to neutralise the blue. For the red, Indian red is commonly used and may suffice, but the purple reds, either of iron or madder, may be employed with advantage. For the lights, the yellow element should slightly predominate, and the deeper shades should be brown—so, in black objects, the deepest parts may sometimes be brown.

The effect of lightening a shadow by scumbling or dragging a lighter tint over it, is to make it colder as well as less dark (light over dark is cold). As every colour contains all the colours, on the principles before explained, and as the *blue* tendency is in excess in the case supposed, the tint employed to correct it should have as much of the *orange* as the nature of the ingredients (used in the local colour) permits. If again the bluish tint (suppose in a rose drapery) has been glazed with lake, as it will evidently be too purple for the local colour, the correcting (and perhaps lightening) tint should then incline to yellow. Once neutralised and harmonised, the usual cool half-tints, and coloured depths can again be inserted if required.

TONING, TO MITIGATE PARTIAL OR GENERAL CRUDENESS.

ALL vivid warm colours, and spots of any such colour in a larger mass, when toned, and reduced by brown, are not only more harmonious and

agreeable, but appear to have their actual hues deepened. The reason may be that such toning partakes of the nature of shade, and the colour is not so much altered as deepened—though slightly neutralised.

Cold colours that are too crude, are, when toned with brown, equally true and deep. In this case the colour would seem to be *opposed* by the toning— but the effect is quite as satisfactory, perhaps more so than in the case of warm crude colours that are toned.

All colours that are crude from whiteness, or lightness, are improved in like manner by a toning brown.

The silvery depths of white even are made more telling by a golden browning, near, and more or less upon them. [The sparkling quality is indispensable in white and in flesh, and, in general, in all light objects—the delicate half-tints are revealed and multiplied by such treatment, which, however, is not to be confounded with the imitation of shine. The sparkling quality depends on (relative) brightness, sharpness and crispness, and ultimate tone, for such a quality is more precious and is even increased really by the glazing, as the points of brightness are less obscured than some of the surrounding portions.]

The toning brown should be used everywhere to mitigate crudeness, even in partial tints (that may be too vivid) and spots—for where, on a very light

scale, the toning is proportioned—not only in draperies, skies, landscape and inanimate objects, but even in flesh.

The general distribution of light and dark, and the modelling in all details should, however, be completed before, as very little modelling can be safely effected by toning—the attempt may end in rankness.

TEXTURE.—CONTRAST OF SURFACE IN SCUMBLING.

THE contrast between the delicacy of scumbling—a delicacy consisting in extreme fineness of tint (by means of semi-transparency) as well as in extreme softness—the contrast between this, and the crisp roughness of lights, against which it stops—is of a most agreeable kind. Suddenness of form, texture, or colour in nature, is best imitated by such means. A rough (roughly painted) isolated small cloud, (light or dark) in the midst of a formless space— formless, but full of gradation of light and tint, and without apparent substance—expresses this peculiar contrast; like a rock in smooth water. The. same effect may be sometimes seen in Titian's flesh; smooth, or apparently smooth depths of half-light lie round a rugged crisp light. The beauty of scumbling is not displayed unless it floats round such sharp, rugged substance. The roughness and brokenness of such points and touches may be

assisted by ground glass used as a pigment—it is always *short*, even when used (not too liquid) with an oil varnish, or wax medium. The roughness may also be assisted, where required, by the pulverised colour itself, (dry on an adhesive surface) or by ground glass, or ground resin, or even by ashes, so applied.

SCUMBLING AND RETOUCHING.

A MOISTENED surface is almost indispensable for delicate and partial scumblings, but modellings produced by comparatively abrupt retouchings may be added at any time on a dry surface. The two methods are most convenient in finishing. Under the first are comprehended the accidents produced not only by dark over light, but by light over dark; the latter producing pearly tints not to be attained by solid painting. The other mode (the retouching) is more akin to solid painting, and may be a means of regaining sharpness and abruptness, which the scumbling system has, of course, a tendency to destroy. In beginning a work, solidity and freedom should be especial objects, as they cannot be so well attained after the work is completed. In order not to get too white, the whole should be scumbled, and re-scumbled from time to time with the local tint, or with the warm or cool corrections which may be required (white being generally sufficient for the latter). Then the modelling may

recommence, and be gradually carried to the delicacies of form. In order to secure apparent freedom and sharpness, those passages should be looked for which admit of an abrupt insertion of light—for in half-lights this abruptness is not so agreeable. Cast shadows may also be abrupt and free. Again, in most other objects, (besides the flesh) this abruptness and solidity may be easily secured.

Thin scumblings with a vehicle (or with the mere colour) much diluted with spike oil or other essential oil, will not become horny, but, on the other hand, they may easily be washed off, and therefore require to be *fixed* with a varnish of some sort. An oil varnish, or mere half-resinified oil, may be used in this case—an essential-oil varnish is in danger of removing the tints unless the surface be first protected with a thin glutinous film. For example, a wash of *beer* fixes the surface sufficiently to bear a varnish. A thicker glutinous medium is not advisable, as it is apt to become white with the varnish. On the whole, perhaps, an oil varnish is safest for recently painted pictures.

CRISPNESS AND SHARPNESS BEFORE TONING.

FOR the "sfumato" system, and the production of pearly tints by light over dark, a crisp and solid under-painting is indispensable. It is undoubtedly possible to give this appearance (as the Venetians,

according to Boschini, sometimes seem to have done, even after a solid beginning) at last, or when the work is advanced, and everything is in its place; but there is danger of some reluctance at that stage to disturb the effect, and to risk losing what has been attained in expression. But anything is better than ivory smoothness; sufficient crispness and ruggedness for glazing can, at all events, be secured; only remembering that what is soft, will be still softer by glazing.

Reynolds says that Titian's chief care was "to express the local colour, to preserve the masses of light and shade, and to give, by contrast, the idea of that solidity which is inseparable from natural objects." The preservation of masses of light and shade is one of the merits of the Venetian colourists, and it is difficult to understand how such a school can be said to be deficient in chiaroscuro. The suppression, or slight indication of markings in the light, gradually led to the suppression of dark shades in the flesh altogether, and, as if this was not enough, we frequently find a very light blond hair added. (The features, however, always tell.) The whole is then relieved by a strong and broad contrast of dark and sometimes cold masses, according to the tint of the flesh and drapery; the light, golden flesh is also sometimes accompanied by a white dress, and then the whole figure (with a few points of dark) is relieved against the equally massed ground.*

* Compare Zanetti, p. 218.

It is in securing, (before toning,) the breadth of light in the flesh, that the scumbling system, or alternate scumbling and modelling, may beget too much smoothness, softness, and finish ; all which will be still more undecided when glazing is added. It is therefore very necessary to keep, or renew, crisp lights; taking care to have as many *abrupt* passages as possible—(abrupt, that is, as to texture). These should be carefully kept, as softness will take care of itself. The equality, or unbrokenness of intermediate passages of half-light, which may look unpleasantly finished in surface, will be sure to receive accidents from glazing. The point is to secure sufficient sharpness where sharpness should be.

This variety of mere surface can be greatly assisted by the vehicle, which of itself supplies substance, and does not obstruct crispness. A sparkling quality is one of the sources of brilliancy, and delicate modelling, in fine Venetian pictures. This is sometimes produced by beating, or stabbing, with the brush with white—(what is called in the Venetian dialect "botizar")—and the same process, over a solid preparation, helps to give that equally granulated and mossy texture which is often observable both in flesh and draperies. But, it should always be remembered that such processes are only agreeable when superadded to a rougher, and more "colpeggiato" (touched) preparation. With regard to the more delicate sparkle which assists the

finest modelling and the niceties of expression, its effect may be first tried by irregularly dotting, with white chalk, on the points or surfaces where its effect is desired. This same effect, when agreeable, can be produced by inserting—no matter whether accidentally or with intention, (provided the result be irregular) the same sparkle with points of white. An old worn brush is useful for the purpose. In such cases it is important that the points, or minute touches of white, should be solid. Their too great brilliancy can be obviated either by tinting upon them to a certain extent when dry; or by using much stiff vehicle, and counteracting its yellowing, as usual, by the purplish hue of the superadded light—but pure white may be used in this way also, and tinted afterwards. *Thin*, partial, and minute tintings of white, though useful in equalising and solidifying, and in distributing minute greys (as they are always employed to stop out relative darks) are not calculated for the sparkling process; *that* can only be produced by solid, diamond-like, but irregular, and irregularly placed points and touches.

The "botizar" system is almost indispensable for producing breadth, without too much sacrificing modelling. Its equality, union, and finish, and its imperceptible gradations require to be sufficiently broken, either by the abruptness of the preparation, or by superadded sharpness, crispness, and definite sparkle. One mode of breaking its soft transitions,

is by spottiness of local colour; for it should be remembered that whatever reason there may be, (in young subjects) for unbroken roundness, there is no such reason for softening colour, as in the cheeks or elsewhere: the more patchy and abrupt this can be, consistently with truth and the appearance of health, the better will it contrast with the soft gradations of the lights and half-tints. This is one of the points in which Titian is superior to Palma Vecchio. Paul Veronese never fails in it, nor in anything that belongs to briskness, or vivacity of execution.

GLAZING SYSTEM.

To give full effect to the glazing system (especially with the old substantial vehicle) it is necessary that the preparation should be more or less solid, and *freely* handled. In Bassan the lights on flesh and other objects were sometimes impinged with much of the local colour in an advanced state of the work, and after all had been laid in in chiaroscuro and glazed. In this way it is always possible to prevent a woolly effect, and to restore something of a sparkling appearance by inserting bright rough touches, and toning them afterwards. Schiavone is a great master in all that relates to colour, brilliancy, and vivacity of execution.

The glazing system (the thick vehicle being always understood to be used) has various condi-

tions, some relating to colour, some to surface and texture, some to chiaroscuro.

In colour the first principle of the glazing system is warmth, and the second broken hues.

The neutrality which the latter seems to involve (as distinguished from positive and gaudy colouring) is still made compatible with warmth by contriving that the cold colours shall be neutralised by warm ones, and the (too) warm and positive by *cool* or neutral, rather than by *cold* hues.

In this system of neutralising and breaking, the application of the exactly opposite (transparent) tints is to be attended to, and as the preparation does not consist of one uniform tint but of cool half-lights of reddish, greenish, bluish, purplish, &c., so the superadded tonings should be varied constantly to antagonise the under-painting. We thus find in draperies of Venetian pictures a nameless colour produced, although we might easily call it red, rose-colour, &c.—the bluest tints are toned with orange, the greenish with lake, the violently red not with a positive green but with an olive, umbry colour; orange the same, the olive inclining more to grey. Blue is toned with rich brown (dark orange) slightly, and has the same warm colour both for its intense darks and, on a light scale, for its lights.

In general, the colour which should be used to neutralise another, is that of the high light and shadow of the colour to be neutralised. Thus

a vivid, crude blue is toned by its opposite, a rich brown, (the depth or darkness of the brown depending of course on the tint of the blue which it duly balances); a rich transparent brown might be the shadow of this blue, and white, a little embrowned or gilded, would be the true light. A vivid and crude green is toned by a reddish brown—that same colour in its deep transparent state is the fit shadow for the green, and white, embrowned or reddened, would be the true light. The bluer the green the more the light would incline to orange, but it is to be remembered that *two* positive or strong colours can hardly come together—when the green is strong, the light is comparatively colourless. The opposite of orange is strictly blue, but, on the same principle, as the orange is strong and positive the opposite should be comparatively neutral, a dusky, greyish, umbry tint is the fittest depth for orange. Blue is strictly a half-tint, not a shade-tint, the opposite, of course, is therefore to be recognised in its half-tints, which are sometimes in Venetian pictures of the neutral character above described. The reflex shadows of *all* colours are warm; and the lights of orange are not its opposite, but only lesser degrees of orange—that is, yellow.

So with regard to yellow—its opposite, purple, belongs neither to the shade nor to the light, but only to the half-light, and *there* requires not to be positive, but rather to be a greyish depth. Its lights are only lesser degrees of yellow.

So with regard to red—its opposite, green, belongs neither to the shade nor to the light, but only to the half-light. The neutral half-light of red is as usual not positive, but is rather an umbry depth.

The opposite of a positive colour is a negative one, but which is still opposite in the quality of tint also.

The opposite of bright red is pearl colour
 ,, ,, ,, bright orange is grey
 ,, ,, ,, bright yellow is purplish grey } neutral grey, black.
 ,, ,, ,, bright green is reddish brown
 ,, ,, ,, purple is yellow brown
 ,, ,, ,, blue is orange brown } brown, warmish white.
The opposite of the warm colours is in their half-lights.
 ,, ,, ,, ,, cold colours is in their shadows and lights.

The lights and shadows of warm colours differ from those colours only in degree.

LIFE IN INANIMATE THINGS.

The surface of the living figure is the most noble object of imitation, and it is this which chiefly limits sculpture to the naked. Life being the fittest aim of representation, it becomes so also, in some form or mode, in inanimate objects. In sculpture, where colour is wanting, the drapery for example is often made to cling to the forms, in order that it may derive from them an interest which the mere expression of folds cannot possess intrinsically. Besides this, drapery, even when not showing so distinctly the forms of the nude, may assist com-

position, and may be grand or beautiful in itself from the arrangement of its lines. But it is in painting, and when the charm of colour is added, that an attribute allied to life may be given to drapery, and to all inanimate objects, independently of their forms. The contrasts of warmth and coolness, of transparency and opacity, of pure and negative hues—contrasts, in short, of all kinds which the eye can appreciate, besides those connected with mere form—these form the *life* of nature, and give interest and beauty to objects that would be otherwise passed over. As painting cannot do without such objects, and as they make up a large portion of every picture—from skies and clouds to trees, rocks, and foreground; from draperies and architecture to all kinds of artificial productions and implements—these inanimate portions of a picture should receive the especial attention of the artist to endow them with life. Light, gradation, and contrast are the means by which this may be effected, but within these words lies the whole soul of refined imitation. The infinite modes in which inanimate objects are rendered charming to the eye, by the means here indicated, can only be studied in well-coloured pictures. Contrast of colour is the chief agent: gradation is, strictly speaking, only a subdivision of contrast, for, as the object of contrast is variety, so no contrasts should be repeated; and this suggests degrees of intensity —varieties in degree as well as in kind.

PALETTE KNIFE.

The expression of alternate sharpness and softness
in the boundaries of forms, (whether forms of sub-
stance, of light, or of colour,) is indispensable to
truth of imitation in painting, and by whatever
mode this peculiar contrast is attained, it can hardly
fail to insure a picturesque and apparently free
execution. An enlightened friend of Reynolds,
Sir George Beaumont, often heard that great
colourist say that accidental appearances in nature
had better be produced by accidental operations.
The same amateur was of opinion that the success
of water-colour painters in skies was greatly owing
to the unavoidable rapidity and uncontrolled free-
dom with which the forms of their clouds were
produced. Be this as it may, there can be no
doubt that not only certain forms of material things,
but the fantastic shapes of masses and accidents of
light, the capricious patches and breakings of colour
on various surfaces, and the gemlike and irregular
crispness of brilliant lights are all better rendered
by methods which may be said to be, at least partly,
accidental; and it is indeed only when accident is
thus called in to imitate accident, that the infinite
variety of nature can be said to be approached.

At the same time all depends on a right use of
this principle. Nothing can be more seemingly at
variance with such a proposed mode of imitation
than the scientific studies and careful practice which

aim at distinct appearances and immutable facts.
The knowledge of anatomy and of beauty of form
in the human figure and in animals, for instance,
are referable to fixed laws; and the artist in such
studies professes to define the types of excellence.
It is one of the difficulties and privileges of painting
that the most apparently opposite aims may, and
must at different times, regulate its practice; the
unprejudiced artist has, in short, to know and feel
when the precision of science is to be his guide,
and when that precision would endanger the very
truth of imitation which he proposes.

Without entering further into the question what
should, and what should not be the objects of pre-
cision, (the living form being admitted to stand
pre-eminent among the recognised and definite
objects,) it is to be remarked that whatever may
be the degree of precision which the boundaries
of some objects require — and they can never
require undeviating hardness or softness — an ir-
regular crispness in the lights is never out of
place, whether in flesh, armour, drapery, or sky.
The question what degree of softness is necessary
to balance that crispness has been variously an-
swered, according to the taste of painters, and it
must also depend on the distance at which the
work is to be seen. All such questions of degree
must necessarily be left undetermined. We have
here only to speak of the operations or methods.
Much may depend on mechanical contrivances, and

on varying and contrasting the operations. For
example, although the brush may, in a bold hand,
be employed to produce a sharp, crisp and irre-
gular handling, and although it must be considered
an indispensable instrument to assist even this kind
of execution, yet it is not so entirely independent
of the will as a harder instrument. In the peculiar
practice here referred to, the brush may be consi-
dered the instrument of softness, the palette knife
of crispness and sharpness. The first may represent
imperceptible gradation, the other the abrupt edge
and point of a crystal sharpness; the one typifies
the cloud, the other the gem. By the palette knife is
to be understood a very flexible ivory blade; several
such, varying in the breadth of their extremity
from an inch to almost a point, may be used. Their
flexibility at the point of course increases with use,
by degrees the point wears away and becomes less
regular, and is not the worse for being so.

In all pictures there must be a scheme of light
and dark, warm and cold. It is plain, there-
fore, that the will of the artist should be most
exercised in the largest scale, and least so in the
smallest details. The same may be observed of
forms; their general proportions and true relation
of masses are more important than the accuracy of
minute parts. In the latter, freedom can do no
harm.

THE GEM-LIKE QUALITY.

In general it may be safe to assert that it is a defect for anything in a picture to be capable of being *likened* to another. Nothing is so charming as when things have their *own* quality, and are like nothing but themselves : always remembering that of the many qualities of which one object may be composed or partake, such only will be most prominent which are forced into notice from existing comparisons. It may be observed, however, that in description things can only be presented to the mind's eye by resemblances, and, in this case, when the object is to exalt the particular thing, exaggeration is allowable and necessary. Thus cheeks are like roses, clouds like gold, flesh like snow and vermilion, &c. In imitative art, where these substances are addressed to the actual eye, they require to be *distinguished* from each other. Still, in the various modes in which nature may be rendered (according as the letter or the spirit is most aimed at, and above all according to the comparison or contrast of the moment), there will always be a resemblance between a painted imitation as an effect, and some general quality in nature independent of, and in addition to, the particular imitation aimed at. The truth of this is admitted by the terms of praise, and still more by those of dispraise, used to characterize pictures. A picture, for instance, is said to be golden, to be silvery, to

be gem-like—to be mossy, to be woolly, to be wooden, to be tinny, &c. Now if we consider the laudatory comparisons which relate either to the colour or some collateral quality, we find that no quality comprehends such absolute and universal excellence as the *gem-like*. It comprehends the golden and the silvery, only adding the quality of transparency; the pearly, the sparkling, the velvetty, the glittering, the pure, the definite, are all comprehended in the *gem-like*. What is or may be wanting is the solid which borders on the opaque, the soft which borders on the misty, the flexible or undulating, &c. The qualities which more particularly constitute the gem, and which may be aimed at in painting, are precision of *leading* forms, and sharpness soon lost in softness which may always insure a sufficient approach to the flexible; this may be translated into precision of *touch* rather than of *general form*. The lights are the minimum of the colour, the deepest shades the maximum; reflexions are infinite and bright, but only sparkling in points. The shades are transparent, but all is transparent; and the character of the gem certainly is to be most lucid and clear in the lightest parts. This is Tintoret's system: his deep shades are often opaque and too black, but they are lighted up by sparks of brilliancy which, originally no doubt, gave transparency to the whole mass. Any colour, whether trunk of tree, rock, earth, or what not, may thus partake of the gem.

The greatest care should be to make the reflexions sparkling and brilliant, for the lights will take care of themselves. A transparent substance exhibits its own colour, and reflects but little of others. To avoid too much monotony in a drapery, for instance, the hue may be varied ad infinitum if necessary by glazing variously, but still it will present but a series of gems, and not give the idea of an opaque substance reflecting foreign hues. Violent orange, vermilion, and all colours whose light is their maximum are not gem-like, but they give great value to those that are so. White can hardly be gem-like, unless the lights are treated with precision. Its cool shade is generally surrounded with a warm outline, for everything beyond it is probably warmer than itself. This warm outline is agreeable even when coming on blue. Black is most gem-like when glazed on white, so as to have none but *internal* lights, and if any are on the surface, still precise and definite. Hair has a silken quality of its own which does not partake of the gem; it reflects the light (does not drink it like a jewel), but with as much of its own colour as possible. The purple lights on black hair give it a very opaque look.

The same sort of resemblance in this good sense of the word (that is, a resemblance to something most perfect of its kind) may be aimed at in the choice of colours: various reds, for instance, are beautiful when they resemble the rose, the blood,

the flame, the ruby : the colour of wine in a transparent glass is the same as the gem. (The Venetians loved to place it on a silvery white tablecloth.) Yellow, the golden, the gem-like; blue, the sapphire : the last is the most difficult colour to make brilliant, yet Titian does it.

FACILITY OF EXECUTION.

THE spontaneous and effortless freedom of some painters, no doubt, belonged to their general character. The " mocking at toil," the " sprezzatura" of Giorgione—the "judicious strokes that supersede labour," are the surest test of genius and of the fit temperament for a painter; for such a power necessarily supposes the comprehension of a whole, a habit of viewing things in their largest relations. The idea of power is always conveyed when we have an impression that the actor, whatever he may be doing, can or could do more than he actually does—that the strength shown is only a part of the strength that might be shown. This is true, even literally, in the wielding of the brush; the line should be a part of a larger line; the direction and impetus of the hand should not be limited to the form or touch actually produced, but should have a larger sway. There can be no doubt that the evidence of this liberty and range of hand, eye, and mind (for all go together in legitimate freedom) is charming to the spectator. And this is not all, it

is really more imitative; the cramped and bounded is not nature.

The rules of art can go far to correct that spiritless stiffness which arises from equality of shapes and masses, from parallelism of lines and monotony of hues, indeed, if it were not so, tolerable works of art would be much rarer than they are. The question here proposed is how far mere freedom of hand, which is often a source of variety, especially in surface and in sharpness and softness, can be, and has sometimes been, assisted by judicious methods, and attainable in short by study.

In painting, as in writing, it is undoubtedly true that the appearance of facility itself may be the result of labour. In writing, indeed, it is scarcely an object of ambition to have it believed that the work cost little time and trouble. Few writers are seen to compose their works; the labour of months may be read in an hour, and may yet appear to have been produced by some powerful mind in as short a time. But when Addison was gently reproved for writing a long answer to a letter, he replied, "I had not time to write a short one." The appearance of power and facility would have cost him more trouble. To a greater extent it is the same in painting. It is the condition of the art to require a certain method.

Let us examine the ordinary process of Rubens —one of the greatest masters of facility the world has seen. In order to secure the possibility of exe-

cuting his work with apparent rapidity, and without
torturing the colours as it is called, he defined
everything in a coloured sketch, from which, as is
well-known, his scholars "got in" the large picture.
If it be asked what preceded his masterly sketch,
it is replied designs on paper, studies from nature,
and a careful outline rarely departed from, even
in that sketch. There was nothing of what is
called Invention in his large picture. Not only
the composition, but the masses of light and dark
and colour were all determined, and the details of
the drapery, architecture, &c., all sufficiently de-
fined. There remained literally little but execu-
tion to think of : the labour of covering the canvas
with colours fitted for his ultimate effects was per-
formed by others; he was thus set free from the
necessity of labour partly by the assistance of
others, but chiefly by his own well directed pre-
vious labour. If there was genius in such a man,
it must be admitted that there was also admirable
judgment, and that his judgment was shown in
making the fairest occasions and freest scope for
the display of his genius. "Divide, et impera,"
the motto of the Hero of the Nile, was exemplified
in every picture by his hand. To invent, compose,
draw, give gradations of light, and clothe with true
colours, all at once, might have been done, if by
any man, by Rubens. He adopted, however, the
more cautious mode of giving his energies to each
in turn, though each was prophetically viewed in

relation to its neighbour quality. The whole effect was indeed already planned and embodied—gradually even then—in the sketch. Nothing remained for the last operation, but to think of beauties of execution and harmony. Had he laboured his work after all the previous steps (it matters not whether we consider the freest operations of the picture or the freest of the sketch, for both were results), there would have been no consistent principle in his processes : the object of the first labour was that there might be a finer labour—rather delight—in the completion. Without this evidence of liberty and joy the plant which had crept to its fullness by the successive aid of every ministering energy would have been without its "consummate flower." " Quem mulcent auræ, firmat sol, educat imber."

Facility is therefore secured by labour. It is quite conceivable, and experience constantly shows that what is first done in careful and laborious succession may at last be done by a strong effort of attention at once. The previous labour here resides in the previous life. The well-known answer of Reynolds to one who complained that his price was high for the work of an hour is here applicable.

But the sense here intended by the expression " facility is secured by labour" requires, for the purpose in view, to be explained. It is understood with reference to the efficacy of the processes which precede the exercise of freedom. That ultimate freedom may be called another kind of

labour, for most certainly it is not to be exer-
cised carelessly, though sometimes apparently so.
The lesson which Rubens gives, in short, may be
useful in an humbler form for those who, from
whatever cause, are wont to take refuge in labour
of a mechanical kind, instead of doing everything
with apparent will. The greater the timidity or
the less the amount of that instinctive energy
which gives soul to trifles, the more the workman
requires to calculate his previous labour so as to
enable him to attain the desired facility at last; to
place it, in short, as completely in his power as
possible. Van Mander says of Van Eyck that his
dead colouring, or preparations, were more careful
than the finished works of other painters. This is
quite possible, and may have been the case even
with Rubens' pictures as prepared by his scholars
or even by himself. The preparations of the
Florentine painters, Fra Bartolommeo and Andrea
del Sarto especially, were also more careful than
their finished works. A judicious economy would
on every account suggest this; the appearance of
freedom is, we have assumed, an excellence—it is
specious, winning, fascinating—it is not the quality
to bury under subsequent and more laboured opera-
tions; it should be the consequence and not the
forerunner of labour.

What is called dead colouring is any stage of a
picture short of its ultimate vivacity and intended
completeness. The appearance of freedom after

most careful study might be given in the very last stage. The preparation, however advanced, should be calculated accordingly. If, for instance, a cutting edge of ploughed pigment next a form be intended, it would be necessary to keep the previous surface flat and thin; to *repeat* a ridge of paint or a raised touch is an evidence of failure. Sometimes this cannot be avoided, but it is best avoided by care in the previous preparation, and by a fixed intention which is supposed to be justified by the effect of the sketch.

The preparation of the groundwork, in every sense of the term, which is to receive the free painting, has been hitherto dwelt on, that stage which precedes the thin washes and glazings that complete and harmonise a picture. The preparation of the pigment itself for the final work, is equally essential. It by no means follows that the apparently brisk execution of fine pictures was really done in haste; a false colour in a light is a greater defect than a wrong direction of its form, (for the outline at least may be correct). Not only the tint as such, but in sufficient quantity, should be duly prepared; there can be no facility without abundance of colour: the brush even requires to be loaded with care, and not at random— then the " sprezzatura " or " bravura " of the hand will accomplish its task without hesitation. In some cases a single touch is absolutely requisite, and therefore requires to be in all respects right,

but "right" does not mean formal, nor even neat; an accidental "abandon" is the (apparent) quality to aim at, the object still being to conceal labour. In other cases touches may be repeated, but only for the sake of more *impasto*, for better modelling. In such instances all that is requisite is that the last and most visible work should be quite free.

The preparation of the tints in due quantity leads to the consideration of the sometimes disputed general question respecting mixing tints. Sir George Beaumont used to tell a story of Wilson, who, after visiting the landscape painter, George Lambert, complained that he could see on Lambert's palette "the cow, and the grass she was going to eat." Some portrait painters (see *Bouvier's Manual*) mix an infinity of tints for flesh. All this has been condemned, but the opposite extreme is equally unadvisable. Time, labour, and attention, are dissipated in constantly mixing tints with the brush from the pure colours on the palette; brushes are used soft, there are unequal proportions of oil in the colours, and the palette may be said to receive more attention than the picture. The tints, a few at least, should therefore be prepared for the work of the moment. This is more especially necessary (though not at first seen to be so) in the final retouchings. There should be colour enough and to spare, and each tint, whether for high lights or anything else, should be accurately prepared. The

advanced work easily furnishes a key for the tones, and trials, to make all sure, are quite possible, for as the surface is assumed to be dry a tint may be tried and wiped off again.

Finally, it may be repeated, the appearance of dexterity and rapidity, the sweep of the brush, the sparkle of the touch are not only graces but necessities in painting. When a work lacks these, it should rather be carefully hard than carefully soft, for hardness, however objectionable, is allied to determination and exertion, softness to weakness and indolence.

REMEDIES.

IT has been elsewhere observed that the best pictures are but blunders dexterously remedied, and as, in inventing a picture, the necessity of certain picturesque arrangements suggests the introduction of incidents that often add greatly to the moral or imaginative interest of the subject, so the remedies above alluded to may be the means of giving new character and zest to a subject. It is in this way that length is sometimes added to lines or extent to masses of light, shade, or colour, and both advantageously so, where such would not have been thought of but from the necessity of remedying a defect. The result of accident in this way brings the art nearer to nature, for where pictures are the result of so much pondering and design (all which tends to neutralise character), any arrange-

ment independent of the painter's *will*, if at all compatible with the subject, should be carefully preserved.

The great principle of lessening the effect of a form, or mass, or arrangement which is unpleasant to the eye is to *divert the attention from it*. Sometimes very little will do this, but, to do it effectually, to apply the proper remedy, the nature of the defects should be clearly understood. It will not then always be found that some *opposite* attraction will annihilate it, for this, on the contrary, may sometimes make the objectionable feature still more conspicuous. It is obvious that no mere rules (as such) can be intelligible or applicable in these cases, but the general principle of diverting the attention is always safe, for it even includes putting the defective object in shade, which certainly diverts the attention from it by making it less conspicuous. But the other mode is by making some other object *more* conspicuous, and it is precisely in this sort of remedy that the new object or attraction may be the means, never thought of before, of eking out a composition, or mass, or line, which adds much to the general effect. It is obvious that in introducing a remedy, care should be taken to make a *virtue of necessity*, and to make the remedy serve some positive as well as negative purpose; at any rate when accident has thus suggested an improvement it should be followed up to completion.

HOW TO COMPOSE AND PAINT A SINGLE HEAD.

To give grace, nature, ease, and all that which makes a picture attractive, to a single head (without hands), is one of the difficulties with which portrait painters, and even painters who are not tied to a likeness, have to contend; and it is worth enquiring what are among the causes which contribute to success in this particular.

Extraordinary beauty, or an expression which seems to speak volumes, and with which we can converse, are the first and highest qualities in a single head. For it is obvious that when so little of a figure is seen, the only excuse for representing it doing nothing, is because it is very worthy to be looked at. A particular dress is often considered a sufficient reason, but it will never be admired if put on an unattractive person. In the next place all the powers of fascination which painting possesses are necessary, even with a beautiful and expressive countenance, to make so *abridged* a representation truly effective, and equivalent to pictures which contain more. It may be observed that every picture, no matter what it contains or represents, should be calculated for effect in a gallery of excellent works. We find for instance that a single head by Rembrandt will bear down before it large masses of figures by inferior colourists; so

that it is not because it is a part of a figure or a
small picture that a head must necessarily be with-
out much interest. The fascinating effect which is
produced by the powers of colour, light, and shade,
requires the hand, science, and experience of a
master, and to attempt to show in what that fasci-
nation consists would be to unveil, were it possible,
all the resources of the art. But in minor things
there are some observations to be made on the
general practice of painters.

The placing the head high in the canvas is
always to be observed; the contrary proceeding
gives the idea of a short person, or the impression
that we might have seen more of the figure. The
next thing to attend to (and not so easily done), is
to avoid a truncated appearance at the lower edge
of the picture where the arms and body are cut off
by the frame. When the bend of the arms can be
shown they look less glued to the sides of the
figure, but even a very graceful action of the arms
when cut off a little above the elbow may produce
a very unpleasant and awkward effect. The action
itself has, however, something to do with this, and
it is better to let the portions of the arms take the
direction which is least unpleasant, without think-
ing what becomes of them afterwards, than to ima-
gine a complete action, which may not, as above
observed, be pleasing, seen piecemeal. The safest
way, however, to get over this truncated appear-
ance is either to lose the lower part in drapery, or

to merge the outlines, if seen, in shadow or light, in short, to do away with the idea of division and cutting off, by hiding the intersection.

The opposite to this principle would be to make the part of the figure cut off by the frame the most conspicuous, when we immediately feel that there is more of the figure which we do not see. On the contrary when the head is most conspicuous, and the lower part left in uncertainty, we are not so much reminded that it is a half figure.

The making the head conspicuous is indeed the sine quâ non of this branch of art, and would only be neglected by an artist who had theorised himself out of the first and obvious requisites of a picture; viz., *that the greatest attention must be paid to, or at least attracted by the parts which are most important.**

The grace and ease which are sometimes eminently pleasing in pictures of only head and shoulders, depend on truth of drawing and proportion. To render a common and natural action well, seems, in so small a portion of the figure, a matter of little difficulty, but if it were not really extremely difficult we should see it oftener well done. The cause of failure generally is the fitting on of a neck and shoulders to a face without sufficiently

* In a small part of a figure, as in a three-quarter canvas, *any* sort of background with detail and lights and darks is dangerous. It is *supposed* that the head only is worth exhibiting, otherwise so small a canvas would not be chosen— all else must, therefore, be nothing in comparison.

studying the harmony of the action as well as of the proportions from nature. The face is generally advanced considerably before much is done to the rest. It is not necessary perhaps that all should be carried on together, but a drawing of the *whole* is necessary (either on the canvas or on a separate paper) from the model. The forms and proportions may be afterwards improved.

The more the representation is confined to the head, the more the head should not only be effective and attractive, but the more it should have in it an expression and appearance which in nature would force us to forget the rest of the figure. A mere head perhaps is always best represented looking at the spectator, and if it has a depth of expression and something uncommon which realises or accords with some unuttered thought, in addition to all the charms of colour and effect, it will rivet the spectator as much as an historical picture.

But it is much better in fancy subjects, where an artist is not tied to size, to introduce the hands. The difficulty of getting over the truncated effect is greatly diminished, and, what is of more importance still, a definite and motived expression and action can be given throughout what we see of the figure. It is true some difficulties are increased, such as the skilful management of the light, now rendered complicated by the spots of light formed by the hands, the paramount necessity of making

the general masses take pleasing shapes, &c. The hands, when thus introduced, should only serve to increase the expression of the head and the general beauty of the picture, but a more positive part they should not play. The actions and the feelings of a figure in a portrait or fancy subject of this kind are sufficiently limited if we reduce them to those truly interesting. We must always remember that the picture is supposed to exhibit the particular *mind* of the human being represented. A man with his hand extended, as if speaking to or about to receive one who addresses him, may be excused in a portrait as a mode of identifying the individual, but it is worth nothing as a means of affecting or impressing the spectator. To do this the person represented must do something or look something which exhibits him in his essential and peculiar, not in an accidental and common character. A deviation from such a principle is less pardonable in fancy subjects because the character there is left to the painter's own choosing, and a work of this kind with no particular *meaning* (always remembering that it is the face which should mean most) is even less interesting than a portrait.

In ideal subjects it is obviously safest to let the character and expression agree with the age and sex of the person. A lovely woman for instance will be more attractive (because more generally natural) with an expression of deep tenderness,

melancholy, innocence, hope, devotion, or benevo-
lence, than with a look of profound meditation or
grief; which latter supposes a remote cause of
which we are left in ignorance, and also destroys
beauty. But of all expressions in the head of a
beautiful woman that of innocent, confiding, and
devoted love is what will best *tell* in a picture.

Next to the expression, *par excellence*, should be
considered all that contributes to heighten the
effect of this union of the physical and moral cha-
racter. Titian makes his female heads really
women by the flow of soft luxurious hair, golden
and waving, with part loose on the shoulders.
The Greeks represented women *round* in outline
and in relief, the bones suppressed, the angles of
the shoulders softened. Titian had the same pene-
tration in catching what is truly nature; his half-
tints are composed of imperceptible gradations on
the cheeks, forehead, neck, and bosom, and thus
the features tell with power. The greatest con-
trasts in the figure have been placed by nature in
the head, where the shadow of the hair gives value
to the face, and in the face (where all the features
should tell more than any accidental shade) the
eye has more contrast, from its lightness, darkness
and sparkle, than any other feature.

The most ordinary colour of flesh and that which
we find imitated in the works of the Italian masters,
even including the Venetians, is a hue much lower
than white and very different from any positive

colour; yet it may be warm or cool and still be comparatively neutral, and if warm it will either verge towards *red*, *yellow* or *orange*. A negative colour of the latter kind, and more or less lower than warm white linen, is the predominant hue of Titian's fairest flesh colour. If such a colour is supposed, it may be well to examine what ground will give it most value. It is first evident that a delicate colour of any kind * will betray the mixed nature of the flesh, the neutrality of which will become muddiness. But a positive colour of a vigorous kind will exhibit its neutrality without impairing its brightness, and if warmth and glow can also be exhibited we shall have many characteristics of flesh. The rest, such as transparency, gradation, &c., being intrinsic qualities, are less dependent on opposition, though still greatly dependent. Various tones of blue and green of the deepest kind will therefore give *warmth* and comparative *neutrality* to flesh of the mixed and low kind, while the darkness of these colours will prevent even their purest parts from making the flesh look muddy. But any positive colour, very light indeed, near flesh which is composed of many broken colours, will make the latter muddy. Ridolfi relates that Titian preferred red

* Hence the purity of white linen is not only unpleasant from its boldness, as Sir Joshua Reynolds remarks, but also because where flesh is truly rendered, it may betray its mixed nature. White, " tinged with the rays of the setting sun," may be as *mixed* a colour as the flesh, only more colourless, it will thus differ in *degree,* not in *kind,* and therefore harmonise.

and blue as grounds to flesh, because, he says, they
never injure the colour. A red ground to flesh
will exhibit its pearliness and its neutrality, and
should therefore be used where the flesh is neutral
on the *cool* side—blue or green will best exhibit a
flesh when that is neutral in the *warm* key; but
the *sort* of red we sometimes see in finely coloured
pictures as a ground to flesh supposes a total sacri-
fice of the flesh as to brightness; or, if its purity be
also preserved, it supposes a very high key for the
flesh and not so literal an imitation as the Venetians
generally adopt. In Bonifazio we have rose-coloured
draperies like gems and with bright lights, but the
flesh next it no longer pretends to brightness, it is
a low, pearly middle tint. In a portrait this would
be too great a sacrifice, for the drapery may be
said to be principal in such a case.

Again, in Palma Vecchio we have sometimes
gem-like lake draperies with bright lights, but the
flesh is painted in the purest and highest key, and
still has a superior brightness without losing its
neutrality. Lastly, in Titian, we have the safer
practice of deep, warm lake draperies next to flesh
true in tone (neutral in a warm key) which give it
brightness by their depth, and pearliness by their
redness, and neutrality by their positiveness.
Titian seems to have aimed at giving the transpa-
rency of flesh, not by surrounding it with muddy
colours (because his flesh is itself too mixed and
broken) but by colouring it in such a mode as

characterises a transparent body—viz., by making the shadows, at least at their beginning, very warm (the dark shadows will of necessity be warm). If we make the experiment of looking at a coloured drapery—a curtain, for instance—between us and the light, we shall find the colour deepened in the shades instead of becoming weaker, and we shall also observe that the colour of the object is, as it were, multiplied. This rich and pleasing effect is aimed at by all the Venetian painters in their draperies, and by Titian very much in the flesh. To avoid a glassy and unsubstantial appearance this great master used draperies coloured still more in this system, while his flesh, which we know from Boschini,* was composed of the commonest earths, does not appear to have been finally glazed like his draperies with an absolutely transparent colour, but with one composed of semi-transparent washes; thus acquiring a comparative solidity and earthiness compared to lighter substances.

On the other hand a muddy background may be used with effect next to flesh which is remarkable for its positiveness and which abounds in unbroken tints. Such a practice is the reverse of Titian's general method, but the principle of contrast is the same, and beautiful effects have been sometimes thus produced. This method gives flesh *every* agreeable quality and consequently at

* *Carta del Navigar*, v. 5.

the expense of general truth, but in a half figure
with little accompaniment this may be safely done
if we have no means of detecting the artifice.
That flesh should be warm, sufficiently neutral, and
bright, is an object compatible with general imita-
tion, but that it should be more transparent than
any other substance, and lighter than any other
substance, can only happen (to be true) when no
other substances are visible. It follows that in a
head, or (what is called) three quarters, where flesh
is absolutely principal and alone, it may be prin-
cipal in every way without losing its character.
But after all, it must be remembered that Titian
(and Giorgione perhaps) seldom availed themselves
of this artifice, but always aimed at the general and
true character of flesh, whether in a confined or ex-
tended subject.

We have thus considered how *warmth,* compara-
tive *neutrality, brightness,* and *transparency*—four
great qualities of flesh—are to be approached. The
imperceptible gradations of its half-lights are best
heightened by visible sharpness upon or near them ;
ornaments, such as black or gold necklaces, or gems,
or dark cutting strings, and similar things, are in-
troduced by the Venetians with the utmost hard-
ness on flesh so softly graduated that we cannot
arrest the division of the half-tints. Lastly, not
only the edges of shadows are soft, but all *shadows*
which are constant and do not express a hollow are
lightened up with reflexions so as to keep the flesh

free from large portions of darkness,* and hence the darks of the features and leading points tell with double meaning and vivacity.

Of all these qualities that which admits of the greater *variety of scale* is the quality of brightness. Flesh may be made much whiter than it is and yet appear true if we have no white or any superior brightness near it. Where gems, gold, or silver are introduced the true scale of nature can only be given by painting flesh as low as it is. It is remarkable that Titian did this, and yet disdained to use the brightness in his power by making gems and metal sparkle. His flesh probably was always lower than nature, and richer and warmer, so that had he chosen to give the brightness of gems he might have done so, but we remark in his female portraits that he dwells rather on the colour than on the polish of gold—he dwells on its reflexions where its own colour is multiplied and enriched— but not on the direct shine of the light which naturally destroys the colour of the object. The same may be observed in his mode of painting the eye, the sparkle of white, powerful as it is in giving speculation to the eye, is not to the taste of a colourist; the liquid appearance of the eye par- takes of and enriches its colour and transparency, but the direct light robs it of its colour, and, if a

* That is to say, the general idea of the colour should be preserved unimpaired by light and shade, as far as is com- patible with truth.

considerable touch, produces undue and inharmo-
nious contrasts. These direct touches of light are
greatly suppressed in Titian when they come on
the dark of the eye. But his method is quite
different when large masses of polished substance
are to be treated. The colour of the object is here
nothing, its character is to *reflect*, and it reflects all
things. The beaming look of armour opposed to
flesh, *in which all polish is carefully suppressed*,
gives great beauty to both. A polish on flesh is
to be suppressed generally, as the light would differ
from the colour, but more especially when metals,
silks, or any glossy things are near.

ON SUBJECTS FOR PAINTING.

I⊤ is a common error with unpractised artists,
especially if their minds are cultivated, to consider
those subjects fittest for painting which excite the
most important historical recollections, and in which
the actors are interesting, at least from their names.
The real interest of such pictures would be best
tried by submitting them to spectators ignorant
of the persons represented (as most spectators
probably would be unless their names were written
under the figures). In description it is of the
first consequence that the actors, whatever they
are doing, should be morally interesting. It is not
what they are doing but *who* are doing which is
the great source of interest ; for no one act, not

even the greatest in a man's life, is equivalent to the impression produced by the sum of his acts and the world's opinion—in short, by his *fame*— which makes the individual interesting *whatever* he may be doing. In painting, on the contrary, it is not who is doing but what is being done, as presented to our sight, which is the first as well as the last and longest source of interest. Great, or well-known names, in addition to this *sine quâ non*, undoubtedly add to the effect.

There are many persons so unconscious of the difference between the best and the worst pictures that to them the association is all in all; this exists with all spectators more or less, and is only in danger of being totally unfelt by that class of artists who make the impression on the eye alone the only rule for choice of subject, composition, costume, &c. When once this becomes the sole guide (and it is admitted in all cases to be a very principal one), no absurdities in a moral, historical, or chronological point of view check the artist. His object (he says) is to produce a powerful and pleasing impression on the sense, and he not unjustly argues that those who criticise him for errors in costume, or for liberties taken with his subject, would have the right to find still greater fault with him if he produced an insipid picture. He works with his own materials, as the writer does with his, and the art of representation can only pretend to independence and, in short, to *style* when its prin-

ciples and practice are regulated by its proper and distinct end. This view which contains much truth, but which easily admits of exaggeration, explains the extraordinary liberties which artists took at a time when the *art* was in its most perfect development. These licenses form a singular contrast with the fidelity to costume and the insipid propriety of modern pictures. A very little reflexion is sufficient to convince us that the masterworks of art would never have received the sanction of universal and enduring approbation but for the truest and the largest reasons—that the world's approbation has been given them because they unite as much of the end of art with as much of the means as is compatible, and that the defects above alluded to may often be necessary to, and even the chief cause of their excellence.

A habit of contemplating works of art merely with reference to those qualities which are common to description and general learning is the cause of the quantity of false criticism which has so often fallen from the pens of cultivated men. Nothing in short is easier than to find the greatest defects as to history, situation &c. in the finest works, and nothing can be a greater mistake (in most cases, we do not say in all) than to suppose that the remedying of these defects would improve the *work of art*. Let the Laocoon be clothed (as he should be) in his sacerdotal robes, and the coldest of these critics would acknowledge that no drapery nor

ornament, especially in the monotony of marble, would be so beautiful or so impressive as his fine and convulsed form. Here then is an instance of the translation which is necessary when a subject is changed from one language to another—from description to representation. The first object of the artist who works in marble is to overcome its *lifelessness*, and no representation of drapery or any inanimate substance as a principal object ever does this. Drapery was therefore treated generally as an accessory by the ancient sculptors, and, when entire figures were clothed, as the marble could not be turned into a surface of animated life, its hardness and rigidity were converted, in the form of drapery, into an illusion of softness and flexibility; but such qualities were inferior to the expression of voluntary action, in short, of life, and, above all, of human life.

In painting too, nothing is so beautiful as the colour of the flesh, and we must not be surprised to find that the greatest colourists not only sought every opportunity of unclothing their figures but introduced all sorts of contrasts near them, whether warranted or not, in order to give them value. Michael Angelo's love of nude figures was of another, perhaps of a higher kind; he aimed at expressing grand ideas of nature, and with the feeling of a sculptor he disdained to waste his powers in painting cloth instead of human forms. The excesses to which Michael Angelo and the

colourists carried this feeling, though for different
reasons, are well known. Raphael, with the highest
forms, was fortunate in having no particular passion
either for colour, or for anatomy, and was therefore
enabled to unite more of general propriety with the
claims of art than any other painter. But let it
not be supposed that even he will stand the test of
the false criticism above alluded to. No painter is
fuller of anachronisms. Like all the other great
artists, he aims at satisfying the feelings and the
eye, but not the *learning* of the spectator. Lastly,
even Poussin—the classic, correct, and pure—is
full of errors in costume, while he gives a general
impression of the chaste and simple principles of
composition so admired in the ancients.

But if errors to this extent are to be found in
the purest schools and examples what shall we say
of those artists who confined themselves entirely to
the ends of the art, and how can we account for
the admiration bestowed upon them? Many of the
mere colourists may be censured for having occu-
pied themselves with an important part of the style,
but not with the whole of the style of their art.
Rembrandt, for instance, in compositions which did
not require beauty, may be said to have attained
perfection by satisfying the eye and the imagination
and deeply interesting the feelings, and yet with
every conceivable error of costume. The colourists
of the Venetian school (always excepting Titian)
atone for the want of interest often visible in their

works, by a certain refinement of elegance which
we always associate with splendour of colour, and
which, in Paul Veronese, is often accompanied
with a vivacity in the air and attitude, which
although soon tiring, is addressed to the imagination
and allied to ideas of beauty. Rubens, again, has
not even this quality; he seldom approaches the
idea of beauty in his forms or attitudes, yet he is
always great in the particular beauty (that of
colour) which constitutes the essence of painting,
and every part of his works is evidence of his
deep feeling for all that constitutes the style of
this art as distinguished from any other.

When intelligent spectators (who have not paid
particular attention to art) are sincere in their
opinions on such works, they judge them merely as
expressive of a subject, and fasten immediately on
anything that shocks their notions of propriety as to
invention, costume, &c. Those again who are less
severe endeavour to make up the sum of praise,
which they know it is usual to bestow, by supposing
excellences which come within their sphere of com-
prehension. It is to be lamented that sensible men
should think it necessary on these occasions to
assume a virtue which they have not. Dr. Beattie,
after sitting to Reynolds, declares that, whatever
might be thought of his colouring, he was a great
designer. This was altogether affectation, because
he could judge as little of the one as of the other;
but it is not uncommon for intelligent people to

praise a picture for that which it has not, merely because they know that something ought to be praised.

It is an undeniable fact that there are certain requisites in a work of art which are more necessary than any others. *That which addresses the sense must delight the sense before it can reach the mind.* Again, there is a difference in the interest of objects, and another difference in their sort of interest. It may be assumed first, that nothing is so interesting to human beings as human beings; and secondly, that the exhibition of female beauty will always first attract the eye. But although interest in the object and beauty in colouring may be thus secured, a picture may still need some moral interest—that is, the feelings must be interested—and, lastly, the intellect may be addressed by as much attention to costume or history as can be kept subordinate to more proper claims.

MEANS AND END OF ART.

[Fragment from a Journal Book of 1828.]

ONE thing is certain, that whatever the *end* of art may be, whatever feelings in men it may address, its *means* must be ever the same. These are not measured by the temper of society in any age, but by the nature of the art itself, which is immutable. If it is not *itself* it will be surpassed by something else, either by Sculpture or by Poetry. There

can be no question or no difficulty in settling the question as to what the strength and character and beauty of painting consist in—as a means. But what end these means shall serve,—in short what feeling in man should be addressed, is the question. It would at first appear that as the senses must necessarily be addressed and pleased, some feeling connected with the mere enjoyment of nature ought to constitute the strongest impression made by the arts. This would, however, at once involve the necessity (in theory) of suppressing them altogether. It is evident, therefore, that they can be only fitted for the refined enjoyment of human beings when they correct the indispensable appeal to the senses by a pure moral impression.

This is almost what the Memlings and Van Eycks do; their notion of colour is of the largest kind (making some allowance for the general infancy of art), the true character of things is everywhere expressed (black is never lighted—flesh is always transparent—white is always brilliant), and while the sense is charmed with this large and true view of nature, which might give tenfold interest to a subject of more beauty, the end all this serves is of the most solemn, pure, innocent and noble kind. The beauties of nature and all the pleasures of sense may be presented in the same way, for we know it is quite possible for human beings to love Nature in her most attractive forms, without sensual associations, and if it were not so,

our reason would be useless to us. By attractive forms are not meant voluptuous ones, for these are in their nature unfit for imitation; but there is no more reason why a pure subject should not be connected with the whole attractions of art in colour, &c., than that the beauties of nature should not be compatible with an innocent feeling. It is the privilege of reasonable beings to unite the two: united they must ever be, more or less, for the attempt to suppress the attractions of sense in life, is only as absurd as to attempt to reject colour from Painting. It comes then to this that, as the method or language of Painting is one, immutable, and indispensable, the great object is to take care that the *end* be noble, human, refined; for the means will take care of themselves. The end is defined by the nature of the feelings excited, and no matter what the subject is (if always sufficiently beautiful to the eye) so long as the feelings excited are noble and elevated. If they excite human sympathy in its pleasing degrees, all that is permanently graceful or refined, all that is rational and intellectual in joy, and all that is dignified in sorrow—all in short that is human and religious—the end of art may be safely said to be accomplished in any age, for the human and Christian character is as certain in its definition as the character of the art. It appears then that the *means* are determined by examining the nature of the art itself,—as it were blindly, impli-

citly, with a docile and passive spirit of enquiry—
independently of any other consideration, and from
this determination there is no appeal. The *end*, on
the other hand, is measured by the general feeling in
the human spectator to be addressed, and as the
senses *must* be sensual, the end cannot be too high
and pure, provided it be within our sympathies, and
sufficiently analogous to human sensibilities. This
is using the imitation of nature as wise men tell us
to use nature itself—viz., in subordination to our
immortal and *not natural* being. The union of the
two in Painting is extremely pleasing, because the
very means by which the sense is delighted (as is
elsewhere shown) make the ruling impression more
strong. The more perfect the appeal to the sense
in the *means*, the more impressive will be the *end*.
The Greeks seem to have contented themselves
with clearly defining the nature of the means, and
the means and end were one with them. Nature
only existed to be enjoyed; there was no moral
monitor to check the indulgence of what nature
offered; but let it not be supposed that their art is
therefore more consistent and perfect; it was more
easily *made* consistent, it is true, with the then ex-
isting state of things. Still, there is no more im-
possibility, as before said, in uniting a pure end
with the indispensable means of art, than there
is for a man to live for the health of body and
mind, and not for his appetites: and, moreover, if
accomplished, such a style of art would be more

strictly human and characteristic of our nature,—
more fitted for beings made of body and soul to-
gether. If brutes could draw and model they
would minister to earthly objects only; but beings
who confess immortal aspirations must distinguish
even their abstract ideas of Nature from such
as mere mortals would arrive at. The Greeks
defined the object of the hopes of mere mortals to
consist in the enjoyment of nature—they defined
them consistently, accurately, perfectly, as ad-
dressed to the senses and the imagination. They
defined too the feelings of the natural man to which
their works were addressed—his pride, his dignity,
his courage, his love, his taste—but his soul-felt
trust, his peace, his faith, his humility, his contri-
tion, they could not address, because they knew
them not. They could represent the joys of
nature, and the feelings of the natural man har-
monized then with those joys as they do now: but
evil in any shape was without solace to them:
without resignation, without comprehension, with-
out submission, the exhibition of evil in art appeals
to human sympathies as if there were none else to
help. Thus evil or pain if represented in antique
sculpture either underwent modifications suited to
the art, or was a means only to exhibit the
human form in finer action.

INDEX.

A CATALOGUE OF SELECTED DOVER BOOKS
IN ALL FIELDS OF INTEREST

A CATALOGUE OF SELECTED DOVER BOOKS
IN ALL FIELDS OF INTEREST

AMERICA'S OLD MASTERS, James T. Flexner. Four men emerged unexpectedly from provincial 18th century America to leadership in European art: Benjamin West, J. S. Copley, C. R. Peale, Gilbert Stuart. Brilliant coverage of lives and contributions. Revised, 1967 edition. 69 plates. 365pp. of text.

21806-6 Paperbound $2.75

FIRST FLOWERS OF OUR WILDERNESS: AMERICAN PAINTING, THE COLONIAL PERIOD, James T. Flexner. Painters, and regional painting traditions from earliest Colonial times up to the emergence of Copley, West and Peale Sr., Foster, Gustavus Hesselius, Feke, John Smibert and many anonymous painters in the primitive manner. Engaging presentation, with 162 illustrations. xxii + 368pp.

22180-6 Paperbound $3.50

THE LIGHT OF DISTANT SKIES: AMERICAN PAINTING, 1760-1835, James T. Flexner. The great generation of early American painters goes to Europe to learn and to teach: West, Copley, Gilbert Stuart and others. Allston, Trumbull, Morse; also contemporary American painters—primitives, derivatives, academics—who remained in America. 102 illustrations. xiii + 306pp. 22179-2 Paperbound $3.00

A HISTORY OF THE RISE AND PROGRESS OF THE ARTS OF DESIGN IN THE UNITED STATES, William Dunlap. Much the richest mine of information on early American painters, sculptors, architects, engravers, miniaturists, etc. The only source of information for scores of artists, the major primary source for many others. Unabridged reprint of rare original 1834 edition, with new introduction by James T. Flexner, and 394 new illustrations. Edited by Rita Weiss. 6⅝ x 9⅝.

21695-0, 21696-9, 21697-7 Three volumes, Paperbound $13.50

EPOCHS OF CHINESE AND JAPANESE ART, Ernest F. Fenollosa. From primitive Chinese art to the 20th century, thorough history, explanation of every important art period and form, including Japanese woodcuts; main stress on China and Japan, but Tibet, Korea also included. Still unexcelled for its detailed, rich coverage of cultural background, aesthetic elements, diffusion studies, particularly of the historical period. 2nd, 1913 edition. 242 illustrations. lii + 439pp. of text.

20364-6, 20365-4 Two volumes, Paperbound $5.00

THE GENTLE ART OF MAKING ENEMIES, James A. M. Whistler. Greatest wit of his day deflates Oscar Wilde, Ruskin, Swinburne; strikes back at inane critics, exhibitions, art journalism; aesthetics of impressionist revolution in most striking form. Highly readable classic by great painter. Reproduction of edition designed by Whistler. Introduction by Alfred Werner. xxxvi + 334pp.

21875-9 Paperbound $2.25

THE END.

VISUAL ILLUSIONS: THEIR CAUSES, CHARACTERISTICS, AND APPLICATIONS, Matthew Luckiesh. Thorough description and discussion of optical illusion, geometric and perspective, particularly; size and shape distortions, illusions of color, of motion; natural illusions; use of illusion in art and magic, industry, etc. Most useful today with op art, also for classical art. Scores of effects illustrated. Introduction by William H. Ittleson. 100 illustrations. xxi + 252pp.
21530-X Paperbound $1.50

A HANDBOOK OF ANATOMY FOR ART STUDENTS, Arthur Thomson. Thorough, virtually exhaustive coverage of skeletal structure, musculature, etc. Full text, supplemented by anatomical diagrams and drawings and by photographs of undraped figures. Unique in its comparison of male and female forms, pointing out differences of contour, texture, form. 211 figures, 40 drawings, 86 photographs. xx + 459pp. 5⅜ x 8⅜.
21163-0 Paperbound $3.00

150 MASTERPIECES OF DRAWING, Selected by Anthony Toney. Full page reproductions of drawings from the early 16th to the end of the 18th century, all beautifully reproduced: Rembrandt, Michelangelo, Dürer, Fragonard, Urs, Graf, Wouwerman, many others. First-rate browsing book, model book for artists. xviii + 150pp. 8⅜ x 11¼.
21032-4 Paperbound $2.00

THE LATER WORK OF AUBREY BEARDSLEY, Aubrey Beardsley. Exotic, erotic, ironic masterpieces in full maturity: Comedy Ballet, Venus and Tannhauser, Pierrot, Lysistrata, Rape of the Lock, Savoy material, Ali Baba, Volpone, etc. This material revolutionized the art world, and is still powerful, fresh, brilliant. With *The Early Work,* all Beardsley's finest work. 174 plates, 2 in color. xiv + 176pp. 8⅛ x 11.
21817-1 Paperbound $3.00

DRAWINGS OF REMBRANDT, Rembrandt van Rijn. Complete reproduction of fabulously rare edition by Lippmann and Hofstede de Groot, completely reedited, updated, improved by Prof. Seymour Slive, Fogg Museum. Portraits, Biblical sketches, landscapes, Oriental types, nudes, episodes from classical mythology—All Rembrandt's fertile genius. Also selection of drawings by his pupils and followers. "Stunning volumes," *Saturday Review.* 550 illustrations. lxxviii + 552pp. 9⅛ x 12¼.
21485-0, 21486-9 Two volumes, Paperbound $6.50

THE DISASTERS OF WAR, Francisco Goya. One of the masterpieces of Western civilization—83 etchings that record Goya's shattering, bitter reaction to the Napoleonic war that swept through Spain after the insurrection of 1808 and to war in general. Reprint of the first edition, with three additional plates from Boston's Museum of Fine Arts. All plates facsimile size. Introduction by Philip Hofer, Fogg Museum. v + 97pp. 9⅜ x 8¼.
21872-4 Paperbound $1.75

GRAPHIC WORKS OF ODILON REDON. Largest collection of Redon's graphic works ever assembled: 172 lithographs, 28 etchings and engravings, 9 drawings. These include some of his most famous works. All the plates from *Odilon Redon: oeuvre graphique complet,* plus additional plates. New introduction and caption translations by Alfred Werner. 209 illustrations. xxvii + 209pp. 9⅛ x 12¼.
21966-8 Paperbound $4.00

DESIGN BY ACCIDENT; A BOOK OF "ACCIDENTAL EFFECTS" FOR ARTISTS AND DESIGNERS, James F. O'Brien. Create your own unique, striking, imaginative effects by "controlled accident" interaction of materials: paints and lacquers, oil and water based paints, splatter, crackling materials, shatter, similar items. Everything you do will be different; first book on this limitless art, so useful to both fine artist and commercial artist. Full instructions. 192 plates showing "accidents," 8 in color. viii + 215pp. 8⅜ x 11¼. 21942-9 Paperbound $3.50

THE BOOK OF SIGNS, Rudolf Koch. Famed German type designer draws 493 beautiful symbols: religious, mystical, alchemical, imperial, property marks, runes, etc. Remarkable fusion of traditional and modern. Good for suggestions of timelessness, smartness, modernity. Text. vi + 104pp. 6⅛ x 9¼. 20162-7 Paperbound $1.25

HISTORY OF INDIAN AND INDONESIAN ART, Ananda K. Coomaraswamy. An unabridged republication of one of the finest books by a great scholar in Eastern art. Rich in descriptive material, history, social backgrounds; Sunga reliefs, Rajput paintings, Gupta temples, Burmese frescoes, textiles, jewelry, sculpture, etc. 400 photos. viii + 423pp. 6⅜ x 9¾. 21436-2 Paperbound $3.50

PRIMITIVE ART, Franz Boas. America's foremost anthropologist surveys textiles, ceramics, woodcarving, basketry, metalwork, etc.; patterns, technology, creation of symbols, style origins. All areas of world, but very full on Northwest Coast Indians. More than 350 illustrations of baskets, boxes, totem poles, weapons, etc. 378 pp. 20025-6 Paperbound $2.50

THE GENTLEMAN AND CABINET MAKER'S DIRECTOR, Thomas Chippendale. Full reprint (third edition, 1762) of most influential furniture book of all time, by master cabinetmaker. 200 plates, illustrating chairs, sofas, mirrors, tables, cabinets, plus 24 photographs of surviving pieces. Biographical introduction by N. Bienenstock. vi + 249pp. 9⅞ x 12¾. 21601-2 Paperbound $3.50

AMERICAN ANTIQUE FURNITURE, Edgar G. Miller, Jr. The basic coverage of all American furniture before 1840. Individual chapters cover type of furniture—clocks, tables, sideboards, etc.—chronologically, with inexhaustible wealth of data. More than 2100 photographs, all identified, commented on. Essential to all early American collectors. Introduction by H. E. Keyes. vi + 1106pp. 7⅞ x 10¾. 21599-7, 21600-4 Two volumes, Paperbound $7.50

PENNSYLVANIA DUTCH AMERICAN FOLK ART, Henry J. Kauffman. 279 photos, 28 drawings of tulipware, Fraktur script, painted tinware, toys, flowered furniture, quilts, samplers, hex signs, house interiors, etc. Full descriptive text. Excellent for tourist, rewarding for designer, collector. Map. 146pp. 7⅞ x 10¾. 21205-X Paperbound $2.00

EARLY NEW ENGLAND GRAVESTONE RUBBINGS, Edmund V. Gillon, Jr. 43 photographs, 226 carefully reproduced rubbings show heavily symbolic, sometimes macabre early gravestones, up to early 19th century. Remarkable early American primitive art, occasionally strikingly beautiful; always powerful. Text. xxvi + 207pp. 8⅜ x 11¼. 21380-3 Paperbound $3.00

ALPHABETS AND ORNAMENTS, Ernst Lehner. Well-known pictorial source for decorative alphabets, script examples, cartouches, frames, decorative title pages, calligraphic initials, borders, similar material. 14th to 19th century, mostly European. Useful in almost any graphic arts designing, varied styles. 750 illustrations. 256pp. 7 x 10. 21905-4 Paperbound $3.50

PAINTING: A CREATIVE APPROACH, Norman Colquhoun. For the beginner simple guide provides an instructive approach to painting: major stumbling blocks for beginner; overcoming them, technical points; paints and pigments; oil painting; watercolor and other media and color. New section on "plastic" paints. Glossary. Formerly *Paint Your Own Pictures.* 221pp. 22000-1 Paperbound $1.75

THE ENJOYMENT AND USE OF COLOR, Walter Sargent. Explanation of the relations between colors themselves and between colors in nature and art, including hundreds of little-known facts about color values, intensities, effects of high and low illumination, complementary colors. Many practical hints for painters, references to great masters. 7 color plates, 29 illustrations. x + 274pp.
 20944-X Paperbound $2.50

THE NOTEBOOKS OF LEONARDO DA VINCI, compiled and edited by Jean Paul Richter. 1566 extracts from original manuscripts reveal the full range of Leonardo's versatile genius: all his writings on painting, sculpture, architecture, anatomy, astronomy, geography, topography, physiology, mining, music, etc., in both Italian and English, with 186 plates of manuscript pages and more than 500 additional drawings. Includes studies for the Last Supper, the lost Sforza monument, and other works. Total of xlvii + 866pp. $7\frac{7}{8}$ x $10\frac{3}{4}$.
 22572-0, 22573-9 Two volumes, Paperbound $10.00

MONTGOMERY WARD CATALOGUE OF 1895. Tea gowns, yards of flannel and pillow-case lace, stereoscopes, books of gospel hymns, the New Improved Singer Sewing Machine, side saddles, milk skimmers, straight-edged razors, high-button shoes, spittoons, and on and on . . . listing some 25,000 items, practically all illustrated. Essential to the shoppers of the 1890's, it is our truest record of the spirit of the period. Unaltered reprint of Issue No. 57, Spring and Summer 1895. Introduction by Boris Emmet. Innumerable illustrations. xiii + 624pp. $8\frac{1}{2}$ x $11\frac{5}{8}$.
 22377-9 Paperbound $6.95

THE CRYSTAL PALACE EXHIBITION ILLUSTRATED CATALOGUE (LONDON, 1851). One of the wonders of the modern world—the Crystal Palace Exhibition in which all the nations of the civilized world exhibited their achievements in the arts and sciences—presented in an equally important illustrated catalogue. More than 1700 items pictured with accompanying text—ceramics, textiles, cast-iron work, carpets, pianos, sleds, razors, wall-papers, billiard tables, beehives, silverware and hundreds of other artifacts—represent the focal point of Victorian culture in the Western World. Probably the largest collection of Victorian decorative art ever assembled—indispensable for antiquarians and designers. Unabridged republication of the Art-Journal Catalogue of the Great Exhibition of 1851, with all terminal essays. New introduction by John Gloag, F.S.A. xxxiv + 426pp. 9 x 12.
 22503-8 Paperbound $4.50

A HISTORY OF COSTUME, Carl Köhler. Definitive history, based on surviving pieces of clothing primarily, and paintings, statues, etc. secondarily. Highly readable text, supplemented by 594 illustrations of costumes of the ancient Mediterranean peoples, Greece and Rome, the Teutonic prehistoric period; costumes of the Middle Ages, Renaissance, Baroque, 18th and 19th centuries. Clear, measured patterns are provided for many clothing articles. Approach is practical throughout. Enlarged by Emma von Sichart. 464pp. 21030-8 Paperbound $3.00

ORIENTAL RUGS, ANTIQUE AND MODERN, Walter A. Hawley. A complete and authoritative treatise on the Oriental rug—where they are made, by whom and how, designs and symbols, characteristics in detail of the six major groups, how to distinguish them and how to buy them. Detailed technical data is provided on periods, weaves, warps, wefts, textures, sides, ends and knots, although no technical background is required for an understanding. 11 color plates, 80 halftones, 4 maps. vi + 320pp. 6⅛ x 9⅛. 22366-3 Paperbound $5.00

TEN BOOKS ON ARCHITECTURE, Vitruvius. By any standards the most important book on architecture ever written. Early Roman discussion of aesthetics of building, construction methods, orders, sites, and every other aspect of architecture has inspired, instructed architecture for about 2,000 years. Stands behind Palladio, Michelangelo, Bramante, Wren, countless others. Definitive Morris H. Morgan translation. 68 illustrations. xii + 331pp. 20645-9 Paperbound $2.50

THE FOUR BOOKS OF ARCHITECTURE, Andrea Palladio. Translated into every major Western European language in the two centuries following its publication in 1570, this has been one of the most influential books in the history of architecture. Complete reprint of the 1738 Isaac Ware edition. New introduction by Adolf Placzek, Columbia Univ. 216 plates. xxii + 110pp. of text. 9½ x 12¾. 21308-0 Clothbound $10.00

STICKS AND STONES: A STUDY OF AMERICAN ARCHITECTURE AND CIVILIZATION, Lewis Mumford.One of the great classics of American cultural history. American architecture from the medieval-inspired earliest forms to the early 20th century; evolution of structure and style, and reciprocal influences on environment. 21 photographic illustrations. 238pp. 20202-X Paperbound $2.00

THE AMERICAN BUILDER'S COMPANION, Asher Benjamin. The most widely used early 19th century architectural style and source book, for colonial up into Greek Revival periods. Extensive development of geometry of carpentering, construction of sashes, frames, doors, stairs; plans and elevations of domestic and other buildings. Hundreds of thousands of houses were built according to this book, now invaluable to historians, architects, restorers, etc. 1827 edition. 59 plates. 114pp. 7⅞ x 10¾. 22236-5 Paperbound $3.00

DUTCH HOUSES IN THE HUDSON VALLEY BEFORE 1776, Helen Wilkinson Reynolds. The standard survey of the Dutch colonial house and outbuildings, with constructional features, decoration, and local history associated with individual homesteads. Introduction by Franklin D. Roosevelt. Map. 150 illustrations. 469pp. 6⅝ x 9¼. 21469-9 Paperbound $3.50

THE ARCHITECTURE OF COUNTRY HOUSES, Andrew J. Downing. Together with Vaux's *Villas and Cottages* this is the basic book for Hudson River Gothic architecture of the middle Victorian period. Full, sound discussions of general aspects of housing, architecture, style, decoration, furnishing, together with scores of detailed house plans, illustrations of specific buildings, accompanied by full text. Perhaps the most influential single American architectural book. 1850 edition. Introduction by J. Stewart Johnson. 321 figures, 34 architectural designs. xvi + 560pp.

22003-6 Paperbound $3.50

LOST EXAMPLES OF COLONIAL ARCHITECTURE, John Mead Howells. Full-page photographs of buildings that have disappeared or been so altered as to be denatured, including many designed by major early American architects. 245 plates. xvii + 248pp. 7⅞ x 10¾.

21143-6 Paperbound $3.00

DOMESTIC ARCHITECTURE OF THE AMERICAN COLONIES AND OF THE EARLY REPUBLIC, Fiske Kimball. Foremost architect and restorer of Williamsburg and Monticello covers nearly 200 homes between 1620-1825. Architectural details, construction, style features, special fixtures, floor plans, etc. Generally considered finest work in its area. 219 illustrations of houses, doorways, windows, capital mantels. xx + 314pp. 7⅞ x 10¾.

21743-4 Paperbound $3.50

EARLY AMERICAN ROOMS: 1650-1858, edited by Russell Hawes Kettell. Tour of 12 rooms, each representative of a different era in American history and each furnished, decorated, designed and occupied in the style of the era. 72 plans and elevations, 8-page color section, etc., show fabrics, wall papers, arrangements, etc. Full descriptive text. xvii + 200pp. of text. 8⅜ x 11¼.

21633-0 Paperbound $4.00

THE FITZWILLIAM VIRGINAL BOOK, edited by J. Fuller Maitland and W. B. Squire. Full modern printing of famous early 17th-century ms. volume of 300 works by Morley, Byrd, Bull, Gibbons, etc. For piano or other modern keyboard instrument; easy to read format. xxxvi + 938pp. 8⅜ x 11.

21068-5, 21069-3 Two volumes, Paperbound $8.00

HARPSICHORD MUSIC, Johann Sebastian Bach. Bach Gesellschaft edition. A rich selection of Bach's masterpieces for the harpsichord: the six English Suites, six French Suites, the six Partitas (Clavierübung part I), the Goldberg Variations (Clavierübung part IV), the fifteen Two-Part Inventions and the fifteen Three-Part Sinfonias. Clearly reproduced on large sheets with ample margins; eminently playable. vi + 312pp. 8⅛ x 11.

22360-4 Paperbound $5.00

THE MUSIC OF BACH: AN INTRODUCTION, Charles Sanford Terry. A fine, nontechnical introduction to Bach's music, both instrumental and vocal. Covers organ music, chamber music, passion music, other types. Analyzes themes, developments, innovations. x + 114pp.

21075-8 Paperbound $1.25

BEETHOVEN AND HIS NINE SYMPHONIES, Sir George Grove. Noted British musicologist provides best history, analysis, commentary on symphonies. Very thorough, rigorously accurate; necessary to both advanced student and amateur music lover. 436 musical passages. vii + 407 pp.

20334-4 Paperbound $2.25

JOHANN SEBASTIAN BACH, Philipp Spitta. One of the great classics of musicology, this definitive analysis of Bach's music (and life) has never been surpassed. Lucid, nontechnical analyses of hundreds of pieces (30 pages devoted to St. Matthew Passion, 26 to B Minor Mass). Also includes major analysis of 18th-century music. 450 musical examples. 40-page musical supplement. Total of xx + 1799pp.
(EUK) 22278-0, 22279-9 Two volumes, Clothbound $15.00

MOZART AND HIS PIANO CONCERTOS, Cuthbert Girdlestone. The only full-length study of an important area of Mozart's creativity. Provides detailed analyses of all 23 concertos, traces inspirational sources. 417 musical examples. Second edition. 509pp. (USO) 21271-8 Paperbound $3.50

THE PERFECT WAGNERITE: A COMMENTARY ON THE NIBLUNG'S RING, George Bernard Shaw. Brilliant and still relevant criticism in remarkable essays on Wagner's Ring cycle, Shaw's ideas on political and social ideology behind the plots, role of Leitmotifs, vocal requisites, etc. Prefaces. xxi + 136pp.
21707-8 Paperbound $1.50

DON GIOVANNI, W. A. Mozart. Complete libretto, modern English translation; biographies of composer and librettist; accounts of early performances and critical reaction. Lavishly illustrated. All the material you need to understand and appreciate this great work. Dover Opera Guide and Libretto Series; translated and introduced by Ellen Bleiler. 92 illustrations. 209pp.
21134-7 Paperbound $1.50

HIGH FIDELITY SYSTEMS: A LAYMAN'S GUIDE, Roy F. Allison. All the basic information you need for setting up your own audio system: high fidelity and stereo record players, tape records, F.M. Connections, adjusting tone arm, cartridge, checking needle alignment, positioning speakers, phasing speakers, adjusting hums, trouble-shooting, maintenance, and similar topics. Enlarged 1965 edition. More than 50 charts, diagrams, photos. iv + 91pp. 21514-8 Paperbound $1.25

REPRODUCTION OF SOUND, Edgar Villchur. Thorough coverage for laymen of high fidelity systems, reproducing systems in general, needles, amplifiers, preamps, loudspeakers, feedback, explaining physical background. "A rare talent for making technicalities vividly comprehensible," R. Darrell, *High Fidelity*. 69 figures. iv + 92pp. 21515-6 Paperbound $1.00

HEAR ME TALKIN' TO YA: THE STORY OF JAZZ AS TOLD BY THE MEN WHO MADE IT, Nat Shapiro and Nat Hentoff. Louis Armstrong, Fats Waller, Jo Jones, Clarence Williams, Billy Holiday, Duke Ellington, Jelly Roll Morton and dozens of other jazz greats tell how it was in Chicago's South Side, New Orleans, depression Harlem and the modern West Coast as jazz was born and grew. xvi + 429pp.
21726-4 Paperbound $2.00

FABLES OF AESOP, translated by Sir Roger L'Estrange. A reproduction of the very rare 1931 Paris edition; a selection of the most interesting fables, together with 50 imaginative drawings by Alexander Calder. v + 128pp. 6½x9¼.
21780-9 Paperbound $1.25

AGAINST THE GRAIN (A REBOURS), Joris K. Huysmans. Filled with weird images, evidences of a bizarre imagination, exotic experiments with hallucinatory drugs, rich tastes and smells and the diversions of its sybarite hero Duc Jean des Esseintes, this classic novel pushed 19th-century literary decadence to its limits. Full unabridged edition. Do not confuse this with abridged editions generally sold. Introduction by Havelock Ellis. xlix + 206pp. 22190-3 Paperbound $2.00

VARIORUM SHAKESPEARE: HAMLET. Edited by Horace H. Furness; a landmark of American scholarship. Exhaustive footnotes and appendices treat all doubtful words and phrases, as well as suggested critical emendations throughout the play's history. First volume contains editor's own text, collated with all Quartos and Folios. Second volume contains full first Quarto, translations of Shakespeare's sources (Belleforest, and Saxo Grammaticus), Der Bestrafte Brudermord, and many essays on critical and historical points of interest by major authorities of past and present. Includes details of staging and costuming over the years. By far the best edition available for serious students of Shakespeare. Total of xx + 905pp.
21004-9, 21005-7, 2 volumes, Paperbound $5.25

A LIFE OF WILLIAM SHAKESPEARE, Sir Sidney Lee. This is the standard life of Shakespeare, summarizing everything known about Shakespeare and his plays. Incredibly rich in material, broad in coverage, clear and judicious, it has served thousands as the best introduction to Shakespeare. 1931 edition. 9 plates. xxix + 792pp. (USO) 21967-4 Paperbound $3.75

MASTERS OF THE DRAMA, John Gassner. Most comprehensive history of the drama in print, covering every tradition from Greeks to modern Europe and America, including India, Far East, etc. Covers more than 800 dramatists, 2000 plays, with biographical material, plot summaries, theatre history, criticism, etc. "Best of its kind in English," New Republic. 77 illustrations. xxii + 890pp.
20100-7 Clothbound $7.50

THE EVOLUTION OF THE ENGLISH LANGUAGE, George McKnight. The growth of English, from the 14th century to the present. Unusual, non-technical account presents basic information in very interesting form: sound shifts, change in grammar and syntax, vocabulary growth, similar topics. Abundantly illustrated with quotations. Formerly Modern English in the Making. xii + 590pp.
21932-1 Paperbound $3.50

AN ETYMOLOGICAL DICTIONARY OF MODERN ENGLISH, Ernest Weekley. Fullest, richest work of its sort, by foremost British lexicographer. Detailed word histories, including many colloquial and archaic words; extensive quotations. Do not confuse this with the Concise Etymological Dictionary, which is much abridged. Total of xxvii + 830pp. 6½ x 9¼.
21873-2, 21874-0 Two volumes, Paperbound $5.50

FLATLAND: A ROMANCE OF MANY DIMENSIONS, E. A. Abbott. Classic of science-fiction explores ramifications of life in a two-dimensional world, and what happens when a three-dimensional being intrudes. Amusing reading, but also useful as introduction to thought about hyperspace. Introduction by Banesh Hoffmann. 16 illustrations. xx + 103pp. 20001-9 Paperbound $1.00

POEMS OF ANNE BRADSTREET, edited with an introduction by Robert Hutchinson. A new selection of poems by America's first poet and perhaps the first significant woman poet in the English language. 48 poems display her development in works of considerable variety—love poems, domestic poems, religious meditations, formal elegies, "quaternions," etc. Notes, bibliography. viii + 222pp.

22160-1 Paperbound $2.00

THREE GOTHIC NOVELS: THE CASTLE OF OTRANTO BY HORACE WALPOLE; VATHEK BY WILLIAM BECKFORD; THE VAMPYRE BY JOHN POLIDORI, WITH FRAGMENT OF A NOVEL BY LORD BYRON, edited by E. F. Bleiler. The first Gothic novel, by Walpole; the finest Oriental tale in English, by Beckford; powerful Romantic supernatural story in versions by Polidori and Byron. All extremely important in history of literature; all still exciting, packed with supernatural thrills, ghosts, haunted castles, magic, etc. xl + 291pp.

21232-7 Paperbound $2.00

THE BEST TALES OF HOFFMANN, E. T. A. Hoffmann. 10 of Hoffmann's most important stories, in modern re-editings of standard translations: Nutcracker and the King of Mice, Signor Formica, Automata, The Sandman, Rath Krespel, The Golden Flowerpot, Master Martin the Cooper, The Mines of Falun, The King's Betrothed, A New Year's Eve Adventure. 7 illustrations by Hoffmann. Edited by E. F. Bleiler. xxxix + 419pp.

21793-0 Paperbound $2.25

GHOST AND HORROR STORIES OF AMBROSE BIERCE, Ambrose Bierce. 23 strikingly modern stories of the horrors latent in the human mind: The Eyes of the Panther, The Damned Thing, An Occurrence at Owl Creek Bridge, An Inhabitant of Carcosa, etc., plus the dream-essay, Visions of the Night. Edited by E. F. Bleiler. xxii + 199pp.

20767-6 Paperbound $1.50

BEST GHOST STORIES OF J. S. LeFANU, J. Sheridan LeFanu. Finest stories by Victorian master often considered greatest supernatural writer of all. Carmilla, Green Tea, The Haunted Baronet, The Familiar, and 12 others. Most never before available in the U. S. A. Edited by E. F. Bleiler. 8 illustrations from Victorian publications. xvii + 467pp.

20415-4 Paperbound $2.50

THE TIME STREAM, THE GREATEST ADVENTURE, AND THE PURPLE SAPPHIRE— THREE SCIENCE FICTION NOVELS, John Taine (Eric Temple Bell). Great American mathematician was also foremost science fiction novelist of the 1920's. *The Time Stream,* one of all-time classics, uses concepts of circular time; *The Greatest Adventure,* incredibly ancient biological experiments from Antarctica threaten to escape; The *Purple Sapphire,* superscience, lost races in Central Tibet, survivors of the Great Race. 4 illustrations by Frank R. Paul. v + 532pp.

21180-0 Paperbound $2.50

SEVEN SCIENCE FICTION NOVELS, H. G. Wells. The standard collection of the great novels. Complete, unabridged. *First Men in the Moon, Island of Dr. Moreau, War of the Worlds, Food of the Gods, Invisible Man, Time Machine, In the Days of the Comet.* Not only science fiction fans, but every educated person owes it to himself to read these novels. 1015pp.

20264-X Clothbound $5.00

CATALOGUE OF DOVER BOOKS

LAST AND FIRST MEN AND STAR MAKER, TWO SCIENCE FICTION NOVELS, Olaf Stapledon. Greatest future histories in science fiction. In the first, human intelligence is the "hero," through strange paths of evolution, interplanetary invasions, incredible technologies, near extinctions and reemergences. Star Maker describes the quest of a band of star rovers for intelligence itself, through time and space: weird inhuman civilizations, crustacean minds, symbiotic worlds, etc. Complete, unabridged. v + 438pp. 21962-3 Paperbound $2.00

THREE PROPHETIC NOVELS, H. G. WELLS. Stages of a consistently planned future for mankind. *When the Sleeper Wakes,* and *A Story of the Days to Come,* anticipate *Brave New World* and *1984,* in the 21st Century; *The Time Machine,* only complete version in print, shows farther future and the end of mankind. All show Wells's greatest gifts as storyteller and novelist. Edited by E. F. Bleiler. x + 335pp. (USO) 20605-X Paperbound $2.00

THE DEVIL'S DICTIONARY, Ambrose Bierce. America's own Oscar Wilde— Ambrose Bierce—offers his barbed iconoclastic wisdom in over 1,000 definitions hailed by H. L. Mencken as "some of the most gorgeous witticisms in the English language." 145pp. 20487-1 Paperbound $1.25

MAX AND MORITZ, Wilhelm Busch. Great children's classic, father of comic strip, of two bad boys, Max and Moritz. Also Ker and Plunk (Plisch und Plumm), Cat and Mouse, Deceitful Henry, Ice-Peter, The Boy and the Pipe, and five other pieces. Original German, with English translation. Edited by H. Arthur Klein; translations by various hands and H. Arthur Klein. vi + 216pp. 20181-3 Paperbound $1.50

PIGS IS PIGS AND OTHER FAVORITES, Ellis Parker Butler. The title story is one of the best humor short stories, as Mike Flannery obfuscates biology and English. Also included, That Pup of Murchison's, The Great American Pie Company, and Perkins of Portland. 14 illustrations. v + 109pp. 21532-6 Paperbound $1.00

THE PETERKIN PAPERS, Lucretia P. Hale. It takes genius to be as stupidly mad as the Peterkins, as they decide to become wise, celebrate the "Fourth," keep a cow, and otherwise strain the resources of the Lady from Philadelphia. Basic book of American humor. 153 illustrations. 219pp. 20794-3 Paperbound $1.25

PERRAULT'S FAIRY TALES, translated by A. E. Johnson and S. R. Littlewood, with 34 full-page illustrations by Gustave Doré. All the original Perrault stories— Cinderella, Sleeping Beauty, Bluebeard, Little Red Riding Hood, Puss in Boots, Tom Thumb, etc.—with their witty verse morals and the magnificent illustrations of Doré. One of the five or six great books of European fairy tales. viii + 117pp. 8⅛ x 11. 22311-6 Paperbound $2.00

OLD HUNGARIAN FAIRY TALES, Baroness Orczy. Favorites translated and adapted by author of the *Scarlet Pimpernel.* Eight fairy tales include "The Suitors of Princess Fire-Fly," "The Twin Hunchbacks," "Mr. Cuttlefish's Love Story," and "The Enchanted Cat." This little volume of magic and adventure will captivate children as it has for generations. 90 drawings by Montagu Barstow. 96pp. (USO) 22293-4 Paperbound $1.95

THE RED FAIRY BOOK, Andrew Lang. Lang's color fairy books have long been children's favorites. This volume includes Rapunzel, Jack and the Bean-stalk and 35 other stories, familiar and unfamiliar. 4 plates, 93 illustrations x + 367pp.
21673-X Paperbound $1.95

THE BLUE FAIRY BOOK, Andrew Lang. Lang's tales come from all countries and all times. Here are 37 tales from Grimm, the Arabian Nights, Greek Mythology, and other fascinating sources. 8 plates, 130 illustrations. xi + 390pp.
21437-0 Paperbound $1.95

HOUSEHOLD STORIES BY THE BROTHERS GRIMM. Classic English-language edition of the well-known tales — Rumpelstiltskin, Snow White, Hansel and Gretel, The Twelve Brothers, Faithful John, Rapunzel, Tom Thumb (52 stories in all). Translated into simple, straightforward English by Lucy Crane. Ornamented with headpieces, vignettes, elaborate decorative initials and a dozen full-page illustrations by Walter Crane. x + 269pp.
21080-4 Paperbound $2.00

THE MERRY ADVENTURES OF ROBIN HOOD, Howard Pyle. The finest modern versions of the traditional ballads and tales about the great English outlaw. Howard Pyle's complete prose version, with every word, every illustration of the first edition. Do not confuse this facsimile of the original (1883) with modern editions that change text or illustrations. 23 plates plus many page decorations. xxii + 296pp.
22043-5 Paperbound $2.00

THE STORY OF KING ARTHUR AND HIS KNIGHTS, Howard Pyle. The finest children's version of the life of King Arthur; brilliantly retold by Pyle, with 48 of his most imaginative illustrations. xviii + 313pp. 6⅛ x 9¼.
21445-1 Paperbound $2.00

THE WONDERFUL WIZARD OF OZ, L. Frank Baum. America's finest children's book in facsimile of first edition with all Denslow illustrations in full color. The edition a child should have. Introduction by Martin Gardner. 23 color plates, scores of drawings. iv + 267pp.
20691-2 Paperbound $1.95

THE MARVELOUS LAND OF OZ, L. Frank Baum. The second Oz book, every bit as imaginative as the Wizard. The hero is a boy named Tip, but the Scarecrow and the Tin Woodman are back, as is the Oz magic. 16 color plates, 120 drawings by John R. Neill. 287pp.
20692-0 Paperbound $1.75

THE MAGICAL MONARCH OF MO, L. Frank Baum. Remarkable adventures in a land even stranger than Oz. The best of Baum's books not in the Oz series. 15 color plates and dozens of drawings by Frank Verbeck. xviii + 237pp.
21892-9 Paperbound $2.00

THE BAD CHILD'S BOOK OF BEASTS, MORE BEASTS FOR WORSE CHILDREN, A MORAL ALPHABET, Hilaire Belloc. Three complete humor classics in one volume. Be kind to the frog, and do not call him names . . . and 28 other whimsical animals. Familiar favorites and some not so well known. Illustrated by Basil Blackwell. 156pp.
(USO) 20749-8 Paperbound $1.25

CATALOGUE OF DOVER BOOKS

EAST O' THE SUN AND WEST O' THE MOON, George W. Dasent. Considered the best of all translations of these Norwegian folk tales, this collection has been enjoyed by generations of children (and folklorists too). Includes True and Untrue, Why the Sea is Salt, East O' the Sun and West O' the Moon, Why the Bear is Stumpy-Tailed, Boots and the Troll, The Cock and the Hen, Rich Peter the Pedlar, and 52 more. The only edition with all 59 tales. 77 illustrations by Erik Werenskiold and Theodor Kittelsen. xv + 418pp. 22521-6 Paperbound $3.00

GOOPS AND HOW TO BE THEM, Gelett Burgess. Classic of tongue-in-cheek humor, masquerading as etiquette book. 87 verses, twice as many cartoons, show mischievous Goops as they demonstrate to children virtues of table manners, neatness, courtesy, etc. Favorite for generations. viii + 88pp. 6½ x 9¼.
22233-0 Paperbound $1.25

ALICE'S ADVENTURES UNDER GROUND, Lewis Carroll. The first version, quite different from the final Alice in Wonderland, printed out by Carroll himself with his own illustrations. Complete facsimile of the "million dollar" manuscript Carroll gave to Alice Liddell in 1864. Introduction by Martin Gardner. viii + 96pp. Title and dedication pages in color. 21482-6 Paperbound $1.25

THE BROWNIES, THEIR BOOK, Palmer Cox. Small as mice, cunning as foxes, exuberant and full of mischief, the Brownies go to the zoo, toy shop, seashore, circus, etc., in 24 verse adventures and 266 illustrations. Long a favorite, since their first appearance in St. Nicholas Magazine. xi + 144pp. 6⅝ x 9¼.
21265-3 Paperbound $1.75

SONGS OF CHILDHOOD, Walter De La Mare. Published (under the pseudonym Walter Ramal) when De La Mare was only 29, this charming collection has long been a favorite children's book. A facsimile of the first edition in paper, the 47 poems capture the simplicity of the nursery rhyme and the ballad, including such lyrics as I Met Eve, Tartary, The Silver Penny. vii + 106pp. 21972-0 Paperbound $1.25

THE COMPLETE NONSENSE OF EDWARD LEAR, Edward Lear. The finest 19th-century humorist-cartoonist in full: all nonsense limericks, zany alphabets, Owl and Pussycat, songs, nonsense botany, and more than 500 illustrations by Lear himself. Edited by Holbrook Jackson. xxix + 287pp. (USO) 20167-8 Paperbound $1.75

BILLY WHISKERS: THE AUTOBIOGRAPHY OF A GOAT, Frances Trego Montgomery. A favorite of children since the early 20th century, here are the escapades of that rambunctious, irresistible and mischievous goat—Billy Whiskers. Much in the spirit of Peck's Bad Boy, this is a book that children never tire of reading or hearing. All the original familiar illustrations by W. H. Fry are included: 6 color plates, 18 black and white drawings. 159pp. 22345-0 Paperbound $2.00

MOTHER GOOSE MELODIES. Faithful republication of the fabulously rare Munroe and Francis "copyright 1833" Boston edition—the most important Mother Goose collection, usually referred to as the "original." Familiar rhymes plus many rare ones, with wonderful old woodcut illustrations. Edited by E. F. Bleiler. 128pp. 4½ x 6⅜. 22577-1 Paperbound $1.25

TWO LITTLE SAVAGES; BEING THE ADVENTURES OF TWO BOYS WHO LIVED AS INDIANS AND WHAT THEY LEARNED, Ernest Thompson Seton. Great classic of nature and boyhood provides a vast range of woodlore in most palatable form, a genuinely entertaining story. Two farm boys build a teepee in woods and live in it for a month, working out Indian solutions to living problems, star lore, birds and animals, plants, etc. 293 illustrations. vii + 286pp.

20985-7 Paperbound $2.50

PETER PIPER'S PRACTICAL PRINCIPLES OF PLAIN & PERFECT PRONUNCIATION. Alliterative jingles and tongue-twisters of surprising charm, that made their first appearance in America about 1830. Republished in full with the spirited woodcut illustrations from this earliest American edition. 32pp. 4½ x 6⅜.

22560-7 Paperbound $1.00

SCIENCE EXPERIMENTS AND AMUSEMENTS FOR CHILDREN, Charles Vivian. 73 easy experiments, requiring only materials found at home or easily available, such as candles, coins, steel wool, etc.; illustrate basic phenomena like vacuum, simple chemical reaction, etc. All safe. Modern, well-planned. Formerly *Science Games for Children.* 102 photos, numerous drawings. 96pp. 6⅛ x 9¼.

21856-2 Paperbound $1.25

AN INTRODUCTION TO CHESS MOVES AND TACTICS SIMPLY EXPLAINED, Leonard Barden. Informal intermediate introduction, quite strong in explaining reasons for moves. Covers basic material, tactics, important openings, traps, positional play in middle game, end game. Attempts to isolate patterns and recurrent configurations. Formerly *Chess.* 58 figures. 102pp. (USO) 21210-6 Paperbound $1.25

LASKER'S MANUAL OF CHESS, Dr. Emanuel Lasker. Lasker was not only one of the five great World Champions, he was also one of the ablest expositors, theorists, and analysts. In many ways, his Manual, permeated with his philosophy of battle, filled with keen insights, is one of the greatest works ever written on chess. Filled with analyzed games by the great players. A single-volume library that will profit almost any chess player, beginner or master. 308 diagrams. xli x 349pp.

20640-8 Paperbound $2.50

THE MASTER BOOK OF MATHEMATICAL RECREATIONS, Fred Schuh. In opinion of many the finest work ever prepared on mathematical puzzles, stunts, recreations; exhaustively thorough explanations of mathematics involved, analysis of effects, citation of puzzles and games. Mathematics involved is elementary. Translated by F. Göbel. 194 figures. xxiv + 430pp. 22134-2 Paperbound $3.00

MATHEMATICS, MAGIC AND MYSTERY, Martin Gardner. Puzzle editor for Scientific American explains mathematics behind various mystifying tricks: card tricks, stage "mind reading," coin and match tricks, counting out games, geometric dissections, etc. Probability sets, theory of numbers clearly explained. Also provides more than 400 tricks, guaranteed to work, that you can do. 135 illustrations. xii + 176pp.

20338-2 Paperbound $1.50

MATHEMATICAL PUZZLES FOR BEGINNERS AND ENTHUSIASTS, Geoffrey Mott-Smith. 189 puzzles from easy to difficult—involving arithmetic, logic, algebra, properties of digits, probability, etc.—for enjoyment and mental stimulus. Explanation of mathematical principles behind the puzzles. 135 illustrations. viii + 248pp.
20198-8 Paperbound $1.25

PAPER FOLDING FOR BEGINNERS, William D. Murray and Francis J. Rigney. Easiest book on the market, clearest instructions on making interesting, beautiful origami. Sail boats, cups, roosters, frogs that move legs, bonbon boxes, standing birds, etc. 40 projects; more than 275 diagrams and photographs. 94pp.
20713-7 Paperbound $1.00

TRICKS AND GAMES ON THE POOL TABLE, Fred Herrmann. 79 tricks and games— some solitaires, some for two or more players, some competitive games—to entertain you between formal games. Mystifying shots and throws, unusual caroms, tricks involving such props as cork, coins, a hat, etc. Formerly *Fun on the Pool Table*. 77 figures. 95pp.
21814-7 Paperbound $1.00

HAND SHADOWS TO BE THROWN UPON THE WALL: A SERIES OF NOVEL AND AMUSING FIGURES FORMED BY THE HAND, Henry Bursill. Delightful picturebook from great-grandfather's day shows how to make 18 different hand shadows: a bird that flies, duck that quacks, dog that wags his tail, camel, goose, deer, boy, turtle, etc. Only book of its sort. vi + 33pp. 6½ x 9¼.
21779-5 Paperbound $1.00

WHITTLING AND WOODCARVING, E. J. Tangerman. 18th printing of best book on market. "If you can cut a potato you can carve" toys and puzzles, chains, chessmen, caricatures, masks, frames, woodcut blocks, surface patterns, much more. Information on tools, woods, techniques. Also goes into serious wood sculpture from Middle Ages to present, East and West. 464 photos, figures. x + 293pp.
20965-2 Paperbound $2.00

HISTORY OF PHILOSOPHY, Julián Marias. Possibly the clearest, most easily followed, best planned, most useful one-volume history of philosophy on the market; neither skimpy nor overfull. Full details on system of every major philosopher and dozens of less important thinkers from pre-Socratics up to Existentialism and later. Strong on many European figures usually omitted. Has gone through dozens of editions in Europe. 1966 edition, translated by Stanley Appelbaum and Clarence Strowbridge. xviii + 505pp.
21739-6 Paperbound $2.75

YOGA: A SCIENTIFIC EVALUATION, Kovoor T. Behanan. Scientific but non-technical study of physiological results of yoga exercises; done under auspices of Yale U. Relations to Indian thought, to psychoanalysis, etc. 16 photos. xxiii + 270pp.
20505-3 Paperbound $2.50

Prices subject to change without notice.
Available at your book dealer or write for free catalogue to Dept. GI, Dover Publications, Inc., 180 Varick St., N. Y., N. Y. 10014. Dover publishes more than 150 books each year on science, elementary and advanced mathematics, biology, music, art, literary history, social sciences and other areas.